INTRODUCTION TO AMERICAN GOVERNMENT

2nd Edition

Larry Elowitz, Ph.D.

Georgia College and State University
Milledgeville, GA

Contributing Editor

J. Matthew Wilson, Ph.D.
Southern Methodist University

Collins

An Imprint of HarperCollinsPublishers

ocm64771086

An American BookWorks Corporation Production

HarperCollins books may be purchased for educational, business, or sales promotional use. For information please write: Special Markets Department, HarperCollins Publishers, 10 East 53rd Street, New York, NY 10022.

Library of Congress Cataloging-in-Publication has been applied for.

ISBN: 13: 978-0-06-088151-1

ISBN: 10: 0-06-088151-8

06 07 08 09 10 CW 10 9 8 7 6 5 4 3 2 1

Contents

Preface

Introduction to American Government, 2nd Edition, part of the Collins College Outline series, is intended as a supplement to the main American government textbooks, both softbound and hardcover, currently used in high schools and at the undergraduate level in colleges and universities throughout the nation.

Introduction to American Government, 2nd Edition, provides essential information about American political institutions, leaders, events, processes, and concepts, so that you can better comprehend the related materials found in comprehensive textbooks. Real-life political examples are disseminated throughout in order to reinforce substantive material. This 2nd Edition covers the three branches of government, federalism, public opinion, the media, political parties, interest groups, the bureaucracy, voting, campaigns, and elections. There is also a chapter on public policy. The book contains a glossary of key terms important to the study of American government as well as relevant appendices. This work also can serve as an effective review device when preparing for major course examinations. Included are end-of-chapter opportunities to test yourself. Each chapter also includes answers to the test questions.

I am grateful to Fred N. Grayson for his invaluable technical assistance and encouragement extended to me during this project's evolution. In addition, my appreciation is extended to Dr. J. Mathew Wilson of Southern Methodist University and Tere Stouffer for their editing skills and substantive suggestions. Finally, I would like to thank my wife, Sharon, whose support, patience, and computer skills were all essential to this book's completion.

Larry Elowitz
Georgia College and State University

Government, Politics, and the Creation of the U.S. Constitution

I t is virtually impossible for an American citizen to escape the personal impact of government and the political process. The citizen confronts the diverse effects of political decision-making by an elected or appointed public official at the local, state, or federal governmental level. These "effects" may include a variety of taxes, environmental and consumer regulations, voting registration guidelines, city traffic regulations, or even the interest rates paid on a mortgage or college student loan. Conversely, a citizen can also influence his or her political world by exercising the constitutional freedoms incorporated and developed within the context of the Constitution.

That American constitutional system can be traced to the dramatic events of the 1787 convention in Philadelphia. The fifty-five delegates possessed certain political ideals and a desire to forge a stronger nation. The compromises they agreed to and the document they produced have clearly stood the test of time. This first chapter's coverage explains how an eighteenth-century plan of government still can have considerable relevance for a technologically advanced nation in the twenty-first century.

■ GOVERNMENT, POLITICS, AND POWER: SOME BASIC DEFINITIONS

Government, politics, and power are all interrelated. The following discussion of their respective meanings helps illustrate this fundamental point.

What Do We Mean by *Government*?

In the United States, government consists of institutions (Congress, the Supreme Court, a city council), agencies (Federal Reserve Board, Environmental Protection Agency, Internal Revenue Service), and elected/appointed political officials (mayors, legislators, governors, judges, cabinet heads, president) whose purpose is to write, enforce, or interpret laws and public policies in general. The main goals of local, state, and federal governments are to maintain public order, provide goods and services that help the lives of citizens, and protect basic freedoms and liberties.

A good example of government's potent force in the lives of Americans occurred after the tragic terrorist attacks of September 11, 2001, upon U.S. soil. Subsequently, President George W. Bush's administration took a series of steps, both at home (intelligence reform, establishing the Department of Homeland Security, tightening airport/border security) and abroad (military interventions in Afghanistan and Iraq), to defend and prevent the nation from experiencing a repeat of 9/11.

What Do We Mean by *Politics*?

Politics refers to the activities of influencing or controlling government for the purpose of formulating or guiding public policy. Two commonly used definitions coined by political scientists David Easton and Harold Lasswell are, respectively, "the authoritative allocation of values," and "who gets what, when, and how." The two definitions suggest that there must be some authority (governmental personnel) who can decide on those preferences (values) that will be selected over other choices. In short, politics is rooted in the inevitability of social conflict.

Why Are There Conflicts in American Society?

First, individuals differ in terms of needs, values, abilities, and attitudes. Disagreements follow over moral issues of right and wrong, such as abortion or the death penalty.

Second, individuals may quarrel over which problems are the most important to solve. For example, should the federal government spend more money on defense or social programs?

Third, individuals compete for scarce goods and services. Senior citizens over the age of sixty-five want higher Social Security benefits, but workers in their mid-twenties would prefer that less money be taken from their paychecks. Using Lasswell's definition, will the elderly get "what" they desire this year ("when") by convincing Congress, a part of government, to pass a law benefiting them ("how")? Or will Congress be politically influenced by thousands of young workers writing letters of protest against higher Social Security deductions? Whatever the final decision, values, as Easton would phrase it, will be "allocated" in an authoritative manner.

What Is Power?

Government has the power to enforce any law it passes. For example, a driver may feel that a seventy-mile-per-hour speed limit is a bad law and refuse to obey it. But the driver does face the consequences of breaking the law if he or she speeds excessively; for example, a fine or even time in jail. Similarly, many American citizens do not like to pay federal income taxes. But the Internal Revenue Service, an agency of the federal government, can prosecute individuals who fail to pay.

Power, then, is the ability of government to make a person do something he or she does not necessarily want to do. Still, the power of government is not unlimited. The people, through elections, protests, initiatives/referendums/recalls (citizens directly proposing legislation, expressing approval/disapproval on policy measures, removing officials) in some states or localities, and other forms of communication, do have the right to question governmental power in a democracy.

What Other Non-Democratic Forms of Government Exist?

Non-democratic or authoritarian governments are still prevalent in the modern era. In these types of governments, leadership accountability to the general population is weak or non-existent.

These governments include **autocracy,** a political system that involves rule by a single individual with unlimited power, such as a king, queen, or dictator (for example, Libya under the rule of Muammar al-Qaddafi). Likewise, an **oligarchy** is a country ruled by a relatively small self-appointed elite, perhaps by very wealthy landowners or a military junta. This elite largely oversees and controls governmental decision-making. Simply put, such authoritarian political systems place few restrictions on government or its leaders. An even more extreme form of **authoritarianism** is a **totalitarian political system**, where the government and its leaders are in complete control of every aspect of society (for example, the old Soviet Union under the aegis of the Communist Party). Finally, a **theocracy** refers to religious leaders constituting and running the government (for example, in contemporary Iran). Today, non-democratic regimes still rule more than one-third of the world's population.

What Are Direct and Representative Democracies?

The United States is a democracy, a term that means government by the people. Historically, there have been two types of democracies.

One, termed **direct democracy,** originated in the ancient Greek city-state of Athens, where citizens were expected to participate in political life (although women, slaves, and foreigners were ineligible for citizenship). All vital decisions were voted on by the entire citizenry. Contemporary America still practices direct democracy, most notably through the New England Town Meeting, in which nearly all of the town's voters play a role in deciding on tax rates, hiring city officials, adopting local laws, and so on through a majority vote. But direct democracy in a nation of 300 million individuals is simply not practical.

The second type of democracy—**representative** or **republican form of government**—was selected by the framers of the U.S. Constitution. The exercise of political power ultimately rests with the people, but policy decisions and running the nation are delegated to the people's chosen representatives through the election process. In the early days of the republic, only property owners were allowed to vote. Although the electorate was gradually broadened, it was not until the twentieth century that the voting rights of women and African Americans were fully permitted and sanctioned by all levels of government.

■ THE EARLIEST U.S. GOVERNMENT: THE ARTICLES OF CONFEDERATION

The only national political institution that evolved after the signing of the Declaration of Independence in 1776 was the Continental Congress. But the Congress had few resources with which to wage a war against the British. Small farmers and debtors preferred that power be held by state legislatures, rather than a national government, so that they could maximize their influence over local affairs. Wealthier farmers, merchants, land owners, and financial speculators preferred that property be protected by a strong central government. A compromise had to be reached between these two groups. The result was a government established under the Articles of Confederation.

The Articles of Confederation provided a plan of government that had some successes. The American government negotiated a favorable peace treaty with the British, provided for payment of war debts, and successfully passed the Northwest Ordinance, which allowed settlements (and eventual statehood) in a large region north of the Ohio River.

Defects in the Articles

The Articles suffered from some serious defects. Under the Articles, it was very difficult to raise and fund a viable national military. Congress could not tax goods or income, regulate commerce, or control a national currency. Congress could only ask for voluntary tax contributions from the states. Furthermore, passage of controversial bills required a difficult-to-attain two-thirds vote of the states, and amendments to the Articles required a near-impossible unanimous agreement of the thirteen state legislatures. In short, government under the Articles was actually a firm league of friendship, in which each state was a sovereign or independent political entity.

The Articles were also unable to cope with a series of economic and social misfortunes in the 1780s. First, a serious economic depression followed the Revolutionary War. Contributing to the depression were what amounted to economic wars between and among the states. For example, Rhode Island and Massachusetts placed protective tariffs on each other's manufactured goods. Second, there were troubles with European trade. Independence had led to American ships being barred from the British West Indies. The new government under the Articles was unsuccessful in obtaining important commercial treaties with Spain and France. Third, some states were controlled by the debtor class, which preferred inflationary monetary policies; others by the wealthy creditors, who desired restrictions on credit.

Shays' Rebellion

In western Massachusetts, farmers who could not pay their mortgages or high taxes interfered with the conduct of foreclosures and tax delinquency proceedings. In the winter of 1786, a former captain in the Revolutionary War, Daniel Shays, led a group of some 2,500 angry, musket-bearing debt-ridden farmers in a march on the federal arsenal at Springfield. Although the state militia put down the insurrection, the fears of economic disintegration in the colonies and outright anarchy disturbed many of America's leaders. The Articles of Confederation were unable to provide a strong central government that could promote stable economic growth or even develop a strong national army. (Massachusetts had put down the rebellion by using a private army financed through individual contributions.) It was time for major political change.

■ THE BIRTH OF THE UNITED STATES CONSTITUTION

Delegates to the 1787 Constitutional Convention in Philadelphia realized that America confronted a serious political crisis. Despite major differences between the large and small states and philosophical conflicts among the delegates, a series of vital compromises ultimately led to the writing of a historic plan of government. The Constitution was eventually ratified by all thirteen states despite major opposition from the **anti-Federalists.**

The Constitutional Convention

In 1786, a meeting was held in Annapolis, Maryland, to discuss problems associated with the Articles of Confederation. Alexander Hamilton's resolution, approved by the Annapolis delegates, called for Congress to authorize a convention in Philadelphia that would consider, in Hamilton's words, the "trade and commerce of the United States." Congress so acted, setting a date of May 14, 1787, for the convention. The Continental Congress directed that the convention's purpose was to revise and possibly

strengthen the Articles, not to create a new form of government. But amending the Articles would require the unanimous consent of the states.

The Delegates

Although seventy-four delegates were selected by twelve states (Rhode Island refused to send representatives), only fifty-five men attended. Some notable political figures of the day did not participate in the convention's proceedings. Thomas Jefferson was in France as U.S. ambassador, and John Adams was the ambassador to Great Britain. Thomas Paine, Patrick Henry, Richard Henry Lee, Samuel Adams, and John Hancock all feared a tyrannical centralization of power. Generally, the delegates who did attend were well-to-do, college-educated, and had ample political experience in colonial government. No African Americans, women, Native Americans, or common workers attended.

Most delegates did agree on a basic political philosophy—they believed in preserving property, had a pessimistic view of human nature (believing that people were selfish and base), and feared mass democracy. Therefore, government's role was to restrain humanity's love of power. As James Madison phrased it, "Ambition must be made to counteract ambition!" When the framers referred to the "people," they really meant the educated men of property. However, there were others, such as Benjamin Franklin, who were more trusting, believing that government by the consent of the governed meant all the people or at least all white males, and not just the "better" classes.

The delegates convened on May 25, 1787, and quickly agreed that George Washington should be the presiding officer, and that all proceedings would be held in secret. Then, after a few days of procedural questions, Edmund Randolph, who headed the Virginia delegation, introduced fifteen resolutions that represented the large states' plan for a new government.

The Virginia Plan

Randolph's plan called for a strong national government with a legislative branch making laws, an executive branch running the government day-to-day, and a judicial branch operating the court system and interpreting laws. There would be a **bicameral** (two-house) Congress, with representation in both chambers being based on state population. Voters would elect members of the lower house. Upper-house members would be elected by the lower house from nominations proposed by the state legislatures. Congress would elect both the executive and the Supreme Court judges. The national government would influence the people directly, in effect bypassing the states. One clear example of the central government's power was the concept of the executive and selected judges forming a Council of Revision that could veto both federal and state laws.

The New Jersey Plan

On June 15, William Paterson of New Jersey introduced the small-state plan. Congress would be a **unicameral** (one-house) legislature, with each state being entitled to one vote. Its members would be elected by the state legislatures. Congress would elect a plural executive for a nonrenewable term. The Supreme Court would comprise the judiciary, its judges appointed to life terms by the executive. Congress was granted the authority to regulate interstate trade and collect additional taxes from the states. Finally, national laws and treaties would be considered supreme and binding upon all the states.

The Connecticut Compromise

In mid-July 1787, a compromise between the large- and small-state plans was devised by Roger Sherman and William Johnson of Connecticut. The House of Representatives would have representation based upon population. In the Senate, or upper chamber, the small states would have equality of state representation—two senators per state. Furthermore, any new proposed laws would have to pass both legislative chambers, thus preventing the large states from dominating the small states, and vice-versa. The delegates accepted this compromise.

The Compromise over Slavery

Slaves accounted for roughly one-third of the South's population. Should these slaves count as citizens in apportioning representation (and taxes) to the southern states? After some heated debate, **three-fifths** of the slave population was counted. In addition, the South, in exchange for its approval of the national government controlling commerce, was allowed to continue the slave trade until 1808. After that date, Congress was allowed to ban the trans-Atlantic slave trade, which it promptly did at the first opportunity.

The Ratification Test

The signing of the Constitution meant only that the new document was a finished proposal. According to Article IV of the Constitution, nine states would have to **ratify** (approve) the plan. Majorities in each state's ratifying convention were required. However, a bitter debate subsequently unfolded between constitutional supporters, known as the Federalists, and their opposition, the anti-Federalists.

The Anti-Federalist Position. Anti-Federalists objected to the Constitution on the following grounds:
* The document benefited rich aristocrats, who would use a strong national government to control public policies.
* The political rights and independence of the states would be crushed.
* There was no Bill of Rights guaranteeing individual freedoms.

The *Federalist* Papers. Federalists counterattacked through the *Federalist Papers*, a series of newspaper articles written by Alexander Hamilton, James Madison, and John Jay. They argued for the following:
* No one faction could gain political control in a large federation in which many groups contested for power (based on Madison's assertion that "ambition must check ambition").
* The government would be divided into three branches—executive, legislative, and judicial—and each branch allowed to have partial control over the other two (example: the president could veto a bill, Congress could override that veto, the courts could interpret the meaning of a law), which would ensure liberty.
* The states would be granted "reserved powers" (those powers not specifically assigned by the Constitution to the federal government but simultaneously not constitutionally forbidden for use by the states) and have their existence protected.
* A **Bill of Rights** would be added to the Constitution after ratification.

Eventually, the Federalists would win the ratification struggle. But there were several close votes, as revealed in the Table 1.1.

Table 1.1 **State Ratification Votes**

State	Date	Yes	No
Delaware	December 7, 1787	30	0
Pennsylvania	December 12, 1787	46	23
New Jersey	December 18, 1787	38	0
Georgia	January 2, 1788	26	0
Connecticut	January 9, 1788	128	40
Massachusetts	February 6, 1788	187	168
Maryland	April 28, 1788	63	11
South Carolina	May 23, 1788	149	73
New Hampshire	June 21, 1788	57	46
Virginia	June 25, 1788	89	79
New York	July 26, 1788	39	27
North Carolina	November 21, 1789	195	77
Rhode Island	May 29, 1790	34	32

Amending the Constitution

The rules for amending the Constitution remain unchanged today and may take one of four forms:

1. An amendment may be proposed by a two-thirds vote of both houses of Congress, and then ratified by the legislatures of three-fourths of the states.
2. An amendment may be proposed by two-thirds of both houses of Congress, and then ratified by conventions in three-fourths of the states (thirty-eight in all).
3. An amendment may be proposed by a national convention, and then ratified by the legislatures of three-fourths of the states.
4. An amendment may be proposed by a national convention, and then ratified by conventions in three-fourths of the states.

Of the twenty-seven amendments added to the U.S. Constitution, all but one have been adopted by the first method. Only the Twenty-first Amendment was adopted by the second method. There has not been a national constitutional convention held since 1787.

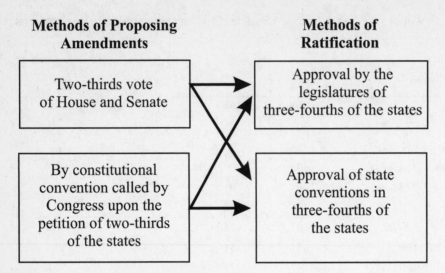

Methods of Proposing Amendments	Methods of Ratification
Two-thirds vote of House and Senate	Approval by the legislatures of three-fourths of the states
By constitutional convention called by Congress upon the petition of two-thirds of the states	Approval of state conventions in three-fourths of the states

Fig. 1.1 Amending the Constitution

■ POLITICAL IDEAS THAT INFLUENCED THE FRAMERS OF THE CONSTITUTION

The key political ideas that influenced the thinking of the framers included John Locke's concepts of the **social contract** and natural rights, majority rule and minority rights, and Jefferson's assertions of moral and legal equality for the individual. The concept of limited government was also inherent in the Bill of Rights.

John Locke: The Social Contract and Natural Rights

The framers of the Constitution were well versed in the political ideas of the English philosophers, particularly **John Locke** (1632–1704). In his *Two Treatises on Government,* Locke, through his concept of the social contract, argued that human beings had the capacity to perceive and understand higher or natural law, which posed standards for human conduct. Flowing from natural law are the natural rights of the individual—life, liberty, and property—that cannot be infringed upon by the state or government. It is the responsibility of those who rule to protect these natural rights. In turn, the people have the right to abolish those governments that violate such rights. Jefferson voiced these sentiments in the Declaration of Independence:

> To secure these rights, governments are instituted among Men, deriving their just powers from the Consent of the Governed. That whenever any Form of Government becomes destructive of these ends, it is the right of the people to alter or abolish it . . .

Implied in the framework of the social contract was Locke's principle of self-government—that people were intelligent enough to rule themselves by creating government for protection and societal order. They could also change the government when it no longer performed justly those basic political and social functions.

Locke's theories seemed to offer a potential balance between individual freedom and societal anarchy. First, his social-contract theory postulated that there was a mutual obligation between the state and the individual. The members of society accepted laws as binding upon them, giving their allegiance to the

government in exchange for protection and justice. But the government also had to keep its contractual bargain by preserving and defending the natural rights of the people.

Other Views: Hobbes and Hume

Locke's theories were not universally accepted by the framers. Two other British philosophers, **Thomas Hobbes** (1588–1679) and David Hume (1711–1776), viewed humanity as far more irrational, passionate, selfish, and even evil. The role of the state was mainly to restrain the emotional and moral excesses of the ruled; otherwise, order would dissolve into chaos. As James Madison asserted in the *Federalist Papers* (*The Federalist* No. 51; see Appendix E), "if men were angels, no government would be necessary." In short, the framers had to wrestle with an age-old political dilemma: how to guarantee individual freedom, protect it from governmental tyranny, and ensure that such freedom would not be abused by the individual himself.

Majority Rule and Minority Rights

The framers realized that individual freedom was not unlimited. The will of the majority was to be reflected in laws and policies, and these were to be obeyed by all, even the minority who might be opposed to those decisions. But how would the majority be prevented from tyrannizing the minority? In the U.S. political system, the Constitution sets definite limits on the majority. **Civil liberties** are guaranteed in the **Bill of Rights.** This is why the absence of a Bill of Rights in the original Constitution troubled so many of the anti-Federalists. (The Bill of Rights was adopted after ratification in 1791.) In addition, a Bill of Rights reaffirmed the doctrine of limited government, a doctrine popular in colonial America. Even a powerful centralized government had to respect such rights as a jury trial, freedom of speech, and freedom of religion.

Jefferson's famous contention in the Declaration that "all men are created equal" referred only to a moral and legal equality (note that Jefferson did own slaves). The framers clearly accepted the reality of differences among people in terms of ambition, motivation, temperament, and intelligence. In short, Americans today support the idea of **political equality,** whereby every qualified citizen should have the right to vote and, if desired, the chance to participate freely in the political system. Conversely, the idea of a government-enforced eradication of **economic and social inequality,** or what is sometimes referred to as **equality of result,** runs counter to the American idea of each individual determining his or her own status in life by hard work and personal abilities.

■ THE KEY CHARACTERISTICS OF CONSTITUTIONAL DEMOCRACY

The key characteristics of constitutional democracy include separation of powers, through checks and balances, free elections, freedom of expression (ensconced in the First Amendment), and universal education.

Separation of Powers through Checks and Balances

The constitutional framers wanted to control government by a division of government into three branches—the legislative, executive, and judicial. This **separation-of-powers principle** was the work of

the eighteenth-century French political philosopher Baron de Montesquieu. Montesquieu also insisted that a system of checks and balances, or overlapping of the powers of the branches of government, would prevent a potentially dangerous concentration of power. For example, the president would have the power to appoint Supreme Court justices. But the Senate would have to confirm these appointments. As Madison phrased it, the objective was "to divide and arrange the several offices [of government] in such a manner as that each may be a check on each other. . . ."

Free Elections

Free elections are indispensable to a democracy. In the United States today, regularly scheduled elections are open to registered voters who are eighteen years of age or older. Elections are frequent in the United States, constantly forcing candidates for public office to win the approval of the voters and respond to the challenge of the opposition.

Elections perform several important political functions:

- They transfer power from one set of leaders to another in a peaceful fashion.
- They promote stability and order in governing society over time.
- They allow citizens a chance to express their preferences on public policy.
- They promote accountability, because elected officials must consider the wishes of the people.

Freedom of Expression

Democratic dialogue is possible only if people are free and unafraid to express their opinions on issues, and to listen to the views of others. This principle is enshrined in the First Amendment to the Constitution.

Universal Education

Jefferson claimed that "a nation which expects to be ignorant and free expects what never was and what never will be." Jefferson contended that a democracy could be supported only by an informed citizenry instilled with democratic values and a willingness to defend those values from attack.

■ A BRIEF REVIEW OF THE CONSTITUTIONAL AMENDMENTS

There are currently twenty-seven amendments to the U.S. Constitution. The following represent brief summaries of each amendment:

The Bill of Rights

The first ten amendments constituted the original Bill of Rights added in 1791.

- **First Amendment:** Guarantees the "free exercise" of religion and freedom of speech, the press, assembly, and petition.
- **Second Amendment:** Establishes the people's right "to keep and bear Arms" within the context of a "well-regulated Militia."
- **Third Amendment:** Prohibits quartering of soldiers in private homes.

- **Fourth Amendment:** Prohibits "unreasonable searches and seizures" and establishes the issuance of search warrants upon "probable cause."
- **Fifth Amendment:** Creates the device of the grand jury; prohibits double jeopardy (an individual can't be tried again for the same crime once found innocent); prohibits being coerced into testifying against oneself; guarantees "due process of law" and the right of eminent domain (public acquisition of private property must be duly compensated).
- **Sixth Amendment:** Guarantees to the accused the right "to a speedy and public trial" by a jury. The rights of knowing the charges, being confronted with witnesses, and having the assistance of a lawyer for the defense are also included.
- **Seventh Amendment:** Preserves the right of a jury trial in common lawsuits exceeding twenty dollars.
- **Eighth Amendment:** Prohibits excessive bail (monetary guarantee that the defendant will appear in court at a particular time in the future) and "cruel and unusual punishments."
- **Ninth Amendment:** Establishes that numerated or detailed rights in the Constitution do not eliminate other rights "retained by the people."
- **Tenth Amendment**: Acknowledges that there are "reserved" powers granted to the states or the people.

Additional Amendments

The remaining seventeen amendments were added in the 1795 to 1992 time frame.

- **Eleventh Amendment:** Establishes that the judicial power of the United States does not extend to any law or equity suit brought by a foreign state or citizen against any state.
- **Twelfth Amendment:** Details the role and operation of the electors in the electoral college; also describes the mechanics of the House of Representatives' selection of the president and the Senate selection of the vice-president.
- **Thirteenth Amendment:** Abolishes the practice of slavery.
- **Fourteenth Amendment:** Forbids any state from depriving a person of life, liberty, or property without due process of law. It also "incorporates" the Bill of Rights and applies it to the states.
- **Fifteenth Amendment:** Establishes that citizens cannot be denied the right to vote on the grounds of "race, color, or previous condition of servitude."
- **Sixteenth Amendment:** Granted Congress the power to establish the federal income tax.
- **Seventeenth Amendment:** Provides for direct popular election of U.S. senators, rather than the previous method of selection by state legislatures.
- **Eighteenth Amendment:** Prohibits the "manufacture, sale, or transportation of intoxicating liquors" within the United States (the Prohibition Amendment).
- **Nineteenth Amendment:** Grants women the right to vote in the United States.
- **Twentieth Amendment:** Sets presidential and vice-presidential terms to begin on January 20; sets congressional representatives' and senators' terms to begin on January 3.
- **Twenty-first Amendment:** Repeals the Eighteenth Amendment (Prohibition).
- **Twenty-second Amendment:** Limits the president to a maximum of two elected terms.
- **Twenty-third Amendment:** Grants the District of Columbia electors in the electoral college.

- **Twenty-fourth Amendment:** Abolishes the poll tax as a requirement for voting in the United States.
- **Twenty-fifth Amendment:** Establishes that when there is a vice-presidential vacancy, the president may appoint a new vice-president with the approval of a majority vote by Congress. Also, when the president is unable to perform his office duties, the vice-president becomes acting president. Finally, if a conflict ensues between the acting president and the original president over who should occupy the office, Congress decides by a two-thirds vote within twenty-one days.
- **Twenty-sixth Amendment:** Grants eighteen-year-old American citizens the right to vote.
- **Twenty-seventh Amendment:** Stops members of Congress from receiving a pay raise until after an election for members of the House of Representatives has occurred.

The Constitution limits and fragments political power. Over 200 years, the Constitution's modifications through amendments and judicial interpretation have solidified the Lockean principles relating to governmental protection of life, liberty, and property. The American system of government, while certainly not perfect, has largely remained true to the social-contract ideal.

However, the American experiment in democratic self-government is still evolving. For example, the delicate balance of power between the national and state governments must still be redefined for each generation. Federalism, the subject of Chapter 2, is an apt reminder that the revolution of 1787 is far from over.

Selected Readings

Bernstein, Richard B. *Are We to Be a Nation? The Making of the Constitution* (1987).

Levy, Leonard W., ed. *Essays on the Making of the Constitution,* 2nd Edition (1987).

MacDonald, Forrest F. *Novus Ordo Seclorum: The Intellectual Origins of the Constitution* (1985).

Mead, Walter B. *The United States Constitution; Personalities, Principles, and Issues* (1987).

Rossiter, Clinton. *1787: The Great Convention* (1965).

Test Yourself

1) "Who gets what, when, and how" best defines the following:
 a) politics
 b) government
 c) power
 d) a constitutional system

2) True or false: A key role of government is to resolve social conflict.

3) A political system in which the government controls virtually every aspect of society and that of the individual's entire life is known as a(n) _____ system.
 a) theocratic
 b) totalitarian
 c) democratic
 d) oligarchic

4) True or false: America's style of government can best be described as a direct democracy.

5) Under the Articles of Confederation, which was a power of the Congress?
 a) mandatory taxation of the states
 b) regulation of commerce
 c) controlling a national currency
 d) none of the above

6) True or false: The rebellion led by Daniel Shays occurred after the Constitutional Convention.

7) Which of the following was not a part of the Virginia Plan at the Constitutional Convention?
 a) a unicameral national legislature
 b) members of Congress would be elected by state legislatures
 c) Congress would elect both the executive and Supreme Court judges
 d) A Council of Revision would veto both federal and state laws

8) True or false: The proceedings of the 1787 Constitutional Convention were open to the public.

9) If a southern state had 100,000 slaves, which fraction would be counted for purposes of representation according to the slavery compromise achieved at the Constitutional Convention?
 a) one-eighth
 b) one-half
 c) two-thirds
 d) three-fifths

10) True or false: The compromise between the large and small states at the Constitutional Convention of 1787 was devised by the Pennsylvania state delegation.

11) Which was the last state to ratify the Constitution in 1790?
 a) Massachusetts
 b) Delaware
 c) North Carolina
 d) Rhode Island

12) True or false: The anti-Federalists objected to the new Constitution because it lacked a Bill of Rights.

13) Except for the Twenty-first Amendment, all other amendments to the Constitution have been proposed by a _____ (fraction) vote of each house of Congress, and then ratified by _____ (fraction) of the states.
 a) three-fourths; three-fourths
 b) two-thirds; two-thirds
 c) two-thirds; three-fourths
 d) simple majority; four-fifths

14) True or false: Political philosopher Thomas Hobbes agreed with John Locke that human beings were able to rule themselves by creating governments for personal protection and societal order.

15) Which constitutional amendment grants "reserved powers" to the states?
 a) the First Amendment
 b) the Second Amendment
 c) the Tenth Amendment
 d) the Eleventh Amendment

16) True or false: There are currently twenty-seven amendments to the U.S. Constitution.

17) Who observed the importance of education in a democracy by asserting that "a nation that expects to be ignorant and free, expects what never was and what never will be"?
 a) Thomas Jefferson
 b) James Madison
 c) Baron de Montesquieu
 d) John Locke

18) True or false: The authors of the *Federalist Papers* were Franklin, Jefferson, and William Paterson.

19) The separation-of-powers principle was the work of which eighteenth-century political philosopher?
 a) John Locke
 b) James Madison
 c) Thomas Hobbes
 d) none of the above

20) True or false: According to the Constitution, every state, whether large or small, has equality of representation in the House.

Test Yourself Answers

1) **a.** This was political scientist Harold Lasswell's definition of politics.

2) **True.** Conflicts among individuals, groups, or institutions in a society are inevitable. Only government has the power to enforce resolutions of those conflicts for the entire society.

3) **b.** The other choices do not have "total control" over the individual and society.

4) **False.** The American style of government is a representative democracy, in which voters select public officials who, in turn, enforce, interpret, or make policy.

5) **d.** Congress had none of these powers under the Articles of Confederation system.

6) **False.** The rebellion occurred in 1786; the Constitutional Convention began in 1787.

7) **a.** The Virginia Plan proposed a bicameral, or two-house, national legislature.

8) **False.** The Convention proceedings were conducted in utmost secrecy.

9) **d.** Under the "three-fifths" (or sixty percent) compromise, 100,000 slaves would be reduced to 60,000.

10) **False.** It was devised by the Connecticut delegation.

11) **d.** Rhode Island ratified in May of 1790. The other twelve states ratified between 1787 and 1789.

12) **True.** The anti-Federalists believed that a strong central government could endanger the rights of the people. A Bill of Rights was a constitutional guarantee of protection.

13) **c.** This method has been used for twenty-six of the twenty-seven amendments.

14) **False.** Hobbes believed that humanity was incapable of governing itself.

15) **c.** The other three amendments do not grant this power.

16) **True.** The Twenty-seventh Amendment, delaying a salary increase for Congress for at least one election cycle, was ratified in 1992. Seventeen amendments have been added to the original Bill of Rights (ten amendments) in U.S. history.

17) **a.** This quote is attributed to Jefferson.

18) **False.** The authors were Hamilton, Madison, and Jay.

19) **d.** The philosopher was Baron de Montesquieu.

20) **False.** The House of Representatives is based upon state population. States with large populations are entitled to more legislators than states with much smaller populations.

Federalism

Federalism in America refers to the division and sharing of constitutionally assigned and/or implied powers between the national and state governments. America's federal system, a mixture of states' rights and national supremacy, allows states and municipalities to control a number of important programs: highway construction, some welfare programs, education, the police, and land-use regulations (zoning). Although the federal government possesses enormous power, it must persuade the states to govern in ways that will meet national, political, economic, and social goals. The states may not always be so persuaded—witness the years of resistance to progressive civil rights legislation passed by Congress, or the desegregation rulings of the United States Supreme Court. Despite federalism's imperfections, American federalism has been an attractive political arrangement shared by other nations, such as Canada, Australia, India, Brazil, and Germany.

■ UNITARY AND CONFEDERATION GOVERNMENTS

Unitary and **confederation** governments represent two other ways of distributing political power. In the unitary system, almost all of the political power is vested in the central government. Many democracies use this model, including France, Israel, England, Japan, and Sweden. By comparison, a confederation (such as the Confederate States of America during the U.S. Civil War) is an association of several sovereign units (states, provinces, republics) in which the central government has minimal powers.

America's national government depends upon cooperation from the states in order to function effectively. In 1786, that cooperation was far from satisfactory, hence the call for a constitutional convention (see Chapter 1). States also may secede from a confederation, but not from a federal system. The American Civil War established this principle by force of arms.

■ FEDERALISM AND THE CONSTITUTION

The following material covers the contrasting Jefferson vs. Hamiltonian views on federalism regarding the appropriate power allocation between the national and state governments (local governments can be created or abolished by state action) and the importance of delegated (specifically granted in the Constitution), implied (see the **elastic clause**), and concurrent (exercised by both the federal government and the states) powers. Governing relationships between and/or among the states are symbolized by those constitutional provisions dealing with the **full faith and credit clause** (each state recognizes the legal documents and records of another), the **interstate privileges and immunities clause** (rights of a citizen are protected in every state), and the interstate rendition clause (extradition). Finally, **interstate compacts** promote cooperation across state lines, as exemplified by the Port Authority of New York and New Jersey that supervises bridges, tunnels, ports, bus and railroad routes.

The Perspective of Framers

The founders were divided over the meaning of federalism. One group subscribed to the views of Alexander Hamilton, who argued for a powerful federal government that followed the concept of national supremacy. The other view, espoused by Thomas Jefferson, assumed the federal government to be a creation of the states. Jeffersonians believed that an "oppressive" national government could threaten individual liberties. It should, therefore, have limited powers. This struggle between national supremacy and states' rights would intensify over time.

Contemporary Federalism

Today, the United States consists of more than 88,000 separate governmental units. Along with the one national government and fifty state governments, there are cities, counties, school districts, and special districts, typically handling water supplies or sewage disposal systems, that collectively constitute local polities. The Constitution, however, recognizes only federal and state authority. Each state can create, abolish, or modify its local governmental units (in this sense they are actually unitary systems). For example, the state of Virginia could take territory away from any of its own cities.

Constitutional Provisions Relating to Federalism:
Delegated, Implied, and Concurrent Powers

States are given responsibilities in drawing congressional districts for members of the House of Representatives, ratifying or proposing constitutional amendments, and tapping the reserved powers granted to them by the Tenth Amendment. The federal government is allocated a long list of delegated (expressed) or specifically granted powers in Article I, Section 8, of the Constitution, such as borrowing money, raising armies, declaring war, and regulating commerce. In addition, the Constitution tells states what they may not do—no state can make a treaty with a foreign nation, grant titles of nobility, pass a bill of attainder (a law declaring an individual or group guilty of a crime and administering punishment without benefit of trial), approve *ex post facto laws* (laws that retroactively make an earlier non-criminal act a crime), levy taxes on imports or exports (without permission of Congress), impair the **obligation of contracts** (the legal basis of valid agreements between two or more parties cannot be arbitrarily abrogated by state governments) or keep military forces in peacetime. Finally, five amendments to the Constitution place restrictions on the actions of the states—the Thirteenth (no slavery), the Fourteenth (no denial of due process, equal protection of the

laws), the Fifteenth (no denial of vote due to race, color, or previous condition of servitude), the Nineteenth (no denial of vote on the basis of sex), and the Twenty-sixth (no denial of the vote to eighteen-year-olds).

In addition, the federal government derives **implied powers** from the so-called elastic clause or the **necessary and proper clause** of Article 1, Section 8, allowing it to implement delegated powers by any appropriate means. For example, the delegated power of raising an army or navy can be carried out via the implied powers of creating a draft or through the creation of the current volunteer army system.

Concurrent powers are those that can be exercised by both the national and state/local governments. Examples include taxation (federal income tax, state income tax, local sales tax), creation of courts, protection of civil rights, borrowing/spending money, and the chartering of banks or corporations.

The States Are Protected from the Federal Government

The U.S. Constitution declares that state representation in the U.S. Senate may not be altered without agreement from the affected state. Also, a state may not be divided or merged with another state without its consent. Finally, constitutional amendments may not be added without the ratifying vote of three-fourths of the states.

Constitutional Rules Governing Relations among the States

Rules for relations among the states, as set forth by the Constitution, include the full faith and credit clause, the privileges and immunities clause, the interstate rendition clause, and the implied use of interstate compacts, each of which is discussed in the following sections.

The Full Faith and Credit Clause. Found in Article IV, Section 1, the clause mandates that a state must accept the official records, documents, and civil rulings (a property sales contract, as one example) of other states in the union. In addition, a marriage or divorce obtained under the laws of one state are normally (but not always) considered legally valid by all other states. A recent controversy has been that of same-sex marriages (in 2005, only Massachusetts allowed gay marriages; such unions are banned in over thirty states), as only a handful of states have given legal rights to same-sex couples.

Note that this clause does not usually apply to professional credentials. A physician or lawyer practicing in one state has to recertify those credentials upon moving to a new state.

The Interstate Privileges and Immunities Clause. According to Article IV, Section 2, "The citizens of each state shall be entitled to all privileges and immunities of citizens in the several states." Each state is expected to extend the same courteous treatment to citizens of other states as well as the same legal protections. For example, a citizen has access to the courts in another state. Also, a new resident of a state cannot be forced to pay higher taxes than residents who have lived in the state for many years. In short, this clause protects fundamental rights across the nation.

The Interstate Rendition Clause. This clause, found in Article IV, Section 2, states the following: ". . . a person charged in any state with Treason, Felony, or other Crime, who shall flee from Justice, and be found in another State, shall on Demand of the executive authority of the State from which he fled, be delivered up to be removed to the State having jurisdiction of the Crime."

Normally, a fugitive who flees to another state is willingly extradited or sent back to the state where the alleged crime was committed. However, the Supreme Court has ruled that the federal courts cannot compel a governor to extradite a fugitive, especially if the governor of a non-capital punishment state believes that fugitive will be mistreated upon his or her return in the form of an unjust trial and even the imposition of the death penalty

Interstate Compacts. Article I, Section 10, asserts that "no State shall, without the Consent of Congress, enter into any Agreement or Compact with another State." However, assuming congressional permission, interstate compacts or agreements have been realized through negotiations by the governors of those involved states. Currently, these binding compacts, enforceable by the federal judiciary, try to manage problems that cross state borders. In recent years, these compacts have dealt with interstate problems such as transportation, crime, the environment, and trade. For example, the Port Authority of New York and New Jersey, founded in 1921, supervises interstate bridges and tunnels, ports for ships, and bus and railroad routes. Future compacts may deal with such difficult problems as radioactive waste disposal from nuclear power plants.

■ THE NATIONAL GOVERNMENT'S RELATIONSHIP WITH THE STATES

The Constitution mandates that each state must establish a "republican" government (one based on democratic principles, protection of the citizenry's liberties, and internal stability). However, it also places ultimate power in the hands of the national government, i.e., the national supremacy principle, whose legal origins stem from the famous 1819 case of *McCulloch v. Maryland* decided by Chief Justice John Marshall. State law that contradicts or invalidates federal law is not permitted (note John C. Calhoun and the principle of **nullification**). Finally, contemporary federalism has evolved from **dual federalism** (the layer-cake analogy implying separation of federal and state political jurisdictions) to **cooperative,** or picket-fence, **federalism** (federal and state government sharing responsibility over public policies).

Guarantee of a Republican Form of Government/ Protection Against Internal Violence

According to the Constitution (Article IV, Section 4), the national government is required to guarantee a "republican" form of government within each state and to protect each state against foreign invasion or internal violence. (States can request federal aid to suppress domestic violence.) The president may use federal troops or federalize the state militia. As an example, President Lyndon B. Johnson sent federal troops to Selma, Alabama, in 1965 in order to protect a voting rights march led by the Rev. Martin Luther King, Jr.

The "republican form of government" guarantee is not defined clearly in the Constitution, nor has the Supreme Court ruled conclusively on its meaning. The Court considers the issue a "political question" that should be addressed by the president and Congress. However, the term is generally understood to mean a "representative democracy," whereby fundamental liberties are preserved.

After the Civil War, Congress charged that several southern states did not have a republican form due to continuing discriminatory practices against blacks. Congress refused to admit "elected" senators and representatives from these states.

Respect for Territorial Integrity

The federal government is constitutionally required to acknowledge the legal existence and boundaries of each state in the Union. Consequently, Congress cannot carve out a new state from the existing territory of another state without the approval of that state's legislature.

The Principle of National Supremacy

Article VI is clear on the issue of **national supremacy**: states may not pass laws or enact policies that are in conflict with the Constitution, acts of Congress, or national treaties. If there is a conflict, state laws/policies are clearly subservient to federal statutes. This is the doctrine of **pre-emption,** in which the federal government takes precedence over state/local laws. Policy areas typifying the doctrine include ultimate federal control over civil rights, voting rights, and clean air/water statutes.

The concept of national supremacy was established in the 1819 Supreme Court case of *McCulloch v. Maryland.* Chief Justice John Marshall declared that the state of Maryland did not have the power to tax the national bank of the United States, an act that clearly violated the Supremacy Clause. As Marshall phrased it: "If any one proposition could command the universal assent of mankind we might expect it to be this—that the government of the Union, though limited in its powers, is supreme within its sphere of action. The States have no power to retard, impede, burden, or in any manner control the operation of the constitutional laws enacted by Congress."

Marshall's Argument

To Marshall, the government of the United States was established by the people, not the states. The federal government and its related institutions were accordingly immune to destructive policies passed by the states. In Marshall's words, "The power to tax was the power to destroy." Hence, the Maryland law was unconstitutional. In addition, the federal government had the right to establish a national bank under the implied powers of the necessary and proper clause. The Marshall Court also expanded congressional controls over interstate commerce through such historic cases as *Gibbons v. Ogden* in 1824. But the battle between states' rights and federal power was far from over.

Nullification and War

The doctrine of nullification, first proposed by Thomas Jefferson and James Madison and later revived by John C. Calhoun, argued that the states could declare a federal law invalid if they believed it to be a violation of the Constitution. Jefferson and Madison had invoked the doctrine in 1798 over a federal law that punished newspaper editors for printing critical stories about the federal government. Calhoun, of South Carolina, used the doctrine to attack national tariffs in 1828 and federal efforts to ban slavery. The Civil War resolved the nullification issue. The Union could not be dissolved, and the states could not unilaterally obviate federal law.

Dual Federalism (Layer-Cake Federalism)

In the era after the Civil War, the states promulgated the theory of **dual federalism**, which held that the national government was supreme in its sphere of influence, but that the states were equally supreme in their areas of political jurisdiction (this was called separate layers). The Tenth Amendment was perceived by the Supreme Court as a barrier to national power. For example, Congress could regulate *interstate commerce*

(commerce between the states), but it was up to the states to handle *intrastate* (within each state) commerce. Industrial production was construed as a local activity under the jurisdiction of the states. The same philosophy was extended to child labor laws in 1916, when it asserted that the national government could not regulate what was essentially a local problem. However, the national scope of huge corporations and the growing complexity of the economy obliterated these artificial distinctions.

The election of Franklin D. Roosevelt as president in 1932 accelerated the decline of dual federalism. Although FDR's predecessor, Herbert Hoover, had remained committed to dual federalism, the Great Depression (twenty-five percent unemployment, thousands of bank failures and business closings) led FDR to maximize the power of the federal government in promoting an economic recovery for the nation. Although the Supreme Court initially struck down as unconstitutional much of FDR's New Deal legislation, it eventually approved the federal government's power to regulate commerce and the economy by the late 1930s. By the 1940s, farming and manufacturing were clearly defined as falling under the scope of federal supervision. Today, dual federalism has yielded to the contemporary model of cooperative federalism.

Cooperative Federalism

Cooperative federalism has been compared to a marble cake, as opposed to dual federalism's layer-cake analogy. The states and federal government frequently share the administrative costs and responsibilities associated with public programs. A good example is the field of public education. The national government provides considerable monetary aid to elementary and secondary schools, but state and local officials handle such areas as curriculum standards and teacher certification requirements. For hundreds of other cooperative programs, the Federal government may pay for part of the bill, but states and cities must also bear some of the costs of the project, be it airport construction or sewage treatment plants.

Consequently, states often vehemently object to **unfunded mandates,** or costly requirements imposed upon them by federal government requirements (see the "A Note on Federal Controls: Mandates and Conditions of Aid" section later in this chapter) without accompanying financial resources. An example was President George W. Bush's "No Child Left Behind" educational program (passed in 2002), which compelled states to engage in annual standardized testing and to fix (or even) close failing schools, but provided no federal money for these purposes.

Note that another variation of cooperative federalism is termed **picket-fence federalism**. Imagine the horizontal boards as the three levels of government (national, state, and local governmental levels) and vertical boards (programs and policies involving each level of government) comprising that fence. The term implies that officials at the three levels will work together or even simultaneously to implement policy at each picket location (for example, welfare reform).

■ WHY THE STATES/LOCALITIES REMAIN IMPORTANT IN THE FEDERAL SYSTEM

The states and localities continue to play a significant role in American politics through their police powers that collectively cover the health, safety, and welfare of their respective populations. There are three governmental services in which they have major control—law enforcement, education, and land controls (zoning and housing patterns). There are two reasons explaining these areas of influence:

- The traditional belief held by the American people that the police and schools should come under local jurisdiction.
- The support of locally elected legislators for such views.

For example, House and Senate members would typically oppose strong federal supervision over the curriculum of the nation's schools.

■ FEDERAL GRANTS-IN-AID

Traditionally, federal grants have constituted important revenue sources for the states and localities. The political philosophy underlying both the distribution of those grants and their specific type (categorical, block) has varied considerably with each presidential administration, especially in the modern era. Important issues surrounding grants have included unfunded mandates and the process of devolution.

The Early Era of Fiscal Federalism

The earliest federal grants given to the states were land grants for colleges and universities. Grants also assisted in the construction of railroads, wagon roads, flood-control zones, and canals. In subsequent decades, grants increased in popularity as states willingly accepted plentiful amounts of federal tax dollars. The federal government, in keeping with the concept of dual federalism, allowed state control over the administration of grant programs.

Politically, state governors could attack wasteful federal spending while still accepting federal money for "important projects" in their respective states. This remains a standard political ploy even today.

The Modern Era of Federal Grants

The modern concept of a federal grant-in-aid derives from the presidency of Franklin D. Roosevelt. FDR established categorical grants for specific problems such as children's health and vocational education. Categorical grants were expanded even more under the Great Society programs of Lyndon Johnson in the 1960s. Five new federal programs accounted for this growth:

- Aid to low-income families.
- Medicaid (health insurance for the poor)
- Highway construction.
- Unemployment assistance.
- Welfare payments to low-income mothers who had disabled children or no spousal support.

State and local governments now were required to put up matching funds, a share of the total cost of the particular program being promoted. Also, these grants had strings attached, such as not using federal funds to discriminate against minorities or approving construction projects that paid workers a below-union wage. Finally, some grants bypassed the states entirely, allocating funds directly to local governments or even community civic groups.

Project and Formula Categorical Grants

There are two basic types of **categorical grants**—project and formula:

- **Project grants:** The most common type of categorical grant, these are awarded on the basis of competitive applications. An example would be university professors applying for funds to be used for scientific research.
- **Formula grants:** These grants are distributed according to a complex formula incorporating population, income, rural population, or other variables. The total amount of money allocated for a school lunch program to a particular state or locality would be formula-based.

Block Grants

These grants, begun in 1966, involve federal funding to the state and local governments in general; they encompass broad areas such as mental health or criminal justice. **Block grants** were more consistent with the conservative political philosophy of allowing greater discretion to the states/localities in determining how and where the funds should actually be spent. Still, federal strings gradually multiplied even with these ostensibly no-strings-attached grants.

A Note on Federal Controls: Mandates and Conditions of Aid

Mandates are federal laws or court rulings that compel cities and states to implement certain policies even if no aid is received. Examples include protection of the environment, Medicaid coverage/eligibility, and federal pure-drinking-water standards. These conditions of aid do not have to be accepted by the states or localities; however, rejection of these conditions usually prevents the receipt of federal dollars. For example, in the past, Western states lost highway construction funds when they did not comply with the then federally mandated fifty-five-mile-per-hour speed-limit standard. In 2000, Congress adopted a national driver safety standard—a blood-alcohol level reading of 0.08%. States that did not comply with that percentage level could lose as much as 80 percent of federal highway construction money (the penalties were to be implemented during the 2004 to 2007 time frame). Finally, note that despite passage in 1995 of the Unfunded Mandates Reform Act, the Congressional Budget Office has indicated that billions in costs are still passed on to the states via federal unfunded mandates.

Federalism under Nixon and Carter

Lyndon Johnson's Great Society was based on the premise that the states could not be trusted to use federal grant money wisely—that is, to help the poor and disadvantaged. But starting with the Nixon administration's **New Federalism,** this assumption was challenged with programs intended to give fiscal decision-making powers back to the states (this return of powers to the states is termed **devolution**). General revenue-sharing allocated federal tax dollars back to state and local officials, who, in turn, were given wide discretion as to how those funds would be spent. Categorical grants also were combined into general funding areas such as the Model Cities or Urban Renewal programs. These block grants proliferated with the Comprehensive Employment and Training Act (CETA) in 1973. CETA was modified by President Jimmy Carter in 1978 in order to send funds directly to the needy, rather than relying on state and locally elected politicians to make the allocation decisions.

Reagan's New Federalism

The Reagan administration tried to reverse even further the centralization trend begun by FDR in the 1930s. Reagan conservatives opposed big government, federal programs to help the poor, and federal expenditures on costly social programs, which they argued contributed to economic inflation and stagnation. They stressed the theme of devolution, which meant shifting federal responsibilities to the states, localities, and the private sector. President Reagan promptly consolidated seventy-seven categorical grants to nine new block grants to be administered by the states. He also proposed the **Great Swap,** whereby the federal government would assume full responsibility for **Medicaid** (health care for the indigent elderly), while the states would handle the food-stamp and other welfare programs. But Congress rejected this plan.

Another Reagan argument was that state and local officials should not depend as much on federal handouts. Instead, these officials should tap other revenue sources at their respective governmental levels. But state officials resented these federal cuts and also objected to revenue-sharing being canceled by the Reagan administration as a way of further reducing federal spending. The states reacted by developing new revenue sources, such as lotteries, which raised billions of dollars. States also cut expenses through such devices as privatizing formerly public services (trash collection) and encouraging more welfare recipients to find employment.

Federalism under Presidents George H.W. Bush, Bill Clinton, and George W. Bush

President George H.W. Bush, like President Reagan, tried to continue the idea of a smaller federal government by asking states and localities to take responsibility for the cost of mass transit and water treatment facilities. President Bush was, however, forced to increase federal Medicaid grants to the states due to rising health costs.

During President Clinton's presidency (1993–2001), national grant funding to the states increased substantially. The passage of the 1996 Welfare Reform Act meant that billions of federal dollars were now given (through block grants) to the states, which, in turn, paid welfare benefits to eligible families and individuals. Welfare recipients were limited to a two-year period of assistance, by which time they had to find jobs (with a lifetime total of five years on welfare was allowed).

President George W. Bush increased federal funding and control over public education through the 2002 No Child Left Behind Act. States and localities had to demonstrate improvement in poorly performing schools through the use of standard achievement tests. In addition, the terrorist attacks of 9/11/01 upon American soil led the Bush Administration to send billions of dollars to the states and localities in a comprehensive attempt to prevent further acts of terrorism.

Supreme Court Decisions Regarding Federalism During the Clinton-Bush Eras

The Supreme Court gave two important rulings between 1992 and 2004 that involved the link between federalism and interstate commerce:

- *United States v. Lopez* (**1995**): The Court placed a limit (for the first time in sixty years) on the range of the national government's interstate commerce authority by ruling that Congress had exceeded its constitutional powers when it passed the 1990 Gun-Free School Zones Act. Under the law, the possession of guns was banned within 1,000 feet of a school. According to the Supreme Court, this ban was not a part of commerce or related to any type of economic activity.

- *United States v. Morrison* (2000): The Supreme Court struck down the provisions of the 1994 Violence Against Women Act, asserting that gender-motivated violence, such as rape, did not have a sufficient impact upon commerce to warrant federal regulation.

■ ADVANTAGES AND DISADVANTAGES OF FEDERALISM

The founders created a federal structure to prevent a tyrannical concentration of political power that might silence the voice of the states. The ultimate goal of the federal system was to strengthen the foundations of democracy through power-sharing. Was the federal vision of the framers fulfilled?

Advantages

Federalism is seen as having a number of advantages:

- It promotes a measure of local control over political life and multiplies the opportunities for political participation through the elections of thousands of state and local officials, so that a citizen or interest group denied access at one level of government can seek redress at another. In short, the opportunity to gain political power is widely disseminated among the fifty states, over 3,000 counties, and among thousands of municipal governing units.
- It encourages experimentation and diversity vis-à-vis the nation's social and political needs; for example, Georgia was the first state to give eighteen-year-olds the right to vote, and California was a pioneer in devising air-pollution policies long before the federal government passed a comprehensive clean-air act for the entire nation.

Disadvantages and Problems

Some notable disadvantages and problems of federalism are:

- Its local orientation encourages provincialism and obstruction of progress.
- Local autonomy can create wasteful duplication, such as the plethora of agricultural agencies at all three levels of government. The bureaucracies become bloated and administrative costs increase proportionately.
- Federal systems may have difficulty coordinating policies that inherently spill over state lines, such as air and water pollution. Acid rain that falls upon states in New England originates in the industrial centers of the Midwest, but those polluting states can refuse to pay for damages.
- Inequalities among states are persistent in such areas as educational spending, crime prevention, health care, and even building codes.
- The lurking fear that the power of the federal government will encroach inappropriately upon the powers, privileges, and constitutionally-assigned responsibilities of the states.

The sharing of political power is the trademark of contemporary federalism. Although national supremacy is now accepted, the states are clearly partners with the federal government on both policy coordination and implementation. Billions of federal grant dollars continue to reinforce the marble-cake relationship. In the past, some experts have predicted that an all powerful federal government would even-

tually render the states politically meaningless. However, state governments have markedly improved their performance in such policy areas as education, urban renewal, and the environment. Political leadership in the states also has improved. In short, the federal tradition seems to be in no danger of extinction.

Selected Readings

Anton, Thomas. *American Federalism and Public Policy* (1989).

Beer, Samuel H. *To Make a Nation: The Rediscovery of American Federalism* (1993).

Dye, Thomas R. *American Federalism: Competition Among Governments* (1990).

Elazar, Daniel. *American Federalism: A View from the States,* 3rd Edition (1984).

Goodman, Frank, ed. *The Supreme Court's Federalism: Can States Be Trusted?* (2001).

Katz, Ellis, and Alan G. Tarr, eds. *Federalism and Rights* (1996).

Posner, Paul J. *Politics of Unfunded Mandates: Whither Federalism?* (1998).

Reagan, Michael, and John G. Sanzone. *The New Federalism* (1981).

Whittington, Keith E. *Constitutional Construction* (2001).

Wright, Deil S. *Understanding Intergovernmental Relations,* 3rd Edition (1988).

Test Yourself

1) Which of the following nations does *not* have a federal system of government?
 a) Australia
 b) Germany
 c) Israel
 d) India

2) True or false: Alexander Hamilton believed that the federal government was a creation of the states.

3) Which of the following is an example of a concurrent power?
 a) borrowing/spending money
 b) creation of courts
 c) chartering of banks
 d) all of the above

4) True or false: None of the fifty American states may make a treaty with a foreign nation.

5) The constitutional clause that mandates that a state must accept the official records, documents, and civil rulings of other states is known as the
 a) privileges and immunities clause
 b) full faith and credit clause
 c) interstate rendition clause
 d) elastic clause

6) True or false: The Port Authority of New York and New Jersey is an example of an interstate compact.

7) The Supreme Court ruling that first established the principle of national supremacy was
 a) *McCulloch v. Maryland*
 b) *Gibbons v. Ogden*
 c) *United States v. Lopez*
 d) none of the above

8) True or false: The term "republican form of government" is generally thought to be equivalent to a representative democracy.

9) Which historical event probably *first* accelerated the decline of dual federalism?
 a) the aftermath of the Civil War
 b) Calhoun's attack on national tariffs in 1828
 c) the Great Society programs of Lyndon Johnson
 d) the election of President Franklin D. Roosevelt

10) True or false: Cooperative federalism is comparable to the layer-cake analogy.

11) An area of major control for most states/localities is
 a) zoning and housing patterns
 b) law enforcement
 c) education
 d) all of the above

12) True or false: In *United States v. Lopez,* the U.S. Supreme Court ruled that banning gun possession within 1,000 feet of a school was a constitutionally accepted use of the commerce clause by Congress.

13) Federal programs that give fiscal decision-making powers back to the states is described as the process of
 a) pre-emption
 b) devolution
 c) imposing unfunded mandates
 d) picket-fence federalism

14) True or false: President George W. Bush's No Child Left Behind program actually represented greater federal controls over education in the states.

15) Which of the following is not an advantage of federalism?
 a) It promotes and encourages cultural diversity.
 b) It multiplies opportunities for political participation.
 c) It promotes equalities in social services among the states.
 d) It encourages social and political experimentation.

16) True or false: The trademark of contemporary federalism is the sharing of political power.

17) Under the 1996 Welfare Reform Act, welfare recipients have a lifetime total of _____ years on welfare.
 a) two
 b) three
 c) four
 d) five

18) True or false: President Reagan's Great Swap proposed giving full responsibility for Medicaid to the states.

19) The awarding of a scientific research grant to a university professor would exemplify a(n) _____ grant.
 a) project
 b) categorical
 c) block
 d) none of the above

20) True or false: Due to the 1995 Unfunded Mandates Reform Act, states no longer face the prospect of unfunded mandates from the federal government.

Test Yourself Answers

1) **c.** Israel has a unitary system of government. The other three have federal systems.

2) **False.** Hamilton was a firm believer in a strong national government. He would not have believed that the federal government was a creation of the states; to Hamilton, the federal government was supreme over the states.

3) **d.** All are concurrent powers; that is, they can be exercised by both the national and state governments.

4) **True.** Only the national government can formulate treaties with other nations.

5) **b.** Privileges and immunities refers to equal legal treatment of all citizens; interstate rendition involves extradition; the elastic clause refers to implied powers.

6) **True.** Interstate compacts are agreements between or among states, approved by Congress and sanctified by the federal judiciary.

7) **a.** *Gibbons* dealt with the expansion of interstate commerce, while *Lopez* restricted the scope of interstate commerce.

8) **True.** A republican form is based upon the freedom of a state's people to elect officials as well as to protect essential democratic liberties.

9) **d.** The aftermath of the Civil War perpetuated dual federalism. Calhoun was a believer in dual federalism; that is, states' rights. Johnson's Great Society occurred in the 1960s, three decades after FDR's New Deal.

10) **False.** It is comparable to the marble-cake analogy, because it represents a mingling of federal/state relationships.

11) **d.** All three choices are examples of activities that come under the jurisdiction of state and local governments.

12) **False.** The Court ruled that the gun ban was not part of the commerce clause; hence, Congress had gone beyond its authority.

13) **b.** Pre-emption refers to national supremacy; mandates refer to states paying the costs imposed upon them by federal actions/laws; picket-fence federalism refers to the simultaneous cooperation of all levels of government on a specific policy.

14) **True.** No Child Left Behind involved an increased federal oversight over the public schools, in terms of accountability, testing, and the closing of failing schools.

15) **c.** Inequalities among states (unfortunately) exist in a federal system.

16) **True.** Federalism divides and shares powers between a central government and subnational units.

17) **d.** All the other numbers are wrong.

18) **False.** The Great Swap referred to Medicaid being handled by the federal government.

19) **a.** Categorical and block do not fit this description.

20) **False.** States still must pay unfunded mandates despite the congressional act.

Public Opinion and the Mass Media

Public opinion may be defined as the collection of views and attitudes held by different groups and individuals in America toward the political system in general, and toward important public issues specifically. There is no one public, but many **publics;** that is, separate groups with different views. Leaders must try to consider these diverse publics when creating new policies. Significantly, a private opinion is transformed into a public opinion through voting, protest, petition, or other forms of public communication that involve broader societal norms.

The **mass media**—books, films, radio, newspapers, television, magazines and journals, and the Internet—transmit information to the American people and their political leaders. The media play an important role in supporting democracy and influencing public opinion. As Thomas Jefferson wrote in 1787, "Were it left to me to decide whether we should have a government without newspapers, or newspapers without a government, I should not hesitate a moment to prefer the latter." The media report on the government's actions (or inaction), the political behavior of public officials, the many events that impact upon the lives of citizens, the views of candidates running for office, and unresolved social problems. The public's degree of respect for, and belief in, the political system can also be shaped by the tone that the media set in their news coverage. In short, the media play a large role in providing the information base from which citizens develop their opinions; conversely, elected officials can learn from media reports and polls what the chief policy concerns of the public may be.

■ PUBLIC OPINION IN A DEMOCRACY

The public's support of and trust in the nation's political leaders are obviously vital components of American democracy. Whether the pattern of public opinion is one of polarization or consensus, leaders must understand the reasons behind that pattern and take appropriate responses. Complicating that assessment are the qualities of public opinion ranging from stable beliefs to highly changeable ones (fluidity). Finally, the material covered in this section reviews the key formative agents of **political socialization**

(family, schools, peer groups, etc.) and how personal characteristics such as gender, religion, or race can impact upon an individual's beliefs and perceptions vis-à-vis public policies.

The Importance and Types of Public Opinion

People have different opinions on issues. But in order for a democracy to function effectively, the many individuals and groups within society must accept democracy's fundamental ideas and values. These ideas and values include an acceptance of majority rule, individual rights, minority protection, peaceful resolution of social problems, and tolerance for dissent. Also, the people must believe that their opinions count and that leaders can be trusted to act responsibly (note that the trust Americans have in the federal government has varied appreciably over time). In turn, elected officials understand that public support is:

- both a source of power and legitimacy.
- an invaluable aid in comprehending which prevailing issues concern the population.

Note that a **consensus** exists when an ample public majority agrees on a particular issue or policy (Americans, for example, generally believe in the necessity of the Social Security system). A **polarization** of opinion exists when public acceptance of an issue and/or elected officials is seriously divided (for example, abortion, the Vietnam War, and the approval rating of a controversial president).

The Qualities of Public Opinion

Political scientists have specified five qualities of public opinion that can vary over time: intensity, relevance, fluidity, stability, and quiescence. Each is discussed in the following sections.

Intensity

Intensity measures how strongly people feel about a given issue and their determination to express their private opinions publicly. For example, most Americans have strong opinions about the right of a woman to have an abortion, both pro and con. Truly intense opinions can frequently help a minority of the public win on a public policy issue over a less-concerned, politically inactive majority. Thus, the National Rifle Association, the largest anti-gun-control group in America, has been successful in thwarting the passage of comprehensive gun-control laws by Congress, despite polls that reveal a majority of the public favors such legislation.

Relevance

Relevant public opinion deals with how important or unimportant an issue may be to individuals. It is closely related to intensity. An elderly citizen facing serious medical expenses will be concerned over increased costs of Medicare health coverage. An eighteen-year-old must think about the possibility of future military service (or even the reinstitution of the draft) when he or she registers with his local selective service board. Homeowners will be upset over a projected increase in property taxes, but apartment renters will be indifferent, because these taxes do not directly affect them.

Fluidity

Public opinion can change very quickly, sometimes overnight. A classic example of opinion fluidity was America's strong **isolationism** (avoiding a war against Germany or Japan) prior to December 7, 1941.

After the Japanese attack on Pearl Harbor, national opinion changed to full support of the war effort. Likewise, in 1965, Americans supported President Lyndon Johnson's handling of the Vietnam War, only to turn against that conflict and force Johnson's announcement in March, 1968, that he would not run again. Prior to 9/11/01, Americans were only mildly concerned about terrorism. The terrorist attacks upon Washington, D.C. and New York City magnified those concerns tremendously, as the public rallied behind the presidency of George W. Bush.

Stability

Stability refers to the constancy of people's opinions. Some individuals maintain their opinions for a very long time; for example, the vast majority of Americans believe that democracy is a good, if not the best, form of government. This type of fundamental acceptance seems constant from generation to generation. Similarly, the American public's support of capitalism and belief in the free market are very steadfast.

Stable opinions are not easily changed, because they are usually linked to inherently important personal or societal values.

Quiescence

Quiescent, or latent public opinion, refers to potential opinion that can become activated through events or the communication of more information, especially by the media. Thus, the American people were ready for a president who was an **outsider**—that is, not a Washington politician—after the Watergate scandal forced President Richard Nixon's resignation in August 1974. Hence, the campaign of Jimmy Carter, an ex-governor of Georgia, was launched, resulting in his 1976 presidential victory over Gerald Ford. As another example, the media's emphasis on the dangers of the fatal disease AIDS from the late 1980s through the first decade of the twenty-first century forced millions of citizens to think about the problem and form appropriate opinions.

The Agents of Political Socialization

Americans learn about their leaders and develop their opinions about government through the lifelong process known as **political socialization.** Important to this process are the family, schools, peer groups, friends, opinion leaders, the media, and generational events. These strong influences are each discussed in the following sections.

Family

Family is the most important agent of political socialization. A child's parents, brothers and sisters, grandparents, or other relatives can all influence his or her early political attitudes. A family that discusses politics around the dinner table can bequeath to the child a lifelong interest in public affairs. Conversely, a family of nonvoters, whose members may describe politicians as crooks, can transmit to children negative feelings toward government.

The Family and Party Identification. One clear legacy of the family is the transfer of party or partisan identification to children. Research reveals that nearly one-third of school-children can identify with a party by the second grade. If both parents are strong supporters of the Republican (or Democratic) party, their children tend to adopt that party as their own as they begin political life. However, recent

studies suggest that young people are becoming more independent, so that a family's partisan influence is somewhat weaker today than it was two decades ago.

Family Influence and Attitudes toward Political Authority. Most children identify with the president as a benevolent figure by the time they are age six or seven. However, low-income, poorly educated families tend to produce children whose attitudes are more hostile to the presidential figure, and to political authority in general.

Schools

The educational system tries to reinforce the legitimacy of the political system through civics courses, student participation in school government, the Pledge of Allegiance, patriotic messages, and treatments of American history and governmental institutions in textbooks. Students who go to a college where most professors are political liberals are likely to be influenced in that ideological direction. The same process applies to politically conservative colleges/universities. Finally, note that higher levels of education are closely associated with an individual's expressions of interest in politics, voting, and the development of informed opinions about the issues of the day.

Peer Groups, Friends, and Opinion Leaders

Groups consisting of friends and associates who share similar social or workplace characteristics can influence opinions as well. Thus, members of a labor union may have fairly uniform views toward the government's protection of their right to collective bargaining. Corporate executives may agree on the desirability of minimum governmental interference in the marketplace. **Opinion leaders**, respected and politically knowledgeable teachers, syndicated columnists, nationally known public officials, and friends or relatives, can also influence political beliefs and attitudes. Citizens who believe they have a limited degree of political awareness will look to these opinion leaders as important suppliers of information on public issues, leaders, and policies.

The Media

The media bombard the citizen with all kinds of political information. However, studies show that people have **selective perception**—that is, they will ignore media reports that run counter to their existing beliefs or are of little interest to them. The media's role in opinion formation is elaborated on in the second half of this chapter.

Generational Events

Major, traumatic events can permanently shape attitudes of each political generation. The Great Depression of the 1930s convinced a majority of the electorate that the Democratic party could best handle the issue of economic prosperity via federal intervention into the nation's economy. The stability of this opinion persisted until the era of Ronald Reagan in the 1980s and through the rest of the century, when the idea of big government fell into disfavor. The World War II generation (1939–1945) believed that American military preparedness and combating aggression overseas were vital to protecting American security. During the 1960s and 1970s, the Vietnam War and the Watergate scandal led millions of Americans to question the integrity of the presidency and politicians in general (and many schoolchildren

acquired a less favorable view of the president as well). Finally, the attacks of 9/11 convinced Americans that terrorism must be defeated. In the 2004 presidential election, this perception immeasurably helped Republican President George W. Bush defeat Democratic Senator John Kerry.

Personal Characteristics and Opinion Differences

Personal characteristics can have a definitive impact upon opinion; included are such factors as race, ethnicity, and income; religion; region and place of residence; and gender. The following sections describe each.

Race, Ethnicity, and Income

White Americans and African Americans have differed over the issues of school busing (more blacks than whites accepted the practice as promoting integration), the death penalty (more whites favor it), higher spending for defense (whites are more supportive), and national health insurance and affirmative action (a greater number of African Americans than whites believe in these policies). Furthermore, African Americans have consistently voted Democratic, while many blue-collar whites have turned their support to the Republican Party.

Hispanic Americans generally favor Democratic candidates, but Hispanics of Cuban ancestry prefer Republicans. Asian Americans narrowly select Democrats over Republicans.

Regarding income differences, a general rule is that very wealthy Americans usually oppose government economic intrusion (and, therefore, tend to support a Republican platform), whereas poorer citizens like government intervention (a more Democratic view).

Religion

Religious backgrounds and educational level affect opinions, and different religious teachings affect an individual's conceptions of morality, social justice, human nature, and obedience to authority. For example, Catholics tend to be more liberal than white Protestants on economic issues; Jewish Americans are more liberal than either Catholics or Protestants on both economic and non-economic concerns. Born-again Christians tend to favor school prayer and oppose abortions with a greater intensity than many other religious groups. Also, regular churchgoers and evangelicals are usually cultural conservatives who have supported the Republican Party in recent presidential elections.

Region and Place of Residence (Large Cities, Suburbs, Small Towns)

A person's geographic region and residence can impact political attitudes. The South, for example, remains more conservative than the Northeast (a region that clearly leans to the Democratic Party), especially on racial issues, law-and-order policies, and the meaning of moral values. Southerners also tend to be more supportive of defense spending than other regions (the presence of many military bases in the South may account for this opinion). In fact, the old **solid South** that once supported the Democratic Party is no more. For example, in 2004, President Bush attracted fifty-eight percent of southern voters, compared to forty-two percent for Senator John Kerry. In presidential elections, Pacific coast states have helped Democrats, whereas the Rocky Mountain and Great Plains states are Republican strongholds.

Regarding places of residence, most of the nation's largest cities have voted Democratic; the suburbs and smaller towns have traditionally supported Republican candidates.

Gender

Until the mid-1970s, few major differences existed between the political views of men and women. One difference was in regard to the use of military force; more women than men were opposed to the Vietnam War. Throughout the next four decades, women retained this attitude toward overseas conflicts. Additionally, women tend to be more opposed to the death penalty than men. Still, on other issues, the so-called **gender gap** was virtually nonexistent. For example, majorities of both men and women approve of abortion.

Gender differences have manifested themselves during the last two presidential elections. In the 2000 election, fifty-four percent of women voted for the Democratic presidential nominee Al Gore compared with forty-two percent of male voters. In 2004, John Kerry attracted fifty-one percent of the female vote, but only forty-four percent of Kerry voters were men.

■ PUBLIC OPINION POLLS

The early history of public opinion polls was marred by failures to obtain **samples** that were scientifically valid or based upon representative, randomly-selected data (*Literary Digest,* the 1948 Gallup Poll). Even modern polls, while typically accurate, can contain flaws due to a variety of reasons as explained in the following material.

The History of Polling

Prior to the era of modem scientific polling, magazines and newspapers would solicit opinions from their readers by face-to-face **straw polls (polls collectively based on the individual responses from those readers)** or mail surveys. However, despite a large number of responses, these techniques were unreliable. The straw vote emphasized quantity of responses over the quality of the sample. In other words, an accurate cross-section of the voting population was by no means assured.

The *Literary Digest Mistake of 1936*

A famous case of faulty surveys was the *Literary Digest* poll that predicted the outcome of the presidential election of 1936 between the Republican candidate, Alfred Landon, and the Democratic incumbent, President Franklin D. Roosevelt. The *Digest,* a popular magazine of its day, mailed postcard ballots to more than ten million individuals whose names had been taken from automobile registration lists and telephone directories. After more than two million ballots were returned, the magazine stated that Landon would easily win the election. The opposite occurred, as Roosevelt won in a landslide, capturing sixty percent of the vote and winning every state except Maine and Vermont.

What had been the *Digest*'s mistake? The magazine contacted wealthier Americans who could afford cars and telephones during a Depression year. Poorer classes of Americans had been omitted— the unemployed, blue-collar workers, and ethnic minorities—and those groups were the heart of FDR's voting strength. Shortly after the 1936 election, the *Digest* went out of business.

The 1948 Gallup Poll's Error

After the *Digest* debacle, more-sophisticated scientific pollsters developed far better techniques, using personal interviews with small samples of selected voters. George Gallup's organization became famous, but it, too, unwittingly created a **biased (inaccurate) sample** in the 1948 election between

Republican challenger Thomas Dewey and the incumbent Democratic candidate, President Harry S. Truman. Roughly two weeks before election day in November, Gallup confidently predicted Dewey to be the winner (it forecast that Truman would win slightly less than forty-five percent of the popular vote). Thinking Dewey to be far ahead, it stopped interviewing voters. Subsequently, many voters changed their minds, switching from Dewey to Truman. The result was a Truman victory with nearly fifty percent of the popular vote.

Proper Polling

Clear lessons of 1936 and 1948 are that the sample of individuals polled must be a microcosm of the much larger population and that interviewing must be continued up to election day since opinion can be very fluid. A poll is only a "snapshot of opinion" at a particular point in time. Accurate polling procedures must:
- Construct a representative or random sample.
- Use valid and reliable questions.
- Carefully communicate with respondents.

These ideas are discussed in more detail in the following sections.

Constructing a Representative, Random Sample

A national sample must be representative in that every major characteristic of the population—income differentials, occupation, race, religion, regional balance, party affiliation, gender, ethnicity, the age spectrum, previous voting tendencies, and life status, among others—from which the sample has been drawn must exist in that sample. Most national polls interview between 1,000 and 2,000 people, usually by telephone, who collectively represent the national U.S. adult voting population. The sample size must also be large enough to reflect the major social, economic, and political characteristics of the American electorate.

A representative sample is chosen through the process of random sampling, which is basically a lottery system whereby every individual in the population and each geographic region has an equal mathematical chance of being included in the sample, just as in a lottery every number has the same probability of being selected. If the sample is large enough and is truly randomly selected, the law of probability states that final results will be satisfactory, usually within a small margin of error—typically no more than plus or minus three percent in national polls. If a poll projects that "Candidate A" will receive fifty-two percent of the vote on election day, his/her actual percentage could vary within a range of forty-nine to fifty-five percent. Over the years, the Gallup Poll, with few exceptions, has accurately predicted the winner of each presidential election. As examples, in 1996, Gallup's final poll predicted that Bill Clinton would win more than forty-nine percent of the vote, compared to his actual winning percentage of fifty-two percent. In 2000, Gallup's last survey awarded George W. Bush fifty percent of the vote, compared to his actual winning total of forty-eight percent. In 2004, the respective percentages were just over forty-nine percent, contrasted with President Bush's final winning percentage of nearly fifty-one percent.

The Use of Valid Questions

The manner in which questions are phrased is quite important to a poll's final results. Questions that are emotionally loaded can predetermine responses from those being interviewed. For example, the question

"Do you agree with a woman's freedom of choice to have an abortion?" will elicit different responses than will the question "Do you agree with a woman's right to murder her unborn child by means of an abortion?"

Communication with Respondents

Questioners conducting polls through face-to-face interviews or over the phone (the typical method used today) must avoid contaminating truthful responses through their voice inflections, pre-existing attitudes toward the questions asked, or unintentional coaching of interviewees. To avoid these problems, polling organizations exercise great care in hiring and training their field personnel.

Problems with the Polls

In addition to the *Literary Digest* and 1948 Gallup classic mistakes, polls in recent years have encountered greater volatility in public opinion as well as evasive, untruthful responses from those interviewed over the phone. There has also been the problem of whether a poll contacts primarily **likely voters** (a smaller population segment) as opposed to **registered voters**, who constitute a much larger population. Consequently, pollsters survey more often, some even on a daily basis, especially during a very close presidential campaign, as was the case in 2000 and 2004. But earlier elections also had difficulties. In 1984, several polls seriously underestimated the final margin between Reagan and Mondale (eighteen percentage points); and in 1988, the polls were in error by as much as seventeen percentage points in the various presidential primaries. Also, exit polls (see the "Use of Exit Surveys" below) caused major problems in the 2000 and 2004 presidential elections.

Five other problems related to polling, all discussed in the following sections, include the bandwagon effect, exit surveys, push polling, people with non-attitudes, and the increasing use of cell phones.

The Bandwagon Effect

Critics charge that publishing poll results will influence voters to vote for the candidate who appears to be far ahead of his opponent. People want to select the obvious winner. Although there is little empirical evidence to support this claim on the national level, some studies suggest that it has influenced election outcomes in state and local races.

Use of Exit Surveys

Exit pollsters interview voters regarding their ballot choices as they leave the voting booth on election day. By taking a random sample and collating voter responses, predictions as to the eventual winner can be made relatively early. One problem with exit surveys (also called **exit polls**) is that some voters will not be truthful with interviewers about how they have voted, thus distorting the process. In addition, not all voters are willing to participate.

Exit polls have been utilized by the networks to predict both congressional and presidential victors, thus discouraging citizens who planned to vote later in the day from even going to their respective precincts. Exit polls in previous elections have reduced voter turnout in the western states based on poll projections made earlier from the Northeast and South. Exit polls have also been misleading or even inaccurate. In the 2000 presidential election, exit polls in the crucial state of Florida incorrectly led the networks to declare at first that Al Gore was the winner in that state and, therefore, the next president.

In 2004, early afternoon exit polls on election day erroneously suggested that John Kerry was running well ahead of President George W. Bush.

Push Polling

Push polling refers to the practice of asking respondents loaded questions about a candidate in order to receive negative responses. Respondents are, in effect, pushed toward a desired attitudinal outcome. These biased polls then can be used against that candidate in the campaign. Of course, questions can be designed to elicit positive responses as well. In either situation, perceptions about a candidate can be strengthened among voters through this deceptive and contrived polling process.

Non-Attitudes

Other problems faced by pollsters include **non-attitude** individuals, who answer poll questions without any real knowledge base or preferences. Whatever the motivation of these individuals, their responses do interfere with an accurate sample.

Cell Phones

Cell phones pose an additional difficulty, in that individuals who *exclusively* use these phones (that is, they do not have a land line) are not ordinarily accessible to survey organizations via computer-generated random dialing based upon conventional phone books. Due to prohibitions enacted by the Federal Communications Commission, it is unlawful for polling organizations to use auto-dialing technology in order to call cell phone numbers. Polling companies may contact cell phones manually, but they cannot do so at a cost to the owner of the cell phone. Hence, exclusive cell phone users, many of whom are under the age of 35, can be underrepresented in the sample.

Polls and the Media

The media publish national and regional poll results on a regular basis. In fact, major newspapers such as the *New York Times, USA Today,* and the *Washington Post* frequently conduct their own polls on important policy questions. Media poll coverage can influence the opinions of those undecided or even uninformed Americans.

The reciprocal relationship between the media and American public opinion is not new. Indeed, the media's role in both reacting to and creating opinion has been historically significant, as discussed in the following section.

■ A BRIEF HISTORY OF PRINT MEDIA

The historical evolution of the media, ranging from the formation of the nation's early newspapers to the modern era of radio, television, and the Internet is covered in the following section. Additionally, federal regulation of the media is discussed.

Early Partisanship and the Press

Partisan newspapers were published during the early years of the American republic. The *Gazette of the United States,* a pro-Federalist newspaper, was sponsored by Alexander Hamilton, while Jefferson

countered with the *National Gazette,* a pro-Republican party publication. Both papers were too expensive for the average citizen to afford (most citizens were illiterate, anyway), and their small circulation was almost exclusively directed at the party faithful. Issues usually appeared only once or twice a week. Clearly, early newspapers did not seek the goal of impartial reporting. In fact, it was not until the 1830s that newspapers moved toward independent ownership and mass circulation.

Press Partisanship Declined; Mass-Circulation Newspapers Became Prominent

In 1845, the invention of the high-speed rotary press ushered in low-cost, mass-produced newspapers. The telegraph permitted a rudimentary wire service, relaying stories between cities at a faster pace. Improved literacy rates caused circulation and sales to increase. This new financial status liberated newspapers from their previously strong ties to party patronage. As newspapers became more issue-oriented, many editors practiced more flamboyant methods of boosting sales, including yellow journalism and muckraking.

The Rise of Yellow Journalism

A new style of reporting, called **yellow journalism,** evolved by the late 1800s, stressing coverage of scandals, violence, disasters, and sports in an effort to expand circulation. This reporting method (the name came from the inexpensive yellow paper used by these newspapers) contributed to the outbreak of the Spanish-American War after William Randolph Hearst's paper, the *New York Journal,* printed inflammatory stories about Cuba, Spain, and the sinking of the American battleship *Maine.*

Muckrakers

Opinion magazines such as *McClure's* and *Collier's* promoted the art of investigative reporting, or **muckraking,** a term coined by Theodore Roosevelt to refer to the dirt being uncovered. Typical muckrakers were Ida M. Tarbell, who analyzed John D. Rockefeller's Standard Oil monopoly in a series of magazine articles, and Lincoln Steffens, whose book *Shame of the Cities* recognized the pervasiveness of urban corruption in America.

The Era of Objective Journalism

American journalism reacted against Hearst's excesses by embracing the concept of objective journalism. Led by Adolph Ochs, owner of the *New York Times,* **objective journalism** avoided partisanship and exaggerated opinions in favor of the facts of a story and the presentation of all sides.

One other factor promoting objectivity was the profit motive, because sales depended on reaching as many groups in society as possible. In addition, newspapers began to separate advertisements from the news, eliminating a source of bias. Finally, newly formed journalism schools at Columbia University and the University of Missouri reinforced the merits of objective journalism. Today, most newspaper publishers follow the principles of objectivity (as they see it), trying to achieve a liberal-conservative balance even in their opinion columns.

■ THE DEVELOPMENT OF RADIO AND TV BROADCAST JOURNALISM

Technology in the twentieth century extended the media's reach dramatically. The electronic media—radio and TV—now reached millions of citizens.

The Rise of Radio and Today's Talk Radio

National political leaders, especially President Franklin D. Roosevelt in the 1930s, grasped the idea of the potential power of radio. Roosevelt used his radio fireside chats to talk directly to the American people. As a result, later presidents did not have to rely upon newspaper editors and reporters to reinterpret their political messages. Radio became the first national media form, reaching millions of Americans instantaneously and simultaneously.

Today, ninety-nine percent of American homes have radios. A contemporary phenomenon, talk radio, has also enjoyed increased popularity among listening audiences. Although most talk radio shows are ideologically slanted (the majority are conservative-oriented; for example, Rush Limbaugh) and not a forum for polite debate, they do involve a segment of the public who may wish to vent political views and opinions.

The Rise of TV

The widespread use of television in the 1950s brought political life into the homes of millions of Americans. TV's full political potential was first realized with the broadcast of the national party conventions in 1952. Republican candidate Eisenhower then pioneered TV political commercials in the following campaign (nationally, there were only fifteen million TV sets at the time). Presidential candidate John F. Kennedy and Vice-President Richard M. Nixon held the first nationally televised debate in 1960. The importance of looking good on TV and projecting competence became apparent when Kennedy, appearing youthful, handsome, and knowledgeable, won the debate handily over Nixon, who looked tired, ill, and unshaven. (Ironically, radio listeners thought Nixon had won the debate, but the TV audience was far larger.) Subsequently, President Kennedy, during the early 1960s, became the first chief executive to utilize TV fully in speeches and live press conferences. TV presidential debates in 1960, 1976, 1980, 1984, 1988, 1992, 1996, 2000, and 2004 have all added to the medium's impact.

Televised congressional hearings, dealing with an issue such as the Watergate scandal in the 1970s, brought viewers closer to another vital political institution. Also, TV network news expanded dramatically in terms of amount of time on the air and range of topics covered. In addition, the emergence of twenty-four-hour cable news in the 1980s deepened the impact of TV exposure.

Today, ninety-eight percent of all homes in America have at least one TV set, and the medium is the major source of political news for the public. Polls reveal that two out of every three Americans consider TV news stories to be more accurate than newspaper accounts. Studies show that as much as ninety percent of all Americans employ TV as their primary source of news. Thus, it was not surprising that the importance of the electronic media requires federal regulation.

Broadcasters Are Licensed by the Government

The **Federal Communications Commission** (FCC) was established in 1934 to regulate the performance standards first of radio and then eventually of television stations. The FCC develops regulations covering station ownership, signal strength and frequency location, advertising rates, and general access to the airwaves by citizens and public officials. The FCC requires that an operating license for each radio and TV station be renewed after eight years.

Federal Regulations Regarding Political Content

Federal law dictates that stations give equal time to all candidates running for the same office. Until 1987, they also operated under the provisions of the fairness doctrine.

The Equal Time Provision. If radio or TV broadcasters make air time available to one candidate running for public office, they must allow **equal time** to all other candidates who seek that same office. All air costs must be the same for each candidate, and rates must also be comparable to those charged to commercial advertisers. Indeed, in many circumstances, stations are required to offer reduced rates for political advertising.

The Fairness Doctrine. Until 1987, broadcasters adhered to the **fairness doctrine,** which mandated the airing of opposing opinions on significant public issues. But, frequently, issues have more than two sides, so strict adherence to the doctrine consumed inordinate amounts of broadcast time. For this reason, owners of stations sometimes avoided controversy altogether. They also objected to the fact that the FCC imposed the doctrine upon their operations, but not upon newspapers or magazines.

Subsequently, the FCC abolished the doctrine in 1987 on the basis that it violated freedom of the press (because broadcasters should be free to cover issues as they wish) and that the great diversity of media outlets already allowed different opinions to be aired. Congress, fearing that broadcasters would shun in-depth examination of controversial material even more than previously, subsequently passed a bill in 1987 reinstating the fairness doctrine, but President Reagan vetoed it.

■ THE RISE OF THE INTERNET

The Internet has become a primary medium for news presentations. It also offers a broader range of perspectives (both from the political left and right) than regular TV news. Newspapers, TV networks, journals and weekly magazines, interest groups, federal agencies, candidates, members of Congress, think tanks, and so on all have their own Web sites. A conservative estimate is that at least two-thirds of Americans have access to the Internet, and the rapid growth of the Internet means that this access number will grow dramatically in the near future.

The Internet has recently become an important fundraising tool for candidates. In 2004, former Vermont Governor Howard Dean enjoyed great success in raising online funds for his presidential quest, acquiring twenty million dollars in contributions. John Kerry, the eventual Democratic nominee, raised eighty-two million dollars from online contributions in his 2004 presidential race.

■ THE SCOPE AND STRUCTURE OF TODAY'S MEDIA

Although the media has evolved to a prominent and influential position in American political life, critics have warned that their concentrated structure was harmful to democratic dissent and discussion. An exploration of that issue now follows.

Media Scope

Collectively, adult Americans purchase more than sixty million newspapers each day (there are approximately 1,400 newspapers, but that number will likely be decreasing due to mergers produced by competitive and financial pressures). An average citizen also watches three to four hours of TV daily. Americans can choose from some 11,000 weekly or monthly periodicals and make their listening or viewing choices from nearly 10,000 commercial radio and 1,500 television stations nationwide. There are also more than 10,000 movie theaters and 1,300 book publishers across the country.

Media Structure

Experts on the media suggest that their structure can be divided among three **circles** of importance—the inner, middle, and outer.

Inner Circle

This circle includes the three major news networks, NBC, CBS, ABC; the news organization CNN; FOX News, the three major national news magazines (*Time, Newsweek,* and *U.S. News and World Report*); four key or nationally popular newspapers (the *New York Times,* the *Washington Post,* the *Wall Street Journal,* and *USA Today*); and the national wire service (Associated Press). The power of this media circle is immense, because its units decide which stories, domestic and foreign, will reach over eighty percent of the nation's households. Also, these twelve organizations have significant influence over journalists within the other two circles.

Middle Circle

The *Los Angeles Times,* the *Chicago Tribune,* the *Christian Science Monitor,* the Scripps-Howard news service, and the Knight-Ridder newspaper chain are included here. Although both national and local reporting is covered, the middle-circle media do not have the same degree of national exposure as those media sources in the inner circle. Magazines included in this circle typically include the *New Republic* and the *National Review.*

Outer Circle

This circle is composed mainly of local newspapers and TV stations. Most newspaper articles and TV stories they report originally appeared in the inner-circle media, and are subsequently reproduced by the various outer-circle media outlets.

Media Concentration

In the early 1900s, there were more than 2,500 daily newspapers in the United States. By 1990, the number had dropped below 1,700. By 2005, that number was 1,400 and dropping. Furthermore, large

corporate media chains, such as Gannett and Newhouse, dominate newspaper ownership. Other media conglomerates (for example, Time Warner) also own a large number of TV stations, cable TV systems, Internet services, radio stations, and newspapers found within the middle and outer circles. Furthermore, as a result of mergers, only about two percent of American cities have the benefit of competing newspapers.

Is Concentration a Danger?

Freedom to present diverse points of view is essential to the preservation of democracy. Will **concentration** of ownership blunt diversity? Do the media represent only the values and priorities of corporate America? The two following sections discuss these issues.

Supporters of the Current System. One side argues that new forms of communication, such as cable television, satellite TV/radio, electronic mail, and especially the Internet, ensure diversity. Second, although much of the media are owned by corporations, reporters and editors are usually left alone to present the news in their own way (profits, not slanted news, are the concern of corporate directors). Third, despite FCC attempts in 2003 to implement rules allowing greater media concentration, older FCC rules remain in place, still prohibiting the same person or company from owning both a television station and a daily newspaper within the same urban area. Fourth, the American tradition of free speech is typically hostile to censorship.

Critics Of Centralization. Critics charge that media corporations are so powerful that their owners can suppress dissent and the views of the minority. A democracy is based on power checking power: How can media monopolies be consistent with that principle? In addition, society depends upon the media to check and balance other political and economic institutions. But if the media belong to corporate America and profits are the main goal, do anti-business views have a fair hearing? In short, can the media report events and issues fairly, openly, and objectively? Can the media's vital political roles be jeopardized?

■ THE MEDIA'S POLITICAL ROLES

The media play a number of important political roles. Included among them are:
- Alerting the public to new developments.
- Shaping the **public agenda.**
- Molding public opinion.
- Linking the public and its leaders.
- Evaluating, positively or negatively, public leaders' reputations.
- Serving as a watchdog for the public.

Alerting the Public to Fast-Breaking Stories

Media journalists alert the public to each and every fast-breaking story, be it an unexpected disaster at a nuclear power plant, the president falling ill, a jump in inflation, a major scandal in Congress, or the explosion of the space shuttle. Media representatives can be at the scene of a particular news story in minutes due to modern communication technology. In 2003, **embedded journalists,** along with their TV satellite hardware, traveled with American combat units inside of Iraq, allowing instantaneous coverage of the battlefield and deepening the public's appreciation of the military.

Shaping the Public Agenda

The media focus attention on particular issues in contrast to others, and suggest solutions to society's problems as well. In effect, the media inform the public as to which problems are the most urgent. The media may not be able to tell people how to think, but they can tell the populace what issues they should be thinking about. Problems and issues not mentioned are usually ignored. Thus, the issue of protecting the environment was not on the public agenda forty years ago. The media generally ignored pollution, destruction of endangered wildlife, recycling of metals or paper, global warming or holes in the earth's ozone layer. But the media began stressing ecological issues in the early 1970s and over the following decades. Currently, environmental issues are still in the public's consciousness. Other examples include the media's coverage of drug abuse in America, which made millions of citizens even more aware of how extensive the problem was, and the debate over the partial privatization of the Social Security system during the second term of President George W. Bush.

Molding Public Opinion

The media transmit information to the electorate. The **two-step flow** of opinion formation is important for this role. In the first step, a person receives information from a TV news broadcast or other media form. Then, this information, in theory, is compared by an alert citizen to other data sources, so as to confirm or deny the first source's validity.

Providing a Link between the Public and Leaders

The media are natural links between the public and leaders. As an illustration, reporters explain the policy positions of a president to voters and periodically survey the electorate's reaction to those positions. Accordingly, presidents pay close attention to these media stories. For example, President Lyndon Johnson often watched three television news shows simultaneously. Other public officials frequently use the media to propose new programs or justify their decisions to the citizenry. Conversely, the public can express its views to officials, via letters to the editor, e-mail, or dramatic and well-advertised demonstrations that are reported by media representatives.

Making or Breaking Public Reputations

The media can tarnish or improve a public figure's reputation. For example, Gary Hart's bid for the presidential nomination in 1988 ran afoul of two reporters from the *Miami Herald,* who staked out his home and learned of his affair with a young woman named Donna Rice. The resultant story of Hart's sexual infidelity forced him to resign his candidacy. Similarly, in the same year, Democratic Senator Joe Biden was forced to end his presidential campaign when the media learned of his plagiarized campaign speeches (taken from a British politician). In 1992, Democratic presidential hopeful Bill Clinton, governor of Arkansas, was plagued by media charges that he was an adulterer. Later, as president, Clinton's reputation was tarnished by his affair with a White House Intern, Monica Lewinsky, and his subsequent impeachment trial in 1998. Even Ronald Reagan's public image was impaired when the media revealed a number of scandals in his administration (for example, Iran-Contra).

Conversely, the media can catapult an unknown candidate to prominence. Jimmy Carter received such media treatment in 1976 after doing well in the Iowa caucus. Eventually, he garnered the presidential

nomination. In 2003 and 2004, Howard Dean was perceived by the media as the early front-runner for the Democratic presidential election, although his failure in the Iowa caucus led to the emergence of John Kerry, who later received the nomination.

Serving as Watchdog for the Public

Media representatives increasingly see themselves as a collective watchdog for the American people. They point to their role in criticizing the conduct of the Vietnam War and hastening its end; exposing the Watergate scandal during the Nixon administration; and periodically uncovering governmental corruption at the federal, state, and local levels of government. But critics argue that the media only occasionally play the **watchdog role,** preferring to concentrate on safe or dramatic stories which will least offend advertisers. The media are also highly selective in their coverage of events and issues. These biases in news reporting are delineated in the next section.

■ NEWS PRESENTATION: TRUTH, BIAS, AND THE NEED FOR PROFITS

How is the news presented? Is the presentation biased? The American people depend almost entirely on the media for the information they receive about politics and government. But are the media truthful and unbiased? Whose interests do reporters serve? There are recurring problems associated with news reporting.

News Reporting: A Business Seeking Profit

Media outlets must find a presentation of stories that will hold the attention of the audience. The chances of a sponsor's products selling are severely minimized if an audience is very small. Competition for advertising revenue and profit is fierce among media outlets. Consequently, TV must be entertaining to the average American, if high ratings (the amount a station can charge advertisers is directly related to the level of ratings) are to be attained. Which news stories, over others, will attract the greatest number of viewers?

Similarly, a story that may lose sponsors is potentially dangerous to a TV or radio station. Pressure can be applied by corporate sponsors upon specific journalists and/or the station's management. For example, Dillard's (a chain of department stores) cancelled its ads with CBS, after that network's news division accused its security guards of engaging in racial profiling.

Objectivity in News Reporting

Ideally, news reporters are supposed to report events truthfully and objectively. However, it is impossible to report every important story in the papers or on TV. Journalists must be selective. Also, reporters are human beings with their own emotions and sensitivities. Invariably, stories will be slanted in one direction or the other. Unfortunately, news and truth rarely go hand in hand. The news can appear to be fair, but it seldom conveys all of the facts necessary whereby viewers can make an independent, informed, responsible, and intelligent judgment.

Personal Backgrounds of Journalists

Surveys of journalists, both in print and electronic media, reveal similar backgrounds. White males still dominate, despite impressive gains by women and minorities in recent years. Both groups

are overwhelmingly college-educated and come from upper-middle-class homes with parents who were professionals or in business. They tend to be secular with many coming from the Northeast.

Are Reporters Biased?

Social science studies suggest that media representatives are not biased toward one party or ideology. For example, while many journalists may be liberals in their support for governmental services, many others support the free enterprise system. Journalists' stories may criticize the political leadership, but rarely the legitimacy of political institutions or values that comprise the American credo. As another example of a mixed-partisan picture, editors of newspapers usually endorse Republican candidates, but reporters identify more often with the Democratic party. Finally, journalists do have their own code of objectivity, and so are sensitive to value biases.

Need for Brevity in Reporting

Newspaper articles dealing with important political events must be relatively brief so that other pages can be reserved for advertising, sports, or local issues. The electronic media have an even greater need for brevity. For example, the half-hour evening news on network TV may have only twenty to twenty-two minutes for actual stories, with the remaining time allotted to commercials. Many stories are reported in one or two minutes (or less). But how can complex issues like inflation, toxic wastes, crime, or the arms race be covered in such a short period of time? In addition, TV often covers campaigns through **sound bites.** Instead of a candidate's full speech being reported, a sound bite of fifteen seconds or less, highlighting a key phrase or slogan, may be the prime type of media coverage.

Fortunately, television documentaries do exist, breaking a general pattern of superficiality through an in-depth look at problems in society. Shows like *60 Minutes* are also helpful in altering TV's penchant for being mainly a headline service.

Dependence upon Government Officials

Broadcasters and journalists, even from elite newspapers like the *New York Times* and the *Washington Post,* acquire a solid majority of their information from elected or appointed officials in government. There are two reasons:
- Officials, both domestic and foreign, are available for questioning.
- Many reporters develop friendships with these officials.

Still, there are examples of independent, investigative reporting at its finest; for example, when reporters Carl Bernstein and Bob Woodward of the *Washington Post* uncovered important evidence in the Watergate scandal that eventually led to President Nixon's resignation on August 9, 1974.

The Personal Side of the News Dominates Reporting

News stories tend to stress the **human-interest factor**—individuals' personal tragedies and triumphs. For example, when Americans have been kidnapped by terrorists in the Middle East and threatened with execution, network reporters interviewed the families of the hostages at length, but devoted far less time to the underlying reasons for the hostages' being seized or the specific demands of the terrorists. Similarly,

the media devoted considerable TV air time and newspaper coverage to the sexual harassment allegations made by Anita Hill against the Supreme Court Justice nominee Clarence Thomas in 1991 (Thomas was eventually confirmed by the Senate). Far less coverage was given to the weeks of hearings prior to the Hill-Thomas confrontation. More recently, Jessica Lynch, a soldier captured by Iraqis during the initial combat phase of the war in 2003, was portrayed as a hero by the media for her courage under fire.

News Stresses Drama, Violence, Action

Lead stories of TV news shows or the newspaper's front page often stress murders, earthquakes, criminal acts, drug use, airplane crashes, tornado damage, wars, and so on. Rioting by protesters attracts media coverage, but reporters may neglect the underlying causal factors that led to the riot in the first place. In short, news shows frequently follow the slogan that "if it bleeds, it leads."

■ HOW THE MEDIA COVER ELECTIONS AND GOVERNMENTAL INSTITUTIONS

The media's handling of campaigns and electoral outcomes includes reporting frequent poll results covering the electorate's attitudes toward candidates and their respective issues, presenting radio, TV, Internet, and newspaper political ads, showing nationally-televised debates between presidential candidates, and providing analyses as to why a particular electoral outcome occurred. In addition, American political institutions and their related personnel from the legislative, executive, and judicial branches receive media time. However, the presidency receives the greatest amount of news attention.

Coverage of Presidential Elections—Plus Paid TV Ads

Media reports in presidential election years indicate who is ahead or behind in securing each party's nomination. Frequently, the media cites poll results to show the potential winner or loser in the November election. This is part of the media's horse-race mentality.

A similar perspective applies to presidential televised debates. For example, Michael Dukakis was labeled as the loser by the *New York Times* after his second TV debate against George Bush in 1988. In 1992, President George H.W. Bush was criticized for looking at his watch in a debate again Democrat Bill Clinton and independent candidate Ross Perot. In 2000, Al Gore's aggressive debate style toward George W. Bush was deemed inappropriate and counterproductive by media pundits. In 2004, John Kerry was judged by the media to be the winner in at least two of the three debates against President Bush, but he still lost the election. Note that debates give TV viewers a chance to assess a presidential candidate's personality, communication skills, and ability to withstand pressure. However, it is also true that debates mainly affect swing or undecided voters, not partisans. Finally, **spin doctors** (representatives from each candidate's campaign who deliberately convey a positive or negative "diagnosis" of the debate's meaning) for each candidate attempt to influence the media's reporting by imparting favorable evaluations of their man's debate performance while denigrating the opponent's performance.

TV political ads are probably more vital to a candidate's successful campaign than debates. According to the Federal Election Commission, $665 billion was spent on ads in the 2000 presidential contest. In 2004, that number soared to $1.5 billion. Frequently, these brief ads, which run anywhere from fifteen to sixty seconds long, can be a major force in cementing the candidate's image. In 2004, for example,

John Kerry's campaign was damaged by a series of critical attacks on his performance as a swift-boat captain in the Vietnam War.

Coverage of the Presidency

The president is the focal point of news coverage. His (or someday her) activities are of continuing interest to the viewing public. The media, always mindful of the ratings, naturally give the president more air time and print space than any other political official. Presidential press conferences, major speeches, policy proposals, overseas trips, health status, or even personal family matters all attract considerable media attention.

Coverage of Congress

Floor proceedings of Congress are covered by the C-SPAN network, although the network has a very small viewing audience. The House permitted TV coverage beginning in 1979, the Senate in 1986, although, originally, there was fear that legislative debate would be disrupted by television and that legislators would posture before the cameras. However, C-SPAN has been successful in allowing the public to at least view and partially understand the workings of Congress.

The major networks rarely cover committee hearings in depth. (Notable exceptions have included the Watergate hearings and Iran-Contra hearings.) They seem to prefer reporting final floor votes or the actions of congressional leaders in both houses.

Coverage of the Courts

Of the three branches (the legislative, executive, and judicial), it is the judiciary that probably receives the least amount of media coverage. Judges are usually reluctant to grant interviews to reporters, and cameras and microphones are normally prohibited in federal courts (although state trials can be televised). Ironically, journalists tend to be more favorable in their treatment of the courts and judges. Still, many lawyers and judges alike have complained that the media may report inaccurate details about legal procedures and problems.

Exceptions to the light-coverage norm involve landmark decisions delivered by the U.S. Supreme Court (*Brown v. Board of Education* or *Roe v. Wade,* for example) or when there is a vacancy on that court. In 2005, Sandra Day O'Connor's announcement that she would retire from the Supreme Court set off a media frenzy regarding her successor and the Court's future ideological composition.

■ THE MEDIA AND DEMOCRACY

Many observers have remarked that information is the essence of democracy. Responsible citizens cannot practice self-rule if the factual bases and diverse values underlying controversial issues are not presented to them by a conscientious, efficient media. Critics contend that the media have failed in this mission. They have provided a vast amount of information, but the end result has not been an informed society.

Media representatives argue that the superficial treatment of the news fits the needs and desires of the American public. Americans want to be entertained by the media. They are indifferent to media presentations involving complex issues. Media representatives suggest that if citizens began demanding more TV shows like *60 Minutes* or *The NewsHour with Jim Lehrer,* the networks would be glad to oblige them.

The precise configuration and content of the public's opinions can be measured by modern scientific polling procedures within a reasonable margin of error. The roots of those opinions can be found in the political socialization process and its agents—families, schools, and peer groups, among others. Personal characteristics, such as race or religion, also play a key role in opinion formation.

Historically, the media have played a number of important roles, from promoting partisan views to defining the public agenda to guarding the public interest. Some critics fear that the contemporary media's concentration of ownership will threaten freedom of thought and dissent; others see the proliferation of media outlets and constitutional guarantees of free speech as firm barriers to this threat. Additional criticisms of the media include an emphasis on their profits over the public interest, the superficiality of the news coverage, the penchant for stressing violence and drama over the reason behind news events, and possible biases among reporters and TV journalists.

Selected Readings

Asher, Herbert. *Polling and the Public: What Every Citizen Should Know* (1988).

Berlinski, Adam J. *Silent Voices: Public Opinion and Political Participation in America* (2004).

Crespi, Irving. *Public Opinion, Polls, and Democracy* (1989).

Gilmor, Dan. *We the Media: Grassroots Journalism By the People, For the People.*

Graber, Doris A. *Media Power in Politics.* 3rd edition (1990).

Jennings, M. Kent and Richard G. Niemi. *Generations and Politics: A Panel Study of Young Adults and Their Parents* (1981).

Newport, Frank. *Policy Matters—Why Leaders Must Listen to the Wisdom of the People* (2004).

Niemi, Richard G., John Mueller, and Tom W. Smith. *Trends in Public Opinion: A Compendium of Survey Data* (1989).

Parenti, Michael. *Inventing Reality: The Politics of the Mass Media* (1986).

Test Yourself

1) Which of the following is *not* an act of public opinion?
 a) writing a letter to a U.S. Senator
 b) voting for a congressional candidate
 c) protesting a law by participating in a street demonstration
 d) voicing an opinion about the president at the family dinner table

2) True or false: One could reasonably assume that Americans have reached a consensus about the importance of the Social Security system.

3) A member of the National Rifle Association would probably have very strong feelings about gun control. This fact best represents the public opinion characteristic of
 a) stability
 b) fluidity
 c) intensity
 d) quiescence

4) True or false: Political socialization is a process that ends for an individual by the time he or she is in high school.

5) The generational event that caused Americans to question the integrity of the presidency was
 a) Pearl Harbor
 b) the terrorist attacks of 9/11/01
 c) the Great Depression
 d) Watergate

6) True or false: African Americans have consistently supported Democratic Party presidential candidates in recent years.

7) The *Literary Digest* unwittingly created a biased sample when trying to predict the
 a) 1936 race between Landon and Roosevelt
 b) 1948 race between Truman and Dewey
 c) 1960 race between Kennedy and Nixon
 d) 2000 race between Gore and Bush

8) True or false: More women oppose the death penalty than men.

9) Gallup incorrectly predicted the presidential winner in which year?
 a) 1940
 b) 1948
 c) 1964
 d) 1996

10) True or false: National polls typically use a sample size of 5,000 to 10,000.

11) If a poll's margin of error were plus or minus three points, and the poll predicted a candidate would receive fifty-three percent of the popular vote, that candidate could theoretically receive a percentage vote on election day ranging between
 a) fifty-one percent to fifty-five percent
 b) forty-nine percent to fifty-seven percent
 c) fifty percent to fifty-six percent
 d) fifty-three percent to fifty-nine percent

12) True or false: The use of fireside chats is associated with the presidency of Harry S. Truman.

13) The first live presidential debate on TV occurred in the year
 a) 1956
 b) 1960
 c) 1976
 d) 1980

14) True or false: The FCC must abide by the fairness doctrine, which mandates the airing of opposing opinions on major public issues.

15) How much in campaign funds did Senator John Kerry raise from Internet fundraising in the 2004 presidential election?
 a) twenty million
 b) forty-two million
 c) sixty-two million
 d) eighty-two million

16) True or false: From 1900 to the present, the number of newspapers in the United States has been declining.

17) Which of the following is a political role of the media?
 a) shaping the public agenda
 b) molding public opinion
 c) linking the public and elected leaders
 d) all of the above

18) True or false: Embedded journalists is a reference to those reporters who were with U.S. troops during the 2003 Iraq war.

19) Floor proceedings of Congress are covered by
 a) Internet Web sites
 b) C-SPAN
 c) CNN
 d) the major television networks

20) True or false: In 2004, the amount of money spent on Presidential campaign TV ads was approximately $665 billion.

Test Yourself Answers

1) **d.** Keeping an opinion within a family discussion is a private opinion, not a public one. The other three choices all involve the expression of an opinion on a broader societal scale and so can be classified as public opinions.

2) **True.** A consensus refers to the public's widespread agreement about an issue. Although Americans may differ over how to fund Social Security, they overwhelmingly believe in the necessity and value of that system.

3) **c.** Intensity refers to the strength of an opinion held by an individual or group. None of the other terms deals with this quality.

4) **False.** Political socialization is a lifelong process, evolving from childhood through the retirement years for individuals.

5) **d.** The Watergate scandal suggested that President Richard Nixon had acted unethically. The other events listed in the question strengthened the power of the presidency.

6) **True.** African Americans are the most pro-Democratic of any racial or ethnic group in America. Typically, eighty to ninety percent of African Americans vote for Democratic presidential candidates.

7) **a.** The *Literary Digest* incorrectly predicted that Alfred Landon would handily defeat Franklin D. Roosevelt in the 1936 presidential election. Shortly thereafter, the magazine went out of business.

8) **True.** This is a component of the gender gap.

9) **b.** This was the Dewey-Truman race, where Gallup stopped polling too soon. Gallup did not pick up the voter shift from Dewey to Truman in the last few weeks of the campaign.

10) **False.** This range is too large. A typical sample size is 1,000 to 2,000.

11) **c.** A plus or minus three points would mean that you add three to the fifty-three percent, resulting in fifty-six percent and you subtract three points from fifty-three, ending up with fifty percent.

12) **False.** Fireside chats were first used by President Franklin D. Roosevelt in the 1930s.

13) **b.** The Kennedy-Nixon debate of 1960 represented the first televised debate.

14) **False.** The fairness doctrine was abolished by the FCC in 1987.

15) **d.** The other totals are all incorrect.

16) **True.** There were 2,500 newspapers in the early 1900s; today, the number is around 1,400.

17) **d**. All the choices represent political roles.

18) **True.** Journalists stayed with the troops in Iraqi combat, reporting back to the public on the military's valor while risking their own lives.

19) **b.** None of the other media sources covers the daily proceedings of Congress.

20) **False.** This was the amount spent in 2000. The 2004 amount was $1.5 billion.

Political Parties and Interest Groups

It is hard to imagine American democracy without **political parties** or **interest groups**. Both parties and interest groups are representative devices that allow the people to interact with government and that employ political power to facilitate or influence the policy process. Parties try to elect their nominees through maximization of support within the electorate. In turn, party winners try to operate government and implement public policy. Interest groups, while not placing candidates on the ballot, do play the important roles of supporting or opposing office-seekers, molding public opinion, and gaining access to decision-makers at all levels of government.

■ POLITICAL PARTIES: FUNDAMENTALS AND COMPONENTS

Political parties provide an important link between the people and their governments. Through parties, voters can make their political will known and hold representatives accountable.

Parties recruit individuals to run for political office under the party label. In the United States, the two major political parties are the Republican and Democratic organizations, along with a number of minor (also called third) parties. If a political party is successful in getting enough of its candidates elected, the party can control the government and develop appropriate public policies.

Parties are important to a democracy in yet another way. They can develop political compromises among contending groups in society so that the legitimacy of the political system is maintained.

Party Components

A political party has three components, each described in the following sections.

The Party in the Electorate

This component consists of citizens who psychologically identify with a political party (a majority of Americans consider themselves Democrats or Republicans) and who usually (although not necessarily

always) vote for their party's candidates. American party identifiers do not carry identification cards or pay dues as is the case with ideologically oriented parties of Europe. In addition, American party members may be divided into either regular voters or party **activists** who work for the party via fundraising activities, campaigns, or mobilization of the party faithful (getting people out to vote) on election day.

The Party in the Government

This component refers to those appointed or elected officeholders in the legislative and executive branches of government who are considered representatives of a specific political party. Incorporated into this category are congressional representatives, state legislators, governors, cabinet heads, mayors, and U.S. presidents. Judges who are elected under a party label are also included.

The Formal Party Organization

This component comprises active party professionals (for example, precinct captains, county chairpersons, convention delegates, and so on) who actually control and direct the party at the local, state, and federal levels. These individuals are involved in important campaign and fundraising activities. They also wish to attract citizens to their party banner, so that a stronger base of volunteers and supporters can be established. Professionals usually enjoy the game of politics and seek positions of power in the party or government. They also tend to be more ideologically extreme than typical voters. Their major goal is to recruit candidates capable of winning elections, candidates who will maximize those values they see as vital to the preservation of American society and the nation's well-being.

■ THE FUNCTIONS OF POLITICAL PARTIES

Political parties perform a number of important functions. As described in the following sections, they include mobilizing voters, selecting candidates, providing campaign resources, simplifying elections and educating the public, aggregating interest groups, organizing the decision-making processes, and playing the watchdog role (the loyal opposition).

Mobilizing Voters

Party workers urge or help voters to go to the polls on election day. Workers may use telephone calls or e-mails; visit homes, apartments, or offices; and even provide transportation for voters.

Selecting Candidates

As indicated earlier, parties seek out individuals who might make attractive candidates for public office. Parties present these individuals to the voters. If a party's candidates win, the party achieves political power through those candidates.

Providing Campaign Resources

Parties help in fundraising so that their candidates have the financial means to run increasingly expensive campaigns. A competitive congressional race, be it for the House or Senate, can easily run into millions of dollars.

Simplifying Elections and Educating the Public

Many citizens do not have the time or motivation to become informed about every candidate's stand on the issues of the day or even to know the background qualifications of each candidate. These voters simply rely on party affiliation and select all of their party's nominees (a **straight-party ticket**) listed on the ballot. The parties also try to educate the public about contemporary public issues through campaign speeches, debates, TV newscasts, newspaper/radio ads, and Internet sites. Therefore, parties do influence public opinion by identifying society's problems and suggesting political solutions. As President John F. Kennedy once observed, the responsibility of parties is to place the unfinished policy agenda before the American people for their consideration.

Aggregating Interests

Parties help to coordinate the combined (aggregate) interests and demands of the electorate. When there is conflict among diverse interests, parties facilitate compromise. It bears repeating that parties encourage peaceful change and allegiance to the political system through the aggregation function. In short, political parties in America are big-tent parties, putting together large, diverse coalitions and focusing on broad issue agendas.

Organizing the Decision-Making Process

Both state legislatures and Congress are organized by party affiliations. Party leaders are influential in selecting the legislature's members to serve on specific committees and subcommittees.

Playing the Watchdog Role (The Loyal Opposition)

The party that is out of power will be sure to criticize the policies and decisions taken by the ruling party. The minority party may hope to influence the majority party's thinking, while also laying the groundwork for an electoral victory in the near future. This was the case for the Democrats after the 2004 presidential election, when they faced the political reality of a Republican president, George W. Bush, and the Republican-controlled Congress.

■ HISTORY OF AMERICA'S PARTY SYSTEMS

America has traditionally been a nation of two major political parties. Today, the Democratic and Republican parties dominate the political landscape. However, a perusal of history reveals that other parties also have been prominent at times, such as the Federalists and anti-Federalists, the Whigs, or Progressives.

Founders' View

The framers of the Constitution viewed political parties as both dangerous and disruptive. (In fact, parties are not even mentioned in the Constitution.) To them, party members promoted societal divisions, pursued selfish interests, and stifled dissent. James Madison considered parties "factions" that threatened the common good in society—although he later became a member of the Democratic-Republican party. In George Washington's famous 1796 Farewell Address, the first chief executive warned that the young nation could be destroyed by the "baneful effects of the spirit of party."

However, parties became a political reality early in the nation's history, and six distinct party systems have followed.

Federalists and Anti-Federalists, 1796–1828

Despite the founders' fears, the early split between Federalists and anti-Federalists, as symbolized by the philosophical clash between Hamilton and Jefferson during Washington's administration, intensified partisan divisions. Hamilton's **Federalists** represented the northern commercial and manufacturing interests, believed in a strong central government, and supported a ruling national aristocracy composed of the wealthy and educated. (Hamilton once told Jefferson that the people were a "great Beast.") By contrast, the Jeffersonians spoke for agricultural concerns in the South, states' rights or a limited role for the federal government, and a faith in the common man.

Jefferson's victory over John Adams in 1800 meant the eventual demise of the Federalist party (it disappeared completely around 1816). Thereafter, Jefferson's **Democratic Republicans** dominated presidential and congressional politics. This period of one-party rule led to the **Era of Good Feelings,** symbolized by James Monroe's near-unanimous election in 1820. However, after 1820, rival factions within the Republicans led by John Quincy Adams (the **National Republicans,** supported by southern planters and the banking/business interests) and Andrew Jackson (the Democratic Republicans, who appealed to smaller farmers and the debtor classes) developed into the Whig and Democratic parties, respectively.

Jacksonian Democrats and Whigs, 1828–1860

Andrew Jackson's election in 1828 ushered in the **Democratic** party, a party that stressed the common man's participation in the political system. Jackson's party introduced suffrage to all white adult males, the popular election of presidential electors (formerly chosen by the state legislatures), and national nominating conventions (instead of congressmen choosing their party's nominee). The Democrats had the support of small farmers, Catholics, new immigrants, and those Americans residing in frontier towns.

The **Whigs,** or the anti-Jacksonians, favored both a strong national government and business interests. Northeastern manufacturers, southern planters, and Protestants constituted the party's core. The Whigs were successful in electing William H. Harrison to the presidency in 1840.

Republican Party Is Born, 1860–1896

The slavery debate divided the Whig party and led to its dissolution by the time of the Civil War. **Northern Whigs** and some disgruntled Democrats, plus members of a third party, the **Know-Nothings,** created the anti-slavery **Republican party,** or the **GOP (Grand Old Party).** In 1860, Republicans elected their first president, Abraham Lincoln.

After the Civil War, Republicans dominated both Congress and the presidency, drawing their support from ex-Union soldiers, blacks, and northern Protestants. The GOP was very much pro-business.

By comparison, Democrats drew support from southerners, Irish Catholics, farmers, labor unions, and anti-Prohibitionists. The Democrats continued to support the doctrines of states' rights and limited government. But during this period, Democrats were able to win with only one presidential candidate: Grover Cleveland, in 1884 and 1892.

Republicans Dominate, 1896–1932

The election of 1896 was a turning point in American politics. The Democrat, William Jennings Bryan, represented the agrarian faction of the party. Although he carried the rural South and West, the industrialized and urban areas of the nation went for the GOP. In effect, the 1896 **realigning election** (a long-term change in the underlying party loyalties of voters) meant that the GOP would be the dominant party for more than three decades (except for the election of the Democratic president Woodrow Wilson in 1912 and 1916).

The GOP appealed to a wide base of voters by opposing social-welfare assistance to the individual but supporting government efforts to assist business. The Democrats' only real base of support was in the rural South and among immigrant groups, such as the Irish.

During this era, the **Progressives** became an important third-party movement, emphasizing political reform of corrupt big-city machines found in the Northeast and Midwest. (Many of these party machines and their party bosses would stuff the ballot boxes on election day.) Several Progressive ideas eventually became law—voter registration, the secret ballot, the direct primary, and civil service laws. The reforms' ultimate impact was to:

* Weaken the hold of party bosses by giving voters greater influence over nominations and elections.
* Dilute the power of political parties in American life.

Democratic Dominance, 1932–1980

President Herbert Hoover's aloof reaction to the stock market crash of 1929 and the subsequent Great Depression convinced millions of disillusioned and unemployed working class voters to select the Democratic nominee, Franklin D. Roosevelt, in 1932. Under FDR's leadership, economic recovery laws were passed. The 1932 election represented another realigning election, whereby the Democrats became the dominant political party. **Roosevelt's New Deal coalition**—an alliance of urban dwellers, blue-collar workers, Catholics, Jews, southern conservatives, and northern liberals—held together long enough to elect FDR to four consecutive terms (he died in April of 1945). After World War II, Republicans did elect to the presidency Dwight D. Eisenhower (1952 and 1956) and Richard Nixon (1968 and 1972). Democrats Harry S. Truman (1948), John F. Kennedy (1960), Lyndon Johnson (1964) and Jimmy Carter (1976) were the Democratic winners.

Note the 1968 election, which some political pundits view as a realigning election, in the sense that Republicans laid the groundwork for their subsequent presidential/congressional dominance by gaining a foothold among Southern Democrats.

Republicans Back in Power, 1980 to the Present

During this time frame, Republican presidents included Ronald Reagan (1980 and 1984), George H.W. Bush (1988), and George W. Bush in 2000 and 2004. Only Democrat Bill Clinton was able to break the GOP presidential stranglehold by winning in 1992 and 1996.

The 1980s witnessed **divided government**—GOP presidential domination, but continued Democratic control of the House (the GOP was the majority party in the Senate during most of Reagan's two terms; Democrats regained control in 1987). However, Republicans controlled both houses of Congress after the 1994 midterm elections and remained in power for most of the next decade.

Given GOP gains, has the Republican party become the new majority party in America? The evidence is compelling to some, but, as history attests, domestic and/or international events can undermine a party's majority status. Perhaps a new party system will emerge in the not-too-distant future.

The Two Parties Today

Many voters now see no significant policy differences between the two parties, but are increasingly aware of candidate styles and personalities. Increasingly, more voters do not identify strongly with the parties. Today, roughly one-third of the electorate considers itself to be independents; in 1950, only a little more than twenty percent claimed that label.

Differences Between the Parties

Although both parties have similar functions, they do have differences. The Republican party attracts large numbers of wealthy, male, rural, suburban, white, college-educated, and conservative supporters. Democrats still appeal to a greater number of women, minorities, inner-city residents, the poor, lesser-educated voters, working class citizens, and liberals. The GOP typically stresses rugged individualism, a strong national defense, minimal governmental intervention into the economy, and limited regulation of big business. Democrats see government as a referee that promotes social justice, business, regulatory policies, and fair employment/hiring policies. Differences between the two parties on cultural values (gay marriage, abortion, the interpretation of morality in American society, and so on), regional strengths/weaknesses, and religious/racial supporters are evident as well (see Chapter 3). Finally, it should be stressed that each party's membership represents a mixture of diverse viewpoints and policy preferences, so that exceptions to the preceding general classifications frequently occur.

Ticket-Splitting

Rather than voting a straight-party ticket, **ticket-splitting** (voters dividing their candidate selections between the two major parties) has become far more common. For example, a minority of southern white voters may still support Democrats for congressional offices, but prefer the more conservative Republican presidential candidates in recent elections. However, a majority of southern whites now are more likely to vote Republican on both the congressional and presidential levels (for example, in 2000 and 2004). Republicans have carried most southern states in every presidential election since 1968, except for Jimmy Carter's victory in 1976 (Carter was a former governor of Georgia).

■ WHY DOES AMERICA HAVE A TWO-PARTY SYSTEM?

Despite a plethora of minor political parties in American history, the nation has essentially maintained a two-party system. The two-party system is not common to most nations. (Most democracies in Europe have multiparty systems, with three or more parties competing for power.) Only five other nations have two-party systems: Australia, Austria, Canada, Great Britain, and New Zealand. Although minor parties in America—Progressive, American Independent, Libertarian, Socialist Workers, the Reform party, and the Green party, among others—have periodically challenged the two major parties, they have not supplanted either of them at any governmental level. What are the reasons for the strength of the two-party system in America?

History and Tradition

The Federalist/anti-Federalist division constituted partisan politics early in America's political history. Since then, Americans have been conditioned through the political socialization process to the permanence of two parties, both of which are seen as moderate exemplifications of American ideals. In general, most citizens see little value in voting for a minor party, considering such action to be wasteful and nonsensical. Still, polls show that a majority of Americans would favor the emergence of a viable third party that could both present credible candidates and challenge the complacency of the two major parties.

The Electoral System

The single-member district system in America means that there can be only one winner per office. The victor is the candidate who receives the greatest number of votes, a plurality, even if that plurality is not a majority. The United States does not have proportional representation, a system common in Europe whereby legislative seats are awarded to each party on the basis of popular vote totals. Under proportional representation, a minor party that receives fifteen percent of the national vote would receive fifteen percent of the seats in the national legislature. In the United States, this party would probably win nothing.

Election Laws

In many states, it is difficult for a minor party to get on the ballot. For example, in 1968, George Wallace's American Independent party found that more than 400,000 signatures would be needed to get on the presidential ballot in Ohio (Wallace appealed to the Supreme Court, and this requirement was ruled unconstitutional). In 1988, George H.W. Bush and Dukakis were on fifty state ballots, but virtually all of the minor parties were unable to get on even half of those ballots. Ross Perot in 1992 and Ralph Nader in 2000 and 2004 confronted similar ballot problems. Specifically, Nader's name was only on thirty-four state ballots and the District of Columbia in 2004.

Another factor is that election laws are primarily the responsibility of the states. The 7,400 state legislators across the nation are nearly all Republicans or Democrats. These legislators have little incentive to pass election procedures that will facilitate minor party challenges against the two major parties.

Flexibility and Adaptability of the Two Parties

The Democratic and Republican parties are broad-based **umbrella parties.** They both accept members from nearly all groups and social classes in America. By clinging to the political center, they maximize their voting appeal (Democrats are viewed by most Americans as center-left or more liberal, while the Republicans are perceived as conservative or center-right). Minor parties with new ideas find that their ideas are frequently co-opted by either one or both of the major parties.

Voter Beliefs

Americans have historically agreed on the rules of the political and economic game. They have accepted democracy, capitalism, and diversity of religious belief. Rich-poor class hatreds, monarchist or socialist parties, and religious control of political life have fortunately not been part of American history. Furthermore, America's abundant resources have furnished a decent standard of living to the vast majority of the population. In short, there is an ideological consensus among Americans, and the two major parties' philosophies reflect this consensus. A purely religious party, or parties composed, for example,

solely of African Americans, farmers, Hispanics, or industrial workers, would not have broad enough appeal for a majority or even plurality of the voters.

Presidential candidates whose views are perceived as being extremist or too distant from the political center will not be supported by a majority of the moderate electorate. When Republican Senator Barry Goldwater ran for the presidency in 1964, his brand of conservatism was seen as being too far to the political right; Senator George McGovern, the Democratic presidential candidate in 1972, was seen as being an extreme liberal or too far to the political left). Both men were badly defeated at the polls by Lyndon Johnson and Richard Nixon, respectively. To a lesser degree, Democratic presidential candidates Michael Dukakis in 1988 and John Kerry in 2004 were also accused by Republicans of being too liberal.

■ MINOR PARTIES: TYPES AND FUNCTIONS

Minor parties in American politics cannot be dismissed as being totally unimportant. Although many disappear with time, they can have a major impact on elections and issues during specific historical eras by challenging the values and/or policies of the major parties.

Categories of Minor Parties

The four main types of minor parties are ideological, one-issue, economic protest, and factional or splinter, each of which is discussed in the following sections.

Ideological

Ideological minor parties espouse radical ideas or values from the perspective of most Americans. But these parties do attract some votes. A specific example was the Socialist party of Eugene V. Debs, which won nearly six percent of the vote in the 1912 presidential election. A more recent illustration is the **Libertarian party** (created in 1971), which adheres to a mostly unregulated free market economy, the legalization of drugs, an ardent defense of civil liberties/the right to bear arms, a foreign policy of free trade, plus a desire to avoid military interventions overseas. In 2000, the Libertarian presidential ticket received 384,431 popular votes (0.36 percent); in 2004, it received 397,367 popular votes (0.34 percent of the national presidential vote).

One-Issue

The Prohibition party would exemplify the one-issue minor party (abolition of alcoholic beverages). Another example is the Free Soil party, founded in 1848, which opposed slavery. Because they are so narrowly based, one-issue parties have difficulty attracting a broad spectrum of the electorate. In addition, their issues may be addressed and resolved by a major party.

Economic Protest

An example of the economic-protest party was the Populist party of the 1890s, which demanded government ownership of rail and phone companies. The Greenback party (1876–1884) called for the free coinage of silver and an income tax.

Splinter

Teddy Roosevelt's Bull Moose party of 1912 was a "splinter" or faction from the regular Republican party (Roosevelt opposed William Howard Taft, the GOP candidate, and the Democrat Woodrow Wilson). In 1968, George Wallace's American Independent party followers claimed that their political views opposing desegregation and supporting strong law-and-order policies had been ignored by the mainstream Democratic party. In 1948, the states-rights faction known as the Dixiecrats, led by South Carolina Governor J. Strom Thurmond, broke away from the Democratic party over the issue of civil rights (Thurmond's party captured thirty-nine electoral votes that year).

Importance of Third Parties

Minor parties have attracted new groups of voters, served as forums for different opinions, and brought new issues to the national political agenda. The Socialist party first raised the issue of a Social Security program, a policy subsequently adopted by FDR's Democratic party in the 1930s. Teddy Roosevelt's Bull Moose party encouraged leaders within the two major parties to consider new laws regulating corporations. It also urged adoption of direct democracy devices, such as the initiative (citizens propose laws), referendum (voters approve legislation), and the recall (citizens can remove officeholders for unsatisfactory job performance between elections). Note also that minor parties have elected candidates to state and local office. In 1998, the Reform party's Jessie Ventura was elected governor of Minnesota.

Minor parties have also begun important political innovations, such as the anti-Masons, who, in 1831, employed a national nominating convention for the first time. Finally, minor parties can play the role of election spoiler, siphoning off enough votes from a major party candidate to change the electoral outcome. Theodore Roosevelt's 1912 candidacy divided the Republican vote to ensure Wilson's election. In 1968, George Wallace garnered over thirteen percent of the popular vote and forty-six electoral votes, achievements that probably hurt most the Democratic candidate Hubert Humphrey in his losing race against Republican Richard Nixon. Ross Perot attracted nineteen percent of the popular vote in 1992 via his Reform party, clearly impacting the dynamics of the Clinton-Bush race. In 2000, Ralph Nader and the Green party gained almost three percent of the national vote (2.9 million popular votes) and most importantly, drew nearly 100,000 votes in the crucial state of Florida. Nader probably took away more votes from Democrat Al Gore than from Republican George W. Bush. Democrats believe that Nader's Florida popular vote cost Gore that state's twenty-five electoral votes and the presidency.

■ POLITICAL PARTY ORGANIZATION

American political parties exist at all three levels of government—national, state, and local. Although an American political party appears hierarchical and integrated, the reality is that parties are decentralized and fragmented. The national party can rarely dictate policy or discipline state and local party officials. Furthermore, power seems concentrated more at state and local levels.

State and Local Party Organizations

At the bottom of a state party is the **precinct,** a small voting district that selects party committee members. The party committee member may be chosen by a local party caucus, state party convention

delegates, or in a primary election. Larger cities use a ward system instead of the precinct unit. In New England, the town is the local unit.

Above the local levels, parties are organized at the city and/or county levels. Intermediate levels can include city, legislative, and judicial committees, then county committees, and congressional district committees. The state committee, headed by the state's party chairman, represents the top level. In some states, the party chairman may be very powerful. However, the more typical case is that the county committee remains the center of party power, because this committee often selects important local officials.

State party organizations, via each state's party chairman and party committee, try to recruit candidates, raise money for campaigns, devise campaign strategies, mobilize voters on election day, and distribute campaign literature.

National Party Organization

The national party organization is headed by the national committee and its chairman. The national committee, composed of congresspersons, representatives from the states (mayors and governors are often members along with state chairpersons) and territories, has limited authority. It decides where and when the next national nominating convention will be held and engages in fundraising duties. It usually ratifies the selection of the **national party chairperson (NPC)** by the presidential nominee of the party. The NPC's responsibilities include hiring personnel, handling the party's administration, and being a spokesperson for the party. The national nominating convention meets every four years, writes the party's platform, and then the assembled delegates select the party's ticket—that is, its presidential and vice-presidential nominees. Finally, each major party has a congressional campaign committee (representatives and senators), chosen by the legislators themselves, that assists in fundraising and re-election efforts.

■ AMERICAN POLITICAL PARTIES: A FUTURE DEALIGNMENT?

To some observers, political parties have lost a degree of their former saliency. Voters identify less with parties today and more with a candidate's image, style, and personality. Independent voters have grown in number (although roughly two-thirds of these voters are those who lean to one of the two major parties; true **swing voters, independent voters** who are not loyal to either political party, may only constitute about ten percent of the electorate). Ticket-splitting is far more common, accounting for one-fifth to two-fifths of voter choices in recent presidential elections. Also, candidates prefer to use their own campaign organizations rather than rely on traditional party machinery. Once elected, officeholders cannot be controlled by party leaders or be held accountable for any campaign promises. In short, **dealignment,** a decline in loyalty or identification with the two major parties, rather than **realignment,** a switching of voter allegiance from one party to the other, may be the primary future pattern. Periodic calls by political reformers for parties that are more centralized, disciplined, and issue-oriented were typically ignored, but Republicans did move in these directions during the 1990s. Conversely, the power of interest groups has increased substantially.

■ INTEREST GROUPS

Unlike political parties, interest groups do not nominate candidates for public office. **Interest groups** are mainly concerned with influencing the policies of government by applying pressure upon public officials. A good example is **MADD—Mothers Against Drunk Driving**—an interest group that pressured Congress into passing a 1984 law withholding federal highway funds from those states that did not raise the legal drinking age to twenty-one. An example of interest groups blocking proposed legislation occurred in 1993 and 1994, when conservative groups and insurance companies successfully blocked President Clinton's plan for universal health care. In addition, interest groups, as policy specialists, are normally concerned with a narrower range of issues (parties, as policy generalists, must be involved with the entire range of public affairs and issues). Thus, interest groups are usually accountable only to their members, not to society as a whole.

Interest groups also try to influence public opinion through advertisements, letters, radio/TV spots, and so on. Finally, interest groups oppose or support candidates for public office, depending on how those candidates stand on key issues. For example, the National Rifle Association would be unlikely to make campaign contributions to a candidate who favored strong gun-control legislation. Conversely, right-to-life groups back anti-abortion candidates on a regular basis.

In short, an interest group is composed of individuals who have similar or shared attitudes on specific issues and who collectively try to influence government decisions at all levels of government. (Who joins interest groups? Those citizens who have more education, plus higher incomes, are more likely to join interest groups. This stratum of the population generally has more time and political motivation than lesser-educated, low-income citizens.) The thousands of interest groups in America may try to prevent a particular action or purposely seek change in existing policies.

Techniques and Strategies of Influence

Interest groups approach their task of trying to influence public policy by two fundamental methods. The first is by meeting legislators and other public officials. The second is to pressure policy-makers through a more circuitous route involving the media. These two approaches can be classified as direct and indirect.

Direct Techniques

Direct lobbying techniques include lobbying, compiling ratings of legislative behavior, and providing campaign assistance.

Lobbying and Lobbyists. A lobbyist is a paid representative of an interest group. The term **lobbying** comes from the historic practice of citizens waiting for and contacting representatives in the lobbies outside legislative chambers. Today, **lobbyists,** many of whom are ex-legislators themselves (federal law states that former legislators must wait at least one year before lobbying their ex-colleagues in Congress), try to persuade legislators to vote for or against a bill or convince members of executive agencies that a program is desirable or undesirable. Their techniques may involve any of the following:

- Private meetings with public officials (gaining political access), whereby specialized information is disseminated, because legislators cannot be experts in every conceivable policy field).
- Testifying before congressional committees and executive agencies.

- Assisting legislators in drafting laws or regulations, developing party platforms, furnishing legal advice, and even providing names for federal appointments.
- Socializing with legislators in order to win their confidence—this is also called **wining and dining.**
- Filing lawsuits or amicus curiae briefs in the courts; *amicus curiae* (friend of the court) briefs are third-party statements that try to influence a judges' decisions in the particular case under consideration.
- Making campaign contributions to legislators.

Ratings of Legislators. Legislators are given a score based on how many times they have voted in accordance with the views of the interest groups involved. For example, a high ADA rating—Americans for Democratic Action—would mean a very liberal voting record (Senator Ted Kennedy of Massachusetts, for example). A high ACU rating—American Conservative Union—would signify a conservative voting pattern (former House Speaker Newt Gingrich of Georgia or House Minority Leader Tom DeLay of Texas during the Bush Administration). One group, Environmental Action, lists legislators with good or bad records on ecological issues.

Campaign Assistance. Legislators wish to be re-elected, so a group's endorsement and financial backing are both important. Many interest groups establish their own fundraising committees, or PACs. PACs are **political action committees** that represent corporations, labor unions, and other special-interest groups. There are about 3,800 PACs today. PACs are limited by law to $5,000 contributions for each candidate per election—primary, runoff, and general.

Indirect Techniques

Interest groups using **indirect lobbying** techniques of influence try to convince the public that their causes are worthy or just. Ads in magazines, newspapers, or on the Internet, TV sponsorship, and radio messages are some of the devices that can be used. A good example of this technique occurred during the late 1970s, when American oil companies spent millions of dollars on ads explaining that oil shortages were due to the restrictive policies of Middle Eastern nations. The ads explained that American oil firms were trying to end those shortages through heavy investments (costing the firms billions of dollars) in drilling hundreds of new wells.

Ads also can be used to promote favorable images for a group or industry. For example, the automotive industry frequently publishes ads asserting their concern for the environment while tobacco companies promote their civic conscience by urging young people to consider the health risks of smoking.

Interest groups also can use their membership to send thousands of letters, telegrams, or e-mail messages to legislators. In 1988, the National Rifle Association spent close to two million dollars urging its membership to contact key legislators. More than ten million pieces of mail flooded congressional offices. A bill proposing a seven-day waiting period before a gun could be purchased was defeated, perhaps reflecting this mail pressure. In 2005, the **American Association of Retired Persons (AARP)** mobilized its membership to oppose President Bush's plan to partially privatize Social Security.

The Growth of Interest Groups

The vast increase in the number of interest groups in America has been linked to the nation's complex social diversity, technological changes, periodic crises, socioeconomic changes, and the broad expansion of government itself. Also, Americans are natural "joiners" who are attracted to groups for material, solidarity, and purposive reasons. Finally, these groups represent a myriad of economic and non-economic interests, with typical examples including business, labor, agriculture, consumers, professionals, senior citizens (AARP), ideological beliefs, environmental, single-issue, and governmental.

Historic Diversity and Tradition

How and why do interest groups form? In the United States, traditional racial, religious, and ethnic diversity has multiplied the number of group interests. Culturally, Americans have always seemed to constitute a nation of joiners. The French observer Alexis de Tocqueville noted this characteristic in the 1830s, when he observed that the **principle of association** had deep roots in the American psyche. Finally, groups also are free to organize under the First Amendment's constitutional protections of free speech, assembly, and petition.

Structure of American Government

Federalism and the separation of powers promote interest-group activity. An interest group that fails to accomplish its goals at the state level can work for change in Washington. A group that is unsuccessful with Congress can try to influence the courts through a test case. Civil rights groups, such as the NAACP (National Association for the Advancement of Colored People), were successful in having the Supreme Court eventually rule segregation unconstitutional in 1954 after decades of congressional resistance (see Chapter 10).

Socioeconomic Changes, New Technology, and Crises

A good example of social change is the large numbers of women since 1960 who have entered the workplace, hence the formation of new women's groups. Also, the Supreme Court's 1973 *Roe v. Wade* abortion ruling galvanized interest group activity among both pro-life and pro-choice citizens.

New technology, such as word processors, satellite TV/Internet, and computerized mailing lists have all enabled group leaders to raise money more easily and to stay in touch with rank-and-file members.

Crises or a sense of issue urgency also can lead to the formation of new groups. Rachel Carson's publication of *Silent Spring* in 1962, an indictment of pesticide use in America, along with offshore oil spills, generated renewed interest in the environment, including the creation of Earth Day and strengthened pro-environmental organizations.

Growth of Government

The expansion of government has meant additional programs and new groups organized to protect those programs. For example, the **AARP** was created to resist any changes in Social Security laws and to persuade Congress to pass new legislation helping the elderly, especially in the area of health care.

Membership in Interest Groups

Among many different reasons people have for becoming members of interest groups are the following incentives: material, solidarity, and purposive.

Material Benefits

Groups can offer members all kinds of benefits, from low-cost insurance to reduced prices for goods and services to special travel packages. Direct monetary benefits can include higher wages, as when a labor union pressures big business. Non-monetary benefits might include better safety conditions for workers or discounts on services available to senior citizens through membership in AARP.

Solidarity Benefits

The benefits of making friends and participating in social events can be a major incentive for group membership. There is also the psychological satisfaction of belonging to a group where common values can be shared and a sense of collective community experienced.

Purposive Benefits

These are benefits that are extended to individuals outside the interest group's own members. A member of an environmental group working for cleaner air and water knows that success will benefit everyone. However, while these benefits promote satisfaction for members, they do pose the free-rider problem. Why should people join this group when they will enjoy the benefits without the cost and effort associated with group membership?

Types of Interest Groups

In the past, most interest groups have pursued economic goals for their membership—for example, farmers, businessmen, workers in labor unions, and professionals. However, non-economic interest groups have proliferated in recent years, dealing with such issues as the environment, race, or even the public interest. Other non-economic groups have fought for the rights of women, Hispanics, and gays. A third category includes governmental interest groups.

Economic Interest Groups

These groups have traditionally involved agriculture, business, labor, and skilled professionals. These groups are primarily concerned with attaining material benefits, such as profits, better pay, or improved job security.

Agriculture. Aside from smaller, specialized-commodity farm groups (dairy, beef, sugar, soybeans, peanuts are examples), the largest agricultural interest group is the American Farm Bureau Federation (AFBF). The AFBF has more than five million members. The National Farmers' Union (NFU; 250,000 farm and ranch families), National Grange (300,000 members), and the National Farmers Organization are smaller in size and represent narrower constituencies. There are clear differences in regional appeal, specific farm groups represented, and political philosophy among these groups. The AFBF is strongest in the South and Midwest, and represents large farmers. It opposes restrictive federal regulations on agriculture, and generally is supportive of conservative Republicans. Conversely, the NFU has its greatest support among Midwestern grain farmers and supports government subsidies. It leans toward the Democratic party. In short, there is no one group that can represent all of the nation's farmers. Note that less than two percent of the U.S. population makes its living by farming.

Business. More than half of all groups registered to lobby Congress are business firms. The three most powerful business interest groups are the United States Chamber of Commerce (USCC), the National Association of Manufacturers (NAM), and the Business Roundtable (BR). The USCC represents well over three million member companies and has been an opponent of consumer-protection laws and stricter antitrust policies. The NAM is a group that mirrors the wishes of about 13,000 fairly large corporations. In the past, the NAM has worked for legislation restraining labor unions and creating protective tariffs. The BR is, from its own Web site, "an association of chief executive officers of leading U.S. corporations with a combined workforce of more than ten million employees." Like other business groups, it is firmly against government regulation of corporations, anti-monopoly legislation, and higher corporate taxes.

Small Business. Groups even more representative of small businesses include the National Federation of Independent Business and the National Small Business Association. The NFIB represents more than 600,000 business proprietors. The NSBA reaches more than 150,000 small businesses.

Trade Associations. Trade associations (examples include gas, coal, railroads, interstate trucking) are concerned with benefiting a particular industry. A good example is the American Petroleum Institute, which according to its Web site, "represents more than 400 members involved in all aspects of the oil and natural gas industry."

Organized Labor. The largest labor interest group is the AFL-CIO, which in 2005 represented more than thirteen million workers. (Note, however, that the solidarity of organized labor was also threatened in July 2005 when dissident unions such as the Teamsters broke away from the AFL-CIO over membership and political fundraising issues and made it possible that the AFL-CIO's membership would be reduced by as much as one-third). The AFL-CIO (created in 1955 by a merger of the American Federation of Labor and the Congress of Industrial Organizations) supports pro-labor policies such as national health insurance and higher minimum-wage standards. In addition to the AFL-CIO, there are other independent unions that are politically influential, such as the United Auto Workers.

Organized labor has suffered a membership decline in recent years, with only thirteen percent of the workforce now unionized (compared to one-third thirty years ago). However, labor interest groups can still be effective, especially if their members turn out heavily on election day to vote for one party's candidates (traditionally Democratic ones). Finally, public employee unions, such as the American Federation of State, County, and Municipal Employees, have more influence today than ever before.

Professional Groups. Typically included in this category is the American Medical Association (doctors; 300,000 members), the American Bar Association (lawyers; more than 400,000), the National Education Association (teachers; 2.7 million members), and the National Association of Realtors (real estate agents; 1.2 million members). Most of the important professional groups have lobbyists in Washington, D.C.

Non-Economic Groups

These groups form in reaction to a specific public issue or controversy, such as the Right to Life Association, which evolved after the 1973 Supreme Court decision allowing abortion (*Roe v. Wade*).

Under this category are public interest/consumer, ideological, women/seniors, religious, political action, environmental, and single-issue interest groups.

Public Interest and Consumer Groups. These groups seek political rewards that extend beyond the actual group membership so that much of society benefits from their lobbying efforts. Where economic groups seek direct private, material gain, a public interest group such as the League of Women Voters (founded in 1920) works for simpler procedures to register voters, a goal that could theoretically strengthen democracy throughout the nation. Similarly, the American Civil Liberties Union (ACLU) is concerned with the protection of constitutional freedoms and especially the Bill of Rights.

A famous consumer advocate is Ralph Nader. Nader first publicized the issue of automobile safety, then proceeded to establish Public Citizen, Inc., with fifteen sub-organizations covering such problems as nuclear power, health care, ethical congressional procedures, pollution control, pure food and drugs, and so on. Although Nader's organization is very prominent, there are countless other consumer groups whose interests can range from producing safe infant toys to lowering interest rates on credit cards. Included here is Consumers Union, the publisher of the monthly magazine *Consumer Reports.*

Ideological Groups. Ideological groups espouse a particular political or moral philosophy that they wish to see incorporated into public policies. The ADA (Americans for Democratic Action) or the once-active Moral Majority (conservative Christian values) are good examples of the genre.

Women and Senior Groups. Groups backing greater equality for women in the workplace have become important. NOW, the National Organization for Women, although failing to pass an Equal Rights Amendment in the late 1970s and early 1980s, remains a strong political force. NOW has 500,000 contributing members and 550 chapters in all fifty states and the District of Columbia.

AARP is an extremely powerful interest group, with a membership of more than thirty-five million seniors. It represents close to one-fifth of the nation's older population. It has figured prominently in legislative battles over health care, social security, pension reform, prescription drugs, and Medicare.

Religious Groups. Religious groups frequently have taken positions on social issues, raging from abortion to nuclear power to the rights of minorities. Foreign policy also has been an area of interest. For example, Jewish groups have strongly backed Israel. In the past, the Catholic Church supported the nuclear-freeze movement.

Political Action Groups. A good example is **Common Cause,** which was established in 1968 by John Gardner and now has nearly 300,000 members. Common Cause is concerned with accountability of government officials to the citizenry, stricter laws governing campaign contributions, the independence of public broadcasting, public financing for presidential elections, and the removal of barriers to voting.

Environmental. Environmental groups have multiplied as the public has become more conscious of environmental problems such as oil spills, pollution, and the need for conservation of America's natural resources. The Sierra Club, founded in 1892, lobbies for clean air and water and unspoiled wilderness areas. It has a membership of more than 750,000. The National Wildlife Federation (4.5 million

members), National Audubon Society (500,000 members), Friends of the Earth, Inc., the Environmental Defense Fund, Nature Conservancy, Earth First (which tends to be a bit radical), Greenpeace USA, and the Wilderness Society are other prominent examples.

Single-Issue. These groups are primarily concerned with influencing policy in one substantive area. Examples include the National Rifle Association (4.2 million members), which opposes gun control; the National Taxpayers Union, which desires a constitutional amendment to balance the federal budget; Planned Parenthood, which is concerned with reproductive freedom for women; and MADD (over 3 million members), which fights the problem of drunk drivers.

Governmental Interest Groups

Because the federal government can influence other nations through arms sales, overseas aid, or trade policy, foreign governments, such as those from Japan, South Korea, and the European Union will send their own lobbyists to Washington. Unlike other groups, they cannot contribute to U.S. political campaigns.

State and city governments in America have their own interest groups. Groups such as the Council of State Governments or the National League of Cities will try to pressure Washington for grant money, defense contracts, federal construction projects, urban renewal, or low-cost housing subsidies. The states and cities continually inform Washington policymakers about current problems and future needs.

Why These Groups Fail or Succeed

The effectiveness of both economic and non-economic interest groups depends upon a number of variables: membership size, money, quality of the lobbying effort, the dedication and intensity of the leadership, general organizational cohesion, and political timing. Interest groups also differ on their alliance-building capabilities, or their willingness to work with other like-minded groups to achieve a specific political goal. While it is true that large, well-financed groups have distinct advantages over smaller groups with fewer resources, David can sometimes best Goliath, as has been the case with victories of environmental groups over the representatives of big business.

Should Interest Groups Be Regulated?

While "pluralist" defenders argue that interest groups are essential to the preservation of American democracy, critics point out that lobbyists may exert undue influence over legislators. Federal laws have grappled with this problem by trying to regulate lobbying activity.

Criticisms of and Support for Interest Groups (Pluralist Theory)

Critics of the American interest-group system argue that it is biased toward the upper social classes and ignores the needs of the poor and minorities. Furthermore, they assert that big business dominates the system. Finally, critics point to the unsavory techniques used by lobbyists to persuade legislators, from influence-peddling (paying for gifts and expensive junkets) to threatening the loss of campaign contributions if acquiescence is not forthcoming. In short, detractors assert that interest groups eventually "buy" political influence and thus need governmental regulation (see following section on the 1946 and 1995 Lobbying Acts).

Proponents of **pluralist theory** argue that no one interest group can dominate the political system for long. Influence will vary over time as different coalitions of groups clash over public policy

alternatives. These group struggles promote stability, fairness, and democratic participation. Furthermore, most lobbyists are men and women of integrity—blackmail, under-the-table payments, and outright corruption are rare, especially at the federal level. Finally, as assumed by the pluralist model of interest group politics, every group has the constitutional freedom to organize and play a role in the political arena with the hope that this group competition will lead to fair compromises on policy. In recent years, the underprivileged strata of American society have become more vocal in articulating their groups' needs through the media or protest demonstrations. Finally, the growing weakness of political parties requires that interest groups fill the void as representatives of the people.

The Federal Regulation of Lobbying Act of 1946 and The Lobbying Disclosure Act of 1995

In 1946, Congress tried to regulate lobbying activities through the Federal Regulation of Lobbying Act. The act required lobbyists to register their names, give background information on their salaries and expenses, and provide quarterly reports on their activities to Congress. The penalty for noncompliance was a possible fine of $10,000 and/or five years in prison.

However, in a Supreme Court ruling testing the act's constitutionality, the Court found that the act pertained mainly to lobbyists who "directly" influenced federal legislation. In short, the act was applicable only to lobbyists who communicated with legislators on proposed or pending legislation or those individuals who solicited, collected, or received money for lobbying. Indirect lobbying (trying to influence public opinion) or social gatherings of lobbyists and legislators would not be covered by the act.

Most of the act's provisions were ignored. Some argued that stricter regulation of lobbying could violate First Amendment rights—for example the guarantee of the right to petition for redress of grievances. So, in an attempt to close the 1946 Act's loopholes, reform legislation—the Lobbying Disclosure Act of 1995—was passed by Congress. Stricter definitions of a lobbyist were passed, so that it included any individual devoting a minimum of twenty percent of his or her time to the lobbying effort or who was paid a sum exceeding $5,000 in a six-month time frame involving lobbying activity. In addition, any organization that spent a sum of more than $20,000 within the 180-days time frame on lobbying activity had to register.

All lobbyists must now file reports identifying any executive agency or house of Congress that was lobbied, along with the names of their clients and the specific issues involved in the actual lobbying. Tax-exempt organizations and groups involved in indirect lobbying, such as asking citizens to write or otherwise contact their representatives in Congress, were excluded from the 1995 law. Interestingly, there was a doubling of registered lobbyists within a few years after the legislation's passage.

Political parties are indispensable tools of democracy, encouraging citizen participation, informing the electorate, linking government to the people, and recruiting those individuals who will serve in official public positions at all three levels of government. In addition, America's two-party system has been congruent with the nation's history and ideological moderation. Despite the prevalence of America's two parties, minor parties have periodically forced the major parties to adopt new programs and ideas. Finally, the organization of American parties mirrors the decentralized and loose chain of command common to our federal structure.

Unlike parties, interest groups do not propose candidates for public office. Interest groups, both economic and non-economic, are concerned mainly with influencing public officials to accept or reject

specific programs and policies. Their methods of influence are both indirect and direct, the former involving grass-roots pressure, the latter skilled lobbyists who personally contact important decision-makers in the executive and legislative branches of government. Members of interest groups are usually drawn from the better-educated, wealthier strata of the population.

Critics of the interest-group system argue that it is undemocratic and unethical. Proponents see the system as necessary to democracy and possessing the capability to represent both the poorer and wealthier classes.

Selected Readings

Black, Earl and Merle Black. *Rise of Southern Republicans* (2003).

Cigler, Alan J. and Burdette A. Loomis, eds. *Interest Group Politics,* 6th Edition (2002).

Goldman, Ralph M. *The National Party Chairman and Committees: Factionalism at the Top* (1990).

Goldstein, Kenneth M. *Interest Groups, Lobbying, and Participation* (2003).

Gould, Lewis. *Grand Old Party: A History of the Republicans* (2003).

Herrnson, Paul S., et al. *The Interest Group Connection: Electioneering, Lobbying, and Policymaking in Washington,* 2nd Edition (2004).

Sifry, Micah L. *Third Party Politics in America* (2002).

Witcover, Jules. *Party of the People: A History of the Democrats* (2003).

Test Yourself

1) The third party candidate who received forty-six electoral votes in the 1968 presidential election was
 a) George Wallace
 b) Theodore Roosevelt
 c) Ross Perot
 d) Ralph Nader

2) True or false: Political parties are specifically provided for in the U.S. Constitution.

3) The period of one-party rule in America known as the Era of Good Feelings is most closely associated with
 a) Andrew Jackson
 b) Abraham Lincoln
 c) James Monroe
 d) Theodore Roosevelt

4) True or false: Political parties are policy generalists, where interest groups are policy specialists.

5) Members of Congress, governors, and state legislators represent which party component?
 a) the party in the electorate
 b) the party in government
 c) the formal party organization
 d) none of the above

6) True or false: The Democratic party dominated the national government in the post-Civil War era.

7) Which presidential election dates represent realigning elections?
 a) 1912 and 1964
 b) 1888 and 1988
 c) 1828 and 1884
 d) 1896 and 1932

8) True or false: If the United States were to adopt a proportional representation voting system, it is most likely that the political power of third parties would increase dramatically.

9) Teddy Roosevelt's 1912 Bull Moose party best exemplifies what type of third party?
 a) splinter
 b) economic protest
 c) single-issue
 d) ideological

10) True or false: Typically, Republicans are on the center-right of the political spectrum, whereas Democrats are located on the center-left of the spectrum.

11) Which does not exemplify a direct technique of lobbyists?
 a) wining and dining legislators
 b) testifying before congressional committees
 c) filing amicus curiae briefs
 d) placing an issue ad in a major newspaper

12) True or false: Joining an interest group because an individual wishes to make friends and participate in social events exemplifies material benefits.

13) The largest agricultural interest group is the
a) Grange
b) American Farm Bureau Federation
c) National Farmers Union
d) National Farmers Organization

14) True or false: The largest labor union group is the AFL-CIO.

15) The famous consumer advocate who established Public Citizen, Inc., was
a) John Gardner
b) Rachel Carson
c) Ralph Nader
d) none of the above

16) True or false: NOW is a large interest group that represents the nation's senior citizens.

17) Which of the following is a professional interest group?
a) NEA
b) NRA
c) NAM
d) all of the above

18) True or false: Members of interest groups tend to be better-educated and wealthier than lower-income or lesser-educated Americans.

19) According to the 1995 Lobbying Disclosure Act, a lobbyist is defined as any individual devoting a minimum of _____ percent of his or her time to the lobbying effort.
a) five
b) ten
c) fifteen
d) twenty

20) True or false: The 1946 Federal Regulation of Lobbying Act covered both direct and indirect lobbying activities.

Test Yourself Answers

1) **a.** The correct choice is George Wallace. Teddy Roosevelt received eighty-eight electoral votes in 1912. Perot and Nader received none.

2) **False.** The framers of the Constitution distrusted parties, fearing they would add to societal conflict and partisan bickering. Typical was Washington's Farewell Address, warning about the "baneful effects of the spirit of party."

3) **c.** James Monroe presided over this party era. Monroe's election to the presidency in 1820 was nearly unanimous. All the other presidents mentioned in the question served during periods of vigorous party competition.

4) **True.** Parties must deal with a wide variety of issues because they represent a broad coalition of different groups and individuals; interest groups usually are concerned with only a few issues at most.

5) **b.** They are the appointed or elected officeholders in the legislative and executive branches of government who are considered representatives of a specific political party.

6) **False.** It was the Republican party that dominated both the executive and legislative branches of government.

7) **d.** The 1896 election guaranteed a Republican majority that lasted until 1932, when Democrat Franklin D. Roosevelt defeated the Republican Herbert Hoover during the midst of the Great Depression. The Democratic party dominated U.S. politics for over three decades until the Nixon victory in 1968.

8) **True.** Proportional Representation would allow a minor or third party to obtain seats in Congress, even if candidates of that party did not receive a plurality of the vote. The PR system allows legislative seats to be awarded to each party strictly on the basis of popular vote totals. Thus, a minor party receiving twenty percent of the national vote would be entitled to twenty percent of the seats in the national legislature. If you applied that formula to the House of Representatives, eighty-seven seats (instead of zero) would be awarded to the minor party.

9) **a.** The Bull Moose party represented a splinter, or faction, breaking away from the regular Republican party in 1912. William Howard Taft was the nominee of the Republican party and Woodrow Wilson the Democratic party's nominee. Roosevelt's Bull Moose party fractured the Republican party and helped Wilson achieve a victory.

10) **True.** Republicans tend to be more conservative than Democrats. Hence, GOP voters will tend to be on the right side of the political spectrum, while Democrats will be slightly to the left or on the more liberal side of the spectrum.

11) **d.** The first three choices involve direct contacts by a lobbyist; placing an ad is an indirect technique of influencing the political process.

12) **False.** These goals represent solidarity benefits. Material benefits refer more to monetary benefits.

13) **b.** The American Farm Bureau Federation has more than five million members. No other farm group approaches this size.

14) **True.** The AFL-CIO has over thirteen million members with ninety affiliated unions.

15) **c.** John Gardner was the founder of Common Cause. Rachel Carson was the author of the environmental work *Silent Spring.*

16) **False.** NOW is the National Organization for Women. AARP is the key interest group representing the nation's seniors.

17) **a.** The NEA stands for the National Education Association, representing the nation's teachers. The NAM is a business group, and the NRA is the National Rifle Association.

18) **True.** Poorer or even average-income Americans do not have the same amount of time or interest as upper-class citizens in terms of joining interest groups.

19) **d.** This is the precise percentage contained in the 1995 law.

20) **False.** Indirect lobbying is not covered by the 1946 act.

Voting, Campaigns, and Elections

The real meaning of democracy occurs on election day when a citizen steps into the voting booth and secretly chooses his or her representative for a local, state, or federal office. (There are more than 500,000 elective offices in America.) The voter's decision is a result of both psychological variables (party loyalty, candidate style, and issues) and sociological factors (socioeconomic background and group affiliations). The candidates' campaigns that preceded election day may have confused, enlightened, or even had a negligible impact upon the voter. Meanwhile, millions of other voter-eligible Americans pay little attention to election day. It is truly ironic that as universal **suffrage** (right to vote) has been finally realized, voter participation in elections has actually declined. The reasons for voting or nonvoting and the interaction among campaign, election, and voter dynamics are explored in this chapter.

■ THE HISTORICAL EXPANSION OF THE SUFFRAGE

In 1789, only a small number of Americans could vote in elections, perhaps one out of every fifteen citizens. The suffrage, the right to vote, was open only to white, adult males who owned property. The next 200 years would witness the elimination of voter restrictions for nonpropertied white adult males and for African Americans, women, and eighteen-year-olds.

Elimination of Religious and Property-Ownership Tests

During the twenty-five years after the Declaration of Independence (1776), many states believed that only citizens who belonged to a majority church (the dominant church in terms of total membership; hence, Jewish and Catholic citizens typically were excluded) and who owned property deserved the right to vote. Why, they wondered, should propertyless individuals have any interest in voting? Fortunately, nearly all of the states had abolished religious voting tests by the early 1800s, but property requirements persisted much longer. However, they were legally abrogated by the middle of the nineteenth century.

The Passage of the Fifteenth and Nineteenth Amendments

Ratified in 1870, the Fifteenth Amendment barred the states from using race as a voting requirement. However, most southern blacks were prevented from voting for close to a century through such devices as the white primaries (African Americans were excluded from party membership and, therefore, primary voting because parties in southern states were legally defined as private associations) and **grandfather clauses** (typical clauses in state constitutions asserted that the suffrage would be granted only to citizens or their descendants who possessed the voting right prior to 1866 or 1867; thus, disenfranchised ancestors, many of whom were slaves, meant voting was now denied for the current generation). Southern states also used literacy tests, and not just ones that tested reading or writing abilities, but ones that required complicated or obscure interpretations of constitutional materials that translated into another voting disqualification. The white primary was abolished by the 1944 Supreme Court ruling in *Smith v. Allwright*. The grandfather clauses were ruled unconstitutional by the Supreme Court both in 1915 and 1939. The Voting Rights Act of 1965 eliminated literacy tests (see the following section).

In 1920, the Nineteenth Amendment gave women the right to vote, on a national basis, in all elections (federal, state, and local) for the first time. Prior to this amendment's passage, a majority of the states had already granted women this privilege, either partially or fully. Congress had finally responded to decades of political pressure both from the women's suffrage movement and respected state leaders.

Voting Rights Act of 1965, and the Twenty-third, Twenty-fourth, and Twenty-sixth Amendments

The Voting Rights Act suspended literacy tests and allowed federal voting examiners to register voters (amendments/extensions of that Act in 1970, 1975, and 1982 expanded the range of federal registrars into additional states, permitted bilingual ballots, and allowed voter-discrimination lawsuits by private parties). The result was a dramatic increase in black voter **registration,** especially in the South. The Twenty-third Amendment, ratified in 1961, extended the suffrage to Washington, D.C., voters in presidential elections. The Twenty-fourth Amendment (1964) eliminated the **poll tax** (a monetary sum paid by a citizen before he or she could be permitted to vote) as a requirement for voting in any federal election. The Twenty-sixth Amendment (1971) stipulated that eighteen-year-olds were now eligible to vote in both state and national elections. Prior to this amendment, twenty-one had been the minimum age for voting. But the argument prevailed that if young Americans were old enough to be drafted into the military, they were old enough to vote.

The Help America Vote Act of 2002

In October of 2002, President George W. Bush signed into law the Help America Vote Act of 2002 (abbreviated as HAVA), legislation designed to improve the conduct of elections by eliminating administrative obstacles to voting that had occurred in the 2000 presidential elections, when millions of Americans may have been denied their right to vote or did not have their ballots counted. Over $3.8 billion was expended during the next three years to eliminate outmoded punch-card/lever voting machines, make polling places more accessible to the handicapped, develop accurate and constantly updated computerized voter registration rolls in the states, and incorporate new ballot security measures via identification documents (driver's license, social security number, proof of residence, and so on) in order to prevent voter fraud. Note that these measures have not been widely implemented, because Democrats and minorities have objected to them on the grounds that they are discriminatory against poorer citizens who wish to vote.

■ CURRENT REQUIREMENTS FOR VOTING

The achievement of universal suffrage extends to any American eighteen years of age or older the political right to vote, provided he or she complies with the legal requirements of citizenship, residence, and registration.

Non-Citizens, Felons, and Those in Mental Institutions

An alien, or non-citizen, may not vote in any election throughout the nation. In addition, those in prison and convicted felons released from incarceration are ineligible to vote.

Residency

The **residency requirement** stipulates that a citizen must have lived in a state's election district for a prescribed period of time, typically no longer than a thirty day maximum, before becoming eligible to vote. Half of the states have residency requirements of less than thirty days, with many setting a zero-day residency rule, as long as a voter is a legal resident of a state. The residency requirement was originally based upon the assumptions that a voter must have enough time to learn about local and/or state candidates and issues, and that voter fraud must be discouraged.

Registration and the Motor-Voter Law

Registration is a process of identifying voters so that electoral fraud is avoided. Except for North Dakota, all states mandate voter registration (a few states, such as Minnesota, Oregon, Wisconsin, Wyoming, and Maine allow registration up to and even on election day). A voter must register his or her name, place of residence, date of birth, and other appropriate information with a county clerk or local election registrar. A voter remains registered until he or she moves to another locality or state, where the registration procedure must be initiated again. Voters are removed from the registration rolls if they are convicted of felonies or are confined to mental institutions.

The registration process was enhanced by congressional passage of the National Voter Registration Act in 1993 or, as it came to be called, the **Motor-Voter law.** The act (it became effective in 1995) allows a citizen to:

- Register to vote when applying for or renewing a driver's license (registration forms should also be found at unemployment, welfare, or other appropriate public agencies).
- Register to vote via mail.

The law also mandates that every four years the states must send out a questionnaire to each registered voter, confirming personal information or whether a death or change in residence has occurred. In this way, the voter rolls can be purged by local election officials of individuals who are no longer qualified to vote. Estimates are that Motor-Voter law has generated ten million new registered voters (many of whom are independents), although this number seems to have had a minimal impact upon overall turnout, as shown in Table 5.1.

Table 5.1 Voting Turnout in Presidential Elections, 1932–2004

Year	Percent Voting of Those Eligible
1932	56.9%
1936	61.0%
1940	62.5%
1944	55.9%
1948	53.0%
1952	63.6%
1956	60.6%
1960	63.1%
1964	61.8%
1968	60.7%
1972	55.1%
1976	53.6%
1980	52.6%
1984	53.1%
1988	50.1%
1992	54.0%
1996	49.0%
2000	51.0%
2004	59.0%

Obviously, registration requirements reduce voter turnout. America is a mobile society, and many Americans who change their residences each year forget to reregister. So, the cutoff date for registration can be a problem, although federal law mandates that no state may end registration more than one month before a federal election day. Also, until the advent of the Motor-Voter law, a citizen could register only at official precinct registration centers that were open during working hours, not on weekends or evenings. By contrast, voters are registered by the federal government in many of the nations of Western Europe and Scandinavia—in effect, citizens have lifetime registration, no matter where they live within that country.

■ WHY CITIZENS DO OR DO NOT VOTE

In the 2004 presidential election, there were 221 million individuals of eligible voting age nationally. However, only slightly more than fifty-nine percent of those eligible actually voted on election day. Turnout is even lower for state and local political races, typically twenty-five to forty percent of the electorate. In a non-presidential election year, turnout for congressional races is lower than when there is a close presidential race that motivates even indifferent voters.

Since 1960, **voter turnout** (as measured by those who actually vote out of the total number of eligible voters) has been declining in national elections, from sixty-three percent in 1960 to a low of forty-nine percent in 1996. The fifty-nine percent figure in 2004 was clearly an exception to the downward trend. (Compare these figures to the 1876 presidential election, when eighty-five percent of eligible voters cast ballots.) The United States has among the lowest turnout percentages when contrasted with other democracies such as Austria or Sweden (where over ninety percent of eligible voters vote). Note also that

other democracies provide automatic registration for citizens or even compel people who do not vote to pay fines, as is the case in Uruguay or Australia.

However, political scientists have observed that U.S. turnout figures are actually higher if another measure of voter turnout is used. In other words, the voter turnout percentage is higher if taken from the smaller registered voters base rather than from the much larger voter-eligible population that comprises both registered and non-registered citizens. In addition, the extension of the franchise to eighteen-year-olds in 1972 created a larger pool of total eligible voters. Because younger voters traditionally have low turnout percentages, the overall turnout percentage was affected adversely.

Handicapped and Ineligible Voters

Millions of American voters cannot vote because they are physically or mentally handicapped. Millions are either in prison or will not vote due to their religious convictions. Finally, perhaps three or four million are traveling on election day and are unable to get back to their home voting precincts in time (absentee ballots are available, but they may not be used due to the paperwork and time involved). In addition to these categories, ordinary citizens might cite one of the following explanations for not going to the polls.

"It Makes No Difference Who Wins"

Many citizens feel that regardless of which party's candidate is elected, the political system will continue to operate effectively. Both parties (and their candidates) are seen by these individuals as virtually identical in philosophy and policy preferences. Others within this category distrust politicians in general, so to them elections have little value or meaning.

"I Can't Influence the Political System by Voting"

Some citizens lack **political efficacy,** the feeling that their votes will not make a difference in public policies. To them, politics is a mysterious, immovable force that is well beyond their control. In addition, many citizens with this view are voter dropouts who no longer find any of the candidates worthy of their time or attention. Contributing to this attitude is the absence of real competition in many elections. Throughout American history, there have been elections won or lost by a comparatively few votes. In 2000, George W. Bush carried Florida by only a little over 500 votes. In 2004, the state of Washington's governor's race was decided by a total of 129 votes out of 2.9 million cast.

"I Know Nothing or Care Nothing about Politics"

These citizens are largely apathetic, disinterested, and uninformed about political life, campaigns, candidates, issues, or elections. To some observers, it is better that these individuals do not vote, because democracy should depend upon that segment of the population that is really concerned about public life. To many voters, caring about politics and the suffrage is an act of civic pride, even patriotism.

"I Wasn't Registered" or "The Polling Lines Were too Long"

This type of voter is stymied by registration requirements or by the inconvenience of going to the polls after a long work day. Some observers have suggested that election day be made a national holiday, with the polls open from 7:00 A.M. to midnight, so as to free up additional time for would-be voters.

Another idea is to move election day from its current time of the first Tuesday in November to the first weekend of that month, thereby freeing the prospective voter from scheduling conflicts and workplace responsibilities.

Possible solutions to this complaint reside with the ideas of extensive voting by mail, the use of the Internet, and early voting in general.

- Mail voting is used most extensively in Oregon. In 2004, the state achieved a voter participation rate of eighty-five percent. This approach alleviates the problem of getting to the precinct, because the voter can send in his or her ballot well in advance of the election. Advantages include reducing the costs of elections, increasing turnout, and simply helping the voter in terms of time and effort. Disadvantages are potential fraud and the fact that the voter cannot change his/her mind at the last minute.

- Internet voting, although used in some local and state contests, has not yet been extended to national elections. Online voting is certainly convenient, but it, too, suffers from possible fraud through hackers or even a technology glitch.

- States also allow advance voting, in which ballots can be completed weeks before election day.

■ WHAT KIND OF PEOPLE VOTE?

It is clear that voters have different perceptions of their political world than do nonvoters. These perceptions are a reflection of socioeconomic backgrounds, loyalty to a political party, occupation, race, and age. Specifically, the following factors are crucial in determining whether a particular citizen will enter the voting booth on election day.

Education and Income

In general, voters have higher levels of education and income than nonvoters. Clearly, education is the single biggest predictor of whether a citizen votes or not. For example, college graduates vote more regularly than high-school graduates; high-school graduates vote in greater numbers than those with only a grade-school education. The reason is that individuals with more schooling tend to be better informed about politics, follow the news more closely, possess a greater sense of political efficacy, and believe that voting is an important civic duty. (Low-education voters have less of a sense of involvement with, or control over, the political environment.) Similarly, high-income citizens are more likely to be property owners who perceive political choices as important to their standard of living and personal futures. For example, recent analysis shows that households with total family incomes over $70,000 approach a seventy percent turnout level, compared to very poor households, whose turnout is only thirty percent.

Party Identification

Voters identify more strongly with political parties than do nonvoters. Party identification intensifies a voter's interest in supporting his or her partisan candidates on election day.

Occupation

Businesspeople, white-collar professionals, and union members vote more frequently than unskilled workers, blue-collar laborers, or nonunion members. The reasons relate to questions of education, income, efficacy, and group affiliation. For example, union members will be pressured by their fellow

workers and union leaders to back pro-labor candidates who are running for office. Their self-interest dictates the voting decision.

Race and Ethnicity

Whites vote more often than members of minority groups, but that is likely more of a factor of income and schooling than anything else. In fact, whites and minority voters who have comparable educational and income levels vote in approximately the same proportions.

Age

Voters in their thirties, forties, fifties, or sixties are more likely to vote than very young voters, especially the eighteen-to-twenty-one age category. The latter, many of whom are still in school, highly mobile, or preoccupied with starting a career, are simply less interested in politics. Conversely, persons over seventy vote less due to their physical infirmities, but still have higher turnout than young voters.

■ VOTING BEHAVIOR: PSYCHOLOGICAL AND SOCIOLOGICAL FACTORS

The following material stresses two sets of causal variables affecting voters. An individual citizen's voting decision is influenced by both psychological (party identification and perceptions of the candidate's issue stands and/or personality) and sociological variables (income, occupation, race, religion, education, sex, age, and group membership).

The Three Basic Psychological Variables

What are the crucial factors that influence the actual voting decision? The three underlying **psychological variables** are:
- The individual voter's perceptions of party identification.
- Campaign issues.
- The candidate's style, image, or personality.

Party Identification and Ideology

Party identification (PI) is the long-term variable. Although Chapter 4 revealed that voters can switch party loyalties and that party identification is weakening (ticket-splitting and the increase of independent voters have reduced the level of partisan support), PI still offers a potent explanation of voting behavior in presidential elections. In 2004, eighty-nine percent of Democrats supported their presidential candidate, John Kerry, while ninety-three percent of Republicans chose their party's candidate, President George W. Bush. Ideology may be closely related to party identification, as self-professed liberals tend to be Democrats, while conservatives prefer the Republican party.

Campaign Issues

Voters can be swayed by the particular issues of a campaign. Issues represent a short-term influence on the voting decision. For example, in 1988, many Democrats did not like their nominee's (Michael Dukakis) opposition to the death penalty. Accordingly, the Dukakis stand on this issue persuaded

Democrats to switch to the pro–death penalty Republican candidate, George H.W. Bush. One out of six Democratic voters cast his or her ballot for Bush.

The significance of particular issues will vary from election to election and may involve both domestic issues (like the economy) or international affairs (for example, the Vietnam War during the 1960s and 1970s; the Iraq War that began in 2003). For many voters, the status of the economy is crucial—Bill Clinton's 1992 campaign stressed economic issues as the core of his campaign, helping him to defeat President George H.W. Bush. The economy helped Ronald Reagan defeat incumbent President Jimmy Carter in 1980 when he asked, "Are you better off today than you were four years ago?" In 2004, the global issue of terrorism and the domestic issue of moral values convinced more Americans to stay with President George W. Bush as commander-in-chief rather than switch to the Democratic challenger, Senator John Kerry.

Candidate Style, Personality, and Image

Voters whose party loyalty is weak and who are uninformed about the issues may vote on the basis of how the candidate looks on TV or whether he or she seems sincere, honest, or trustworthy. Ronald Reagan's likable personality on TV in 1980 and 1984 attracted millions of Democrats. Similarly, in 1964, GOP candidate Barry Goldwater's image of a nuclear risk-taker compelled droves of Republican voters to vote for Democrat Lyndon Johnson. Clinton's TV performances over Bush (1992) and Senator Bob Dole (1996) immeasurably helped him in achieving two presidential terms. Finally, the Bush Administration repeatedly invoked Kerry's congressional vote on the Iraq War as proof that he was a "waffler," offering an image of indecisiveness.

Sociological Voting Variables

Sociological variables refer to a voter's socioeconomic background and his or her group affiliations, which are discussed in the following sections.

Income and Occupation

In general, Republicans attract greater numbers of higher-income voters; Democrats, lower-income voters. For example, in both 1980 and 1984, Ronald Reagan, the Republican candidate, attracted those with incomes above $35,000 by a margin of two to one over the Democratic nominee, Dukakis. Similarly, a majority of wealthy voters supported Republicans George H.W. Bush in 1988 and 1992, Bob Dole in 1996, and George W. Bush in 2000 and 2004. As noted by CNN.com, fifty-seven percent of $75,000-income households supported George W. Bush in 2004, compared to forty-two percent for John Kerry. Conversely, majorities of voters with incomes of $15,000 or less chose Democrats Carter in 1980, Mondale in 1984, Dukakis in 1988, Clinton in 1992 and 1996, Gore in 2000, and Kerry in 2004. Of course, exceptions to the income rule do occur, with some relatively poor voters voting Republican and a number of very wealthy citizens going Democratic.

Regarding the occupation variable, professionals and business people have overwhelmingly voted for the GOP from 1952 to 2004 (except for the 1964 presidential election). Conversely, Democratic nominees can usually attract a majority of labor union members. In 2004, households with labor union members gave John F. Kerry 5.8 million more votes than his Republican opponent, President Bush (CNN.com). Government employees tend to prefer Democrats.

Education

College graduates are likely to back GOP candidates, (fifty-two percent for Bush vs. forty-six percent for Kerry in 2004-Gallup poll),while high-school- and grade-school-educated citizens vote Democratic. Note that the strength of this education-party relationship has weakened over time.

Sex and Age

Men and women traditionally support both parties in roughly equal proportions, although women voters have given an edge to the Democrats during the last decade (in 2004, women supported John Kerry by a fifty-one percent to forty-eight percent margin; in 2000, fifty-four percent went for the Democrat Al Gore, compared to forty-two percent for Bush). Regarding the age factor, younger voters (under thirty) have traditionally supported the Democratic party (Kerry received fifty-four percent of the youth vote in 2004, compared to forty-six percent for Bush; Bill Clinton in 1992 and 1996 did even better with this group), while older voters (over fifty) favor the GOP. However, exceptions to this rule have also occurred, when Republican candidates (Reagan in 1984 and Bush in 1988) received majority support from voters under thirty.

Religion and Race

Northern Protestants typically vote Republican, while Jewish and Catholic voters have usually preferred the Democrats (although Catholics supported Bush over Kerry in 2004). The parties' stands on various issues can affect support from various religious groups—for example, abortion among Catholic voters. **Religiosity,** or how frequently a citizen attends religious services, affects voting patterns. Those who attended more than once a week tend to vote Republican, voting 64–35 for Bush; those who never attend tend to be Democrats voting 62–36 for Kerry. Concerning race, African Americans have supported the Democratic Party by a clear majority (averaging eighty percent or more) in all presidential elections since 1952, largely due to the party's pro–civil rights record. The Democratic party has won a majority of white votes in only one national election—1964—during the last four decades. This racial division is even more salient in the South. For example, in 1988, fifty-seven percent of the national white vote went for Republican George Bush, but he was selected by seventy-four percent of southern white voters.

Geography

The Democratic party once dominated the solid South. However, more southern voters have chosen Republican presidential candidates in recent years, while also selecting Republicans running in congressional or local races. The Republican influence remains strong in sections of the Midwest and most of the Mountain and Plains states, while Democrats carry favor in the Northeast and most of the far West. Democrats still carry the big cities of the North and East, and GOP voters dominate the suburbs.

Families and Group Memberships

It is generally true that family members tend to vote alike, because they are influenced by similar religious, economic, and social experiences. There are, of course, exceptions, for many families are composed of strong-willed, independent individuals. Still, the overwhelming majority of husbands and wives vote the same. Two out of three children, once grown, also identify with their parents' political party.

In the workplace, groups who associate with one another in the office or on the assembly line tend to vote alike, perhaps due to peer pressure or similar socialization patterns. However, some voters are **cross-pressured,** because they may work, for example, among associates who are Democrats but belong to a social club that consists mainly of Republican voters.

■ CAMPAIGNS

Before a prospective candidate decides to run for office, he or she must consider the timing of the race—is it a good year for the party? If not, even a strong potential candidate with good credentials may choose not to enter the race. Also, if applicable, how strong or weak is the incumbent? Does the candidate have wide contacts; that is, do enough people know the candidate and will they be supportive?

Modern Campaigns

The goal of a campaign is to win public office on election day by acquiring support from a plurality or majority of the electorate. To accomplish this fundamental goal, modern presidential and congressional campaigns must build an organization by hiring qualified personnel, formulating effective campaign/ media strategies, and acquiring adequate funding. Note that in many cases, half of a campaign's budget goes for TV time.

Campaign Personnel

A well-organized campaign usually relies on a professional political consultant. A political consultant, for a fee, is responsible for devising campaign strategies, scheduling the candidate, formulating campaign themes and ideas, handling advertising, interpreting poll results, conducting research on the opponent, and even budgeting resources.

Other important personnel may include speechwriters, clerical workers, direct-mail fundraisers, computer programmers, professional pollsters, public-relations experts, lawyers, accountants, and skilled media producers.

Campaign Strategies

Campaign strategies can involve the achievement of name recognition for challengers, acquiring newspaper endorsements, and maintaining the loyalty of party supporters while attracting those who may switch from the other party. Campaigns also may utilize negative campaigning, poll tracking, televised debates (especially in presidential races), and effective political commercials. These strategies are discussed in the following sections.

Achieving Name Recognition. Challengers have a major problem in unseating incumbents, especially in congressional races. Incumbents have the advantages of greater access to campaign funds, free mailings to constituents (called the **franking privilege**), job experience, media recognition, and large campaign staffs. It is no surprise that the overwhelming majority of congressional incumbents are victorious. An unknown challenger will have to get the attention of the voters through innumerable speeches; a simple, memorable campaign theme; countless personal contacts; door-to-door canvassing; and placing ads in newspapers, on TV, and on the radio. Unfortunately for the challenger, these efforts

take time and money. Contributors may be reluctant to give funds to a long-shot challenger against an entrenched incumbent. Finally, it makes sense that a known challenger—someone with pre-existing name recognition, either from holding a previous office or being a celebrity of some kind—may be more successful in taking on an incumbent.

Attaining Newspaper Endorsements. Newspaper endorsements can benefit a candidate, especially if the particular newspaper has a wide circulation. GOP candidates normally receive a larger number of newspaper endorsements than do Democrats. However, Democratic endorsements typically come from large metropolitan dailies, while GOP endorsements dominate smaller-circulation papers.

Avoiding Party Defections while Encouraging Party Switchers. Candidates, in particular those in competitive races, must endeavor to retain loyal party supporters while attracting independent voters and **switchers** (crossover voters from the opposition party). The latter voters can determine the outcome of a close election. A candidate must understand which issue positions or personal messages will appeal to this potentially fluid sector of the electorate.

Negative Campaigning. To some observers, an unfortunate development in modern campaigns has been **mud slinging** (campaign negatively) at every opportunity, especially in televised political commercials, but **negative campaigning** is really not a new development in American political history. Rather than running on what a candidate stands for and what he or she will do if elected, a campaigner will pillory or besmirch the integrity of the opponent; in effect, telling voters that it is better for them to elect him or her than the inferior, incompetent, unethical opponent. Negative campaigning has been especially noticeable in recent presidential races.

However distasteful this approach may be to many, scholarly studies suggest that negative campaigns do influence voters, one way or the other, and that they are more informational and substantiated than positive ones. So, it is probable that this campaign tactic will remain a fixture of American politics.

Poll Tracking and Focus Groups. Candidates increasingly rely on public-opinion polls during the campaign to see whether their issue stands and personal style are effective with voters. Sophisticated tracking polls go beyond traditional surveys. Instead of taking a poll covering the entire sample every few days or once a week, interviews of voters are conducted continuously, revealing how important groups within the electorate are reacting to specific campaign themes and candidate appeals. For example, a congressional challenger who is a Democrat might find from **poll tracking** that labor-union members increasingly believe he is not sympathetic to the average working man. The challenger may quickly produce a TV ad that conveys support for union workers or deliver a pro-worker speech before the local chapter of the AFL-CIO.

A **focus group** is usually a small number of individuals, typically ten to twenty, with whom a candidate's political staff will discuss in-depth, beliefs, emotions, or attitudes toward candidates and issues. Periodic use of focus groups can assist campaign planners in determining political strengths and weaknesses, and whether there is a need for tactical adjustments in the campaign. Focus groups also are used to pre-screen political TV ads.

TV Debates. Because TV plays such an important role in running an effective campaign, televised debates between presidential, congressional, or state/local candidates have become more common than ever. The first nationally televised debate occurred in 1960 between Kennedy and Nixon. Other presidential debates followed in 1976 (Carter-Ford), 1980 (Reagan-Carter), 1984 (Reagan-Mondale), 1988 (George H.W. Bush-Dukakis), 1992 (George H.W. Bush-Clinton-Perot), 1996 (Clinton-Dole), 2000 (George W. Bush-Gore) and 2004 (George W. Bush-Kerry). It appears that Kennedy's and Carter's performances may have helped them achieve narrow victories in 1960 and 1976, respectively. Reagan clearly surpassed Carter in 1980 and was more effective than Mondale in 1984 (except for the first debate). George H.W. Bush did well against Dukakis in 1988, and Clinton was clearly more comfortable than Dole in 1996. Although TV debates are not always conclusive on the presidential level (Kerry did relatively well against George W. Bush in 2004, but it was not enough to stave off an ultimate defeat), TV is still a campaign weapon which politicians must master.

Because voters increasingly rely on TV for most of their political information and perceptions, a poor performance or physical appearance by a candidate on TV can prove politically harmful. In the classic first 1960 nationally televised debate, Republican presidential candidate Richard Nixon, suffering from an illness, improper makeup, poor on-camera lighting, and the wrong-color suit (gray against a gray background), appeared unimpressive in contrast to a rested, tanned, and properly attired John F. Kennedy. Media experts for future presidential debates made sure their candidates did not repeat Nixon's on-air mistakes.

One criticism of televised debates is that they become side-by-side press conferences rather than real debates in which the candidates challenge each other directly. Candidate answers to reporters' questions are well rehearsed and are frequently evasive. Nevertheless, viewers do have the benefit of gauging each candidate's level of knowledge and his (or her) ability to handle the pressures of the debate.

TV Political Commercials. Political commercials on TV can help attract votes for a candidate, because evidence suggests that they may influence up to one-third of the electorate during a presidential campaign. Most commercials try to convey a simple image or theme that will be remembered by the viewer. For example, the 1964 "daisy girl" political commercial run by the Lyndon Johnson campaign committee depicted a small girl plucking petals from daisies and then being enveloped in a nuclear explosion. The implied message was that the Republican candidate, Barry Goldwater, could start a nuclear holocaust that would destroy America's children, and ostensibly all of humanity (the Republicans protested so strongly that the commercial was aired only one time). In 1988, the Bush campaign ran the Willie Horton ad, claiming that Dukakis had furloughed Horton (an African American convicted of murder who also was not eligible for parole) from prison on weekends, allowing Horton to commit additional crimes of rape and robbery. The ad convinced many voters that a liberal Dukakis was soft on the crime issue and weak on keeping violent criminals behind bars. In 2004, Republican ads questioning John Kerry's war record in Vietnam and his subsequent anti-war activity back home were repeatedly aired. Conversely, Democratic ads criticizing President Bush's National Guard service were equally prevalent.

Many TV ads are almost wholly devoid of substantive policy, instead depending upon patriotic symbols or pleasing images. It was not accidental that in 1988, George H.W. Bush was filmed giving a speech in a flag factory with hundreds of American flags placed in the background, or that Michael Dukakis spoke to the voters with his wife beside him in front of a cozy fireplace. Ads that linked the horrors of

9/11 or terrorism in general to President Bush's leadership during the 2004 campaign clearly helped his re-election efforts. These types of images can be very influential for many voters.

Campaign Expenses, Spending, and Funding

Modern campaigns are incredibly expensive. A presidential campaign requires the following: extensive travel arrangements; TV time; newspaper ads; written materials including posters, brochures, pamphlets, and bumper stickers; polling costs; data processing; and staff salaries. TV time rapidly consumes campaign funds, especially a thirty-second ad on national TV during prime time. In 2000, more than three billion dollars was expended on all political campaigns. In 2004, House and Senate races together exceeded $1.1 billion.

Campaign Legislation

The presidential race is **federally funded**. Dukakis and Bush were each limited to spending $23.05 million on their 1988 campaigns, while in 2004, George W. Bush and John Kerry were limited to $74.62 million apiece. However, note that a presidential candidate who does not accept those limits can theoretically spend as much of his or her own money as desired.

Congressional campaigns, on the other hand, require private fundraising efforts, which has resulted in escalating campaign costs. In 1974, a victorious House campaign cost about $90,000; in 1990, the cost was more than $400,000. For winning Senate races, the 1974 figure was about $500,000; in 1990, the cost had ballooned to more than four million dollars. Compare these figures to those in 2004, where incumbents spent an average of $900,000; in ten House races, total funds expended exceeded four million dollars; for senators, the average incumbent raised over seven million dollars. Critics are alarmed by these stupendous expenses, arguing that money buys political office. Congress has tried to correct potential fundraising abuses by passing various forms of campaign finance reform legislation, each discussed in the following sections.

The 1971 Federal Election Campaign Act (FECA)

The Federal Election Campaign Act of 1971 restricted the amount of campaign money that could be spent on mass-media advertising, mandated disclosure of all campaign contributions and expenditures over $100, and limited amounts that candidates and their families could donate to their own campaigns.

The Revenue Act of 1971

This 1971 act encouraged private contributions through a system of tax deductions and credits. Also created was a $1 check-off feature on all federal income-tax returns that would subsidize the campaign costs of major party presidential candidates (today it is a $3 check-off amount). The 1971 statutes did not become operative until the 1976 presidential election.

The 1974 FECA Amendments

Congress decided to change the campaign finance laws once again after the Watergate scandal, when it was learned that illegal and improper amounts of campaign funds had been given to Richard Nixon's re-election campaign committee (for example, dairy producers had donated $680,000 to Nixon's campaign

in exchange for favorable treatment from his administration). This act established a six-person **Federal Election Commission (FEC)** to enforce the law, created public financing for presidential candidates in primaries and general elections (there was no public financing of congressional campaigns), and restricted contributions so that:

- Each citizen was limited to contributing $1,000 per candidate in each federal election or primary, $20,000 to a national party committee, and $5,000 to other **political action committees (PACs).**
- The total amount of all contributions annually per individual was limited to $25,000.
- Groups, such as PACs were limited to a maximum contribution of $5,000 per candidate in any election. No individual could give more than $5,000 per year to any one PAC.
- Personal contributions from candidates or their families could not exceed $50,000 in the pre-nomination stage or $50,000 for the general election, provided the candidate voluntarily accepted federal funds. Candidates not accepting federal funds at all could spend unlimited amounts of their own money. A provision of the act limiting these personal expenditures was eventually ruled unconstitutional by the Supreme Court (*Buckley v. Valeo*) in 1976.

The 1974 act, along with amendments passed in 1976, permitted special interests, unions, and corporations to form PACs as a way of raising funds for candidates' campaigns. A PAC had to raise money from at least fifty contributors and, in turn, disseminate these funds to a minimum of five candidates in a federal election. Individual corporations and labor unions were restricted to having only one PAC each. PAC contributions account for a growing share of campaign funds. In 1974, PACs accounted for about fifteen percent of all congressional campaign funds. By 2004, the figure had exceeded forty percent. In 1976 there were roughly 1,000 PACs. In 2006, there were over 4,000.

The 1979 Amendments to FECA

These amendments strengthened reporting requirements to the FECA (all contributions and expenditures of $200 or more had to be reported), allowed state and local party committees to spend unlimited and unregulated **soft money funds** (money given to the parties for party-building activities and not directly to candidates for re-election purposes; the latter is termed **hard money**), and increased funding support for the national nominating conventions. This amendment was necessary because the parties had exploited a loophole in the campaign finance laws, accumulating soft-money funds that were spent on voter turnout activities: operating telephone banks, printing and mailing out campaign literature, and recruiting field organizers. This money was distributed to state and local parties as a way of helping the national campaign. Both parties had turned to wealthy contributors to build up these soft-money accounts, which totaled $130 million in 1988. By 2000, it was $463 million.

The Bipartisan Campaign Reform Act of 2002

The historic 2002 Bipartisan Campaign Reform Act did the following:

- Banned soft money contributions to the national parties, although a sum of $10,000 per year per individual could still be given to state and local parties.
- Restricted campaign ads from interest groups from being shown thirty days before primary elections and sixty days before the general election.

- Increased the hard-money individual contribution to a candidate from $1,000 to $2,000 ($4,000 total for both the primary and general elections).
- Permitted the total individual contributions to all federal candidates to now range from $25,000 per year to $95,000 for the two-year election cycle.
- Limited PACs to $5,000 per election or $10,000 per election cycle (the primary plus the general).

Most of the act's provisions were declared constitutional (that is, they did not abridge free speech) by the Supreme Court in December of 2003 in *McConnell v. Federal Election Commission.*

Unfortunately for proponents of campaign finance reform, new methods were devised to get around the 2002 law. Groups called 527s (in 2004, examples were America Coming Together for the Democrats and the GOP-oriented Progress for America) were allowed to spend money on issue ads, so long as they did not specifically endorse a candidate or tell the TV and radio audience that they should vote for a candidate. In 2004, the 527s spent over 550 million dollars to advocate policy positions. In addition, PACs got around their legal limits by collecting money from multiple individuals, a process called **bundling.**

The Impact of These Laws

What was the overall impact of these laws? First, due to these laws, presidential campaigns now rely far more on public subsidization, rather than depending exclusively on the potentially corrupting influence of wealthy private donors. Second, these laws have not reduced the total costs of other national campaigns, especially since congressional campaigns are not entitled to public funding. Private money, especially from the PACs, has benefited congressional incumbents. Third, candidates who are independently wealthy are not restricted from contributing as much as they want to their own campaigns, prompting critics to charge that qualified, but moderate-income candidates are at a clear disadvantage. Fourth, subsidies go to presidential candidates and not to strengthen the national parties.

■ PRESIDENTIAL ELECTIONS: DEMOCRACY'S ULTIMATE TEST

Every presidential election has two stages: the nomination stage, in which hopeful candidates from each major party seek the presidential nomination, which is formally awarded at the national nominating convention every four years, and the general election stage, in which the two presidential contenders (and perhaps other, third-party presidential candidates) seek to win the presidency by receiving a majority of electoral votes in the electoral college.

The Nomination Stage

The important steps in the nomination stage are the presidential announcement, the winning of convention delegates through primaries and caucuses, and the selection of the party ticket at the national nominating convention.

Presidential Announcement

Presidential hopefuls usually announce their intention to seek their party's nomination or start thinking about a presidential run a year or longer before an election year, but they may begin testing their

viability more than three years before. Candidates who are not well known nationally also must start early, as was the case with Jimmy Carter's candidacy. Carter, a former governor of Georgia, was known to only two percent of the American people in 1975, but won the presidential election in 1976.

Winning Delegates (individuals from the states and territories who select a presidential and vice-presidential candidate from their party at the national nominating convention held every four years in a major American city)

Candidates may win delegates through two major avenues—caucuses and primaries.

The Iowa Caucuses

A **caucus** is basically a meeting of party members. The Iowa caucuses are particularly important because they represent the start of the official presidential campaign. These caucuses also tend to reward presidential candidates with intensely committed supporters. In a complicated process, Iowa party voters have local meetings (at the precinct or town level), at which they select delegates to a county or district convention (candidates must have large numbers of their supporters organized effectively and participating at these grass-roots levels). From this level, delegates to the Iowa state convention are selected. Then, delegates to the national convention are chosen.

Iowa remains psychologically important, because the media will focus on which candidates do well there, labeling them the front-runners. However, in 1980, George Bush did well in Iowa, but lost to Ronald Reagan in the New Hampshire primary. Reagan's poor showing in Iowa was soon forgotten as he proceeded to secure the nomination. Ironically, in 1988, Bush lost in Iowa to Senator Bob Dole, but in February, he recovered by getting the most votes in the New Hampshire primary. In January 2004, John Kerry's surprise victory in Iowa over contender Howard Dean, and his follow-up win in the New Hampshire primary catapulted him into the lead and gave him the necessary momentum to eventually gain the Democratic presidential nomination by early March.

Presidential Primaries

Presidential primaries are the main method of selecting delegates. In 2004 presidential primaries existed in thirty-six states, plus the District of Columbia and Puerto Rico. These primaries allowed voters to select national convention delegates and/or to express their preference among presidential contenders on the ballot. Because state laws differ, the precise nature of each primary must be examined state by state. Nevertheless, the central importance of primaries is clear: a presidential contender who does well in as many states as possible will win his or her share of delegates. To achieve the nomination, a candidate must win a majority of all delegates at the national convention.

Note that generally there are two main types of primaries: **closed** and **open.** In the former, only registered Republicans (or Democrats) may vote for Republican (or Democratic) nominees. An open primary allows any voter, regardless of partisan identification, to vote for a Republican or Democratic nominee. Clearly, strong-party identifiers prefer a closed primary over an open one, since it is possible in an open primary for a voter to crossover and deliberately vote for the weakest nominee of the party they normally oppose, a practice called **raiding.**

Front-loading refers to the states moving their caucuses/primaries to earlier dates. In 2004, Iowa moved its caucus to January 19, and New Hampshire moved its primary to January 27. In 2000, California had moved up its important primary from June to March.

These shifts and other related primary date changes (multiple states holding their primaries/caucuses on a day of primaries called Super Tuesday) meant that well-funded presidential candidates who win early have a clear advantage over lesser-funded challengers who do not have the time or luxury to mount a political comeback.

In 1982, Democrats added the **superdelegates**—governors, big-city mayors, congressional representatives, state party chairpersons, former presidents and vice-presidents—delegates who were largely unpledged to any one nominee prior to the convention. In future conventions, superdelegates could help a candidate who may have a smaller total of pledged delegates from the primaries and caucuses, but who generates considerable support from these party leaders. There were 715 superdelegates at the Democratic party's 2004 convention.

The Problem of Matching Funds. A candidate who fares poorly in the early caucus/primary states, as in Iowa and New Hampshire, may be forced to withdraw from the nomination race. One reason is budgetary—candidates who appear to be losers will find private campaign contributions drying up and public funding cut off. Under the federal campaign laws, major party contenders who raise $5,000 in twenty states in contributions of $250 or less, a total sum of $100,000, can expect matching federal grants during the pre-nomination period. Candidates who start their nomination quests early can usually comply with these requirements. But maintaining their eligibility for matching funds is far more difficult. A presidential hopeful who receives less than ten percent of the popular vote in two consecutive primaries loses federal matching dollars until he or she is able to win twenty percent of the vote in another primary. So without federal money, the campaign is doomed, unless a candidate is independently wealthy or has a huge campaign chest, as was the case with George W. Bush in 2000. In 2004 both Bush and John Kerry refused federal funding in the primaries because they were able to acquire sufficient contributions from Internet sources and private donors.

The Lack of Media Attention after Losses. A sharp decrease in campaign funds due to failures in the early primaries is compounded by the problem of media inattention. Having no money translates into a lack of TV time, a minimal campaign at best, and newspaper and TV reporters writing off an individual's candidacy. These problems engulfed Democrats Joe Lieberman, Howard Dean, and Dick Gephardt in 2004. In 2000, George W. Bush and Senator John McCain contested early for the GOP presidential nomination, with McCain unable to match the Bush decisive edge in funding.

Evaluating the Presidential Primary System. Presidential primaries have helped to democratize the selection of each party's nominee, while compelling would-be nominees to test their candidacies throughout most of the nation. However, critics argue that the primaries actually test a candidate's media appeal more than those qualities needed for presidential leadership. Also, the large number of primaries fatigues both the candidates and the public. Reformers suggest an elimination of the current primary

system in favor of a single, nationwide primary, in which each party's nominee would be selected. The national conventions, if retained, could help select the vice-presidential nominees. But a national primary would hurt candidates who had less money to spend on TV time. However, it is apparent that the major parties do not wish to change or abolish the national convention, which is held every four years in a major city such as New York, Atlanta, Boston, Chicago, New Orleans, Miami, or Los Angeles. See the following section for details.

The National Nominating Conventions

In the last thirty years or so, thanks to the primary system, each party has known who its presidential nominee would be. Thus, in 2000, Republican George W. Bush and Democrat Al Gore had both attained a majority of the delegates pledged to them through numerous primary victories. Similarly, in 2004, Kerry became the presumptive nominee for the Democrats well before the summer convention. President Bush had no real opposition in the Republican party.

For this reason, recent conventions have focused not on deciding who the candidate will be but on the important functions of writing and adopting a party platform, unifying the party faithful, and formally approving the party's ticket, each of which is discussed in the following sections.

Adopting the Party Platform

The **platform** represents how the party stands on the important issues in an election year. Frequently written by party leaders or by presidential staffers (if an incumbent president is running for re-election), the platform can represent a mixture of both specific and general answers to policy problems (see Table 5.2). Individual issues or **planks** within the platform statement—such as abortion or civil rights—can sometimes prove divisive among convention delegates, requiring compromise.

Contrary to popular belief, most presidential nominees take platforms seriously, and they try to implement many of the document's policy proposals once in office. A majority of the platform proposals become law if the party wins both the presidency and a congressional majority.

Table 5.2 Representative 2004 Democratic and Republican Planks (Party Platforms)

Issue	Democratic Plank	Republican Plank
Abortion	Supported freedom of reproductive choice	Favored amendment to protect the unborn's life
Education	Opposed vouchers for private schools	Endorsed school vouchers
Guns	Extend the assault weapons ban	Let the assault weapons ban expire
Energy	Greater stress on renewable energy	Greater stress on oil drilling and nuclear power
Iraq	Bush administration rushed to war	President Bush's war fully backed without allies
Social Security	Opposed partial privatization	Favored partial privatization
Taxes	Roll back tax cuts for the wealthiest two percent of all taxpayers	Make permanent all Bush tax cuts

Unifying the Party. During the four days of a national convention, numerous speeches are delivered by party leaders. The **keynote address,** typically delivered by one of the party's better orators, is the first major speech of the convention. The opposition party is lambasted, and a call for party harmony echoes throughout the convention hall. Later in the convention, each candidate's name is placed in nomination by a supporter, along with several seconding speeches. Normally, delegates backing each nominee start floor demonstrations, which can last for some time. After all of the nominating speeches are over, balloting begins with each state's delegation called in alphabetical order.

A majority of delegate votes is required. Unlike the 1924 Democratic convention in New York City, which went through 123 ballots, recent conventions have selected a presidential nominee on the first ballot. The most recent convention at which more than one presidential ballot was needed was in 1952, when Democrat Adlai Stevenson was nominated on the third roll call.

Approving and Balancing the Party's Ticket. The new presidential nominee must choose his vice-presidential running mate. In the past, an important principle guiding his selection was **balancing the ticket,** which meant that the vice-presidential nominee's background should have contained political and personal traits helpful to the ticket's national appeal. For example, in 1960, Massachusetts Senator John F. Kennedy, a Catholic, chose Lyndon Johnson, a U.S. senator from Texas and a Protestant, as his V.P. running mate. In 1988, George H.W. Bush chose Senator Dan Quayle, from Indiana, who was younger and more conservative than Bush. The ultimate balance occurred in 1984, when Walter Mondale chose Geraldine Ferraro, the first woman vice-presidential nominee, as his running mate. Mondale wanted to strengthen his appeal to women voters across the nation.

A presidential nominee also may choose a running mate who can help carry a pivotal state with a large number of electoral votes. Thus, in 1988, Michael Dukakis selected Senator Lloyd Bentsen of Texas (the state then had twenty-nine electoral votes). But Texas and its important twenty-nine electoral votes were won by George H.W. Bush on election day. In 2004, John Kerry's running mate was southerner John Edwards from North Carolina, theoretically balancing Kerry's Massachusetts credentials. But Kerry eventually lost every southern state.

Note that exceptions to balancing the ticket also have occurred. In 1992, Bill Clinton chose as his V.P. running-mate Al Gore, a fellow southerner from Tennessee. In 2000, George W. Bush chose Dick Cheney as his V.P., primarily for his loyalty and conservative credentials. Cheney's home state was Wyoming, a state with only three electoral votes and a solid Republican bastion!

Acceptance Speeches and the Convention's End. Both nominees deliver their acceptance speeches on the final evening of the convention, typically in prime-viewing time so that the television networks can carry them live to the nation. Unfortunately, the networks have dramatically reduced their convention coverage. In 2004, there were only three hours of prime-time coverage by the big networks, although Internet sites and some cable TV stations provided extensive reporting of convention events.

The speeches are designed to forge party unity by inspiring convention delegates and the party faithful to support the ticket during the upcoming campaign. For the candidates themselves, the aftermath of the convention is a time to plot campaign strategy so as to secure at least 270 electoral votes—the bare majority for victory—on election day in November.

The General Election Stage and the Electoral College

The presidential campaign usually begins in earnest shortly after Labor Day in September and ends on election day, the Tuesday after the first Monday in November. The campaign's decisions involving use of time and allocation of resources are largely determined by the constraints posed by the **Electoral College** system.

The Electoral College: What It Is, What Its Problems Are, and How It Can Be Reformed

On election day, voters technically do not directly select a presidential candidate, but rather choose a slate of presidential electors within each state of the Union and the District of Columbia. The number of electors within each state equals its total representation in Congress. For example, in 2004, Georgia was allocated fifteen electoral votes because it had thirteen representatives in the House and two senators (13 + 2 = 15). By contrast, California had fifty-five electoral votes (fifty-three in the House, two in the Senate), the most populous state in the nation. The entire Electoral College had 538 votes, based on 435 in the House, 100 in the Senate, and 3 electoral votes awarded to the District of Columbia through the Twenty-third Amendment (435 + 100 + 3 = 538).

On election day, a voter in Georgia choosing a Republican candidate is actually selecting fifteen men and women, the **electors,** who have pledged to support that Republican candidate. A voter choosing the Democratic ticket was really selecting a different fifteen electors, similarly pledged to support the Democratic ticket. If the Republican candidate obtains a majority of popular votes cast in Georgia, that candidate receives all of Georgia's fifteen electoral votes.

After the election, the electors meet in their respective state capitals on the Monday after the second Wednesday in December to cast their electoral votes. The votes are then sent to the president of the Senate, where they will again be counted by the vice-president in early January when Congress reconvenes. If no presidential candidate has received at least 270 electoral votes (a bare majority of 538), the House of Representatives chooses the president by state delegation (each delegation would have one vote, with twenty-six votes needed to elect a president); the Senate chooses the vice-president (each senator would have one vote, with a majority of the 100 senators needed to elect a vice-president).

To critics, the Electoral College has outlived its usefulness. The framers originally created the College to prevent direct popular election of the president and allow the electors to exercise their own judgment. Neither idea is reasonable today. A quick review of the college's defects and potential reforms may be helpful.

A Popular Vote Winner, but a Presidential Loser Scenario. Under the prevailing system, it is possible for a ticket to accumulate the most popular votes nationally, but lose due to the Electoral College's winner-take-all philosophy. A candidate could win the eleven biggest electoral-vote states by the smallest of popular vote margins, then lose by sizable popular vote totals in the other thirty-nine states and the District of Columbia. The candidate chosen by a national voting majority would be denied the presidency, because he or she did not win such states as California, New York, Texas, Pennsylvania, or Illinois. This could have happened in the 1976 Ford-Carter race, with a switch of a few thousand popular votes in Ohio (twenty-five electoral votes) and Hawaii (four electoral votes) from Carter to Ford, giving the latter the necessary 270 electoral votes. It did happen in 2000, when Democrat Al Gore received the

most popular votes nationally (by over 500,000) but lost in the Electoral College by a 271 to 266 count (one elector from the District of Columbia abstained).

The Problem of the Faithless Elector. Note that electors are pledged to vote for their party's ticket, but they are not legally required to do so. Ten times in American history, an elector has changed or abstained from casting his or her vote. Although the outcome of a presidential election has not been affected, the possibility still remains that this could occur. Imagine a close presidential race in which the final electoral vote total is 270 for candidate A and 268 for candidate B. If one candidate A elector switches to B, there is an electoral tie, 269 to 269, and the House must then select a president. If one more elector switches to B, then B is the winner.

A Third-Party Bid Leads to Congressional Deadlock or Chaos. A final problem is the specter of a third party siphoning off enough electoral votes to deny either of the two major parties an Electoral College majority. This almost happened with George Wallace's American Independent party's candidacy in 1968, which claimed forty-six electoral votes. Having the House choose the president could lead to a number of complications, because twenty-six of the fifty state delegations must approve a candidate, each delegation having one vote (a state whose delegation was evenly divided could not cast a vote). If the House was incapable of deciding, then the Senate's choice of a vice-president might become acting president (see the Twenty-fifth Amendment).

Reform #1: Direct Popular Election. The reform with the greatest support is the one whereby the Electoral College would be eliminated entirely and direct popular election would be substituted through a constitutional amendment. Hence, the ticket that received a national voting plurality would always be the winner (provided it received at least forty percent of the popular vote; if not, there would be a runoff election). But opposition from smaller states, the political difficulty of passing another constitutional amendment, and the added pressures on candidates of having to campaign arduously in virtually every state work against this reform. Unless there is an electoral crisis, a direct-election amendment is unlikely to be passed by Congress and ratified by the states.

Reform #2: The National Bonus Plan. This plan would give a bonus of 102 electoral votes to the candidate who received the most popular votes. If the bonus plus the electoral votes already won by the candidate equaled the majority of 321 (538 + 102 = 640; 321 is a majority of 640), the candidate would be declared the winner. Otherwise, a runoff election between the two front-runners would then be scheduled. The plan has received little support.

Reform #3: The Proportional Plan. This plan tackles the winner-take-all feature by awarding electoral votes according to percentages of a state's popular vote realized by each candidate. If candidate A received forty percent of the total popular vote in a state with twenty electoral votes, A would be entitled to eight electoral votes ($20 \times 0.40 = 8$) instead of zero. The problem with this plan is that minor parties could gain enough electoral votes to prevent a 270-vote majority from being attained. Additionally, this plan would have to be implemented individually in every state, as the states retain control over the method of elector selection.

Reform #4: The District Plan. This plan would keep the Electoral College but would change the way electoral votes within the state are allocated. Only two electoral votes would be decided by the total statewide vote, not the entire slate of electors. The state's remaining electoral votes would be based on the popular vote within each congressional district (Maine and Nebraska already choose their electors in this manner). An electoral vote majority would still be required. If no majority existed, then a joint session of Congress would make the presidential selection.

Small states would benefit from this plan, but large states would lose political power. However, the plan would not eliminate the danger of a candidate's receiving a minority of the popular vote but an Electoral College majority. If the plan had been in effect in 1960, Richard Nixon, who won fewer popular votes than did John F. Kennedy, would have received 278 electoral votes, not 219, and thus would have become president.

The Impact on Campaign Strategy. A presidential candidate must do well in at least some of the large states if he or she is to win the presidency. Invariably, presidential candidates concentrate their time, efforts, and funds in the electoral-rich states, which as of 2004 included California (fifty-five); Texas (thirty-four); New York (thirty-one); Florida (twenty-seven); Pennsylvania (twenty-one); Illinois (twenty-one); Ohio (twenty); Michigan (seventeen); New Jersey, North Carolina, and Georgia (fifteen each); Virginia (thirteen); Massachusetts (twelve); Missouri and Tennessee (eleven each); and Wisconsin (ten). It usually makes little sense to spend days campaigning in a state like South Dakota, with only three electoral votes. Also note that in 2004, the top eleven states alone (California through Georgia) would have awarded a candidate 271 electoral votes, one more than needed to become president.

But the small states are still very important in the Electoral College as well and are actually over-represented by the Electoral College system. For example, California has seventy-eight times the population of Wyoming, but only eighteen times the number of electoral votes. In a very close and divisive presidential election, a handful of small swing states could be the decisive factor in determining the winner.

The 2004 Electoral College Totals and Election Results

In the 2004 election, George W. Bush collected 286 electoral votes to 252 for John Kerry. President Bush's popular vote margin was roughly 3.3 million votes. In 2000 Florida was the decisive state. In 2004, it was Ohio and its 20 electoral votes. A shift of 60,000 votes from Bush to Kerry in Ohio would have awarded Kerry the presidency. In Congress, Republicans retained control of both the House (232 Republicans, 203 Democrats) and Senate (55 Republicans, 44 Democrats, and 1 Independent— James Jeffords of Vermont who usually sided with the Democrats).

In the American political system, voting, campaigns, and elections represent the very essence of democracy. Yet despite the near achievement of universal suffrage, millions of eligible citizens in America do not vote due to apathy, residency and/or registration requirements, or a low sense of political efficacy. Studies show that high levels of education and income, group membership, white-collar occupations, a strong sense of party identification, and middle age are correlated with high voting turnout.

Modern campaigns have become expensive enterprises, requiring large amounts of funding, skilled staffers, political consultants, pollsters, and media experts. The stress on TV advertising also has emphasized candidate imagery over substance. The costs of campaigning have led to abuses, and a number of

campaign finance laws are directed at controlling the money-can-buy-elections mentality. The campaign finance reform legislation of 2002 was historic, banning soft money to the national political parties. In addition, while public subsidization of presidential campaigns has limited the role of private money, non-subsidized congressional campaigns increasingly rely on PACs.

Finally, presidential campaigns have two stages: the nomination and general-election periods. The nomination period requires presidential candidates to do well in caucuses and primaries in order to gain the support of convention delegates. Defeats in the early caucuses and primaries can doom a campaign. At the national nominating convention, a party ticket is chosen, a platform written, and party unity is forged. In the presidential campaign that follows, both presidential candidates seek to win a majority from the Electoral College. Although critics see flaws in the Electoral College system and propose reforms, there is little likelihood of changing the system in the near future.

Selected Readings

Bartels, Larry. *Presidential Primaries and the Dynamics of Public Choice* (1988).

Crigler, Ann N., et al., eds. *Rethinking the Vote: The Politics and Prospects of American Election Reform* (2004).

Green, Donald P., and Alan S. Gerber. *Get Out the Vote—How to Increase Voter Turnout* (2004).

Polsby, Nelson W., and Aaron B. Wildavsky. *Presidential Elections* (2004).

Thurber, James A., and Candice Nelson, eds. *Campaigns and Elections American Style* (2004).

Wayne, Stephen J. *The Road to the White House* (2004).

Test Yourself

1) Which group of voters has consistently backed the Democratic Party since 1964 to the greatest degree?
 a) Catholic voters
 b) Jewish voters
 c) African-American voters
 d) very wealthy voters

2) True or false: At the time of the Constitutional Convention in 1787, universal suffrage existed in all thirteen states.

3) The 1944 Supreme Court ruling of *Smith v. Allwright* eliminated which voting restriction?
 a) the grandfather clause
 b) the poll tax
 c) the literacy test
 d) the white primary

4) True or false: HAVA was a congressional law dealing with campaign finance reform.

5) In no state does the residency requirement for voting in states exceed _____ days.
 a) ten
 b) thirty
 c) forty
 d) sixty

6) True or false: In the 2004 election, voting turnout increased compared to turnout in the 2000 election.

7) Which of the following citizens is least likely to vote on election day?
 a) a college graduate
 b) a citizen who is nineteen years of age with a grade-school education
 c) a well-paid factory worker who belongs to a union
 d) a healthy senior citizen

8) True or false: In recent presidential elections, women voters have given greater support to Democratic presidential candidates.

9) In which region of the country do Republican presidential candidates usually have the lowest level of overall voter support, as evidenced by recent elections?
 a) Plains states
 b) Mountain states
 c) the South
 d) the Northeast

10) True or false: One reason so many Americans do not vote is because they may only register at local precinct headquarters.

11) If a state has fifteen electoral votes, how many representatives does it have in the House of Representatives?
 a) thirteen
 b) fourteen
 c) fifteen
 d) seventeen

12) True or false: An overwhelming majority of House and Senate incumbents are re-elected.

13) _____ groups may consist of ten to twenty people who are chosen for interviews because collectively they represent attitudes and values that are vital to a campaign's strategy.
 a) interest
 b) tracking
 c) focus
 d) 527

14) True or false: Televised debates between or among presidential candidates are real debates in that candidates can directly question each other.

15) According to the 2002 campaign finance reform law, an individual is now allowed to give a hard-money contribution of _____ dollars to a candidate for the general election.
 a) $1,000
 b) $1,500
 c) $5,000
 d) $2,000

16) True or false: According to the 2002 campaign finance reform law, soft-money contributions to the national political parties are banned.

17) Which of the following is an important caucus state regarding presidential selection?
 a) California
 b) Iowa
 c) New Hampshire
 d) none of the above

18) True or false: Presidential preference primaries are important to presidential candidates because victories in those primaries produce loyal electors to the national nominating convention.

19) On election day, presidential candidate Smith has 269 electoral votes while candidate Jones has 266 electoral votes. A third party candidate has three electoral votes. Who is president?
 a) Candidate Smith
 b) There is no president—the Supreme Court must decide.
 c) There is no president—the House of Representatives must decide.
 d) There is no president—the U.S. Senate must decide.

20) True or false: The two major political parties prefer closed primaries over open primaries.

Test Yourself Answers

1) **c.** African-American voters have backed the Democratic Party to the greatest extent, averaging more than eighty percent. Very wealthy voters generally prefer Republicans. The other two choices do not approach the eighty-percent figure, although Jewish voters come close.

2) **False.** Only those individuals who owned property could vote. Women were not permitted to vote, nor were slaves.

3) **d.** The poll tax was abolished by the Twenty-fourth Amendment; literacy tests were banned by the Voting Rights Act; the grandfather clause was phased out by state legislatures and ruled unconstitutional by the Supreme Court via the Fifteenth Amendment.

4) **False.** HAVA stands for the Help America Vote Act, a law that was directed at reforming the election administration process by changing the kinds of voting machines used and improving computerized registration data bases in the states.

5) **b.** Thirty days is the limit, but note that half of the states have requirements of less than thirty days.

6) **True.** The turnout of all eligible voters increased from fifty-one percent to fifty-nine percent.

7) **b.** Generally, the less education, the less likely an individual will vote. Younger people also tend to vote less. College graduates are far more likely to vote. A high-income union member would likely be interested in voting due to the wealth/group factor. Healthy senior citizens have both the time and interest in voting.

8) **True.** More women voters have preferred the Democratic presidential candidate than the Republican nominee in recent elections as part of what's called the **gender gap.**

9) **d.** The Northeast has generally been a Democratic stronghold and is the weakest region for recent Republican candidates compared to the other three choices.

10) **False.** The 1993 Motor-Voter law allows a citizen to register when he or she obtains a driver's license.

11) **a.** A state with fifteen electoral votes has thirteen representatives in the House, plus two in the U.S. Senate, for a total of fifteen.

12) **True.** In 2004, well over ninety percent of incumbents in both houses of Congress were re-elected. Incumbents have advantages in terms of name recognition and funding.

13) **c.** Tracking refers to taking polls on a daily basis. Interest groups are much larger. A 527 group relates to a fundraising organization.

14) **False.** This is not permitted. The debates are more like side-by-side press conferences.

15) **d.** The law allowed a hard-money contribution increase from $1,000 to $2,000.

16) **True.** However, soft money can be given to state and local parties.

17) **b.** The other two states use the primary system.

18) **False.** Primaries win loyal delegates to the conventions. Electors are individuals who cast electoral votes after the election is over.

19) **c.** No candidate has received the necessary 270 votes. Hence, the House will choose the next president, and the Senate will choose the vice-president. The Supreme Court has nothing to do with the process.

20) **True.** Closed primaries only allow Republicans (or Democrats) to vote for Republican (or Democratic) candidates. In an open primary, one party's voters could deliberately vote for the opposition party's weaker candidates, a process known as raiding.

Congress

Americans seem to approve of their own congressional representatives as responsible and effective legislators. But according to public opinion polls, they have a very low opinion of Congress as an institution, with a thirty to forty percent approval rating (sometimes even lower) not uncommon. Another indication of this sentiment is the public's outcry whenever the issue of congressional pay raises surfaces in media reports. A frequent public attitude is that representatives and senators are undeserving of higher salaries. But are these public perceptions fair or accurate? Many members of Congress are hard-working public servants whose difficult political missions of both representation and policymaking go unappreciated.

Furthermore, Congress is typically viewed as a doddering, painfully slow, undisciplined assembly unable to cope with the many problems of American society. Is it any wonder, then, that so many incumbents run "against Congress" in order to win re-election? Incumbents emphasize the favors they perform for their constituents or economic benefits they gain for their district or state. They rarely defend Congress, the institution.

But Congress remains a vital component of the American political system. After all, the framers of the Constitution considered Congress to be the most important institution in the American system of government. Today, the 535 men and women of Congress still mirror the American people's needs, hopes, and aspirations for the future. The purpose of this chapter is to provide essential information regarding the composition of Congress, its constitutional powers, leadership, membership qualifications and backgrounds, and the legislative process.

■ CONGRESSIONAL POWERS

Congressional powers are not solely confined to those specifically delineated in the U.S. Constitution. Those expressed or delegated powers are joined by **implied powers** that are derived from the **elastic clause** and nonlegislative powers, as explained in the following sections.

Constitutional Delegated or Expressed Powers

In Article I, Section 8, of the Constitution, twenty-seven different powers are specifically granted to Congress. In addition, Article IV gives Congress the power to admit new states into the Union. The Sixteenth Amendment gives Congress the power to collect federal income tax. Congress also has the "power of enforcement" in relation to the Thirteenth, Fourteenth, Fifteenth, Nineteenth, Twenty-fourth, and Twenty-sixth amendments. The Twenty-seventh Amendment actually is a constraint on congressional power in that legislators may not raise their salaries until a congressional election has intervened.

Power To Tax

Congress has the power to "lay and collect taxes, duties, imposts, and excises, to pay the debts, and provide for the common defense and welfare of the United States. . . ." Taxes are necessary because they finance government operations and programs, but the Constitution specifies limitations on the congressional taxing power:

- Taxes imposed by Congress must benefit public, not private, interests.
- Congress cannot tax exports.
- Taxes must be apportioned by population among the states (all federal taxes must be levied at the same rates across the nation, but the more populous states—New York, for example—will pay more in total tax dollars than a state with fewer people, such as Wyoming).

Commerce Power

Congress has the power "to regulate commerce with foreign nations, and among the several states, and with the Indian tribes." Historically, the commerce clause has led to the expansion of federal power. Supreme Court interpretations in such landmark cases as *Gibbons v. Ogden* (1824) and congressional applications as in the Civil Rights Act of 1964 (prohibiting discrimination in public accommodations) have contributed to this broadening of the commerce clause.

Currency Power

Congress has the power "to coin money," and states are forbidden to have their own currencies. The thirteen different state currencies of the Revolutionary era created financial havoc (even prior to the Civil War, states, cities, and individual banks issued their own notes). The framers of the Constitution strongly desired a single, national currency system, so they gave the power to Congress to create such a system.

Borrowing Power

Congress can "borrow money on the credit of the United States." A common practice has been to issue government bonds in order to finance wars or help the government pay for new social programs. In 2005, the federal government's net public debt was approaching five trillion dollars. The gross or total public debt was nearly eight trillion dollars.

Bankruptcies

Congress has the power to establish uniform bankruptcy laws across the nation. Thus, individuals who are hopelessly in debt have a method of paying off their creditors with whatever assets they may still possess.

Other Expressed Powers

Congress has control over **naturalization** proceedings (that is, becoming a citizen of the United States), the post office (creating new post offices and legislating against mail fraud or other misuses of the mails), patents and copyrights, uniform weights and measures, and the federal judiciary. In regard to the latter, Congress can create new federal courts below the U.S. Supreme Court and alter the jurisdiction or kinds of cases heard by the lower federal courts.

War Power

The Constitution gives Congress the sole power to declare war. Although the president is **commander in chief** of the armed forces, Congress can limit a president's use of troops overseas under the 1973 War Powers Act. Since the Vietnam War, Congress has been sensitive to presidential usurpation of the war power, demanding greater input into decisions to go to war. The congressional debates in 1991 over whether to authorize President George H.W. Bush to use force in the Persian Gulf, and in 1999 regarding U.S. involvement in Kosovo exemplified these types of demands. So did a comparable debate in late 2002 over whether to authorize the use of force against Iraq under President George W. Bush.

Implied Powers

These powers flow from Article I, Section 8, and Clause 18 of the Constitution. Implied powers are not stated specifically, but have been considered reasonable offshoots of delegated powers. Clause 18 has come to be known as the **elastic clause:** "To make all laws which shall be necessary and proper for carrying into execution the foregoing powers. . . ." The doctrine was first stated clearly in *McCulloch v. Maryland* (1819), when the Supreme Court ruled that the federal government had the right to establish a national bank, even though the Constitution made no mention of this power. Chief Justice John Marshall ruled that in order to implement the delegated powers of borrowing money, raising an army, or regulating commerce, it was necessary for the national government to charter a national bank.

The Constitution's Nonlegislative Powers

Nonlegislative powers include congressional responsibilities involving the electoral college, the Twenty-fifth Amendment, impeachment, treaty approvals, confirmation of presidential appointments, and the oversight function. These are discussed in the following sections.

Election of a President and Vice-President

If no candidate receives a majority of votes from the electoral college (at least 270 electoral votes), the House selects a president (by a majority of the state delegations, or twenty-six of fifty) and the Senate chooses a vice-president by a majority vote of its members. See Chapter 5 for details.

The Twenty-fifth Amendment

Whenever there is a vice-presidential vacancy, Congress approves the presidential selection of a new vice-president by a majority vote of both houses.

Impeachment

The House brings impeachment charges against the accused official (and even federal judges have been impeached and convicted), while the Senate acts as the jury and can convict by a two-thirds vote. Conviction leads to removal from office. President Andrew Johnson narrowly escaped removal from office in 1868 by one Senate vote. Richard Nixon resigned the presidency in 1975 before the full **impeachment** process could be implemented. In 1998, Bill Clinton was impeached by the House but not convicted in the Senate.

Presidential Appointments and Treaty Approvals

The Senate has the responsibility for both presidential appointments and the approval of treaties. Usually the Senate approves the president's choice for a cabinet head (for example, Condoleezza Rice, who became Secretary of State in January, 2005), ambassador post, or a Supreme Court justice, although rejections do occur (President Reagan's 1987 nomination of Robert Bork to the Supreme Court is one example).

Regarding **treaties** (a formal understanding that binds two or more nations), it is the U.S. Senate that must give its **advice and consent** (that is, approve) a proposed treaty by a two-thirds vote. Not every treaty in U.S. history has achieved this majority, most notably the Senate rejection of the Versailles Treaty in 1920, leading to America's non-membership in the League of Nations.

The Oversight and Budgeting Functions of Congress

The **oversight,** or investigatory **function** of Congress, remains a major responsibility of Congress. Through committee hearings, Congress has sensitized the public to important problems in American society: the environment, crime, drug testing, foreign trade, and so on. Congress also investigates executive departments and agencies to see whether they are implementing existing laws fairly, effectively, and efficiently. For example, during the Reagan administration, Congress investigated scandals in the Environmental Protection Agency (EPA), discovering that EPA administrators had misused their funds in combating toxic wastes and pollution problems. After the terrorist attacks of 9/11/01, Congress looked at why those attacks had occurred and discussed the effectiveness of American intelligence agencies.

A key oversight function deals with the budgetary power. The power of the purse gives Congress a chance to balance presidential power. The 1974 Congressional Budget and Impoundment Control Act mandated that Congress enact its own budget-spending ceilings and timetable. The act established: budget committees in each chamber and the Congressional Budget Office. The act also allowed the Government Accounting Office (GAO) greater power in assessing how the executive branch was spending congressional appropriations.

The budgeting cycle usually begins eighteen months before the **fiscal year** (from October 1 to September 30), when the executive branch prepares the budget under the auspices of the Office of Management and Budget (OMB). Through a complicated and lengthy process, the OMB, in collaboration with funding requests by executive agencies, delineates a budget and sends it to the president, who, in turn, submits it to Congress (specifically, the Budget and Appropriations Committees in each chamber) perhaps eight to nine months before the October 1 fiscal year start-up date. Congress, with the assistance of and economic analysis by its own staff budgetary agency, called the Congressional Budget Office, then enacts two budget resolutions, the first (passed by May 15) covering revenues and spending goals, the second (by September 15), involving mandatory or binding expenditure ceilings imposed upon all executive agencies.

Congressional budgeting also involves two basic steps:

- Authorization or the obligatory promise of funding amounts for agencies.
- Appropriation; that is, the actual money spent by agencies from specific U.S. Treasury accounts.

Often, budgeting pressures create a funding gap between the two sums.

Congress frequently does not pass all thirteen major appropriations bills by October 1, and is thus forced to enact **continuing resolutions,** emergency funding actions that allow agencies to operate temporarily on funding approved within the previous fiscal year's budget. Finally, note that unlike many of the states, Congress is not required to balance the federal budget.

■ BACKGROUND CHARACTERISTICS OF MEMBERS OF CONGRESS

Members of Congress must meet constitutionally designated requirements for age, geography, and citizenship. In addition, as a group, members of Congress tend to display certain characteristics, including age, race, sex, wealth, occupation, religion, and level of education.

Constitutional Qualifications

According to the Constitution, a House member must be at least twenty five years of age and a citizen of the United States for a minimum of seven years prior to his or her election. A senator is required to be at least thirty years old, and a U.S. citizen for at least nine years prior to election. Representatives must reside in the state from which they are elected, but House members need not live in their congressional districts. Still, it is rare for a legislator to be an outsider, because tradition dictates that the representative should thoroughly know the people and the problems of the locality.

Age and Race

The members of Congress do not represent a cross-section of the American population. White males dominate Congress, while women and African Americans have been underrepresented.

Women comprise slightly more than half of the population, yet, there were only two women in the Senate in 1991: Nancy Kassebaum of Kansas and Barbara Mikulski of Maryland. Even in the 109th Congress (2005–2007), there were only fourteen women (fourteen percent of the total membership) in the Senate and sixty-eight women (slightly more than fifteen percent of the total membership) in the House. Note that in 2002, the first woman in history, Nancy Pelosi of California, became the Democratic Minority Leader.

African Americans account for just over twelve percent of the overall population. However, in 1991, there were no African American senators and in 2005 only one, Barack Obama of Illinois. In the 2005 House, there were forty-two African Americans, close to ten percent of the total membership. Similarly, Hispanics, with more than twelve percent of the U.S. population had two U.S. Senators (Salazar of Colorado and Martinez of Florida, or two percent) and less than six percent of the total House membership (twenty-four representatives in all).

Wealth, Occupation, Education, and Religion

Members of Congress tend to be much wealthier than the general American population, with about one-third of the total membership being millionaires, compared to one percent of the entire U.S. population.

Congressional salaries ($165,200 for each rank-and-file member, effective in 2006) far exceed the U.S. median income of $43,000 in 2005. Occupationally, lawyers, bankers, and businessmen dominate Capitol Hill. Lawyers have the requisite skills for political life—they know how to bargain and they understand legal-contractual relationships.

Educationally, nearly all members of Congress have bachelor's degrees from a college or university. A good many have master's or Ph.D. degrees as well. Although Protestant and Catholic denominations are most numerous in Congress, Jewish U.S. Senators and House members are also represented in significant numbers. For example, the number of Jewish U.S. Senators (there were ten in 2005) exceeded their percentage of the U.S. national population (roughly two percent).

■ THE ORGANIZATION OF CONGRESS

As discussed in the following sections, Congress is a bicameral legislature with 435 House members and a 100-member Senate. In addition, members of Congress are elected from districts or states, and follow specific representation orientations toward their constituents. Finally, important personnel and/or organizational components of Congress include the House Speaker and president pro tempore, majority and minority leaders in both chambers, party whips, the vice-president, and the committee/subcommittee system.

The Basics

Congress is a **bicameral** (two-house) legislature; consisting of a 435-member House of Representatives and a 100-member Senate (the framers preferred a bicameral legislature, so as to preserve a system of checks and balances). House members are elected from congressional districts in their states, one representative per district. The greater the population a state has, the more representatives it has in the House. Thus, California, the most populous state in the nation, had fifty-three members in 2005. Georgia, with a smaller population base, had only thirteen House members. After each census (every ten years), some states gain representatives, because their respective populations increased. States that declined in population or grew very slowly lose House representatives; however, every state must have at least one representative. Given the fact that 435 members is a maximum size fixed by a 1922 law, currently each House member represents a national average of 600,000 constituents.

The boundaries of congressional districts are drawn-up by state legislatures, which in the past led to the problem of political **gerrymandering;** that is, arranging boundaries in such a way as to constitute an unfair advantage for a political party, incumbents, and/or particular interests. (The word *gerrymandering* is derived from Elbridge Gerry, a Massachusetts governor who, in 1812, presided over the alteration of electoral districts to benefit the Jeffersonian Republican party.) In the 1960s, powerful rural state legislators created districts that differed markedly in population size, thus leading to underrepresented urban centers.

Reapportionment along the lines of the one-man, one-vote concept was enunciated by the Supreme Court in the 1964 *Wesberry v. Sanders* ruling (in 1962, the Court had ruled in *Baker v. Carr* that the federal judiciary could review the constitutionality of unequal congressional districts). Recently, the Court has ruled that drawing district lines using the controlling variable of race (**racial gerrymandering**) is unconstitutional, although it subsequently decided that race can be one of several factors in the redrawing of congressional districts. Gerrymandering is by no means a dead practice in

that partisan state legislatures still seek to minimize the voting power of the opposition while maximizing the electoral power of supporters. Consequently, the techniques of **cracking** (dispersing the opposition party's voters across multiple districts so as to dilute their voting power in any one district) and **packing** (moving a significant number of voters into a district in order to minimize their collective electoral strength in other districts) are still used.

Every state is entitled to have two senators. Each senator is elected by his or her entire state (senators were chosen by state legislatures until 1913). Because there are fifty states, there are one hundred senators.

The term of office for a House member is two years. A senator's term is six years. However, only one-third of the Senate is up for re-election every two years (the terms have been staggered historically). The entire body of the House of Representatives is up for re-election every two years. Each congressional term is, therefore, divided into two sessions, one for each year of the term.

The Representative or Senator, and His or Her District or State

The typical representative or senator must devote a considerable amount of his or her time to political fence-mending—that is, helping constituents with their problems or what is also called **casework.** New members of Congress try to visit their districts or states as much as possible. Political speeches, town meetings with voters, media interviews, and one-on-one conversations all play a part in making the voters aware of who their representatives or senators are and that the representatives care about them and their political views. Typically, a representative can adopt four types of legislator-constituent relationships: the trustee, delegate or agent, the partisan, or **politico.**

Trustees

Trustees mainly follow their own judgment when it comes to voting. Their belief is that voting on bills should not merely reflect what constituents back home desire. Trustees feel that they are better able to make the right choice due to their professional expertise and access to information. Trustees may even cross over to the opposition party when their ideological or personal beliefs dictate such a move.

Delegates or Agents

Delegates see their vote as an expression of the majority view among their constituents. These legislators ignore what party leaders desire or what special interest groups want if those wishes run counter to popular will. For example, a representative from a district containing a major military base responsible for thousands of jobs would probably be committing political suicide if he or she voted to close that base.

Partisan Legislators

Partisan legislators follow the advice and direction of the House and Senate party leadership on a majority of voting decisions. They also may look to fellow legislators or colleagues on their standing committees or subcommittees for cues on how to vote on a bill. A congressional **caucus,** or a group of congresspersons sharing common interests or issues, can be a distinct influence. Examples include the Congressional Caucus for Women's Issues, the Congressional Black Caucus, and the Congressional Internet Caucus (devoted to the sustained growth and adoption of the Internet).

Politico

A **politico** is a mixture of all three preceding roles, depending on the issue being voted upon. Only a few bills may really be heavily publicized or important to a representative's voters, so the delegate function may prevail. However, in cases in which there is voter apathy or ignorance, the trustee function can be embraced. Finally, party voting is important in Congress—studies show that on important votes, a majority of Democrats will oppose a majority of Republicans, especially in the House. The **partisan orientation** will also depend upon the effectiveness of the House and Senate leadership, as described in the following section.

House and Senate Leadership

There are only three congressional officers mentioned in the Constitution: the Speaker of the House, the vice-president (as president of the Senate), and the president pro tempore of the Senate.

President Pro Tempore of the Senate

The president pro tempore, who chairs the chamber when the vice-president is absent, is normally a senator of the majority party who has considerable seniority and/or the longest continuing service. The president pro tempore also succeeds to the presidency after the vice-president and Speaker.

Vice-President (as President of the Senate)

The vice-president has little influence in the Senate, except to break a tie vote. By contrast, the Speaker of the House is very influential (see the following section).

The Speaker of the House, and House Minority and Majority Leaders

The **Speaker** is the most influential member of the House. He or she is the presiding officer of the chamber and the recognized leader of his or her majority party. (The Speaker is chosen by the members of the majority party in the House). He or she is not a member of any standing committee, but can still vote on bills and enter into floor debate. The Speaker interprets House rules, acts as a key source of information for legislation and committee assignments, refers bills to appropriate committees, rules on procedural questions, puts questions to a vote, appoints members of conference committees, and announces the outcome of floor voting.

The most effective Speakers work closely with their staff, the House majority leader, the party **whip** (who polls members before key votes and sends them summaries of bills coming up for floor debate), and minority party leaders. The Speaker, even if a member of the opposing party, should try to have a reasonably close relationship with both the president and the president's staff. The Speaker is also next in line to become president after the vice-president.

Under ideal circumstances, the House Majority and Minority Leaders work closely with the Speaker in the interests of bipartisanship while still actively promoting party cohesion. However, fierce partisanship in recent years has undermined this spirit of cooperation.

Senate Leaders

Although the Senate does not have a leader who is equivalent to the Speaker, the Senate majority leader (elected by his own party that has a majority of the 100 seats in the Senate) is the proverbial center of the majority party's communications network. The **Senate majority leader** must work closely with the **Senate**

minority leader as well as with the president. The majority leader also has the right to be recognized first on the floor when debate begins on a bill. Senate majority leaders have varied in their overall legislative effectiveness, but few have matched Lyndon Johnson's legendary abilities displayed during the late 1950s and early 1960s.

The Committee System

Congress does its legislative work through the system of standing committees and its smaller divisions termed subcommittees. **Committees** are the mini-legislatures whereby the vast volume of legislation can be parceled out in an effective division of labor. Imagine each one of the 20,000-plus bills in the two-year congressional term being considered by the entire 435-person House and 100 senators! Little would be accomplished. In addition, representatives and senators become "specialists" by serving on a particular committee and acquiring expertise in energy matters, national defense issues, taxation, or agricultural subsidies, among others. Naturally, freshman representatives want to get on the right committee, one that has prestige and that deals with issues important to their constituents back home. A representative or senator from Iowa, for example, would probably be more interested in the agricultural committees than in the Transportation/Infrastructure (House) or the Homeland Security and Governmental Affairs (Senate) committees.

Select, or special, **committees** are usually temporary arrangements designed to investigate an important current issue, be it social security reform, campaign finance reform, or a foreign policy problem. Specific special or select committees in the 109th Congress included those on Aging, Ethics, Indian Affairs, and Intelligence. **Joint committees,** composed of both House and Senate members, may be permanent or temporary and deal with taxation, the economy, or even the Library of Congress.

Control over Committee Assignments

In the Senate, the Democratic Steering Committee makes the party's committee assignments; the Republicans use their Committee on Committees for their assignments. In the House, the Democrats give this power to its own Democratic Steering Committee, which includes the Speaker and other party leaders. House Republicans have also formed a Committee on Committees, which includes one member from each state having a Republican representative. However, the final selection is assigned to the executive committee headed by the party's floor leaders.

The actual division of seats on each committee is based upon the percentage of party strength in each house. If sixty percent of the Senate are Democrats, the sixty-percent figure would be carried over to each committee (except Ethics, which is evenly divided between the two parties).

The Role of Seniority

Committee assignments have traditionally been guided by the principle of **seniority.** This is especially true regarding committee chairs. The representative or senator who has served the longest consecutive period of time on a particular committee and is a member of the majority party stands a good chance of becoming chair (the member of the minority party with the most seniority is termed the **ranking member**). However, seniority is no longer an automatic procedure. For example, House Democrats removed three committee chairs in 1975, and there have been periodic revolts against the seniority principle. In 1995, under the leadership of Republican House Speaker Newt Gingrich, several younger

congressmen became chairs of key committees, bypassing more senior representatives. Reforms now require that all chairs be approved by secret ballot of each party's rank-and-file.

Some younger members of Congress criticize the seniority practice, arguing that longevity of service is not always associated with legislative competence. But supporters claim that seniority helps avoid political squabbling among competitors for chair positions, develops expertise and experience, and promotes stability in committee memberships over time.

Committee and Subcommittee Chairs

Legislators who chair committees and subcommittees are influential members of Congress; they can delay or expedite legislation to a significant extent. However, reforms have forced committee chairs to operate in a far less tyrannical manner than was previously the case. Ironically, subcommittee chairs have increased their powers and are far more likely to delay bills or refuse to hold hearings. The power of the subcommittee has complicated the legislative process by decentralizing authority and diffusing responsibility.

■ A BILL'S PASSAGE INTO LAW

More than 20,000 bills may be introduced into both houses of Congress during a two-year congressional term. Yet fewer than ten percent of all legislative proposals are typically converted into finished laws. The many legislative obstacles in Congress help explain why this high failure rate exists.

Who Proposes a Bill?

The majority of bills are proposed by officials in executive departments and agencies in accordance with presidential wishes. Presidential supporters in Congress can then formally introduce these bills. In addition, legislative ideas can originate with interest groups and even private citizens. Finally, representatives and senators also may draft their own bills.

A bill may be introduced in either house or simultaneously in both houses. Note the stipulation in the U.S. Constitution that all revenue or tax bills must first be introduced in the House of Representatives.

Different Kinds of Bills

The different types of bills include public, private, and joint resolutions (which, although not law, is equivalent to a law).

Public Bills

These bills are measures that are applicable to the entire nation, such as a defense-spending bill, a new tax measure, or a clean-air bill.

Private Bills

These bills apply to specific individuals. For example, a person may want special permission to become a naturalized citizen.

Joint Resolutions

These are resolutions that require approval by both houses and require the president's signature. They are equivalent to a law. Joint resolutions also are used to propose constitutional amendments.

Introducing a Bill and Referring It to Committee

The formal introduction of a bill involves the assignment of a number by the House or Senate clerk (for example, H.R. 2000 would be the 2,000th bill introduced in the House during the term; S 2000 is the prefix in the Senate). The **first reading** involves the clerk titling the bill and giving it a short summary description. The bill is then entered in the House Journal and in the Congressional Record. Its **second reading** occurs during floor discussion (if it gets that far); the **third reading** occurs just before a final vote is taken by the House and/or Senate membership.

After the first reading, the Speaker of the House sends the bill to the appropriate committee of jurisdiction. Thus, a bill dealing with new federal price supports for farm crops would be sent to the House or Senate Agricultural Committees. A gun-control bill would likely go to the Judiciary Committee.

The selection of a committee is very important, because one may be more sympathetic to the bill than another. Frequently, several committees can claim jurisdiction over a proposed bill—this has been the case with energy legislation.

In the Senate, the presiding officer of the Senate (in practice, usually the majority leader, or a junior senator appointed by him or her) refers the bill to the appropriate committee. For example, a bill dealing with benefits for veterans would be sent to the Senate Veterans' Affairs Committee.

The Committee or Subcommittee Considers the Bill

Woodrow Wilson once wrote that "Congress in its committee rooms is Congress at work." During the 109th Congress (2005–2007), there were thirty-six **standing** or permanent committees (twenty in the House; sixteen in the Senate) and 156 **subcommittees** (smaller committee divisions within each standing committee). Many bills are killed or pigeonholed in committee. In the 109th Congress, Senate standing committees included Agriculture, Nutrition, and Forestry; Appropriations; Armed Services; Banking, Housing and Urban Affairs; Budget; Commerce, Science, and Transportation; Energy and Natural Resources; Environment and Public Works; Finance; Foreign Relations; Health, Education, Labor, and Pensions; Homeland Security and Governmental Affairs; Judiciary; Rules and Administration; Small Business; and Veterans' Affairs. House standing committees included Agriculture; Appropriations; Armed Services; Budget; Education and the Workforce; Energy and Commerce; Financial Services; Government Reform; Homeland Security; House Administration; International Relations; Judiciary; Resources; Rules; Science; Small Business; Standards of Official Conduct; Transportation and Infrastructure; Veterans' Affairs; and Ways and Means.

The **committee chair** (always a member of the majority party) will delegate the bill to the appropriate subcommittee. Public hearings will be held, whereby interested parties, lobbyists from interest groups, and government officials can testify for or against the legislation. Hearings can attract media attention while giving opposing sides a chance to be heard. After these hearings, the subcommittee can take any of the following actions:

- Report the bill favorably with a "do pass" recommendation.
- Refuse to report out the bill, thus killing the bill.
- Report out the bill in an amended or changed format through "mark-up" efforts.
- Report the bill unfavorably.
- Report out a **committee bill**—that is, a completely new bill that the subcommittee has written as a substitute for the original bill.

The full standing committee usually accepts the subcommittee's recommendation, but it also can engage in its own mark-up editing process, add amendments, and hold hearings. A bill favorably reported out in the Senate is placed on a calendar for floor action. In the House, another obstacle to the bill looms: the Rules Committee.

The House Rules Committee and the Types of Rules

This committee is the traffic cop and gatekeeper of the House. This committee grants a rule that allows a bill to go to the House floor at a scheduled time for discussion, debate, and a final vote. A time limit on floor debate also may be included in the rule.

There are two kinds of rules: open and closed. An **open rule** permits the bill to be amended on the floor, while a **closed rule** forbids any amendments. If no rule is forthcoming from the Rules Committee, the bill has effectively been killed for that congressional session.

In previous years, a very conservative **Rules Committee** blocked liberal legislation, especially in regard to civil rights. Today, the Speaker of the House has acquired the power to nominate the majority party members and chair of this vital committee. Thus, the Rules Committee has become more responsive to the will of the House leadership.

Figure 6.1 illustrates the process of a bill becoming a law.

The Discharge Petition

The House may use the **discharge petition,** whereby an absolute majority—218 members—sign a petition requesting that the bill be forced out of committee for floor consideration. The Rules Committee may have a bill discharged after seven legislative days. Other House committees can be subject to a discharge if a bill is not reported out within thirty days after initial referral. In the Senate, a discharge resolution can be initiated through a simple motion by a member. Only a very few discharge petitions result in the "freed" legislation actually becoming law.

The Bill Is Considered on the Floor of Each House

The second reading of the bill occurs when it reaches the floor. Once the rule is approved, actual debate commences, but the nature of the debate differs considerably between the House and Senate. Normal debate per House member is always placed under some type of time restriction, typically ranging from one to five minutes, given the 435 legislators in the lower chamber. In the Senate, composed of one hundred members, debate is virtually unlimited.

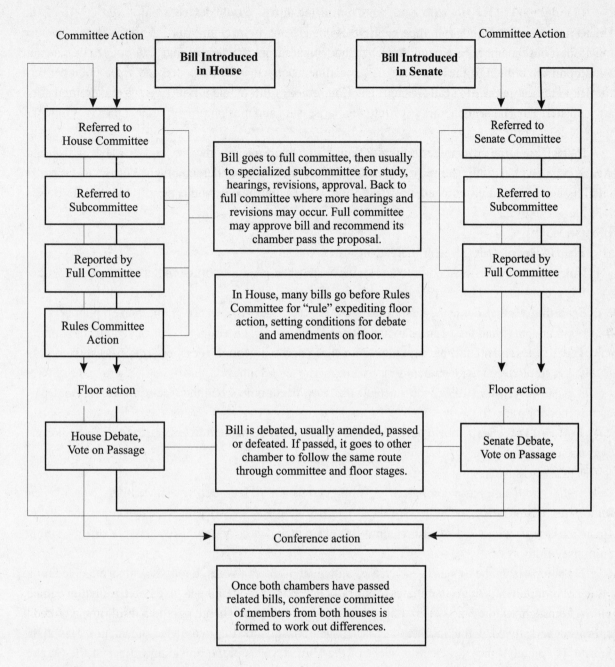

Fig. 6.1 How a Bill Becomes a Law

Source: "CQ's Guide to Current American Government," Spring 1992 (Washington D.C.: *Congressional Quarterly Inc.*), p. 119.

In order to expedite House debate, the **Committee of the Whole** device is employed. In effect, the House becomes one large committee of itself. Rules are not as strict and floor action is faster, because only 100 House members are required to conduct business, not the normal majority of 218. Debate and voting on each section of the bill proceeds (amendments also may be proposed and voted upon per section) until the entire bill has been covered. The Committee of the Whole is now finished and promptly dissolves itself. The House then goes back into regular session and must approve or reject the Committee of the Whole's action by a vote of the total membership.

In the House, the majority and minority floor leadership agree on how they will divide debating time. At any point, a House member may "move the previous question" or demand that a vote be taken on the bill." If such a motion is approved, only forty minutes of additional debate is permitted.

House Voting

The House has four different methods for floor votes:

1. **Voice votes** are the most common, with the Speaker or presiding officer determining which side—the ayes or nays—has won by sheer volume.
2. **Standing votes** occur if the voice vote is close. All House members in favor, then all members opposed, stand and are counted by the House clerk.
3. **Teller votes,** rare today, have a **teller** from each party who counts members who pass between them, for and against; members vote by turning in signed index cards—green for yea and red for nay. However, since 1993, House teller votes may occur only when the electronic voting system is inoperative.
4. **Roll-call votes,** also known as a **recorded vote,** can be demanded by one-fifth of the members present.

Today, the House has a computerized voting system for all recorded votes. Members' votes appear on a large master board above the Speaker's chair. Voting is over when the Speaker locks the system (members are usually allowed fifteen minutes to cast their vote). A tremendous saving of time results from use of this system.

By comparison, the Senate uses voice, standing, and roll-call votes, but does not have an electronic voting board. Still, less than ten minutes is typically needed for a roll-call vote in the much smaller Senate.

After approval, the bill is engrossed, printed in its final form. Then it is read a third time, voted on, approved, and signed by the Speaker. A House page transports the bill to the vice-president's desk in the Senate. (Remember that the vice-president of the United States is the presiding officer of the Senate, according to the U.S. Constitution.)

Senate Debate

The Senate of the United States is more of a debating club in comparison to the House. Debate is unrestricted in the Senate, which means that senators may speak for as long as they wish. There is no time limit. Also, senators, once they have the floor, may speak on any topic they choose.

Today, a **filibuster** is possible only in the Senate. It is a means whereby senators may deliberately try to talk a bill to death. The filibuster prevents a final vote on the bill, because all debate must end before the vote can occur. The record for a one-man filibuster is the twenty-four hours and eighteen minutes of

continuous talking by Senator Strom Thurmond of South Carolina against the passage of the Civil Rights Act of 1957 (the filibuster, however, was unsuccessful). Many other filibusters have been team efforts, in which senators speak one after another in order to delay or obstruct a bill.

A filibuster can be ended by the **cloture process,** whereby sixteen or more senators sign a petition requesting a cloture vote. If sixty percent of the senators present vote for cloture, each senator is restricted to one hour of debate. A final vote must occur within one hundred hours of debate after the cloture vote has been successful. Cloture votes are not easy to attain, and fewer than one-third have been historically successful. Cloture votes are rare, because senators are reluctant to interfere with legislative custom. They also see the filibuster as a weapon of the minority that they may want to use one day. Still, a successful cloture vote means that a vote can occur on the bill. If a majority of the Senate concurs, the bill has finally been approved.

During the presidency of George W. Bush, controversy arose in the Senate over whether the filibuster should be used to block the administration's judicial nominations to the federal courts. The Republican majority threatened the Democratic minority with elimination of the filibuster by changing Senate rules. While this **nuclear option** (meaning that Senate civility and cooperation might have been permanently damaged) was averted through compromise, there was no guarantee that the issue would not manifest itself in the future.

Role of the Conference Committee

A **conference committee's** function is to reconcile different House-Senate versions of a bill. For example, a House student-loan bill that authorizes loan payments for four years and the Senate version that allows two years of loans are not identical. Members of the standing committees who originally debated the bill in both houses work together to arrive at one bill. If they cannot arrive at a compromise, the bill dies; if they can, the conference bill in the form of a **conference report** is sent to each floor chamber for a final vote. Rarely does the Congress reject the work of the conference committee. Also, the conference bill cannot be amended. It must be approved by both houses. When this happens, the bill is signed by the Speaker of the House and Senate president pro tempore. The bill is sent to the President of the United States for final consideration.

The President Now Decides

The president has four choices in regard to the bill on his desk. First, he or she may choose to sign the bill and turn the proposal into an actual law. Second, the president can **veto** the bill—that is, reject it outright. The unsigned bill is then sent back to the house where it originated, along with the president's reasons for the veto. Congress can respond by overriding the presidential veto through a two-thirds vote of each house. If this proves impossible, the **veto is sustained** (it remains in effect), and the bill is dead for the particular session. Historically, however, few presidential vetoes are overridden. Third, the president can keep the bill on his or her desk for a period of ten days (Sundays excluded) without signing it or exercising the veto—in this instance, the bill automatically becomes law. The fourth choice is the **pocket veto,** in which the president doesn't act on the bill and Congress adjourns within ten days of the bill's submission to him or her, thus killing the bill.

Although many state governors have the power of an **item veto,** presidents do not possess this power under the Constitution. Presidents cannot reject individual sections of a bill, so they must accept or reject

the entire bill. This lack of an item veto encourages legislators to add **riders** to a bill—unrelated provisions that ride through the legislative process and that may be repugnant to the president. The Congress did once pass a law allowing the president to delete up to three items of appropriation in a single bill. However, in 1998, the Supreme Court ruled the approach unconstitutional in *Clinton v. City of New York*.

Throughout most of the nineteenth and early twentieth centuries, Congress was the active and dominant branch of the federal government. But presidents such as Woodrow Wilson, Franklin Roosevelt, Harry Truman, and Lyndon Johnson, among others, gradually took the initiative until the presidency became the center of American political life. Perhaps congressional prestige dropped to its lowest point in the late 1960s and early 1970s. Critics charged that the internal operations of Congress were undemocratic because elderly committee chairmen blocked progressive, liberal legislation. Furthermore, Congress had yielded control over war and the budget to the president. But the Watergate scandal and the Vietnam War diminished the prestige of the presidency. In addition, internal reforms made Congress more open, democratic, and decentralized. Newcomers to Congress were allowed more influence in the legislative process as well.

It bears repeating that most voters think favorably of their own representatives and senators, but not of Congress as a collective institution. Many Americans perceive Congress as too slow and antiquated when compared to the dynamism of the modern presidency. Nevertheless, Congress has been a major source of political change in American society for more than two centuries. It directly affects the lives of Americans in innumerable ways through its spending priorities, laws passed, tax policies, and connection to local and state interests via its members. It will surely have similar roles to play throughout the twenty-first century.

Selected Readings

Brown, Sherrod. *Congress From the Inside* (2004).

Davidson, Roger H., and Walter J. Oleszek. *Congress and Its Members,* 4th Edition (2003).

Hamilton, Lee H. *How Congress Works and Why You Should Care* (2004).

Oleszek, Walter. *Congressional Procedures and the Policy Process* (2004).

Test Yourself

1) The Sixteenth Amendment gives the Congress the power to
 a) raise the salaries of its members after an election has intervened
 b) collect the federal income tax
 c) admit new states into the union
 d) none of the above

2) True or false: In 2005, the federal government's net public debt was approaching eight trillion dollars.

3) What type of vote is needed for the Senate to convict an impeached federal official?
 a) a simple majority
 b) three-fourths
 c) two-thirds
 d) three-fifths

4) True or false: The Office of Management and Budget represents the staff budgetary agency for Congress.

5) The minimum required constitutional age for House members is _____ and for Senators is _____ years.
 a) thirty; thirty-five
 b) twenty; twenty-five
 c) thirty-five; forty
 d) twenty-five; thirty

6) True or false: Roughly one-half of the Senate is up for re-election every two years.

7) In which legislator-constituent relationship is the legislator the most independent from his or her voters back home and his or her own party?
 a) trustee
 b) delegate
 c) partisan
 d) politico

8) True or false: Members of Congress are wealthier and better educated than the general American population.

9) As the first woman to do so, Nancy Pelosi made history in 2002 by becoming the _____.
 a) Senate Majority Leader
 b) Senate Minority Leader
 c) House Majority Leader
 d) House Minority Leader

10) True or false: A congressional committee chair is always a member of the majority party in either the House or the Senate.

11) In the 109th Congress, _____committees included those on Aging, Ethics, Indian Affairs, and Intelligence.
 a) standing
 b) permanent
 c) select
 d) conference

12) True or false: Approximately twenty to twenty-five percent of all bills introduced during a congressional session eventually become law.

13) The traffic-cop committee refers to the
 a) House Armed Services Committee
 b) Senate Budget Committee
 c) House Rules Committee
 d) House and Senate Judiciary Committees

14) True or false: All revenue or tax bills must originate in the House of Representatives.

15) Which type of House vote is rarely used today?
 a) voice votes
 b) standing votes
 c) roll-call or recorded votes
 d) teller votes

16) True or false: Debate is restricted in the House, but normally unlimited in the Senate.

17) Before a cloture vote can be initiated, a minimum of _____ senators must sign a petition requesting cloture.
 a) thirty
 b) sixteen
 c) nineteen
 d) sixty

18) True or false: A conference committee's compromise bill may not be amended on either the House or Senate floor.

19) The 1998 case of *Clinton v. City of New York* dealt with the issue of
 a) reapportionment of congressional districts
 b) the item veto
 c) congressional authority over the budget
 d) congressional checks over the presidential war power

20) True or false: A pocket veto means that a bill will not become a law.

Test Yourself Answers

1) **b.** Choice a refers to the Twenty-seventh Amendment. Choice c refers to Article IV.

2) **False.** It was approaching five trillion dollars.

3) **c.** A two-thirds vote is needed, making it difficult for the Senate to achieve conviction. One more vote for conviction would have removed Andrew Johnson from office in 1868.

4) **False.** The OMB is the executive agency for budgeting. The congressional budgeting agency is the Congressional Budget Office.

5) **d.** These are the specific ages found in the Constitution.

6) **False.** Approximately one-third of the Senate is up for re-election every two years.

7) **a.** Generally, the trustee orientation allows the legislator to follow his or her own judgment to the greatest degree. The delegate orientation is linked to opinion back home. The partisan relationship involves party or caucus views. Politico represents a combination of trustee, delegate, and partisan styles.

8) **True.** Members of Congress are wealthier (salaries are higher, and one-third or so are millionaires) and better educated (college graduates and advanced degrees) than the American people as a whole.

9) **d.** Nancy Pelosi (D, California) was elected House Minority Leader in 2002, the first woman in political history to be elected to this post.

10) **True.** The majority party in both the House and Senate is rewarded with all the major committee (and subcommittee) chairmanships. Minority party legislators with the most seniority are called ranking members on these committees.

11) **c.** These are not part of the thirty-six standing or permanent committees. Also, conference committees are temporary arrangements designed to reconcile conflicting versions of House and Senate bills.

12) **False.** Less than ten percent of all bills introduced become law.

13) **c.** The House Rules Committee schedules legislation before it goes to the House floor for debate. There is no equivalent of Rules in the U.S. Senate. The Armed Services Committee deals with defense and national security issues, not scheduling.

14) **True.** This requirement is stipulated in the U.S. Constitution.

15) **d.** Teller votes are rare and are allowed only if the electronic recording system is broken in the House. The other three types of votes are far more common.

16) **True.** Because of its 435 members, House debate must be limited (normal speeches are one to five minutes). The Senate, with one hundred members, has unlimited debate unless a cloture vote is taken that restricts debate to one hundred hours before a vote.

17) **b.** Sixteen is the requirement. The other numbers are simply wrong. Sixty represents the three-fifths requirement for a cloture vote to be successful (assuming all one hundred senators are present).

18) **True.** A conference committee, consisting of both House and Senate members, reports out a bill that represents a final, compromised version. It must be voted on without change by both the House and Senate.

19) **b.** In this case, the U.S. Supreme Court ruled a congressional law allowing a presidential item veto to be unconstitutional. The case had nothing to do with congressional districts, war powers, or budgets.

20) **True.** A pocket veto refers to the president not taking any action on a bill, and Congress adjourning within ten days of the bill's submission to him or her. The bill dies.

The Presidency

In the minds of many Americans, the presidency is the proverbial center of the political system. A large number of citizens do not know who their representatives are in Congress, but most citizens will almost certainly know who the president is and have opinions as to the quality of his or her performance while in office. As the leader of the world's only superpower, an American president dominates the news and is the subject of intense scrutiny by syndicated columnists, historians, supporters and opponents in Congress, pollsters, and foreign leaders, among others. The purpose of this chapter is to examine constitutional perspectives on the presidency, presidential powers and roles, constraints on presidential power, "presidential greatness," the cabinet, and the responsibilities of the vice-president and First Lady.

■ THE CONSTITUTION AND THE PRESIDENCY

Article II of the Constitution describes presidential powers, presidential qualifications, and those constitutional amendments related to the presidency. In addition, presidential salary and the impeachment process also are delineated.

The Founding Fathers and Their Conception of the Presidency

The framers of the Constitution accepted the need for a strong leader, but also they did not want the president to become a tyrant trampling upon individual liberties. Various checks and balances were placed upon the chief executive in an effort to constrain presidential power, such as Congress overriding a veto or the courts invalidating a presidential action. None of the framers could have foreseen the degree of power the president would possess in the twenty-first century. In fact, they believed that the Congress would be the dominant institution of American government.

Article II of the Constitution: Description of Presidential Powers

Article II has a brief description of presidential powers. There are four short sections that, respectively, vest executive power in the president, establish his control over foreign affairs through his **commander-in-chief** role and treaty-making powers, delineate his responsibility to inform Congress about the state of the Union and "to take care that the laws be faithfully executed," and cover impeachment procedures by which a president can be removed from office.

Constitutional Qualifications, Career Background, and Age

The Constitution lists only three qualifications that one must possess to be president (Article II, Section 1). A chief executive must be at least thirty-five years old, a natural-born citizen, and a resident of the United States for at least fourteen years. The framers believed that a foreign-born president would have dangerous loyalties to his country of birth. Today, some object to this stipulation, arguing that in a nation of immigrants, an individual who becomes an American citizen should not be excluded from the presidency.

In recent decades, presidents have primarily been state governors (Carter, Reagan, and George W. Bush), vice-presidents (Nixon, George H.W. Bush), or U.S. senators (Kennedy, Johnson) before ascending to the Oval Office. A majority of presidents have been lawyers and over the age of fifty when assuming office. Kennedy was the youngest elected president at forty-three, while Teddy Roosevelt, at the age of forty-two, was the youngest to assume office via the vice-presidency upon the assassination of William McKinley; Ronald Reagan was the oldest president at sixty-nine when his first term began.

There are traditional qualifications for the presidency not found in the Constitution. Nearly all presidents have been white, Anglo-Saxon Protestants. The only Catholic president was John F. Kennedy. There has never been a black, Hispanic, female, or Jewish president of the United States, although public opinion polls reveal that a majority of Americans would vote for a woman or African-American presidential nominee, so someday this may change. In the modern era (from 1932 to the present), presidents have been college graduates and men who have had ample political or military experience (such as Eisenhower) before assuming the office.

Constitutional Amendments Relating to the Presidency

There are two constitutional amendments that affect the presidential term and the issue of succession, and both are discussed in the following sections.

The Twenty-second Amendment

The framers originally agreed on a four-year term, believing this would be enough time for a president to gain experience and develop leadership skills. Until Franklin D. Roosevelt held office for more than twelve years (he was elected to four terms, dying in April of 1945), no president had served longer than two full terms (George Washington set the informal precedent of a two-term limit that stood until FDR). In 1951, the Twenty-second Amendment was adopted. In part, it stated: "No person shall be elected to the office of the President more than twice, and no person who has held the office of President, or acted as President, for more than two years of a term to which some other person was elected President shall be elected to the office of the President more than once."

It is possible for an individual to serve ten years as president. A vice-president who served two years or less of an unfinished term would then be eligible to serve an additional two full terms, or eight years.

The Twenty-fifth Amendment

This amendment permits the president to appoint a new vice-president when there is a vacancy in that office (if the vice-president has resigned, died, or been impeached). The presidential appointment is subject to congressional approval by a majority vote in the House and Senate. This scenario occurred in 1974 when President Gerald Ford chose Governor Nelson Rockefeller as his vice-president. Ford himself had been chosen vice-president by Richard Nixon when vice-president Spiro Agnew was forced to leave office; Ford then became president upon the resignation of President Nixon. It was the first time in American political history that both the president and vice-president had not been elected by the American people.

Also, if the president is unable to carry out his duties temporarily, the vice-president becomes acting president. If a conflict ensues later between the acting president and the original president over whom shall occupy the office, Congress decides who the president will be by a two-thirds vote of both houses within twenty-one days. This latter scenario has never happened.

Presidential Succession

Although the Twenty-fifth Amendment makes it nearly impossible for the line of succession to pass below the vice-president (nine vice-presidents have succeeded to the presidency in American history), there is always the remote possibility that simultaneous vacancies could occur in both the presidential and vice-presidential offices. In this case, the order of presidential succession would be the Speaker of the House, president pro tempore of the Senate (the presiding officer when the vice-president is absent), secretary of state, secretary of treasury, secretary of defense, and down through the other cabinet department heads by order of each department's year of creation (the last would be the Department of Homeland Security's secretary).

Presidential Salary

According to the Constitution, the president's salary is established by Congress and cannot be changed during a term in office. The salary was last set in 1999 at $400,000. (The president also receives an annual $50,000 expense account, which is taxable.) Although the presidential salary seems low by today's standards when compared to corporate CEOs, his fringe benefits—the White House, staffers and servants, a yacht, Air Force One, unrestricted travel, the Camp David hideaway, and extensive medical care, among them—would probably be worth an equivalent of $15 million to $20 million a year for an average wage earner.

It should be noted that former presidents receive ample lifetime pensions. President Clinton's was initially set at over $180,000 a year, and substantial additional funding is provided for staffing, office expenses, postage, secret service protection, and so on. Each widow of a president is allowed a pension of $20,000 per year.

Impeachment and Removal from Office

As described in the Constitution and Chapter 6, the House of Representatives can impeach a president (and other federal officers) by bringing charges against him for misuse of powers or committing criminal actions. If the Articles of Impeachment are approved by a House majority, the Senate then sits as a jury to determine ultimate guilt or innocence. A two-thirds majority vote by the Senate is required for conviction and subsequent removal from office.

The chief justice of the Supreme Court serves as the presiding judge over the impeachment trial. Both President Andrew Johnson and President Bill Clinton were impeached by the House, but neither was convicted by the Senate (Johnson avoided conviction in the Senate by a single vote). President Richard Nixon resigned the presidency in 1974 before formal impeachment voting could proceed in the lower chamber.

■ THE ROLES AND POWERS OF THE PRESIDENT

The various roles of the president include chief executive, chief of state, chief diplomat, chief legislator, molder of public opinion, and party leader. The president also is the head of the armed forces (the commander-in-chief role) and is responsible for conducting foreign policy. The president's use of the veto and the issuance of executive orders are other important powers.

Chief Executive, Chief of State, and Chief Diplomat

As head of the executive branch of government, the president is the enforcer of congressional laws, treaties, and federal court/agency decisions. In addition, he has the power to grant pardons (President Ford's 1974 pardon of Richard Nixon for any federal offenses is a famous example), reprieves and acts of amnesty (President Carter proclaimed amnesty for Vietnam War draft resisters, many of whom had fled to Canada), and appoint federal officers (judges, agency and cabinet heads, and so on).

As the chief of state, the president symbolizes the government of the United States and the unity of the nation. He often presides over important ceremonies, such as laying a wreath upon the Tomb of the Unknown Soldier, contacting astronauts on the Space Shuttle, or throwing out the first baseball when the Major League season begins each April.

Of course, as chief diplomat, he frequently greets foreign leaders upon their arrival in Washington or meets with them overseas, often at summit conferences. He also can extend diplomatic recognition to a state. In 1995, President Clinton recognized communist Vietnam, America's erstwhile enemy; thereby establishing full diplomatic and trade relations with that nation.

Leader in Foreign Policy

The Constitution gives the president the power to appoint U.S. ambassadors and formulate international treaties. Both actions require Senate approval. Although a president's ambassadorial appointments are seldom repudiated, the Senate has rejected treaties at least twenty times. The most famous example was President Wilson and the Treaty of Versailles, which established the League of Nations after World War I. A more recent example occurred in 1979, when President Carter's SALT II Treaty (arms limitation) was never acted upon by the Senate. Conversely, Carter's Panama Canal Treaty that eventually returned control of the canal back to the Panamanian government passed the Senate by one vote. President Clinton also was successful in gaining Senate approval for the NAFTA (North American Free Trade Agreement) Treaty in 1993, an agreement establishing an economic market among the United States, Canada, and Mexico.

Presidents also use the **executive agreement,** which is an international understanding with another head of state. Executive agreements, which are far more common than treaties, do not require the advice and consent of the Senate. (The Supreme Court has ruled that executive agreements have the same legal status as treaties.) Executive agreements have covered such areas as the establishment of military bases

overseas and resolving financial or international trade disputes. A classic example was FDR's Destroyers for Bases Agreement in 1940, when the United States sent fifty Navy destroyers to beleaguered Great Britain in exchange for 99-year rent-free leases on naval and air bases. Historically, there have been more than 9,000 executive agreements, compared to some 1,300 treaties. Treaties are considered binding on succeeding presidents, but this is not the case with executive agreements.

The Commander-in-Chief Role

The Constitution asserts that "The President shall be Commander-in-Chief of the Army and Navy of the United States, and of the Militia of the several States, when called into the actual Service of the United States." In short, the American military is under civilian control, and the top civilian general is the president (General MacArthur found this out in April 1951 when he was removed from his Korean command by President Truman for insubordination). Presidents may dispatch troops overseas or use military force as deemed necessary. The president also can give the order to use nuclear weapons against an adversary. As commander-in-chief, the president can send the armed forces into conflict situations that may lead to full-scale, undeclared wars. (Presidents have ordered troops overseas more than 200 times in American history.) Examples include Truman's dispatch of troops to Korea in 1950, Johnson's commitment of more than a half-million troops to Vietnam from 1965 to 1968, President George H.W. Bush's interventions into Panama (1989) and Kuwait (1991), Clinton's sending of troops into Haiti (1994) and Bosnia (1995), and President George W. Bush's moves into Afghanistan (2001) and Iraq (2003). Earlier illustrations include Thomas Jefferson conducting a war against the Barbary pirates in the early 1800s, and John Adams ordering the navy to stop French warships from harassing the American merchant fleet in 1798. Neither Adams nor Jefferson sought congressional approval.

However, only Congress has the constitutional right to declare war. (It has done so five times in American history.) In order to check presidential power in the war-making arena, Congress passed the War Powers Act in 1973 (over President Richard Nixon's veto), requiring that a president:

- Consult with Congress before sending troops into combat overseas.
- Inform Congress within forty-eight hours after the dispatch of troops as to the reasons behind and implications of this decision.
- Withdraw those combat forces if Congress votes to do so after sixty days have passed.
- Complete the withdrawal within an additional thirty-day period.

In general, presidents have ignored the War Powers Act, and Congress has not forced a president to abide strictly by its provisions (there is also a question about its constitutionality). For example, Congress permitted President Reagan an eighteen-month period during which American troops could stay in Lebanon in 1983 (they were pulled out early after a tragic terrorist bombing occurred, killing 250 U.S. marines). Conversely, presidents have tried to observe the consultation requirement of the act. President George H.W. Bush did ask Congress for approval to use force in the Persian Gulf, which he ultimately received in 1990 (so did President George W. Bush in 2002, regarding the possible use of force against Iraq). Note that a president has never openly defied the forced withdrawal provision (because Congress has never invoked it); so, consequently, there has never been a real forum to test the act's constitutionality.

Presidents normally have a freer hand in conducting foreign policy, because Congress has traditionally deferred to presidents, especially in the post World War II era. (In 1936, the Supreme Court ruled

in *U.S. v. Curtiss-Wright Export Corp.* that the president had exclusive power in the handling of international relations.) The president also has access to better information about foreign nations and leaders from various federal intelligence agencies, such as the Central Intelligence Agency (CIA). Finally, in times of global crisis, the public sees the president, not Congress, as the reassuring voice of the nation and the individual who is best equipped to cope rapidly with grave threats to national security.

Chief Legislator

The president plays a vital role in proposing new legislation, while exercising the right to approve or veto laws passed by Congress. Presidents are the only nationally elected government officials (along with vice-presidents). They will frequently try to rally the country behind their legislative agenda through TV speeches, press conferences, newspaper interviews, and radio appeals. Massive public support may influence Congress to vote for the president's legislative programs.

The President's Three Major Addresses

The president delivers three major addresses that relate to legislative proposals. The State of the Union message (required as stated in Article II, Section 3, of the Constitution), the most important of the three, is presented annually in late January before a nationally-televised joint session of Congress. It covers the desired presidential agenda for Congress to consider, and conveys to the public a sense of presidential perspective and direction. In the National Budget message, the president recommends federal expenditures for different policy areas and social programs. The president analyzes economic trends and difficulties in the Annual Economic Report. In addition, the president's staff prepares innumerable legislative recommendations for Congress to consider.

The Presidential Veto

The veto power (see Chapter 6) allows the president to reject legislation passed by Congress. There are a number of ways he can exercise the veto.

Veto the Bill. The president may actually **veto** the bill by means of a written statement noting the objections, and then deliver the actual bill back to Congress. Congress has the opportunity to override the veto by a two-thirds vote of each house. This is difficult to attain. The vast majority of presidential vetoes are sustained (approximately 7 percent of all vetoes have been overridden), so that they remain in effect. For example, President Carter had only two vetoes overridden out of a total of thirty-one. Franklin Roosevelt, in his twelve years in office, had 626 of 635 vetoes sustained; Bill Clinton had only two overridden. Presidents also vary greatly in the number of total vetoes they employ—Carter (thirty-one), Reagan (seventy-eight vetoes), George H.W. Bush (forty-four), Clinton (thirty-seven), and George W. Bush (none during his first term). Vetoes are largely a function of whether a president's political party controls Congress.

Use the Pocket Veto. The president may employ the **pocket veto** (see Chapter 6), whereby Congress adjourns within ten days after receipt of the bill and the bill goes unsigned. In effect, the president pockets the bill without giving Congress the chance of overriding the veto. This, of course, is possible only when Congress passes a bill within ten days of its scheduled adjournment.

The Item Veto

Presidents, unlike most state governors, do not have the power of an **item veto.** They have to approve or reject the entire bill. They cannot delete certain sections or provisions, such as pork barrel items (spending for local projects tacked onto bills). Congressional authorization for the line-item veto was ruled unconstitutional in 1998, due to the improper use of legislative powers by President Clinton.

Presidential-Congressional Relations: Why Conflict Occurs

Whether presidents have a hostile or cooperative Congress vis-à-vis their legislative proposals depends upon a number of factors: presidential popularity, presidential communication/lobbying skills, timing of proposed legislation, and current international and domestic conditions (for example, is the nation at war, or does economic prosperity exist?), and whether or not the president's party controls Congress. However, conflict can occur even when the president's party has voting majorities in both houses. President Jimmy Carter, a Democrat, had to confront a Democratic Congress that refused to pass many of his proposals, such as tax reform, national health insurance, and a comprehensive energy policy. Usually, presidents have much greater legislative success early in their term of office, especially during the honeymoon period with Congress during the three to six months after taking office (sometimes termed the **100 days,** after FDR's experience in 1933). Kennedy, Reagan, and Clinton all enjoyed initial success rates (the number of their proposals actually becoming laws) of over eighty percent. But there are also failures even for popular presidents. Congress opposed Reagan's request for aid to the Contra rebellion in Nicaragua as well as Clinton's proposed revamping of the nation's health care system. Even a Republican-controlled Congress could not enact President George W. Bush's original plan for partial privatization of Social Security during his second term. In general, presidents tend to be more successful with Congress in foreign rather than in domestic policy.

Conflict between Congress and the president is built into the American system of government. First, there is the reality of **divergent constituencies.** Members of Congress are elected from districts and states, so their election prospects are linked to local or regional interests. Presidents are nationally elected and must look at policy from a much broader perspective. Second, there is the issue of **different office terms.** Presidents come and go every four (or eight) years, while congressional legislators can be re-elected over and over again, either every two years or six years (remember that one-third of U.S. senators are up for reelection every two years). Presidents who are nearing the end of their second term are often called **lame ducks** or **politically disadvantaged,** because Congress knows that another president with new priorities will soon occupy the White House. There is the third factor of **divided government,** when either the Democrats control one house of Congress and Republicans the other, or the president confronts the problem of both houses of Congress being controlled by the opposition party. Bill Clinton's first year eighty-percent legislative success rate dropped precipitously to thirty-six percent after 1994, when the GOP gained voting majorities in both congressional chambers. Finally, there is the **rapidity of action** quality of the presidency versus the comparative slowness of Congress and its 535 individuals. A president often has to act quickly and even secretly when he or she perceives that a national security threat is emerging. These actions may eventually antagonize members of Congress, who charge that there was flawed executive decision-making resulting from presidential usurpation of power and the lack of appropriate legislative input.

Executive Privilege and Executive Orders

The term **executive privilege** refers to the inherent presidential power of withholding sensitive or secret information from Congress, the public, or media on the grounds of national security, the need for presidents to preserve confidentiality, or the general separation of powers principle. This power originated with George Washington, who in 1792 initially refused a request from the House of Representatives for documents relating to an Indian attack upon federal troops. In 1974, the Supreme Court ruled in *U.S. v. Nixon* that executive privilege did not apply to the withholding of White House tape recordings that collectively represented important evidence in a court of law. Nevertheless, subsequent presidents have repeatedly invoked executive privilege on other matters, such as Bill Clinton (U.S. policy toward Haiti) and George W. Bush (preventing testimony before Congress by Homeland Security head Tom Ridge). In short, Congress can request secret information from the White House, but the latter can resist under the aegis of executive privilege.

Executive orders are presidential directives or regulations that have legal standing in so far as they can be directly linked to a constitutional source ("executive power" in Article II, Section 1, or the phrase "take care that the Laws be faithfully executed" in Article II, Section 3) or a statute enacted by Congress. When they cannot be so linked, they may be ruled unconstitutional, as was the case with President Truman's seizure of the nation's steel mills during the Korean War (*Youngstown Sheet and Tube v. Sawyer*) on the grounds the president was making the law rather than reflecting existing legal and constitutional precedent. Executive orders have been used by presidents throughout the nation's history, including those resulting in the Louisiana Purchase (Jefferson), emancipation of slaves (Lincoln), internment of Japanese-Americans in relocation camps after Pearl Harbor (Franklin D. Roosevelt), desegregation of the armed forces (Truman), affirmative action implementation (Johnson), establishment of the Peace Corps (Kennedy), creation of the Environmental Protection Agency (Nixon), formulation of the "don't ask, don't tell policy" for gays in the military (Clinton), and establishing military tribunals to try terrorist suspects (George W. Bush). Executive orders also can be used to create or modify existing policies and regulations employed by federal agencies. Finally, Congress has periodically charged that executive orders, even when justified by the president, really do constitute an infringement upon its lawmaking power. However, the courts have supported this presidential power (the total number of executive orders in U.S. history will surpass 14,000 in the near future).

Party Leader

The president is the national advocate of his party's platform and political philosophy. He is expected to campaign for the party's congressional, state, and local candidates. However, presidents frequently have trouble passing along their popularity to other candidates. Candidates also may wish to avoid locally unpopular presidents. On the other hand, President George W. Bush campaigned extensively for Republican candidates with good results in the 2002 midterm elections.

Presidents also are active in raising funds for party candidates; appointing party members as ambassadors, judges, or cabinet department heads; selecting the chair of the party's national committee; and trying to increase party support in Congress. A president also will be concerned about how policy decisions will affect his or her party's prospects in forthcoming elections.

Molder of National Opinion

A dynamic president who uses TV and radio effectively can definitely shape the public's views on key national issues. Some presidents, like Kennedy and Reagan, were especially skilled communicators whose dramatic press conferences and TV speeches influenced the views of millions of American voters. Other presidents have been less successful due to their personality or historical circumstances (for example, the Grant and Harding administrations were plagued by scandal and corruption). Presidents who try to sell the public unpopular positions may find public opinion turning against them, as was the case with Johnson's support for the Vietnam War. The same phenomenon occurred during George W. Bush's second term in office, when casualties in Iraq depressed the president's public approval ratings.

Presidential popularity tends to drop over time. Consequently, many presidents leave office with lower public-approval ratings than when they first entered the Oval Office. One explanation is the **coalition of the minorities** principle, whereby presidents gradually antagonize one group after another due to their decisions. Inevitably, collective disillusionment with presidential policies intensifies dramatically with time. Another reason is the inevitable gap between what presidential candidates promise during the campaign and what they can actually deliver once in office. Presidents are not all-powerful. They cannot always control events, such as an oil cutoff, a scandal caused by one of their subordinates, an economic downturn, among others. But they will nevertheless be lambasted by the political opposition and perhaps unfairly blamed by the general public. It also should be noted that historic events (also called **rally points**) can transform a president's approval base. Immediately prior to the terrorist attacks of 9/11/01, the presidential approval rating of George W. Bush was fifty-one percent. After 9/11, that rating soared to ninety percent as the President united the nation behind the war against terrorism. Conversely, President Bush's popularity dropped substantially four years later in the wake of Hurricane Katrina's destruction of New Orleans when the public, either fairly or unfairly, blamed the president and his administration for not handling the natural disaster in a more effective manner.

National Economic Manager

Modern presidents are expected by the public to handle the national economy in a manner that will promote prosperity (that is, full employment and low taxes) and abundance for all. This is unrealistic, because the economy can be influenced by private individuals and companies, both at home and abroad. Furthermore, many economic regulatory agencies, such as the Federal Reserve Board, determine interest rates and other monetary policies. They are not subject to direct presidential control. Still, the opposition party in Congress will invariably fault the president for mishandling the economy, reiterating those charges as the drumbeats of the next election grow louder.

Nevertheless, powerful presidents can forcefully present their economic remedies to the nation. A president who is able to move the nation out of economic recession prior to or during an election year (or take credit for existing prosperity) will be in an enviable political position. Thus, President Reagan benefited from a strong economy in his 1984 re-election campaign against Walter Mondale. Conversely, high levels of unemployment, severe inflation, or a persistent recession will usually doom an incumbent president's chances of re-election. In early 1992, President George H.W. Bush, aware of the impending November election, proposed several policies intended to shake the American economy out of a prolonged downturn and improve his prospects for re-election. These steps failed to prevent his defeat at the hands of Bill Clinton, whose prophetic campaign mantra was "It's the economy, stupid."

Presidential Greatness

What makes a president "great" in the eyes of his (or someday "her") contemporaries and historians? Students of the presidency typically cite the following virtues: the ability to handle crises and challenges, personal courage, a vision for change that will inspire others, a willingness to use and stretch presidential powers for the good of the nation, skill in assembling a team of talented advisers, the wisdom to learn from and admit mistakes, and effective communication skills, especially in the era of TV and the mass media. Historians' polls usually list the following presidents as great or near-great: George Washington, Thomas Jefferson, Abraham Lincoln, Theodore Roosevelt, Woodrow Wilson, Franklin D. Roosevelt, Harry S. Truman, John F. Kennedy, and Ronald Reagan. Presidential failures also are mentioned, including Ulysses S. Grant, Warren G. Harding, and Richard Nixon due to major scandals that plagued their administrations. Finally, modern presidential analysts, such as political scientist James Barber, link greatness to the active-positive president, a chief executive who conveys a high energy level, a strong desire for change, and a personal character that is both conducive to leadership and one that really enjoys the political challenges of the presidency.

■ CONSTRAINTS ON PRESIDENTIAL POWER

Presidents may be powerful, but their powers are not unlimited. As political scientist Richard Neustadt once put it, presidential power is really the "power to persuade." Presidents must bargain with and convince other individuals and institutions in the political system that their policies will be effective and worthy of support. Presidents who imperiously try to order other political actors to do their bidding or are perceived as misusing their powers by the courts, the public, Congress, the media, or the bureaucracy will gradually lose their persuasiveness. President Truman once observed that his successor, former army general Dwight D. Eisenhower, would find the presidency to be different from the military. "He'll sit here and he'll say, 'Do this! Do that!' And nothing will happen. Poor Ike—it won't be a bit like the army. He'll find it very frustrating."

Judicial Constraint

The Supreme Court can apply the judicial review process to all presidential actions. Examples have included the Court's ruling voiding President Truman's seizure of the nation's steel mills during the Korean War and its rejection of President Nixon's claim of executive privilege in withholding the Watergate tapes as criminal evidence in 1974. Although appointed by the president, Supreme Court justices and other federal judges may not always render judicial opinions in accordance with presidential desires.

Public Opinion as a Constraint (or Opportunity)

Public opinion can narrow presidents' policy options as well as undercut a chief executive's overall political effectiveness. President Ford's unpopular pardon of Richard Nixon from further prosecution stemming from the Watergate scandal clearly hurt Ford in his race against Jimmy Carter in 1976. In 1980, President Carter, unable to bring the hostages home from Iran and plagued by double-digit inflation prior to election day, saw a majority of voters select his challenger, Ronald Reagan. Conversely, a booming economy buoyed the Clinton presidency. Globally, foreign conflicts that do not go well for U.S. forces can harm a president's support levels, as typified by the cases of Truman and Korea, Johnson

and Vietnam, and George W. Bush and Iraq. However, note that a clear victory in war can win public acclaim for a president (George H.W. Bush and the Gulf War). In normal times, public opinion is usually supportive of the president, but events can transform it into a tidal wave of discontent.

Congressional Constraint

A recalcitrant Congress can make life miserable for a president, blocking or diluting legislative packages and interfering with foreign policy agendas. The authority of Congress to appropriate or withhold money for all federal programs and its right to practice legislative oversight—that is, investigate and scrutinize the performance of the executive branch—are clear constraints.

Media Constraint

The news media—TV, radio, magazines, newspapers, and the Internet—can present to the public an image of presidential competence or failure, dynamism or passivity, sincerity or duplicity. The media concentrate their collective attention on the president, so the president's staff will cultivate a favorable presidential image through carefully chosen speeches, photo opportunities, and timely media interviews. Ronald Reagan's first term in office had very good media coverage, with journalists rarely criticizing the president for his mistakes. In effect, the media created what has been termed a **Teflon presidency** (blame simply did not stick to the president). Televised presidential press conferences also can promote a favorable image, as was the case with John F. Kennedy's showcased wit and charisma during the early 1960s or Ronald Reagan's Great Communicator label in the 1980s.

Conversely, media exposure of scandal can hurt a president's reputation. The Watergate scandal's role in forcing President Nixon to resign in 1974 was unearthed through the investigative reporting of the *Washington Post*. Even President Reagan's image was tarnished by the heavily publicized Iran-Contra affair during his second term; this scandal suggested that the president had delegated too much authority to subordinates. President Clinton's well-publicized affair with a student intern, Monica Lewinsky, is another example.

■ ASSISTING THE PRESIDENT: THE EXECUTIVE ORGANIZATION

All presidents require assistance in making policy and managing the executive branch of government. The president's circle of advisers is drawn from the **Executive Office of the President (EOP),** created in 1939. The EOP's respective agencies have been created to help the president. The most important agencies are the White House Office, the Office of Management and Budget, the National Security Council, and the Council of Economic Advisers. In addition, a president may call on the cabinet—the fourteen secretaries and the attorney general—for policy consultations, although this is admittedly rare.

The White House Office and Presidential Advisers

The White House Office (WHO) incorporates the main presidential advisers. A president's closest advisers in the WHO are usually personal friends who helped him get elected or who have won his

trust over the years. Also included are the president's legal counsel, press secretary, speechwriters, appointments secretary, and other clerical staff. A president also chooses a chief of staff (he or she will have daily access to the president) to coordinate WHO activities. The selection of expert and dedicated WHO assistants can help a presidential administration succeed. The staff can prioritize policy objectives, resolve bureaucratic conflicts, assist with presidential speech-making, handle the White House Press Corps while scheduling press conferences, lobby congressional leaders, and protect the presidential image. Conversely, WHO personnel can handicap a president's effectiveness if they isolate him from important sources of information or are incompetent advisers.

Note that there are three models of presidential advisor systems—**competitive, collegial,** and **hierarchical.** A president, such as FDR, who adopts a competitive system, pits advisor against advisor in a struggle for presidential access, thus encouraging heated arguments over the merits and demerits of ideas or policy options. The objective is that conflicts are not concealed from the president but are actively encouraged. In theory, this process will produce the best advice and critical analysis of policies. The president then makes a final decision as the ultimate arbiter. One problem of the competitive system is that it is time-consuming and places a heavy burden on presidential management. Collegial systems (used by Kennedy, Carter, Clinton) stress consensus-building, brainstorming and equality among advisors, resembling a spokes-in-the-wheel structure, with the president at the center and the advisors (individual spokes) surrounding him. A serious problem with collegiality is the phenomenon of **groupthink,** whereby advisors begin to think similarly while valuing group cohesion over both dissent and the search for the best policy option (reportedly a trait of Johnson's advisors on Vietnam and George W. Bush's advisors on Iraq). Finally, hierarchical systems (used by Eisenhower, Nixon, Reagan, George W. Bush) refer to a pyramidal-shaped, tight chain of command structure, with subordinate staffer views and policy differences working their way from the lower layers through superiors at higher levels (information is synthesized and summarized at each level) and eventually to the top of the pyramid. A weakness is that the flow of information may be excessively filtered or even sanitized as it makes its way up the pyramidal ladder. Crucial details or doubts about a problem may never make it to the president, thereby resulting in flawed decision-making. Finally, one approach that has been advocated as a way around all of the above-problems is the concept of **multiple advocacy,** involving the assignment of competing policy positions to different advisors so that a true give and take can ensue before the president. This procedure places a premium upon a decisive, open-minded, and knowledgeable president.

The Office of Management and Budget

The Office of Management and Budget (OMB) is the largest agency in the EOP. It was originally the Bureau of the Budget, created in 1921 within the Department of the Treasury. President Nixon renamed it the OMB in 1970.

The OMB drafts the president's annual federal budget, which is presented to Congress each January for approval. The director of the OMB can be a powerful figure, such as David Stockman under Reagan or Richard G. Darman under George H.W. Bush. The OMB director also can act as a clearinghouse agent for legislative proposals emanating from the executive agencies.

The National Security Council

The National Security Council (NSC) was created in 1947 and is mandated to advise the "president with respect to the integration of domestic, foreign, and military policies relating to national security." The law requires the president, vice-president, and the secretaries of state and defense to be NSC members. The CIA director and chairman of the Joint Chiefs of Staff also have become important NSC participants. In recent administrations, the National Security Adviser has been influential, be it Henry Kissinger under Nixon, Zbigniew Brzezinski under Carter, Frank Carlucci under Reagan, Brent Scowcroft under George H.W. Bush, Samuel Berger under Clinton, or Condoleezza Rice and Stephen Hadley under George W. Bush.

The Council of Economic Advisers

The CEA was established under the Employment Act of 1946. Three presidential appointed economists (they can be removed from their positions at any time), along with a relatively small staff, analyze the economy and submit their findings to the White House. The CEA's advice is usually incorporated into an annual report. The council frequently recommends policies designed to reduce inflation and unemployment while generating economic growth. The CEA is strictly an advisory organization, because a president can choose not to accept its recommendations.

■ THE CABINET

The idea of the cabinet acting as an advisory body for the president has seldom been implemented. The first president, George Washington, had to mediate a quarrel between Jefferson, his secretary of state, and Hamilton, the secretary of the treasury. Abraham Lincoln, once confronted with a cabinet in total disagreement with him, announced the results as "seven nays, one aye—the ayes have it." In the modern era, only Eisenhower used the cabinet extensively.

The problem is that the fifteen cabinet heads are interested mainly in protecting their own departments. The current composition of the President's cabinet is shown in Table 7.1.

Table 7.1 Members of Presidential Cabinet

Cabinet Post	Year Established
Secretary of State	1789
Secretary of the Treasury	1789
Secretary of Defense (originally the Department of War, created in 1789)	1947
Attorney General (Department of Justice)	1789
Secretary of the Interior	1849
Secretary of Agriculture	1889
Secretary of Commerce (originally the Secretary of Commerce and Labor)	1903
Secretary of Labor	1913
Secretary of Health and Human Services (originally the Secretary of Health, Education and Welfare—renamed Health and Human Services in 1979 when the separate Department of Education was created)	1953
Secretary of Housing and Urban Development	1965
Secretary of Transportation	1966
Secretary of Energy	1977
Secretary of Education	1979
Secretary of Veterans Affairs	1989
Secretary of Homeland Security	2002

These cabinet secretaries may become more concerned with acquiring departmental resources than with the attainment of presidential goals or objectives, because cabinet departments vary tremendously in resources and personnel. Also, cabinet members are frequently independent-minded, due to their previous successful backgrounds in the corporate or political worlds. Thus, they may even oppose presidential policies. Walter J. Hickel, Nixon's Interior secretary, and Joseph Califano, Carter's secretary of Health, Education, and Welfare, were both frequently at odds with the White House.

However, a president often employs an **inner cabinet** or **kitchen cabinet** (the latter name is derived from the presidency of Andrew Jackson), consisting typically of the secretaries of State, Defense, Treasury, and the Attorney General, which may serve as a true advisory body. Of course, the precise configuration of the inner cabinet may vary due to the personal preferences of each president.

■ THE VICE-PRESIDENCY AND THE FIRST LADY

Historically, the vice-presidency was viewed by many observers as a job of little significance, but also one of potential importance. It was the nation's first vice-president, John Adams, who summed up the office by asserting: "I am nothing, but I may be everything." Woodrow Wilson's vice-president, Thomas R. Marshall, frequently told the story of two brothers who ran away from home. "One ran away to sea, the other became vice-president. Neither has ever been heard from again." The vice-president's

only constitutional duty is to preside over the Senate and cast the deciding vote when a tie exists. However, recent presidents have given their vice-presidents important responsibilities. Jimmy Carter kept Walter Mondale informed about and involved in important administrative decisions. Reagan did the same for George H.W. Bush, who assigned significant responsibilities to Dan Quayle. Bill Clinton and George W. Bush also were close to their respective vice-presidents, Al Gore and Dick Cheney. The vice-president still remains the individual who is one heartbeat away from the presidency. Furthermore, the vice-presidential experience can prepare an individual for the presidential job, as was the case with George H.W. Bush, who served eight years as Ronald Reagan's vice-president. Perceptive observers note that thirteen of the nation's forty presidents first served as vice-presidents.

At times, the First Lady has played an important role in a presidential administration. Eleanor Roosevelt was a supporter of women's rights and anti-discrimination laws. Lady Bird Johnson's theme was the beautification of America. Nancy Reagan's mission was to combat drug use in America. Laura Bush was an advocate of literacy. Probably the most policy-active First Lady was Hillary Rodham Clinton, who worked on a comprehensive health care program during her husband's presidency. She was subsequently elected to the U.S. Senate from the state of New York.

Why have the powers of the presidency grown so much during the last eight decades? There are three fundamental reasons: (1) a vast national economy and complex industrial society have accelerated public expectations that the president will practice effective oversight responsibilities. (2) The prevalence of warfare, the battle against terrorism, and America's role as a world leader have also strengthened the presidency. Most Americans view the president as the decisive party who formulates foreign policy and acts first during times of international crisis. (3) The modern media covers presidential actions and rhetoric to a much greater degree than their reporting on Congress or the courts.

The Constitution lists only three qualifications to be president: be a minimum of thirty-five years of age, be a natural-born citizen, and be a resident of the United States for at least fourteen years. Other constitutional provisions limit the president to no more than two full terms, provide for safeguards in case of presidential disability, and delineate impeachment procedures.

Presidential roles and power have expanded over time. They include serving as chief of state, foreign-policy leader, commander-in-chief, chief legislator, party leader, molder of national opinion, and manager of national economic policies. Despite this expansion, presidential powers are still constrained by the courts, public opinion (presidential popularity tends to decline over time), the media, and Congress. Furthermore, the fundamental ability underlying presidential effectiveness is persuasion, not coercion.

Presidents must rely on their close advisers, other key personnel, and advisory institutions within the Executive Office of the President. In contrast to the EOP, presidents rarely depend upon the cabinet. Finally, the status and responsibilities of vice-presidents and First Ladies have increased in recent years. Their potential importance should not be overlooked.

While the memories of Watergate and Vietnam still haunt older Americans, there seems little doubt that the current generation will continue to look first to the president for national guidance, and even inspiration. Indeed, the challenges of the twenty-first century are likely to place an even greater burden on those individuals who will reside at 1600 Pennsylvania Avenue.

Selected Readings

Barber, James David. *The Presidential Character,* 4th Edition (1992).

Clinton, Bill. *My Life.* (2004).

Cronin, Thomas E., and Michael A. Genovese. *The Paradoxes of the American Presidency* (1998).

Gergen, David. *Eyewitness to Power: The Essence of Leadership, Nixon to Clinton.* (2002).

Hess, Stephen. *Organizing the Presidency,* 2nd Edition (2003).

Thurber, James. A. ed. *Rivals for Power: Presidential-Congressional Relations,* 2nd Edition (2002).

Light, Paul C. *The President's Agenda: Domestic Policy from Kennedy through Clinton* (1999).

Neustadt, Richard E. *Presidential Power* (1991).

Woodward, Bob. *Bush at War* (2002).

Test Yourself

1) According to the U.S. Constitution, the president must be at least _____ years of age and a resident of the United States for at least _____ years.
 a) thirty; seven
 b) twenty-five; ten
 c) thirty-five; fourteen
 d) forty; twelve

2) True or false: No president has ever served more than two full terms in office.

3) According to the Twenty-fifth Amendment, if there was a conflict between the acting president and the original president, Congress would have to decide who would be president by what kind of vote within how many days?
 a) a simple majority; fourteen days
 b) three-fourths; thirty-five days
 c) three-fifths; ten days
 d) two-thirds; twenty-one days

4) True or false: The current yearly presidential salary is $400,000.

5) Who would become president if a tragic national calamity simultaneously eliminated the president, vice-president, House Speaker, and president pro tem of the Senate?
 a) the Chief Justice of the Supreme Court
 b) No one; the Constitution provides for a special presidential election if this scenario were to occur
 c) the Secretary of Defense
 d) none of the above

6) True or false: The successful passage of the NAFTA Treaty occurred during the presidency of Bill Clinton.

7) Who has the official constitutional right to declare war?
 a) Congress
 b) the president of the United States
 c) both Congress and the president
 d) a majority of the fifty state governors

8) True or false: The 1936 case of *U.S. v. Curtiss-Wright Export Corp.* simultaneously weakened presidential control over foreign policy while strengthening the congressional power to handle overseas armed conflicts.

9) Which president had 626 of 635 vetoes sustained?
 a) George W. Bush
 b) Franklin D. Roosevelt
 c) Ronald Reagan
 d) George W.H. Bush

10) True or false: The Peace Corps was implemented through an executive agreement by President John F. Kennedy.

11) The coalition of minorities principle refers to the president's
 a) role as party leader
 b) handling of his closest advisors
 c) use of the pocket veto
 d) overall popularity

12) True or false: *U.S. v. Nixon* was concerned with the issue of executive privilege.

13) Which of the following presidents is not ranked as great or near-great by most historians?
 a) Abraham Lincoln
 b) George Washington
 c) Warren G. Harding
 d) Ronald Reagan

14) True or false: The Teflon presidency refers to the presidency of Ronald Reagan.

15) According to political scientist Richard Neustadt, presidential power is fundamentally the power to _____.
 a) dictate
 b) evade
 c) persuade
 d) deceive

16) True or false: The most recent addition to the cabinet is the Department of Veterans Affairs.

17) Which of the following presidents *did not* favor the hierarchical advisor model?
 a) Richard Nixon
 b) Jimmy Carter
 c) Ronald Reagan
 d) George W. Bush

18) True or false: The vast majority of presidents have frequently used the full cabinet as an advisory body.

19) What do Samuel Berger, Frank Carlucci, Brent Scowcroft, and Zbigniew Brzezinski all have in common?
 a) They were all National Security Advisors.
 b) They were all Secretaries of State.
 c) They were all OMB Directors.
 d) none of the above

20) True or false: Bill Clinton's vice-president was Dick Cheney.

Test Yourself Answers

1) **c.** These age and residency requirements are delineated in the Constitution.

2) **False.** Franklin D. Roosevelt served three full terms in office and was elected to a fourth term. He subsequently died in April 1945.

3) **d.** The Constitution specifically stipulates the two-thirds vote and the twenty-one day time frame.

4) **True.** The president also gets $50,000 for expenses, a sum that is taxable.

5) **d.** The Chief Justice is part of the judicial branch and is, therefore, not in the line of succession to the presidency. There is no constitutional provision for a special election. The Secretary of Defense is in the line of succession, but he or she comes after the Secretary of State and the Secretary of the Treasury. The Secretary of State would become president.

6) **True.** The NAFTA Treaty was passed in 1993, during the first term of President Clinton.

7) **a.** Only Congress has the constitutional power to declare war. A president, as commander-in-chief, can send troops into an overseas conflict, but he or she has no official constitutionally assigned right to declare war. State governors have nothing to do with a war declaration.

8) **False.** The ruling established the idea that the president had exclusive power in handling international relations and foreign policy problems. It did not apply to the conduct of overseas conflicts by Congress.

9) **b.** The reason for the large number is the fact that FDR served longer than any other president. None of the other presidents is anywhere near this huge number of vetoes.

10) **False.** It was implemented through an executive order. An executive agreement involves an arrangement between the president and a foreign head of state.

11) **d.** The coalition of minorities principle means that the longer a president stays in office, the more likely he or she will offend and/or disappoint numerous groups that originally supported him or her. Hence, the president's popularity will decline, as disillusionment over presidential performance becomes more pervasive.

12) **True.** The Supreme Court ruled that while executive privilege was a proper presidential power, it could not be used by President Nixon to withhold information pertinent to a court's criminal proceedings.

13) **c.** Harding is usually ranked as a failure for indecisiveness and scandals during his administration. The other three presidential choices in the question have been ranked as great or near-great by most historians.

14) **True.** Reporters coined this phrase because even bad political news did not seem to stick to Reagan or harm his popularity with the nation, at least for a time.

15) **c.** To Neustadt, a president had to bargain with and convince others that presidential policies will be effective so that they will follow him. A president who expects a following without practicing the gift of persuasion will eventually confront ample political trouble.

16) **False.** It is the Department of Homeland Security, created in 2002. Veterans Affairs was created in 1989.

17) **b.** Carter favored the collegial model stressing equality and consensus among advisors, not the strict chain of command hierarchical structure favored by the other three presidents.

18) **False.** Just the opposite, since the overwhelming majority of presidents have preferred to rely upon their own WHO advisors or upon a kitchen cabinet consisting of a few close cabinet heads.

19) **a.** They were all National Security Council Advisors under different presidential administrations.

20) **False.** Dick Cheney was George W. Bush's vice-president. Al Gore was Clinton's vice-president.

The Bureaucracy

Nearly one out of every six Americans works for the government in the United States, at the federal, state, or local level. This chapter focuses mainly on workers who collectively comprise the federal **bureaucracy**, a term derived from the French word *bureau,* meaning "writing desk or office."

Bureaucrats, or career employees of federal agencies, perform important functions, despite a public image of being lazy, wasteful, ineffective, or inefficient. For example, bureaucrats process FHA (Federal Housing Authority) or VA (Veterans Administration) mortgages and guaranteed loans for college students, maintain national parks, levy fines on industrial polluters, and serve as federal registrars protecting the right to vote. Collectively, bureaucrats are responsible for implementing, through specific guidelines and procedures, the general policies promulgated by elected officials.

Every American citizen's life is affected innumerable times by bureaucratic rules and regulations, from the news he or she watches on TV to the vitamins/minerals contained in a breakfast cereal to the safety features found in a modern automobile to the safety of beef to the purity of water that is consumed. This chapter covers bureaucratic functions, policymaking, personnel, and reforms, in order to better understand the **fourth branch of government,** as the bureaucracy is sometimes called.

■ THE NATURE OF BUREAUCRACY

The following sections cover the characteristics of a bureaucracy and also discuss why bureaucracies are necessary for government to function, where bureaucracies are located, and how the size and various responsibilities of bureaucracies are determined.

Characteristics of Bureaucracy

A bureaucracy, a permanent, complex administrative organization, has the following organizational characteristics:

- Written procedures and rules that facilitate communication within the organization (standard operating procedures).
- Specialization and division of labor where individuals, hired on merit and promoted on displayed skills and abilities, work on specific tasks or jobs for which they have trained.
- A hierarchical, fixed chain of command where superiors give orders to subordinates.
- Impersonality, whereby standard rules are followed and all clients are in theory treated alike.

The Need for Bureaucracies

The need for a large bureaucracy stems from a number of factors. A president cannot hope to enforce and implement multiple public policies without extensive bureaucratic assistance. Second, the broad policy directives of congressional legislation must be followed by specific bureaucratic rules and regulations that will give that law operational meaning. Third, the diversity of the American population and the ongoing technological and economic development of the nation have contributed to the need for increased regulation. Fourth, social welfare, social justice, consumer safety (for example, creation of the Consumer Product Safety Commission), and national defense and security concerns also have expanded the bureaucracy. For example, the fear of another terrorist attack upon U.S. soil after 9/11 eventually led to Congress authorizing the Department of Homeland Security in 2002, combining twenty-two government agencies and incorporating close to 150,000 government personnel.

Location and Variable Size of Bureaucracies

Federal bureaucrats administer more than 1,000 different domestic and foreign programs. These bureaucrats are found in every city and state and nearly every country in the world.

Excluding the military, there were 2.7 million federal employees in 2005. Only one in five federal employees work in Washington, D.C.; the rest are dispersed throughout the nation. For example, the Treasury Department's Internal Revenue Service is located in Washington, D.C., but most of the IRS tax work is carried out through regional, district, and local offices. Another obvious example is the U.S. Postal Service, with branches throughout the nation. Government workers, at all three levels of government, constitute fifteen percent of the nation's civilian labor force. Please note that the greatest expansion of government employees has been at the state and local levels, not the federal.

The largest federal bureaucracy is the Department of Defense, or DOD. The DOD employs over 670,000 civilians in addition to its members of the armed forces (1.4 million in uniform). The Department of Veterans Affairs and the State Department have 230,000 and 25,000 total employees, respectively. Currently, the Department of Education is the smallest cabinet department with slightly less than 5,000 employees, because education remains primarily a state and local function. Bureaucratic growth in other federal agencies or departments is linked to regulating and managing a complex American economy, overseeing the environment, assuring the quality or safety of consumer goods, and fostering scientific and technological research.

Bureaucratic Responsibilities

Bureaucratic responsibilities include providing political continuity, execution, and implementation of decisions made by superiors (that is, converting a policy decision into a program of action, then carrying

it out), and providing specialized information about problems and policy proposals to Congress and other units of the executive branch.

Bureaucracies ideally separate politics from policy administration. Bureaucrats are obligated to interpret and apply the laws passed by Congress. Indeed, Congress passes **enabling legislation** when there is need for a new bureaucratic agency, delineating its powers, mission, and internal structure. Once the agency is created, it is responsible for implementing all relevant legislation.

For example, Congress may pass a Clean Air Act that mandates that major metropolitan areas in the nation comply with clean air standards, as developed and enforced by the Environmental Protection Agency (EPA). The EPA will subsequently hold hearings on these proposed standards, listen to arguments by those parties opposed to or in favor of these regulations, and then finally issue directives along with penalties for noncompliance (note that agency rulings can be appealed to the federal courts and possibly overturned).

But the primary function of the bureaucracy is to assure continuity in government. Presidents come and go, Congress changes, but the bureaucracy is virtually immortal (President Ronald Reagan once stated that the closest thing to eternal life on earth was a government bureau). The bureaucracy is the permanent government, in that although there is job turnover (the top politically-appointed administrators change with different presidential eras, but the lower-level functionaries largely remain), the responsibilities and duties inherent in a bureaucratic position are relatively clear and stable. New employees perform specified duties much as their predecessors did.

■ THE CIVIL SERVICE

There are two types of federal bureaucrats—**political appointees** and **career civil servants.** The president appoints the former (roughly 2,500 top-level appointments, including cabinet secretaries, ambassadors, and heads of independent agencies; these may be found in the **Plum Book,** a listing of civil service leadership and support positions). The remaining bureaucrats belong to the **civil service** and acquire their jobs through a formal, competitive process.

History of the Civil Service

In 1789, there were no career bureaucrats. George Washington and his successor, John Adams, argued that qualified people from the aristocratic, wealthier, and educated classes should handle key administrative positions. Both men also preferred that members of their own party, the Federalists, fill federal posts. Similarly, when Jefferson became president, he removed more than one hundred officials and replaced them with his own Democratic-Republican party followers.

The Spoils System of Andrew Jackson

President Jackson's election in 1828 ushered in an even stronger reaffirmation of the **spoils system** begun by Jefferson ("to the victor belong the spoils"). Jackson dismissed some 200 presidential appointees and close to 2,000 other federal bureaucrats, regardless of their actual abilities or merit, replacing them with loyal members of his Democratic party. Jackson argued that the common man was capable of holding public office and that the party in power should control the bureaucracy. In addition, Jackson was the first president to reorganize the federal bureaucracy on a comprehensive scale.

The Pendleton or Civil Service Reform Act of 1883

Jackson's spoils system eventually led to a bloated, corrupt federal bureaucracy. Reformers urged the creation of a professional civil service based on expertise, not political cronyism. In 1883, two years after President James Garfield was assassinated by Charles Guiteau, a disappointed office seeker, the new president, Chester A. Arthur, led the fight for civil service reform. The **Pendleton Act** made merit the basis for hiring personnel in the federal work force through competitive examinations. A bipartisan Civil Service Commission was formed to administer the exams and establish general hiring policies. Eventually, some ninety percent of the federal work force would be covered by the merit system. Note that this reform eventually weakened the influence of political party officials, because they had less patronage to dispense.

Civil Service Reforms under President Carter

Under President Carter, the Civil Service Reform Act of 1978 replaced the Civil Service Commission with the Office of Personnel Management (OPM) and the Merit Systems Protection Board (MSPB). The OPM duties included enforcing civil service laws, testing applicants, setting pay scales, and appointing personnel.

In order to obtain a civil service job, applicants are required to take a test that demonstrates their competence for the position. The OPM then sends the names of the three top choices to the appropriate agency. Usually, under this rule of three, one contender will be appointed. The MSPB hears complaints from federal employees who claim job discrimination or other mistreatment at work.

The 1978 act also created the **Senior Executive Service (SES),** which at that time consisted of 8,500 high-level administrators and managers (today the number is around 7,000). The objective of the SES was to reward superior performance with substantial cash bonuses. However, SES members can be transferred or dismissed more easily than other civil servants.

Civil Service Job Advantages and Occupations

Job security, along with generous fringe benefits, is a key attraction of a federal civil service job, including liberal pensions upon retirement. Typically diverse federal jobs include white-collar managers, secretaries, clerks, mail carriers, engineers, scientists, doctors, telephone operators, veterinarians, aircraft workers, and plumbers. There are estimated to be more than 20,000 personnel skills in the federal bureaucracy.

The Hatch Act and the Federal Employees Political Activities Act

In the past, a disadvantage for federal employees was the legal limitation placed upon their political rights, which other Americans were free to exercise. The 1939 **Hatch Act** prohibited them from actively campaigning for candidates or assuming leadership roles in a political party. The idea behind this law was to create a politically neutral bureaucracy and to protect employees from political harassment by the party in power. All of this was changed by the 1993 Federal Employees Political Activities Act, which amended the Hatch Act. The new legislation allowed federal employees to run for nonpartisan political offices, work on voter registration drives, participate in a candidate's partisan campaign, contribute money to political parties or a candidate, and even hold an office in a political party. Federal employees are still barred from political activity while on the job or on federal property, including soliciting campaign contributions from other federal employees or the public. A federal employee also is forbidden from using his or her government position to affect an election outcome.

Federal Employee Unions

A minority of all **federal** employees belong to **unions** such as the American Federation of Government Employees, the National Association of Government Employees, or the National Federation of Federal Employees. But these groups are not permitted to strike. For example, when federal air traffic controllers went on strike during the 1980s, President Reagan fired all of them. Consequently, federal employees must confine their union activities to improving working conditions and representing civil servants at grievance or disciplinary hearings.

Bureaucratic Pay

Congress regulates the salary and job conditions for federal workers. At the lower and middle grades, civil service pay is equivalent to salaries paid to workers in private firms. Ironically, higher-level salaries are often lower than salaries for comparable positions in private firms. The Civil Service General Schedule contains job grades ranging from GS 1 to GS 18 (the higher the grade, the better the salary). GS 16 to GS 18 grades are applicable only to presidential appointees.

Bureaucrats' Backgrounds

Typically, bureaucratic executives have come from a middle-class background and are male, college-educated, and white. Women, blacks, and Hispanics are underrepresented at the higher levels of civil service management, but this situation is slowly improving. However, in general, federal employees are broadly representative of the American population in terms of social class, religious affiliation, and educational level.

■ ORGANIZATION OF THE FEDERAL BUREAUCRACY

The following sections discuss confusing bureaucratic names (note the distinction between staff and line agencies), bureaucratic divisions, and the fifteen cabinet departments. Discussions of independent executive agencies (NASA), independent regulatory agencies (FDA), and government corporations (FDIC) are also included.

Confusing Bureaucratic Names

Federal bureaucracies operate under a variety of labels that can be both contradictory and confusing. The term **department** is reserved for agencies of cabinet rank. **Agency** often refers to a major unit headed by a single administrator of near-cabinet status, such as the Environmental Protection Agency. But the title **administration** also can have the same connotation: the National Aeronautics and Space Administration or the Veterans Administration. **Commission** usually applies to those agencies that regulate business activities (Securities and Exchange Commission). **Corporation** or **authority** may apply to agencies headed by boards that conduct businesslike activities, such as the Tennessee Valley Authority.

Smaller units within a larger bureaucracy also can reflect inconsistency and confusion. **Bureau** is the name assigned to the major elements in a department, but **service, administration, office, branch,** and **division** can be used as well. Major units within the Treasury Department include the Internal Revenue Service, the Bureau of the Mint, and the Office of the Comptroller of the Currency.

Staff or Line Agencies

Any federal bureaucratic group can be classified as either staff or line agencies. **Staff agencies** are support organizations whose personnel advise administrators and assist in the management and budgeting of the organization (agencies in the Executive Office of the President). **Line agencies** administer those policy goals relating to the central mission of the organization. **Line units,** such as the cabinet departments Defense and Treasury, have direct accountability to the president. Employees within an agency may perform staff or line functions as well.

The Main Divisions of a Bureaucracy

The executive bureaucracy consists of the fifteen cabinet departments and their subdivisions, the independent agencies, government corporations, and the independent regulatory commissions.

Cabinet Departments

The fifteen cabinet departments (see Table 8.1) are the major service units of the federal government, employing a majority of all federal employees. They are line organizations accountable to the president. Each cabinet head, or **secretary,** is appointed by the president with the consent of the Senate. All departments are subdivided into small units, usually called bureaus or agencies, which, in turn, have their own budget and staff. Bureaus are usually divided on the basis of function, such as the Bureau of the Census in the Commerce Department, or by clientele, such as the Bureau of Indian Affairs in the Department of the Interior.

Table 8.1 Cabinet Departments in 2005

Cabinet Department	Basic Functions	Some Representative Agencies
State	Concerned with the nation's foreign policy	Foreign Service, Office of Passport Service
Treasury	Mints money; collects taxes; manages public debt	Internal Revenue Service; U.S. Mint; Bureau of the Public Debt
Defense	Concern with national security and nation's military forces	Army, Navy, and Air Force Departments
Justice	Enforces and prosecutes federal laws; gives legal information to president when necessary	FBI, Civil Rights Division; Drug Enforcement Administration; Bureau of Alcohol, Tobacco, Firearms and Explosives
Interior	Protects national parks and wildlife; handles problems of Native Americans	U.S. Fish and Wildlife Service; Bureau of Land Management; National Park Service; Bureau of Indian Affairs
Agriculture	Helps farmers; inspects food; manages national forests; administers food stamps	Food Safety and Inspection Service; Forest Service; Agricultural Research Service
Commerce	Handles census; gives out patents; supports international trade and economic expansion	Census Bureau; Patent and Trademark Office; NOAA (weather)

(table continued on next page)

Table 8.1 Cabinet Departments in 2005 (continued)

Cabinet Department	Basic Functions	Some Representative Agencies
Labor	Concerned with minimum wage, good working conditions, and job training	Occupational Safety and Health Administration; Bureau of Labor Statistics; Employment Standards Administration
Health and Human Services	Conducts health care research; works on disease prevention; enforces food and drug laws; handles Medicare and Medicare programs	Food and Drug Administration; National Institute of Health; Centers for Disease Control and Prevention
Housing and Urban Development	Programs covering mortgages, public housing, and fair housing laws	Office of Housing; Government National Mortgage Association
Transportation	Regulates highways, air travel, mass transit systems, and oil and gas pipelines	Federal Highway Administration; Federal Aviation Administration; Federal Railroad Administration
Energy	Involved with all forms of energy production: renewable fossil, nuclear, and hydro-electric; conducts research on nuclear weapons	Office of Energy Efficiency and Renewable Energy; Office of Civilian Radioactive Waste Management
Education	Concerned with educational research and governmental aid to schools	Office of Elementary and Secondary Education; Office of Educational Research and Improvement
Veterans Affairs	Handles benefits, health care, and pensions for military veterans; looks after military cemeteries	Veterans Benefits Administration; Veterans Health Administration
Homeland Security	Security for borders and to prevent attacks from chemical, biological, or nuclear agents; provides airline security; conducts intelligence analysis; assesses terrorist threat levels	Secret Service; Coast Guard; Bureau of Citizenship and Immigration Services; Transportation Security Administration

Independent Executive Agencies (IEAs)

These agencies are organizations with a single main function. Many of these agencies have thousands of employees and multi-billion-dollar budgets. NASA, the CIA, and the EPA are three examples. Like cabinet departments, they are headed by one administrator, but they do not have cabinet status. Smaller, but no less important examples include the Civil Rights Commission, the General Services Administration (oversees federal spending projects and property), the Federal Election Commission, and the Small Business Administration. There are dozens of other IEAs that the public rarely hears about, such as the Migratory Bird Conservation Commission and the American Battle Monuments Commission.

Independent Regulatory Commissions (IRCs)

In 1887, Congress created the first independent regulatory commission, the Interstate Commerce Commission, whose original purpose was to regulate the railroads (it was replaced by the Surface Transportation Board in 1995). Subsequently, new commissions were established to supervise other areas of American economic life. For example, the Federal Trade Commission (FTC) tries to protect consumers from false advertising while enforcing antitrust laws. The Federal Communications Commission (FCC) licenses and regulates TV and radio broadcasting. The Securities and Exchange Commission (SEC) guards against fraud in the buying and selling of stocks and bonds. The Nuclear Regulatory Commission oversees the nation's 103 nuclear power plants for safety and operating efficiency and the civilian use of nuclear materials.

Congress had two reasons for establishing the IRCs. The first was to prevent undue political pressures from interfering with their regulatory assignments. Consequently, IRCs have boards of five to seven members appointed by the president, with Senate approval being necessary. However, commissioners, who serve fixed terms, ranging from five to fourteen years (the length depends upon the particular IRC in question), cannot be fired by the president. Also, Congress has required that these boards not be dominated by one political party.

The second reason for creating IRCs was that these organizations could provide closer regulation on a day-to-day basis than was possible by Congress. For example, the Food and Drug Administration (FDA) has the staff and expertise to test new drugs for possible health risks. Congress has neither the time nor the expertise to perform this function. Accordingly, these agencies exercise legislative powers when they develop rules and regulations that are equivalent to laws. IRCs fill in the missing details of congressional law. IRCs also exercise judicial powers when they handle arguments over regulations. They would hold hearings, much like a congressional committee, and then decide the issue.

Government Corporations (GCs)

Government corporations (GCs) combine characteristics of private business firms and federal agencies. However, government corporations differ from private corporations in that Congress decides a GC's purpose, and its personnel are public employees. Also, unlike a private corporation, there are no stockholders, dividends (profits are plowed back into the GC), or private financing by investors. Three examples are the Tennessee Valley Authority (TVA), the Federal Deposit Insurance Corporation (FDIC), and the Export-Import Bank (EIB). The TVA generates electricity and develops flood-control policies; the FDIC protects the savings of bank depositors; and the EIB makes loans to assist the export and sale of American products. Other examples include the U.S. Postal Service and Amtrak.

GCs are appropriate when the federal government wishes to provide a public service free from executive or legislative interference and provide a service not easily found in the private sector. Today, each government corporation has a board of directors whose members are appointed by the president and approved by the Senate. GC operations are financed by congressional appropriations and sometimes by its own practices (for example, TVA sells electric power to its customers).

■ BUREAUCRACY'S INTERACTION WITH THE PRESIDENT, CONGRESS, AND THE PUBLIC

The following sections explain how the bureaucracy interacts with the other branches of government. Also, the importance of iron triangles and issue networks is discussed.

Bureaucracy and the President

President Truman once told NBC correspondent David Brinkley that he experienced great difficulties in controlling the bureaucracy. Kennedy once complained how difficult it was getting things done through the bureaucracy. Nixon bypassed the State Department bureaucracy by sending his secretary of state, Henry Kissinger, to talk directly to Chinese leaders. Nixon even tried to set up his own counter-bureaucracy within the White House. Other presidents have encountered similar frustrations with the bureaucracy.

Presidents also have tried to reorganize/reform the bureaucracy, but with little success. President Nixon wanted to eliminate the Departments of Health, Education, and Welfare; Housing and Urban Development; Labor; Commerce; Transportation; and Agriculture, replacing them with broad-based departments—like Natural Resources and Human Resources. President Reagan came to office promising the abolition of the Energy and Education departments, but failed to do so; instead, actually adding a new Department of Veterans Affairs. George H.W. Bush, Bill Clinton (he instituted the National Performance Review), and George W. Bush all made similar efforts. In short, reorganization and reform is threatening to established political interests, and is, consequently, resisted.

Bureaucracy and Congress

Congress passes laws that the bureaucracy must implement. It also controls the budget of an agency. However, Congress cannot always impose its will on a nonresponsive bureaucracy. For example, in 1978, Congress included a provision in the Airline Deregulation Act of 1978 to protect jobs of fired airline pilots and grant them additional unemployment wages. The Labor Department was supposed to write the regulations necessary to carry out this congressional order. But, by 1984, more than 5,000 pilots had lost their jobs and no regulations had been written. Opposition from the airlines (they wanted to hire new pilots with lower salaries) and the Reagan administration's objection to new regulations benefiting labor unions contributed to the delay. Bureaucracies are sometimes paralyzed due to outside political pressures and strong interest groups.

Budgets and the Bureaucracy

Bureaus that maintain close contact with congressional committees or that can appeal to a special-interest or clientele group can achieve their budgetary goals. For example, an agency responsible for government-guaranteed mortgages can appeal to realtors and construction firms to ask Congress for a funding increase.

Iron Triangles and Issue Networks

Iron triangles consist of heads of bureaucratic agencies, members of congressional committees that have an interest in those agencies, and lobbyists for pressure groups. An example of this structured and relatively unified arrangement would be farm lobbyists, the Agriculture Department, and the congressional

agriculture committees and subcommittees. This political alliance of common interests can help a bureaucratic agency resist presidential calls for cuts in its budget or demands that it be abolished. A comparable alliance would be the Department of Veterans Affairs, congressional committees dealing with veterans' issues, and related interest groups such as the Veterans of Foreign Wars and the American Legion.

Similarly, the more extensive (and newer) concept of **issue networks** refers to experts and policy specialists temporarily united by common concerns over a particular policy. Those experts, which can be drawn from the media, universities, think tanks, scientific research institutes, executive agencies, Congress, and so on, are part of a broader network that is usually more loosely-structured and impermanent than an institutionally entrenched iron triangle. Note also that this network or web can consist of multiple, conflicting interests due to the complexity of the issue. An example would be the issue of oil drilling in Alaska's ANWR (Arctic National Wildlife Refuge) that occurred in George W. Bush's second term, when energy companies, environmentalists, political activists, media commentators, consultants, the Departments of Energy and Interior, Congress, and concerned segments of the public all debated the issue of energy production versus protection of a pristine environment.

Bureaucracy and the Public

Public complaints about the bureaucracy frequently involve the cost in time and money of filling out endless forms, the existence of too many unnecessary regulations, and irritating delays in bureaucratic performance (typically, late mail delivery or not receiving income-tax refunds or Social Security checks). However, opinion surveys indicate that about two-thirds of the citizenry are generally satisfied with the performance of individual bureaucrats. Most individuals who have personal contact with bureaucrats do not consider them to be personally rude or antagonistic. But the public does view bureaucrats, as a group, as being paid too much for doing too little.

■ BUREAUCRATIC CRITICISMS AND REFORMS

Bureaucracies are often perceived by the public and critics as being organizations that impede both progress and appropriate public policies. Consequently, reforming bureaucracies is a recurrent theme of American politics.

What Are the Main Criticisms of the Bureaucracy?

Various criticisms are directed at bureaucratic organizations. They include red tape, inflexible rules of operation, the difficulty of firing bureaucrats, the costs of coordination, turf battles, contradictory policies, and wasteful duplication.

Red Tape

Red tape refers to complicated rules or procedures that must be obeyed if the bureaucratic work is to be accomplished. Red tape also can mean bureaucratic delay or confusion and excessive paperwork. The term derives from the English practice of binding legal and government documents in England with a red-colored tape.

Inflexible Rules and Hard-to-Fire Bureaucrats

Bureaucratic rules are designed to handle routine cases in a standard way. These rules are not designed to handle cases that represent exceptions to those rules. Similarly, complex and time-consuming rules make it very difficult to fire incompetent civil servants. The federal worker can appeal the dismissal, and that appeal can take years. Some agencies do not even try, assigning menial tasks to ineffective workers rather than going through the time-consuming process.

Costs of Coordination

Issues that are complex may require coordination among diverse bureaucracies. Thus, when a new interstate highway is constructed, the Department of Transportation may have to consult with the EPA regarding increased air pollution from auto exhausts. Construction will invariably be delayed and project costs will increase. Therefore, it is difficult to accelerate bureaucratic performance. Senator Dale Bumpers of Arkansas once described the federal bureaucracy as a "700-pound marshmallow that can be kicked, screamed, or cussed at, but it is very reluctant to move."

Turf Battles

Bureaucratic departments and agencies compete over which one has the responsibility for implementing certain policies. Thus, the State Department and the Defense Department may struggle over how to resolve a foreign policy crisis—whether to favor diplomacy or the use of force. It is inevitable that bureaucracies will see problems from their own perspective or vision of the world.

In addition, not all government programs fall within the clear domain of one bureau. A new weapons system, be it a fighter or missile program, may be claimed by the Army, Navy, and Air Force. Competition is expensive and can lead to unnecessary duplication. But when the Department of Defense has tried to encourage more coordination and standardization, the three services have fought the idea.

Contradictory Policies

Government agencies frequently work at cross purposes. The Department of Agriculture may give subsidies to tobacco farmers, but the Department of Health and Human Services will encourage the public not to smoke. Similarly, the Department of Agriculture teaches farmers how to increase crop yields, but it also pays farmers to produce fewer crops.

Wasteful Duplication

Two or more government agencies often perform the same function. For example, both the Customs Service and the Drug Enforcement Agency seek to prevent drugs from being brought into the country.

Bureaucratic Reforms

A variety of bureaucratic reforms is discussed in the following sections: privatization, sunset laws, the ombudsman, and whistle-blowers. In addition, recent laws that have tried to implement bureaucratic reforms also are considered.

Privatization

Governments have contracted with private firms to furnish public services. Although the federal government has tried **privatization** to a limited degree, privatization is far more common at the state and local governmental levels (trash collection, recreation facilities, fire protection are examples). The idea behind privatization is that necessary public services can be more cheaply and effectively implemented than relying on government. However, private firms can become bureaucratized as well, if their service market is extensive and complicated. Also, critics have charged that private companies are less sensitive to the hiring of minorities than government agencies and may not really save money if they have a monopoly on a particular service obligation. Note that private companies, even when performing public activities, are still paid and supervised by government officials.

Sunset Laws

A **sunset law** requires that bureaucracies be re-evaluated periodically in terms of their worth, relevance, or effectiveness. If found wanting, the agency is abolished or reorganized. Most states have sunset laws, but there is none at the federal level. Studies reveal that many more federal bureaucratic agencies are created than are ever eliminated.

Ombudsman

Originally founded in Sweden, an **ombudsman** is a citizen advocate who would receive complaints about bureaucratic performance and possibly take steps to resolve those problems. States and cities do have ombudsmen, and a federal law mandates that all states have ombudsman programs to monitor nursing homes that receive Medicare or Medicaid funding.

Whistle-Blowers

Individuals who report corruption or waste in a federal bureaucracy are called **whistle-blowers**. A classic case of a whistle-blower was A. Ernest Fitzgerald, a financial analyst in the Pentagon who revealed a two billion dollar cost overrun for the Lockheed C5A cargo plane in 1970. Both the defense contractor and the Air Force had tried to conceal the overrun. Fitzgerald, who lost his job, was eventually reinstated, although at a lesser position.

Although there have been other whistle-blowers since Fitzgerald, the risks of retaliation from the federal employer do remain. To help alleviate those risks, the 1989 Whistle-Blowers Protection Act established the Office of Special Counsel, an independent agency that was given the power to investigate charges of agency retaliation against a whistle-blower.

Reagan's Grace Commission and Other Recent Anti-Waste Reforms

In 1984, the Reagan-appointed Grace Commission concluded that bureaucratic streamlining could save more than four hundred billion dollars in only three years. The commission recommended reducing federal employees' fringe and pension benefits, adopting efficient accounting procedures, abolishing unnecessary jobs, and eliminating waste and mismanagement in virtually every government bureaucracy. The commission was heavily criticized by Congress and bureaucrats alike, and relatively few of its proposals were actually implemented.

In recent years, additional legislation has tried to make the bureaucracy perform better while increasing overall efficiency. The 1997 Government Performance and Results Act mandated that every agency (excluding the CIA) delineate its goals and methods of evaluating whether those goals were attained. The 1998 Government Paperwork Elimination Act urged agencies to use electronic communications (e-mails) as much as possible in order to cut spending on excessive paper use. Under President George W. Bush's performance-based budgeting system, funding for federal agencies was linked to real performance. The OMB gave each agency a grade; a failing grade meant the agency's budget would be cut (whether major or even any cuts would actually occur remained an open question).

Bureaucracies are essential government structures designed to implement the laws and policies of the Congress and the president. The executive bureaucracy consists of the fifteen cabinet departments and their subdivisions, the independent agencies, government corporations, and the independent regulatory commissions.

Today, federal employees are hired under a merit system, as opposed to the spoils system of the past. Civil servants have good job security and decent salaries, although in some cases, private-sector compensation may be better. Bureaucrats are broadly representative of the American population.

Finally, while there is a pervasive stereotype of the bureaucrat as an ineffective, lazy, and slow worker, the work of federal employees does involve essential citizen services and important regulatory activities.

Most of the major criticisms of bureaucracies still refer to red tape, inflexible rules, coordination costs, turf battles, contradictory policies, and wasteful duplication. Bureaucratic reforms—privatization, sunset laws, the ombudsman, performance-based budgeting and whistle-blowers—represent attempts to improve efficiency and cut waste, even though they are always resisted by entrenched interests.

Selected Readings

Behn, Robert D. *Rethinking Democratic Accountability* (2001).

Goodsell, Charles T. *The Case for Bureaucracy,* 2nd Edition (1985).

Light, Paul C. *Government's Greatest Achievements, From Civil Rights to Homeland Security* (2002).

Riley, Dennis D. *Controlling the Federal Bureaucracy* (1987).

Wilson, James Q. *What Government Agencies Do and Why They Do It* (2000).

Test Yourself

1) Which of the following is a characteristic of a bureaucracy?
 a) standard operating rules of procedure
 b) a hierarchical fixed chain of command
 c) specialization and division of labor
 d) all of the above

2) True or false: The vast majority of federal government employees work in Washington, D.C.

3) The largest federal bureaucracy in terms of total personnel is the Department of
 a) State
 b) Defense
 c) Homeland Security
 d) Education

4) True or false: The greatest expansion of government workers has occurred at the federal level rather than at the state and local levels of government.

5) In which year was the merit-oriented civil service system established?
 a) 1789
 b) 1828
 c) 1883
 d) 1978

6) True or false: Under current federal law, federal employees may not participate in political party affairs or political campaigns.

7) Which of the following is an example of an independent executive agency?
 a) NASA
 b) the FCC
 c) the TVA
 d) none of the above

8) True or false: One of the advantages of obtaining a federal job is job security.

9) Which independent regulatory commission tries to protect consumers from false advertising while enforcing the antitrust laws?
 a) ICC
 b) FDIC
 c) EPA
 d) FTC

10) True or false: The Department of State is a line agency.

11) The Occupational Safety and Health Administration is located in which cabinet department?
 a) Health and Human Services
 b) Commerce
 c) Interior
 d) none of the above

12) True or false: Issue networks are less unified and more impermanent than iron triangles.

13) The cabinet department most concerned with protecting national parks and wildlife is the Department of
 a) Agriculture
 b) the Interior
 c) Defense
 d) Energy

14) True or false: Government agencies frequently work at cross purposes.

15) The president who became identified with the spoils system in 1828 was
 a) Monroe
 b) Madison
 c) Lincoln
 d) Jackson

16) True or false: The Securities and Exchange Commission is an independent regulatory commission that handles the buying and selling of stocks and bonds.

17) Which of the following presidents tried to reorganize or reform the bureaucracy during his time in office?
 a) George W. Bush
 b) Richard Nixon
 c) Ronald Reagan
 d) all of the above

18) True or false: Surprisingly, the federal government has been more active in privatizing public services than have the state and local governments.

19) Which of the following bureaucratic agencies is designed to help whistle-blowers?
 a) the OMB
 b) Office of Special Counsel
 c) the Federal Ombudsman Office
 d) none of the above

20) True or false: Performance-based budgeting is a bureaucratic reform most closely associated with President Ronald Reagan and the Grace Commission.

Test Yourself Answers

1) **d**. All three choices represent characteristics of a standard bureaucracy.

2) **False.** Only about one in five federal government employees works in Washington, D.C.

3) **b.** The Department of Defense has a grand total of well over two million personnel, including both civilians and individuals in uniform. The other three are nowhere near that total number.

4) **False.** The greatest expansion has occurred at the state and local levels.

5) **c.** The Pendleton Act, establishing merit as the basis for hiring personnel, was passed by Congress in 1883. The dates 1789 and 1828 refer to civil service systems that were based on the spoils system. The date 1978 refers to Jimmy Carter's internal restructuring of Civil Service, but he did not tamper with the merit basis of the system.

6) **False.** The 1993 Federal Employees Political Activities Act modified the 1939 Hatch Act, allowing federal employees to hold an office in a political party and work on political campaigns.

7) **a.** The FCC is an independent regulatory commission, and the TVA is a government corporation.

8) **True.** Job security is a definite plus, because it is extremely difficult to fire a federal worker, even if he or she is incompetent. The employee can appeal the dismissal, and that appeal can take years. Some agencies do not even try, but rather assign menial tasks to incompetent workers rather than going through the time-consuming dismissal process.

9) **d.** The Federal Trade Commission is correct. The ICC originally stood for the Interstate Commerce Commission and handled the regulation of railroads. The FDIC insures an individual's savings account. The EPA is the environmental protection agency.

10) **True.** It is directly accountable to the president regarding policy goals; that is, it is on the line.

11) **d.** The Occupational Safety and Health Administration is located in the Department of Labor.

12) **True.** Issue networks are more complex, diverse, and transitory than iron triangles. The latter is a relatively fixed, mutually supportive, and entrenched structure consisting of key congressmen, congressional committees, bureaucratic agencies, and interest groups.

13) **b.** Interior is the department with this responsibility.

14) **True**. An example is the Department of Agriculture giving subsidies to tobacco farmers, while the Department of Health and Human Services encourages the public not to smoke.

15) **d.** Jackson is the correct choice. None of the other presidents was associated as closely with the spoils system.

16) **True.** The SEC has this responsibility.

17) **d**. All presidents have tried either to reform or reorganize the federal bureaucracy.

18) **False.** Just the opposite, because state and local governments have been far more active in farming out public services to private firms in such areas as trash collection and fire protection.

19) **b.** The Office of Management and Budget (OMB) does not assist whistle-blowers. The Federal Ombudsman Office does not exist. The Office of Special Counsel is an independent agency designed to investigate charges of agency retaliation against a whistle-blower.

20) **False.** Performance-based budgeting is a bureaucratic reform associated with President George W. Bush. Ronald Reagan's Grace Commission was concerned with curbing bureaucratic waste, but most of its final recommendations were not implemented.

The Judicial System

The national government had no court system under the Articles of Confederation. This weakness was remedied by Article III of the Constitution, which specifically provided for one court—the Supreme Court—and authorized Congress to create other inferior courts or tribunals, as deemed necessary.

The American judicial system is probably the most powerful in the world. The basis of that power rests with the fact that American courts interpret the law, with the Supreme Court being the final interpreter of the Constitution. Since 1803 (*Marbury v. Madison*), the Court has exercised the power of **judicial review,** the power to declare an act of Congress unconstitutional.

■ THE NATURE OF AMERICAN LAW

The judicial system is an adversarial one in which the courts allow two parties to bring their conflict to court before a judge so that the truth may emerge out of that conflict. In theory, justice is the product of the struggle between these two contending viewpoints.

Federal judges must deal with real cases, not hypothetical ones, and the courts do not render advisory opinions. All disputes must be **justiciable,** meaning that conflicts must be resolved by strictly legal methods. For example, a case would not go to court that involved the question of whether Congress should be abolished. This would be a political question, not a judicial one, and, thus, a concern for the other branches of government.

The Types of Law

In a democracy, the law both protects and restrains the citizenry. Law may be defined as the principles, rules, and regulations affecting human behavior as established and enforced by government. The six basic types of law are common law, equity, statutory law, constitutional law, case law and administrative law.

Common Law

Common law is often termed **judge-made law**, those rules that have been created by judges through their decisions in numerous cases. Common law was derived from twelfth-century England, where judges traveled around the country and rendered decisions designed to remedy wrongs done to individuals. The colonists brought the body of common law to America. Today, every state in the union bases its judicial procedures on English common law, except Louisiana, which uses French or Napoleonic Law as the core of its legal system.

The basic principle of common law is *stare decisis,* a term from the Latin meaning "let the decision stand" or "to stand on decided cases." Judges are obligated to apply **precedents** (previous court rulings) to future cases that involve similar situations. Precedents can be overturned by newer ones. A clear example was the 1954 Supreme Court decision of *Brown v. Board of Education of Topeka,* which obviated the constitutionality of the separate but equal doctrine established via the 1896 ruling, *Plessy v. Ferguson.*

Equity

Equity law permits judges to issue orders preventing possible damage or to direct that some action be taken. Equity is used when simply waiting until a law is violated further would not be wise. For example, assume that a paper factory is polluting a nearby lake by illegally dumping toxic wastes into the water. A judge can issue an injunction or a cease-and-desist order, mandating that the factory's owners stop their unlawful actions.

Statutory Law

At the federal level, **statutory law** is the legislation passed by Congress. State legislatures and city councils also can create statutory law. The public can do so through the initiative and referendum. A local law may not violate a state constitution. Likewise, a state law may not run counter to the U.S. Constitution.

Constitutional Law and Case Law

Constitutional law involves the interpretation and application of the U.S. Constitution, most notably by the Supreme Court, but also by other federal and state courts as well. It also applies to the fifty state constitutions. The U.S. Constitution contains about 6,000 words, with many of its clauses stated in general terms. The precise meaning of constitutional provisions is left to the courts to interpret. Case law generally refers to the collective judicial decisions of the courts and their inherent legal meanings, which ultimately affect common law and statutes.

Administrative Law

This body of law refers to those rules and regulations that are issued by federal bureaucratic agencies, such as the EPA, IRS, or FDA (state regulatory bodies also comprise this category). For example, in August 2005, the Food and Drug Administration (FDA) issued strict new regulations pertaining to the acne drug Accutane, noting that Accutane contributed to severe birth defects and even caused some patients to become suicidal. The FDA mandated a restricted distribution plan for the drug, involving registration of both doctors and patients in an electronic database prior to dispensing of the drug.

Two Broad Classifications: Civil Law and Criminal Law

Two broader classifications of the law are civil law and criminal law. **Civil law** is concerned with disputes between two private parties, such as divorce. A civil case can involve an individual's lawsuit against the government, as when an individual is unlawfully injured by an agent of the government. Typically, if the individual being sued is found negligent, monetary damages may have to be paid to the plaintiff.

Criminal law involves crimes against society, such as murder or armed robbery. Because the government is the enforcer of criminal law, it is the **plaintiff** (the party that brings the case to court) in all criminal trials; the party accused of the crime is termed the **defendant.** Criminal law violations range from misdemeanors (trespassing) to felonies such as bank robbery and kidnapping. The **state** prosecutes the accused individual in criminal cases, where the burden of proof is greater than with civil cases. If convicted, the penalty can be a serious fine, imprisonment, or execution. Note that the vast majority of all civil and criminal cases involve state laws and, hence, are tried in state courts.

■ THE PARTICIPANTS IN THE JUDICIAL SYSTEM

There are several important participants in the American judicial system. They include litigants (plaintiffs and defendants), interest groups (note the term *amicus curiae*), lawyers, and judges.

Litigants

Litigants include both the plaintiff and defendant. Litigants are in court for a number of reasons—typically to right a perceived wrong, change the existing law, sue for damages, or challenge actions of government and corporations. Litigants must have **standing to sue**—that is, litigants must have a sincere interest in the case and be in danger of suffering an injury or harm from another party, private or public. Standing to sue has been broadened in recent years by **class-action suits,** whereby a small group of people can sue so as to represent other people in similar situations. Class-action suits are typically employed in environmental, civil rights, or personal injury cases. Representative class-action suits have involved women who sustained injuries stemming from use of the Dalkon shield, workers becoming ill from prolonged exposure to asbestos insulation, and drivers suffering accidents caused by unsafe automobiles.

Interest Groups

Interest groups understand the power of the courts to make public policy, so they seek out litigants who have strong cases. For example, the NAACP (National Association for the Advancement of Colored People) chose Linda Brown, a young schoolgirl in Topeka, Kansas, as the plaintiff who would challenge school segregation in 1954. The ACLU (American Civil Liberties Union) is another interest group that chooses cases according to its stated mission of preserving individual freedoms. Interest groups also file *amicus curiae* or friend of the court briefs to help one side or the other in court (these briefs can only be filed if the court in question requests or allows the submission of these documents).

Lawyers

Lawyers defend and prosecute individuals, translate policies into legal terminology, and enforce and challenge existing statutes. Early in the nation's history, lawyers primarily represented the wealthy classes

in American society. In the modern era, public-interest law firms, along with public defenders, represent the middle-class and poorer citizens. In particular, the federally funded Legal Services Corporation helps the poor with legal representations.

Judges

Judges are at the center of the judicial process. Ideally, judges are supposed to be neutral umpires who weigh the facts of a case and guarantee that a court hearing is fair to all of the concerned parties. In reality, judges are human beings whose rulings are invariably influenced by their educational, social, and political backgrounds.

Backgrounds of Judges and Justices

Judges serving in the federal judiciary are virtually all lawyers and are predominantly white males. Typically, federal judges have been politically active. In addition, the majority have been in their fifties or sixties, upper-middle to upper class, and Protestant. (However, by 2005, it appeared likely that there would be a Catholic majority on the U.S. Supreme Court.) Consequently, minorities and women have been clearly underrepresented, especially on the U.S. Supreme Court. As of 2005, only two women and two African Americans had become Supreme Court justices in the nation's history. In addition, a Hispanic has never served on the Court. State court judges are typically drawn from practicing attorneys, law-school professors, and even former members of state legislatures or Congress.

■ THE ORGANIZATION OF THE STATE AND FEDERAL COURT SYSTEMS

The American dual judicial system (state/local and federal levels) is an extensive one, both in terms of scope and jurisdiction. State and local courts (including justices of the peace, superior/circuit courts, appellate courts, supreme courts, and special courts) coexist with the federal judiciary comprised of U.S. District Courts, U.S. Courts of Appeals, the U.S. Supreme Court, and legislative courts. Important terms covered in the following sections include original and appellate jurisdiction, diverse citizenship cases, the Missouri Plan, the FISC/FISA, and federal special courts.

A Dual Court System

America's judiciary is a **dual system**—state and local courts and the federal judiciary. State and local courts handle the vast majority of cases in the nation, including divorces, child-custody disputes, suits between citizens, and traffic violations. Federal courts are concerned only with alleged violations of federal law or the Constitution. They also handle suits between citizens of different states (see the "Concurrent Jurisdiction" section on page 171).

Given their complexity and diversity, only the most common features of the fifty state court systems can be briefly noted in this text. State court systems usually include:

- A justice of the peace or police court (the lowest level); other low-level courts can include municipal, district, or county varieties.
- A superior or circuit court that serves a trial court function.

- An appellate court.
- A court of last resort, typically the state's Supreme Court (appeals from state supreme courts can end up in the U.S. Supreme Court).

In addition, the states will normally have special courts that deal with domestic relations or wills and estates (such as probate court).

The Article III federal court system has the following judicial components: district courts, intermediate courts of appeals, a U.S. Court of International Trade, the U.S. Foreign Intelligence Surveillance Court, and the U.S. Supreme Court. These are the constitutional courts that exercise the judicial powers found in Article III of the Constitution.

Additionally, under Article I, Section 8, Clause 9, Congress is given the power to "constitute tribunals inferior to the Supreme Court." These legislative or special courts, such as the U.S. Court of Federal Claims or the U.S. Tax Court, deal with a much narrower range of issues. Unlike the Article III judges, judges on the special courts are not appointed for life, but have fixed terms, ranging from four to fifteen years. Special courts are discussed below.

Jurisdiction

Jurisdiction is the authority of a court to hear, try, and decide a case. The federal courts have jurisdiction over cases dealing with constitutional interpretation, violations of federal law, and questions of admiralty or maritime law. They also hear cases in which the parties or litigants in the case are the United States, a sovereign state, or a citizen of a state suing another state. There are different types of jurisdiction, each discussed in the following sections.

Exclusive Jurisdiction

Cases involving an ambassador, federal crime, infringement of a patent or copyright, or act of Congress can be heard only in a federal court. This is known as **exclusive jurisdiction.**

Concurrent Jurisdiction

Cases may be tried in either a federal or state court, so it has **concurrent jurisdiction.** A case involving citizens of different states is an example. (These cases are known as cases in **diverse citizenship.**) If the amount of money involved in the lawsuit is more than $75,000, the plaintiff can bring the suit to either court level. If the case is brought before the state court, the defendant can have the case transferred to federal district court.

Original and Appellate Jurisdiction

A court that hears a case for the first time has **original jurisdiction**. A court that is hearing a case on appeal from a lower court has **appellate jurisdiction** (from the word appeal). District courts have only original jurisdiction, the courts of appeals have only appellate jurisdiction, and the Supreme Court has both original (in very limited circumstances) and appellate jurisdiction.

Selection of Federal, State, and Local Judges

The president appoints all federal judges, provided the Senate confirms them by a majority vote. Presidents prefer judges who are members of their party and who share their political philosophy. Senatorial courtesy has traditionally been followed, whereby senators from the president's party have a veto on judicial appointments from their states. (Note that after the 2002 congressional elections, Senate Republicans, the majority party, informed Democrats that senatorial courtesy could no longer be invoked by them to block a judicial appointment.) The Senate Judiciary Committee holds hearings on the nominees, with confirmation usually being automatic. In general, federal judges, unlike state and local judges, have lifetime appointments. They are subject to impeachment and removal if they are found guilty of criminal offenses while in office. Federal judges who retire at sixty-five and served for fifteen years (or retire at seventy and served for ten years on the bench) enjoy a full salary for the rest of their lives.

The selection method for state and local judges ranges from direct election with a specific fixed term to mayoral or gubernatorial appointment to a combination of both appointment and election. The latter refers to a method, often called the **Missouri Plan,** whereby a judge is at first appointed (usually by the governor from lists compiled by judicial nominating commissions) to a specific number of years in office until the first post-appointment general election occurs. He or she must then gain voter approval (the judge's name appears on the ballot unopposed) in order to stay in office. In Missouri (and about half of the states, which have adopted some version of the Missouri Plan), approval in this retain-or-reject election means an extended term in office, anywhere from six to twelve years, depending upon the importance or legal power of the particular state court.

U.S. District Courts

District courts are the federal trial courts, handling the vast majority of the entire federal caseload. District courts are courts of original jurisdiction, handling both civil and criminal cases. There are ninety-four U.S. district courts, which are located in judicial districts in the nation and territories (one each in the District of Columbia, Guam, Puerto Rico, the Northern Marianas Islands and the Virgin Islands). A large state, like New York, has several district courts (it has four). Every state has at least one. District courts are the only federal courts that have grand juries (which indict individuals after determining there is enough evidence to justify a criminal trial) and jury trials to try defendants.

The number of judges in each district ranges from one to twenty-seven, depending upon population. Single judges typically hear a case, but three-judge panels are used in some instances, such as voting-rights cases or antitrust actions. Typical cases that are tried in these courts for the first time (original jurisdiction) include federal crimes, such as tampering with the mail, counterfeiting, interstate theft, bank robbery, kidnapping, tax evasion, and treason. Civil cases in which the U.S. government is a party and bankruptcy cases filed in accordance with federal statutes are also typical.

District court judges also are helped via their appointments of U.S. magistrates (more than 400), each of whom has an eight-year term. Magistrates have a variety of duties, including the issuing of warrants and bail-setting in criminal cases. Other key personnel in each district include bankruptcy judges, U.S. attorneys (prosecutors for the government), and U.S. marshals (they have four-year terms and are concerned with arrest procedures and the implementation of judicial orders).

The U.S. Courts of Appeals, the U.S. Court of International Trade, and the U.S. Foreign Intelligence Surveillance Court

Established by Congress in 1891, these courts were designed to relieve the burden of so many cases being handled by the Supreme Court. Today, most losing district court litigants appeal their cases to a United States Court of Appeals. However, appeals from federal administrative agencies, such as the Federal Trade Commission, can reach these courts as well. Currently, there are thirteen of these courts, one in each of eleven judicial circuits (regions), one for the District of Columbia, and a thirteenth court called the United States Court of Appeals for the Federal Circuit that specializes in customs and patent appeals. This latter court was designed in 1982 to accelerate appeals from the lower courts, and hence has national jurisdiction. The range of judges for each circuit is anywhere from three to twenty-four, with panels of three judges usually hearing cases.

A **circuit** embraces more than one state. For example, the First Circuit covers the states of Maine, New Hampshire, Rhode Island, and Massachusetts. The Eleventh Circuit is composed of Alabama, Florida, and Georgia.

These U.S. Courts of Appeals do not retry cases, but review records of the lower-court proceedings and evaluate arguments about legal questions raised in those cases. They have only appellate jurisdiction, which means that appeals-court justices can only uphold the lower court decision or modify part of its ruling. An appeals court can **remand** (send back) a case to the trial court for additional review. The Courts of Appeals review about 55,000 cases a year.

As its name implies, the nine judges on the U.S. Court of International Trade (originally established in 1890 as the Board of U.S General Appraisers and reorganized and renamed by Congress in 1980) deal with disputes arising from tariff and trade (civil law) issues. A panel of three judges handles these cases, typically heard in key port cities around the nation. The United States Foreign Intelligence Surveillance Court (FISC) was created from the 1978 Foreign Intelligence Surveillance Act (FISA). Originally composed of seven federal district judges, it was expanded to eleven judges after passage of the USA Patriot Act in 2001. The FISC's basic function is to hear requests (in secret proceedings) from the FBI, National Security Agency, or other federal intelligence organizations for surveillance warrants, allowing further investigation of possible foreign subversives or terrorist suspects operating on American soil.

U.S. Supreme Court

The Court currently consists of nine members—the chief justice and eight associate justices (it had five in 1789, but was expanded to ten during the Civil War)—who are appointed for life by the president, with Senate confirmation. The Supreme Court is the court of last resort on all questions of federal law, due to its power of judicial review as first established in the 1803 case of *Marbury v. Madison*. It has both original and appellate jurisdiction.

Original Jurisdiction

The Court's original jurisdiction (Article III, Section 2) pertains to cases involving ambassadors of foreign nations and those in which a state is a party to a dispute. Examples of the latter have included an argument between California and Arizona over the control of water from the Colorado River, a conflict

between Maryland and Virginia over oyster-fishing rights, and a New Jersey–New York argument over which owned the landfill portion of Ellis Island. Very few original jurisdiction cases come before the Supreme Court each term. The vast majority of cases before the Court fall under appellate jurisdiction.

Appellate Jurisdiction

Under appellate jurisdiction, only cases that are appealed from lower courts are heard by the Court. Although roughly 8,000 to 9,000 cases are filed with the Supreme Court each year, the Court hears arguments and actually renders a decision for only about one hundred.

Legislative or Special Courts

As noted previously, Congress also has created **legislative or special courts** that serve a highly specialized function based upon congressional expressed powers. They are staffed by judges with fixed terms in office (usually fifteen-year terms). These courts hear a more restricted range of cases than those heard under the broad-based jurisdiction of the Article III constitutional courts. The legislative courts are the U.S. Court of Appeals for the Armed Forces (this is a civilian court set apart from the military), the Court of Appeals for Veterans Claims, the Court of Federal Claims, the U.S. Tax Court, the various territorial courts (Virgin Islands, Guam, and so on), and the courts of the District of Columbia (local courts for D.C. residents are included).

■ THE OPERATION OF THE SUPREME COURT

The U.S. Supreme Court's term (typically from October to June), methods of justice selection (presidential nomination and Senate confirmation), justices' backgrounds, case-selection criteria, and decision-making procedures are all discussed in the following sections. Also note such important terms as *writ of certiorari; per curiam* decision; and majority, dissenting, and concurrent opinions.

Terms and Backgrounds of Justices

The Supreme Court's term is approximately nine months, from the first Monday in October to the following June or July. The Court is open each week from Monday to Thursday. Cases that are not decided upon in one term are usually carried over to the next term.

In the modern era, federal judges or prominent attorneys have comprised the pre-Court backgrounds. In 2005 President George W. Bush initially nominated District of Columbia Court of Appeals judge John G. Roberts for the Court after the retirement of Justice Sandra Day O'Connor. Upon the death of Chief Justice William Rehnquist, the nomination's assignment was changed by President Bush. Roberts eventually became the new Chief Justice of the U.S. Supreme Court.

Selection of Justices

The formal process involves presidential nomination and Senate confirmation. However, presidents realize that a Supreme Court appointment can influence public policy for decades to come. They are careful to select nominees who are competent, ethical, and, most important, share their own political values and ideological beliefs, both for lower federal courts and the U.S. Supreme Court. President Ronald Reagan chose conservative Republicans for over half of all lower-court judgeships as well as four Supreme Court

vacancies. In similar fashion, President George H.W. Bush appointed Clarence Thomas, an African-American conservative, to the Court in 1991 (Thomas was a judge on the Court of Appeals for the District of Columbia), plus 187 other federal judges. Conversely, President Clinton selected two Supreme Court justices, Ruth Bader Ginsburg (a judge on the Court of Appeals for the District of Columbia) in 1993 and Stephen G. Breyer (chief judge of the First Circuit Court of Appeals) in 1994, both of whom were generally considered by judicial observers to be more moderate or to the left (liberal) of the political spectrum. In addition, Clinton selected more women and African Americans for the federal courts (close to 400) than Reagan and George H.W. Bush combined. George W. Bush continued in the tradition of his father by nominating primarily conservative judges to the federal bench, despite opposition from Senate Democrats, particularly in his first term. Note that the presidential selection process often lacks certainty regarding a judge's decisions. Supreme Court justices such as David Souter and Sandra Day O'Connor turned out to be more liberal than the presidents who appointed them suspected.

The Senate Judiciary Committee questions Supreme Court nominees carefully in open hearings that can sometimes be intensely critical. (Charges of sexual harassment by Anita Hill against Clarence Thomas in 1991 led to widely publicized hearings questioning the nominee's ethics and morality.) If the committee approves the nominee, the full Senate debates the nomination and ultimately votes to confirm or reject. (Thomas was narrowly confirmed by a Senate vote of fifty-two to forty-eight.) In the twentieth century, the Senate rejected only ten out of forty-nine nominees. One relatively recent example occurred in 1987, when Ronald Reagan's proposed nominee for the Supreme Court, Robert Bork, was rejected in the Senate by a fifty-eight to forty-two vote.

How Cases Reach the Court

About half the cases appealed to the Court are disposed of quickly by returning the case to a lower court. The Court usually perceives these **disposed cases** as not containing significant constitutional challenges, or it agrees with the lower-court ruling (which means that ruling remains legally in effect within that particular lower court's jurisdiction). The Court decides which cases should be heard based on the **rule of four**—if four of the nine justices agree. *Certiorari* or appeal is then granted.

Most cases reach the Court by a *writ of certiorari* (meaning, "to be made more certain"), an order by the Court to send up the case record because there is a claim that the lower court mishandled the case. More than ninety percent of all writs are denied by the Court.

The second method of reaching the Court is the **appeal,** a petition by one of the parties to a case requesting the Court's review of the lower court's decision. Most cases that do reach the Court come from the federal Courts of Appeals and the highest state courts. Keep in mind the very high selectivity of the Court—of the 8,000 to 9,000 cases that are appealed to the Court annually, less than one-half of one-percent will be accepted for review.

Which Cases Are Heard by the Court

The Court does not issue advisory opinions—it must wait for a case. Accepting a case is contingent on a number of factors, including whether there have been different rulings by the lower courts or if a specific lower court ruling is in conflict with a previous Supreme Court decision. Also, a case that has important constitutional or societal implications is a strong candidate for acceptance; for example, abortion, capital punishment, affirmative action, the use of medical marijuana, church-state issues (displaying the

Ten Commandments in a government facility), or the right of eminent domain. A related factor can be the individuals or groups behind an appeal. The involvement of the solicitor general (SG), the federal government's attorney in Supreme Court cases, is one example. The SG's decision to appeal a lower court's ruling is usually deemed as salient by the Court and normally invites a review. Also, interest groups frequently use test cases to challenge the constitutionality of an issue. Skilled, articulate, and knowledgeable attorneys can file briefs explaining why their clients' cases deserve the Court's review.

Poor appellants can file pauper petitions. A good illustration of the pauper petition was the case of Clarence E. Gideon, who, while in a Florida prison serving time for burglary, petitioned the Court on the grounds that he had been denied a lawyer during his trial. Subsequently, the Court ruled in *Gideon v. Wainwright* that Gideon's right to have an attorney, as provided for in the Sixth Amendment, had been violated. In short, the interpretation of the Sixth Amendment was broadened by the Court to mean that the state must not only *allow* a lawyer but *provide* one as well.

How a Case Is Decided

The Court decides about three-fourths of all reviewed cases without oral arguments. The Court issues a ruling and an unsigned written opinion, termed a **per curiam opinion,** that explains the decision. In the remainder of the cases, attorneys for the litigants submit important briefs that argue the case's merits or flaws. Each side is permitted half an hour to present its case orally and answer questions from the justices, who may interrupt the attorneys at any time (arguments and questions are recorded). After these oral arguments, justices, significantly assisted by their clerks' research on the case (each justice is entitled to four clerks), meet in a secret conference, discuss the case, and eventually vote. The chief justice, if agreeing with the majority, will write the majority opinion or assign another justice to do so. If the chief justice is not with the majority, the senior justice may write the opinion. (The final opinion may take months to be formulated.) Other justices can write a concurring opinion that agrees with the majority opinion, but for different legal reasons. Dissenting opinions disagree with the majority decision. These opinions are important because they serve as precedents to be followed in similar cases in the future. Minority opinions also can become the majority's legal reasoning in a future case. In summary, the Court's majority decision can affirm (approve) or reverse the lower court's ruling. A case can also be remanded (sent back) to the lower court, which means that court's original ruling remains operative for the time being.

The Actual Decision

The final decision is announced in open court, with all decisions being published in the United States Reports. Cases can be decided by a mere 5-to-4 majority vote.

The Decision's Implementation

Lower courts are supposed to follow a Supreme Court ruling, although their judges can ignore its applicability to a future new case that may be thematically similar but whose legal circumstances are not identical. Government agencies and businesses must implement Court decisions. For example, state legislatures had to rewrite the death-penalty laws after the Court's *Furman* decision. (In the 1972 *Furman v. Georgia* decision, the Court ruled in a 5-to-4 vote that the death penalty as imposed by existing state laws was unconstitutional. The laws arbitrarily discriminated against minorities and the poor in that these groups were far more likely to be sentenced to death by judges and juries.) Local school boards had to

formulate desegregation strategies after the *Brown v. Board of Education* decision. Outright defiance of Supreme Court rulings is rare. Delay and evasion are the more common strategies, such as organized prayer still being practiced in some public schools despite the Court's disapproval of the practice.

■ HISTORICAL EVOLUTION OF THE SUPREME COURT

The Supreme Court has evolved through several distinct eras. The eras represent the changing political climates of the nation, as presidents have appointed new justices and public attitudes have changed toward the Court as well.

The Marshall Era

Chief Justice John Marshall instituted the idea of giving a single opinion for the entire Court, established the doctrine of judicial review in *Marbury v. Madison*, improved the Court's image, and built the judicial foundation for a powerful national government. He also wanted to protect private property through support for a strong national government.

Taney Court

From 1836 to 1864, the Roger Taney Court developed the constitutional basis for state police powers. It could not resolve the slavery issue and became infamous due to the *Dred Scott* decision, which held that a slave could not be a citizen.

Civil War and Reconstruction

During this era, the Court tried to overturn Reconstruction statutes of Congress, so Congress repealed its appellate jurisdiction. Congress also reduced the size of the Court to seven members. Under President Grant, Congress reinstated the Court's size to nine justices.

Era of Corporate Power

From 1875 to 1937, the Supreme Court was sympathetic to the growth of corporate power; consequently, it limited national government and states' regulatory statutes. However, with the New Deal, FDR initiated extensive governmental measures to alleviate the Great Depression. Subsequently, FDR tried unsuccessfully to **pack the Court** (expand it to fifteen). However, after 1937, the Court began to uphold economic and social legislation favored by the federal government.

Warren Court: 1953–1969

The Court was dominated by a liberal majority, led by Chief Justice Earl Warren, who had been appointed by President Eisenhower (Eisenhower, a political conservative, later regretted selecting Warren, whom he perceived as being too liberal). Its constitutional rulings benefited the disadvantaged, strengthened civil liberties in regard to self-incrimination, reaffirmed the right to counsel and speedy trials, changed the nature of legislative reapportionment, and promoted the historic desegregation policy incorporated in *Brown v. Board of Education* (1954). The latter decision greatly expanded federal power at the expense of the states through a broad interpretation of the commerce clause.

Burger Court

Warren E. Burger replaced the retiring Earl Warren in 1969. As a Nixon appointee, Burger presided over a Court that became increasingly conservative. The Burger Court was less protective of the rights of alleged criminals and underprivileged individuals. Still, this Court preserved many of the civil rights and civil liberties gains implemented by the Warren Court. The Burger Court was supportive of a woman's right to an abortion (*Roe v. Wade*) and against laws that discriminated economically against women in the workforce. But it also ruled that a woman who was on pregnancy leave from work was ineligible for temporary disability or sick-pay benefits. Additionally, the Burger Court required school busing to eliminate school segregation and upheld affirmative-action programs. Ironically for President Nixon, it was the unanimous decision of the Burger Court that forced him to turn over the secret White House Watergate tapes, thus, eventually leading to his resignation in 1974.

Rehnquist Court

William H. Rehnquist, who had dissented from many of the Burger Court's majority rulings, became the sixteenth chief justice in 1986 upon Burger's retirement. With the addition of Reagan-appointed Justices O'Connor, Scalia, and Kennedy, and George H.W. Bush appointee Thomas, a conservative bloc constituted a voting majority by 1991. The retirement of liberal Thurgood Marshall further strengthened the conservatives. Only Justices Blackmun and Stevens could be counted on in the liberal bloc. The Rehnquist Court gradually eroded previous liberal decisions on the issues of criminal rights, abortion, and affirmative action, and Rehnquist himself seemed to accept as a basic judicial goal the limitation of congressional power over the states. Most observers also expected that *Roe v. Wade*'s pro-abortion ruling would eventually be overturned by the conservative Rehnquist Court.

However, President Clinton's appointments of Ginsburg and Breyer changed the complexion of the Court, moving it back to the center and placing it upon a more sensitive ideological fulcrum. O'Connor gradually became the swing vote between the liberal and conservative coalitions on the Court (her vote for the 5–4 majority in the 2000 case of *Bush v. Gore* stopped the manual recounting of ballots in Florida and gave the presidency to George W. Bush), particularly as Bush-appointed David Souter belied his conservative credentials by frequently voting with the centrist or liberal coalition. By 2005, when O'Connor retired, the conservative faction clearly included Rehnquist, Scalia, and Thomas. Stevens, Souter, Ginsburg, and Breyer could usually be found on the left. O'Connor and Kennedy could best be classified as the independent bloc. George W. Bush's original appointment of John G. Roberts in 2005 to fill the O'Connor vacancy and then to become Chief Justice upon the death of Rehnquist in September of 2005 possibly signaled a different ideological mix for the Court's future. This uncertainty deepened when President Bush nominated a conservative appeals court judge Samuel Alito to replace O'Connor. Alito was confirmed by the Senate in 2006.

■ CONSTRAINTS ON JUDICIAL POWER

Judicial power is not unlimited in the American system of government. Limitations upon judicial power may originate from U.S. presidents, state governors, Congress, and public opinion.

Presidents, Governors, and the Courts

Presidents can speak out forcefully against a judicial ruling. Andrew Jackson once remarked (after a Supreme Court ruling he opposed) about Chief Justice John Marshall that "John Marshall has made his decision; now let him enforce it." The Supreme Court and other federal courts have no power to implement their decisions. State governors also can refuse to obey a court order, as exemplified by the opposition of southern governors to the 1954 and 1955 desegregation rulings.

Congress and the Courts

Congress can impeach judges or reject judicial appointments. Congress also can increase the number of judges, allowing a president to appoint more judges who share his judicial philosophy. For example, Congress created positions for 152 new federal district and appellate judges during President Carter's administration. This gave President Carter a chance to appoint more than forty percent of the federal bench.

Congress can pass constitutional amendments or change a law that the Court had declared unconstitutional. The Twenty-sixth Amendment, giving eighteen-year-olds voting rights, was passed after the Supreme Court had ruled that Congress could not lower the voting age through regular legislation. In 1978, the Supreme Court ruled that a Tennessee dam's river location was endangering a tiny fish called the snail darter, an action in violation of the Endangered Species Act. In 1979 Congress passed legislation reversing the Court's ruling.

Of course, the Court also can invalidate a congressional action. In 1993 Congress passed the Religious Freedom Restoration Act (RFRA), a political reaction to a 1990 Supreme Court ruling (*Oregon v. Smith*) that had restricted religious expression. In 1997 the Court declared the RFRA unconstitutional.

Other powerful weapons of congressional (or state legislature) control include the power of Congress to decide areas of jurisdiction for the lower courts and to redefine Supreme Court appellate jurisdiction (during the 1950s, Congress was hostile to Supreme Court rulings on civil rights and proposed legislation that would have curtailed Court jurisdiction in this policy area). Congress also can refuse to authorize appropriations needed to implement judicial decisions. For example, on the state level, a legislature faced with a court order to improve the prison system could simply choose not to fund that project.

Public Opinion and the Court

The Supreme Court is aware of public opinion, especially changing political moods during different historical eras. Opinion not only restrains the Court, it may energize it. The Court must be sure to maintain its legitimacy before the people. For example, the 2000 Court, sensitive to public concerns, ruled that mentally handicapped criminals could not be executed. It also is true that polls consistently show ample public support and respect for the both the judiciary in general and the Supreme Court. This general level of support may help the Court defy specific public majorities on an issue (such as burning the American flag).

■ ACTIVISM AND BROAD CONSTRUCTIONISM VERSUS JUDICIAL RESTRAINT (STRICT CONSTRUCTIONISM)

Two judicial philosophies are examined in the following sections. Judicial restraint and judicial activism refer to the controversy over whether judges go too far in making the law rather than adhering to the letter of the law.

Position #1: The Courts Are too Powerful or Judicially Active (the Judicial-Restraint Position)

Critics of the judiciary argue that courts go too far in policymaking. The courts have developed policies for school busing, abortion, nuclear power, affirmative action, environmental pollution, educational reforms, and the death penalty, ad infinitum. Critics argue that because federal judges are not elected, they are the least democratic public officials to be found among the three branches of government. Courts should not go beyond the referee principle, nor should they block laws or the rules of bureaucratic agencies that are based on solid expertise unless those laws or rules are unquestionably unconstitutional. Judicial restraint should be practiced, while leaving policy decisions to the executive and legislative branches of government. Similarly, strict constructionists argue that judges should adhere closely to the letter of the law, not make the law. In other words, judges should look at the original intent of the constitutional framers in order to discern those enduring, fixed constitutional principles that still apply to the modern era.

Position #2: The Courts Must Be Judicially Active

Advocates of **judicial activism** argue that the courts frequently must make policy in order to meet pressing social needs and to help those who are disadvantaged economically or politically. Broad constructionists believe that laws should be applied dynamically vis-à-vis those important value and technological changes that occur in society every generation. These modernists question how a 18th-century document like the Constitution, written by a small elite group of white males representing a nation of four million, can still have total, unchanging relevance to an ethnically diverse, complex nation of three hundred million. Judicial modernists also argue that the framers themselves had differences over the meaning of the Constitution and so deliberately left many of its phrases vague, knowing that future generations would have to fill in the blanks. Furthermore, Congress and the state legislatures should leave the courts and judges alone, because political interference will seriously harm the separation of powers principle. That principle works to restore a policy balance even when the courts go astray, because judicial rulings can always be constitutionally overturned by executive or legislative actions. For example, when the Supreme Court ruled the federal income tax illegal, Congress initiated the Sixteenth Amendment legitimizing such a tax. The amendment was ratified in 1913.

The founders saw the importance of an independent judiciary as a bulwark against the potential political excesses of the executive and legislative branches. The courts also have evolved into protectors of those citizens who lack political influence or economic power.

It should be noted that the courts seldom attack the fundamental principles of American society. Collectively, they can be constrained by other institutions, as well as by public opinion. In short, most case decisions will reflect the basic values of American society at a particular point of time or within the context of a specific historical era.

The American judicial system is an adversarial one, in which legally resolvable issues, not political questions, are handled. Litigants must have standing to sue. The six types of law are common, equity, statutory, constitutional, case, and administrative. Civil and criminal law represent two broad classifications.

Structurally, America's judiciary is a dual system, consisting of both federal and state and local courts. Federal courts may have either original or appellate jurisdiction, depending upon the nature of the

case. The Supreme Court, which has both original and appellate jurisdiction, is at the apex of the federal judicial pyramid, although it agrees to hear only a small percentage of cases appealed from the lower courts. Since the 1930s, the Court has generally moved to protect civil liberties and civil rights. Finally, the historic debate over judicial activism versus judicial restraint continues into the twenty-first century.

Selected Readings

Breyer, Stephen. *Active Liberty: Interpreting our Democratic Constitution* (2005).

Comiskey, Michael. *The Judging of Supreme Court Nominees* (2004).

Finkelman, Paul, and Melvin Urofsky. *Landmark Decisions of the United States Supreme Court* (2002).

Keck, Thomas M. *The Most Activist Supreme Court in History* (2004).

Klarman, Michael J. *From Jim Crow to Civil Rights: The Supreme Court and the Struggle for Racial Equality* (2004).

Murphy, Bruce Allen. *Wild Bill: The Legend and Life of William O. Douglas* (2003).

O'Connor, Sandra Day. *The Majesty of the Law: Reflections of a Supreme Court Justice* (2003).

Scalia, Antonin (Amy Gutmann, editor). *A Matter of Interpretation—Federal Courts and the Law* (1998).

Woodward, Bob, and Scott Armstrong. *The Brethren: Inside the Supreme Court* (1979).

Test Yourself

1) The doctrine of *stare decisis* refers to the importance of which judicial idea?
 a) jurisdiction
 b) appeals
 c) precedent
 d) activism

2) True or false: The majority of all civil and criminal cases in America are tried in federal courts.

3) Which of the following types of law involves judges issuing orders to prevent possible damage or to direct that some action be taken?
 a) statutory
 b) constitutional
 c) equity
 d) administrative

4) True or false: Presidents tend to choose federal judges who share their political philosophy or belong to their political party.

5) Which federal court is the only one that allows jury trials?
 a) U.S. District Court
 b) U.S. Supreme Court
 c) U.S. Tax Court
 d) U.S. Courts of Appeals

6) True or false: Like Article III judges, Article I judges serve for life on their federal courts.

7) Which of the following is an example of a special court established under Article I of the Constitution?
 a) U.S. District Court
 b) U.S. Court of Federal Claims
 c) U.S. Supreme Court
 d) none of the above

8) True or false: The Missouri Plan involves both the appointment and election methods in choosing state judges.

9) The United States Court for the Federal Circuit differs from other U.S. Courts of Appeals in that it has
 a) to deal only with cases originating from the District of Columbia
 b) only original jurisdiction
 c) national jurisdiction
 d) none of the above

10) True or false: The FISC is a federal court that mainly deals with trade and tariff issues.

11) The president who tried to pack the U.S. Supreme Court by expanding it to fifteen members was
 a) Richard M. Nixon
 b) Ronald Reagan
 c) Abraham Lincoln
 d) Franklin D. Roosevelt

12) True or false: From 1875 to 1937, the Supreme Court, through its rulings, increased the power of national regulations over big businesses or corporations.

13) A case involving an argument over water rights between the states of California and Arizona would be heard first in which court?
 a) the California and Arizona state supreme courts
 b) a U.S. District Court
 c) the U.S. Supreme Court
 d) the U.S. Court of International Trade

14) True or false: Supreme Court justices usually render a decision within two or three weeks from the time oral arguments before the Court have finished.

15) The individual who became Chief Justice of the U.S. Supreme Court after Earl Warren was
 a) William Rehnquist
 b) Roger Taney
 c) Sandra Day O'Connor
 d) Warren Burger

16) True or false: In general, polls reveal that the public gives the U.S. Supreme Court high approval ratings.

17) How many Supreme Court justices must agree to hear a particular case that has appealed to the Court from a lower court?
 a) two
 b) three
 c) four
 d) five

18) True or false: A written concurrent opinion is also a majority opinion on the Supreme Court.

19) Which of the following Supreme Court justices decided to retire in 2005?
 a) Scalia
 b) O'Connor
 c) Stevens
 d) Kennedy

20) True or false: Advocates of judicial restraint believe that federal or state judges should not make policy through their legal rulings.

Test Yourself Answers

1) **c.** Jurisdiction refers to the right to hear and try a case. Appeals are requests from a lower court to a higher court to review a case. Activism refers to a judicial philosophy of making the law through court rulings.

2) **False.** The vast majority of all civil and criminal cases are heard in state courts.

3) **c.** Equity law is directed at stopping an unlawful action before the effects of that action become progressively worse. Administrative law refers to the rules and regulations promulgated by federal and stage agencies. Statutory refers mainly to legislation passed by Congress or state legislatures. Constitutional law involves the interpretation and application of provisions of the U.S. Constitution or even state constitutions.

4) **True.** Every president prefers nominating federal judges who share his or her political and ideological beliefs. Doing so ensures that a president's impact upon the nation will continue in the courts for years after he or she leaves office.

5) **a.** U.S. District Courts have both trial and grand juries. All other federal courts use individual judges or panel of judges to rule on cases.

6) **False.** Article I judges have fixed terms (ranging from four to fifteen years). Article III judges serve for life.

7) **b.** The other courts are Article III courts.

8) **True.** Under the Missouri Plan, the governor appoints a judge to a short term in office, eventually followed by a retain-reject election. If the judge is approved by the voters, he or she is given a term ranging from six to twelve years.

9) **c.** The Court has appellate jurisdiction on a nationwide basis. Therefore, it does not deal only with Washington, D.C., cases.

10) **False.** The FISC deals with requests from U.S. intelligence agencies for surveillance warrants that, in turn, will assist in the investigation of foreign saboteurs or suspected terrorists operating inside of the United States.

11) **d.** The court-packing plan does not apply to any other president.

12) **False.** The Court was sympathetic to corporations, weakening federal regulations over big business.

13) **c.** The U.S. Supreme Court has original or exclusive jurisdiction in cases involving disputes between or among states.

14) **False.** The Court usually takes at least several months to render a decision after oral arguments have been delivered.

15) **d.** Burger became Chief Justice in 1969.

16) **True.** The public gives the Court high ratings, especially when compared to other institutions such as Congress.

17) **c.** This is known as the proverbial rule of four.

18) **True**. A concurrent opinion is written by a justice who belongs to the majority. His or her opinion, while agreeing with the majority view, explains that the agreement is based upon different legal reasoning.

19) **b.** O'Connor's 2005 planned retirement led to President Bush's nomination of John G. Roberts as her successor. However, when Chief Justice Rehnquist died, Roberts succeeded Rehnquist as the new Chief Justice. Judge Samuel Alito would eventually replace O'Connor in 2006.

20) **True.** Advocates of judicial constraint argue that the courts should not make policy, but rather should behave only as impartial referees between conflicting parties. Judges are not elected, so they should leave policy decisions to the executive and legislative branches of government.

Civil Liberties and Civil Rights

The **Bill of Rights** was added to the original Constitution as a collective guarantee that the liberties of citizens—including such basic freedoms as speech, press, and religion—could not be arbitrarily infringed upon by the ruling power of the federal government or the wishes of a tyrannical majority. The Fourteenth Amendment then established the **due process clause** as a further reaffirmation of these freedoms.

Civil liberties can create conflicts among competing interests in society. The accused may desire a fair, objective trial, but the press's wish for maximum, even sensationalized coverage could bias that trial's objectivity. Citizens in a community may wish to censor sexually explicit publications, but others will believe in freedom of speech. These and innumerable other disputes demand resolution.

Civil liberties are not the same as **civil rights.** Civil liberties are the individual rights that are guaranteed by the Constitution, as exemplified in the Bill of Rights. They are the citizen's legal and constitutional protections against the government; those practices that government may not implement. Civil rights involve the protection of individuals and groups (women, African Americans, Native Americans, gays, and so on) against discrimination based upon race, national origin, religion, age, disability, or sexual orientation. The struggle for civil rights is ultimately to gain access to public facilities, better job opportunities, legal equality, or other societal services previously denied. Consequently, government is mandated by these rights to guarantee equality under the law for every American. Civil rights are largely derived from federal or state statutes, and from the equal protection clause of the Fourteenth Amendment.

The content, application, scope, and extension of civil liberties and civil rights have been interpreted by the judiciary, and, particularly, through innumerable rulings from the Supreme Court. This chapter is concerned with many of these decisions and their significance.

■ CIVIL LIBERTIES

Civil liberties are closely linked to the principle of limited government. They represent freedoms that governmental authority cannot normally suppress. However, these freedoms are relative, not absolute. For

example, although the Constitution provides for free speech, an individual cannot, to use the paraphrased words of Supreme Court Justice Oliver Wendell Holmes, yell "Fire" in a crowded theater when there is no fire, thereby inciting panic that could harm others. The civil liberties contained in the Bill of Rights, originally applicable only to the federal government, were eventually extended to state and local governments.

The original intent of the Bill of Rights was to restrain the new federal government, not to place restrictions on the existing states. Thus, in the 1833 case of *Barron v. Baltimore,* the Supreme Court had ruled that the Bill of Rights did not apply to the states. The incorporation of the Bill of Rights into the Fourteenth Amendment's due process clause (that "No State shall . . . deprive any person of life, liberty, or property, without due process of law") by the courts meant that constitutional rights of individuals could not be infringed upon by state governments. (Note that there are two forms of due process: **procedural**, such as a right to a fair, impartial jury trial, and **substantive,** meaning that a particular law or action may not impair an individual's basic rights or equality, unless a compelling state interest can be demonstrated.)

The **incorporation** process began with the case of *Gitlow v. New York* in 1925, when the Supreme Court ruled that freedom of speech could not be impaired by the states. Today, virtually the entire Bill of Rights has been incorporated, with only a few exceptions, such as the right to a grand jury hearing and the Second Amendment's right-to-bear-arms provision.

The First-Amendment Freedoms: Religion, Speech, Press, Assembly, and Petition

First Amendment freedoms are perhaps the most important for the promotion and protection of American democracy. Freedom of religion (note the **establishment** and **free-exercise** clauses), speech (**libel, slander,** symbolic speech, the clear and present danger doctrine, and the obscenity issue), press (**prior restraint** and **shield laws**), assembly, and petition are discussed in the following sections.

Freedom of Religion

The First Amendment states that "Congress shall make no law respecting an establishment of religion or prohibiting the free exercise thereof." This portion of the amendment has respectively strengthened church-state separation and the freedom to practice one's religious beliefs, whatever they may be.

Establishment Clause. This clause implies a "wall of separation" (a phrase used by Thomas Jefferson but borrowed from Roger Williams, the founder of the colony of Rhode Island) between church and state. There is no official state religion in America, although a majority of the original thirteen colonies did have official state churches for a time. Government may not show favoritism toward one religion over another—it must be impartial toward all (note that conservative justices argue that there is nothing wrong with government support of religion in a general sense, although liberal justices would dispute this assertion). These fundamental views were articulated further by the Supreme Court through its three-part test first enunciated in the 1971 case of *Lemon v. Kurtzman.* To determine whether a law or government policy violated the clause, the following points from *Lemon v. Kurtzman* required evaluation:

- The law must have a secular purpose.
- The law must not advance or interfere with religion.
- The statute must not result in "excessive entanglement" of church and state.

Subsequently, the Supreme Court has found most types of public assistance to church-supported schools unconstitutional; exceptions from *Agostini v. Felton* in 1997 include textbook loans, bus travel, costs of standardized testing, the purchase of computers, and special educational help for disadvantaged pupils, because they are all fundamentally considered neutral activities assisting children's welfare, not religious values. In *Engel v. Vitale* (1962), the Court had invalidated the use of a state-written prayer by the New York Board of Regents in the public schools. However, the Court has ruled in favor of schools giving released time to students so they can participate in religious activities, provided that these do not occur on public school grounds. Conversely, the Supreme Court has struck down religiously motivated moments of silence for the public schools in Alabama (*Wallace v. Jaffree,* 1985), although other moment-of-silence practices have been accepted, as well as student-led prayers prior to public school football games.

In 2005, the Court dealt with the public display of the Ten Commandments in the states of Texas and Kentucky in *McCreary County v. ACLU* and *Van Orden v. Perry,* respectively. In the former, the Kentucky courthouses' displays were ruled to be an impermissible government endorsement of religion, while in the latter, a Ten Commandments monument on the grounds of the Texas state Capitol was seen in secular terms as a "historical marker" and, therefore, constitutional. Other important cases dealt with school vouchers (the Court upheld a Cleveland, Ohio, voucher system in the 2002 case of *Zelman v. Simmons-Harris,* permitting public tax dollars to subsidize parochial and private school educational instruction in that the voucher program was secular, not religious); the teaching of creationism and/or intelligent design versus evolution; and the phrase "under God" in the Pledge of Allegiance (in 2005, the Court did not actually rule in *Newdow v. U.S. Congress* on the phrase's constitutionality, but further legal tests may be forthcoming in the future).

Free-Exercise Clause. In America, government cannot force any individual to believe in or practice a particular religion. But the free-exercise clause does not constitute a license for the perpetration of harmful or antisocial religious practices. For example, the courts would not allow a religious ritual of human sacrifice. Nor would the courts permit a sick child to be denied a needed blood transfusion due to religious dogma. In a much older case, the Supreme Court banned polygamy, even though the Mormon Church approved of it (*Reynolds v. United States,* 1878).

The Supreme Court has usually protected an individual's religious beliefs (or absence of them), if deemed legitimate, from state intrusion. The Court eventually ruled that Jehovah's Witnesses did not have to salute the American flag (their religious values interpreted the salute as a violation of the biblical commandment against idolatry; an earlier decision had ruled against the Jehovah's Witnesses), that the Amish were not required to send their children to any kind of school after the eighth grade (modern education conflicted with the agrarian lifestyle of the Amish, so their children could stop attending school altogether), and that an atheist did not have to take a public oath of office (expressing a belief in God) to keep his government job. Similarly, a conscientious objector can legally avoid military service due to his or her religious beliefs.

But it is important to remember that free exercise is not absolute. Thus, an Orthodox Jewish chaplain in the U.S. Air Force could not wear his yarmulke (skullcap), because it violated the military's dress code. The chaplain had asserted that wearing a yarmulke was essential to his functioning as a total

Orthodox being. However, in 1999, two Muslim police officers who argued that their beards should not be shaved due to their faith's requirements had that practice upheld by a lower federal appeals court. In an earlier Supreme Court case, *Oregon v. Smith* (1990), the Court ruled that unemployment benefits could be withheld from two Native Americans who used an illegal drug, peyote, as part of their religious ritual.

Freedom of Speech and the Press

The First Amendment asserts that "Congress shall make no law abridging the freedom of speech, or of the press." Although freedom of speech and the press have been given preferred positions by the judiciary in terms of their extreme importance within a democracy, government can still issue restrictions on freedom of expression when circumstances warrant or if it can be shown that those restrictions were absolutely necessary. A discussion of these limits follows.

Libel and Slander. No one has the right to write (**libel**) or verbalize (**slander**) deliberately false, malicious statements about someone's character or reputation. For example, a reporter (and his or her paper as the third party that conveyed those remarks publicly) who did so could face a civil lawsuit by an aggrieved plaintiff seeking financial damages. The tabloid *National Enquirer* was brought to court by Carol Burnett, the entertainer, after the paper alleged that she had been seen inebriated in public; Ms. Burnett won and collected monetary restitution. But public figures or celebrities must demonstrate conclusively that libelous or slanderous statements are false and were intentionally made via a reckless disregard for the facts—true statements void the possibility of collecting damages.

Symbolic Speech. An illegal act cannot be justified under a freedom-of-speech umbrella. An individual who burns his or her draft card to protest foreign policy is still violating the law. However, the courts have approved symbolic speech in some situations. For example, in 1965 (*Tinker v. Des Moines School District*), court approval was awarded to high-school students who wore black arm bands to protest the Vietnam War. Burning the American flag as a form of political protest also has been ruled constitutional (*Texas v. Johnson,* 1989). A more recent case of symbolic speech occurred in 2003, when a Virginia statute banning cross-burning was declared by the Supreme Court to be consistent with the First Amendment, since the unsavory aspects of the practice (fear, intimidation, terror) trumped free speech worries.

Clear and Present Danger Test. Speech cannot lead to an immediate and recognizable harm to people and/or property (see *Schenck v. United States,* 1919), including hate speech, fighting words, or inflammatory utterances. In other words, speech can be restrained if it follows the **bad tendency rule;** that is, it leads to an obvious evil (*Gitlow v. New York,* 1925). For example, a speaker who urged his audience to commit crimes (with audience members doing so shortly after the speaker had finished) would have violated the acceptable boundaries of free speech. Similarly, members of a subversive hate group who advocated the violent overthrow of the U.S. government would be guilty of sedition, as mandated by the Smith Act of 1940. Thus, in 1951, the Supreme Court upheld the conviction of eleven members of the American Communist party under the anti-sedition provisions of the Smith Act.

Prior Restraint. Can the government censor a newspaper story and the ideas within its content before it is published; that is, implement the concept of **prior restraint**? The Supreme Court has normally ruled

the practice unconstitutional on the grounds that a free press is vital to the preservation of democracy. A famous 1971 case of prior restraint involved the Pentagon Papers (*New York Times v. United States*), top-secret documents relating to the real reasons behind America's involvement in Vietnam. When the documents were leaked to the *New York Times* and parts of it were printed, the Nixon administration sought a court injunction to stop further publication on national security grounds. But the Court rejected this plea, asserting that the public's right to know superseded governmental secrecy. In short, the government must carry a "heavy or definitive burden" of justification when practicing prior restraint (*Nebraska Press Association v. Stuart,* 1976). Finally, note that on a local level (*Hazelwood School District v. Kuhlmeier,* 1988), the Court ruled that a high school principal could censor portions of a school newspaper, because the paper was an integral part of the curriculum and not a societal forum for the widespread dissemination of ideas. As a general rule, the rights of students are usually viewed by the courts as being more limited than those of adults.

A similar situation applies to **gag orders,** which are court orders that prevent the press from writing stories about a criminal case before that case is tried in a courtroom. Formerly, judges used gag orders to guard defendants against adverse pre-trial publicity. But Supreme Court decisions have since voided these orders as but another kind of prior restraint (*Nebraska Press Association v. Stuart,* 1976). In general, the judiciary has backed the idea that regular trials should be open to public view, except when there are very special circumstances that prevent this practice.

Shield Laws. Are reporters protected from revealing confidential sources of information under the First Amendment's freedom-of-press provision? In the 1972 case of *Branzburg v. Hayes,* the Supreme Court ruled that reporters were not exempt from supplying information to a federal grand jury as part of a criminal investigation. Special exemptions for the news media would have to be furnished by congressional or state law. Since the *Branzburg* ruling, more than thirty states and the District of Columbia have passed their own **shield laws**, which grant reporters limited immunity from divulging confidential information in nonfederal cases. Since that time, Congress has periodically flirted with passage of a federal shield law, as was the case in 2005 when *New York Times* reporter Judith Miller was put in jail for refusing to divulge her confidential sources before a grand jury.

The Issue of Obscenity (including Internet Obscenity). Can governments legally censor books, movies, magazines, plays, records, artwork, or other forms of expression that are considered obscene and, therefore, not entitled to First Amendment protection? The problem arises over how to define what is or what is not obscene, because moral sensitivities differ among disparate communities and even regions of the nation. Although the Supreme Court has admitted that there is no universal definition of obscenity (Justice Potter Stewart once stated that he could not define obscenity, but he knew it when he saw it), it has decided that each community can judge for itself whether a literary or cinematic work violates standards of morality. The Court has also reiterated that a literary or video work, to be considered obscene in its entirety, must appeal exclusively to "prurient interests," depict sexual conduct in an offensive manner, and lack literary or artistic merit (*Miller v. California,* 1973).

The Internet poses new problems for the obscenity question, because it is relatively easy for children and minors to gain access to pornographic Web sites and because it transcends geographic boundaries. Congress has grappled with the Internet dilemma by passing a series of laws in 1996 and 2000: the

Communications Decency Act, the Child Pornography Prevention Act, and the Children's Internet Protection Act (CIPA). Although the first two were eventually ruled unconstitutional on free speech grounds, CIPA, mandating the use of filtering software in schools and libraries to prevent underage access (and these institutions would lose federal funding if they did not comply), was upheld by the Supreme Court on the grounds that those filters could be turned off by requesting adults.

Freedoms of Assembly and Petition

The right of the people to assemble peaceably in groups and voice their grievances is broadly permitted, but far from absolute. A balance between freedom and order must be struck. For example, a group will usually not be allowed to hold a protest demonstration if it interferes with city traffic or blocks entrances to public buildings. A march near a school that disrupts normal learning activities can be prohibited. Governments can formulate and enforce reasonable laws that control the time, place, and organization of the assembly. Local governments also can grant or deny permits for planned protest marches.

Anti-loitering laws have been both affirmed and overturned, depending upon how the laws are written, the meaning of *loitering,* and the method of enforcement. A related issue is how street gangs assembling on local streets or in neighborhoods should be handled via ordinances that are consistent with constitutional constraints.

Protecting the Accused: Amendments Four, Five, Six, and Eight

A significant portion of the Bill of Rights is devoted to protecting citizens who are accused of crimes from being subjected to illegal government procedures or coercion. In the United States, an individual is presumed innocent until proved guilty. The civil liberties of the accused are designed to strengthen these important principles.

The Fourth Amendment's Search-and-Seizure Provisions, the Exclusionary Rule, and the 2001 Patriot Act's Modifications

The Fourth Amendment's fundamental purpose is to prevent law enforcement personnel who collectively represent the government or state from arbitrarily searching a citizen's residence without a judge-issued search warrant that is based on the probable cause principle (note that warrantless searches are possible under certain circumstances). However, this basic constitutional procedure has been altered with the passage of the Patriot Act, a law designed to cope with the new era of terrorism that emerged after the attacks of 9/11/01.

Search-and-Seizure Provisions. The Fourth Amendment requires that the police must have a search warrant before entering a person's home, apartment, trailer, or other place of residence. The warrant must be issued by a judge after authorities have established **probable cause** (meaning that good reason exists to believe a crime has occurred or that evidence will be found at the particular location). The warrant usually describes the place to be searched and what type of evidence is to be seized.

Most searches are conducted without a warrant. Examples of warrantless searches include the following:
- The individual voluntarily agrees to a search.
- The police search following a lawful arrest.

- The police search of all parts of a car if probable cause is shown after the fact (the car and its owner could be long gone before an officer returned with a warrant).
- A person may be arrested in a public place on the grounds that a crime was about to be committed by him or her.
- The police may stop a person's car and test that driver for signs of intoxication.
- A warrant is not needed to seize evidence in plain view—for example, stolen firearms, even if the original warrant specifies that the search is for illegal drugs.

The Exclusionary Rule. Evidence that is improperly obtained cannot be used as evidence in a court of law. This is the **exclusionary rule,** a rule that was eventually applied to the states by the 1961 Supreme Court case of *Mapp v. Ohio.* The exclusionary rule is controversial, with opponents claiming that it can interfere with the prosecution and conviction of truly guilty people. Supporters of the rule argue that it compels the police to acquire evidence in a procedurally just manner. In recent years, the Supreme Court has relaxed the rule somewhat, allowing the police to use evidence that would have inevitably been found through legal methods and establishing a good-faith exception; that is, evidence can be used if the police believed they had a constitutionally valid warrant, even though it is later found to be defective in some way.

Wiretapping and Electronic Surveillance. The framers of the Constitution could not have imagined the sophisticated eavesdropping equipment of the twenty-first century. Hence, the Supreme Court for many years ruled wiretapping to be legal, then reversed itself, stating that it violated the Fourth Amendment. But today, after congressional legislation (the 1968 Omnibus Crime Control Act) and further judicial review, wiretapping is permitted if certain procedures are followed.

Law enforcement personnel must first secure a warrant from a local, state, or federal judge authorizing electronic bugging before the actual surveillance can begin. Normally, that warrant was based upon probable cause—a reasonable suspicion by authorities that criminal acts were occurring, necessitating electronic surveillance.

The 2001 Patriot Act: Modifications to the Fourth Amendment. On October 26, 2001, the **Patriot Act** (officially named "Uniting and Strengthening America By Providing Appropriate Tools Required to Intercept and Obstruct Terrorist Acts") became law as a response to the terrorist attacks of 9/11/01 upon the World Trade Center Towers and the Pentagon. A chief objective of the Act was to prevent a second 9/11 by improving the investigative abilities of the FBI and other federal national security and intelligence agencies. Consequently, the act permitted an expansion of roving and sneak-and-peek warrants and wiretaps, procedures that, to civil libertarians, weakened judicial oversight and the traditional concept of probable cause. **Roving** allowed surveillance of a suspected terrorist's total communications' devices—cellular and home phones, e-mails, Internet usage, all computers used, and so on, rather than taps for a single phone or computer. These taps also could be approved on a national basis, making judicial oversight far more difficult, because the taps would not be confined to a narrow geographical and judicial jurisdiction, but expanded and transferred to any location in the country. **Sneak-and-peek** warrants (as opposed to the old knock-and-announce warrants) allowed for secret searches of a person's home and property without prior notice. Law enforcement authorities must still inform the individual that a search has occurred, but the time

for dispensing that information can be extended almost indefinitely when national security is deemed in jeopardy. Finally, the Patriot Act weakened the specificity of probable cause, replacing it with either a "significant purpose" or "relevant to an on-going investigation" criterion.

The Fifth Amendment: Self-Incrimination, Grand Juries, and Double Jeopardy

The Fifth Amendment protects a citizen from unknowingly providing information that could taint his or her presumption of innocence. In addition, it establishes grand juries and the **double jeopardy** principle (which usually prevents an individual from being tried for the exact same crime twice after he or she has been found innocent of that crime, although there are exceptions).

Self-Incrimination. The Fifth Amendment states that no person "shall be compelled in any criminal case to be a witness against himself." In other words, a citizen does not have to say anything that could lead others to believe he or she is guilty of the alleged offense. The famed **Miranda Rules** (*Miranda v. Arizona*, 1966) stem from the Fifth Amendment: An arresting officer must inform the suspect that he or she has the "right to remain silent, for anything you say may be used against you in a court of law." Note that the right to an attorney, originally stemming from *Gideon v. Wainwright*, is also a component of Miranda, flowing from the Sixth Amendment. Similarly, a defendant's refusal to testify at his or her trial is not an indication of guilt, and the judge will so remind the jury. The Miranda Rules have been weakened somewhat during the past fifteen years by the courts, but their essential importance remains intact.

Grand-Jury Indictments. Members of a federal **grand jury,** numbering between sixteen and twenty-three, may issue a **true bill of indictment,** a statement that there is enough evidence (or not enough evidence) to justify a **petit** or **jury** trial for an alleged federal crime (after listening to a prosecutor). Grand juries are supposed to prevent unwarranted criminal trials, but they usually issue indictments (a minimum of twelve juror votes is needed) in ninety percent or more of the cases they hear. Grand juries also are criticized because their sessions are held in secret and their members hear only the prosecution's arguments. More than half of the states have abolished grand juries, relying on an **affidavit of information,** whereby a prosecutor files formal charges and swears to their validity.

Double Jeopardy. The Fifth Amendment also states that no person should be "twice put in jeopardy of life or limb" for the same alleged offense. The rationale for double jeopardy is that it prevents the state from repeatedly prosecuting a citizen in court until it finally achieves a guilty verdict. An individual may not be tried again for the exact same crime after being found innocent of that crime in a court of law. Note that double jeopardy does not prevent a new trial for a citizen who is found guilty. Also, an individual could be tried twice—one time in a federal court, then again in a state court for a crime that involved an alleged violation of both state and federal laws, such as selling narcotics. Finally, there can be two separate crimes emanating from the same action, thereby requiring two different trials.

The Sixth Amendment: The Right to Counsel and a Speedy Trial

The Sixth Amendment states that "In all criminal prosecutions, the accused shall enjoy the right . . . to have the Assistance of Counsel for his defense." The right of a citizen to have an attorney for his or her

defense originally applied only to federal offenses. In 1963, the Supreme Court ruled in *Gideon v. Wainwright* that this right applied to all state felony trials (the Court later extended the right to include misdemeanor cases in which a person might have to serve a jail sentence). Subsequently, thousands of prisoners across the country who had been denied counsel were released.

In addition, the Sixth Amendment enjoins that "In all criminal prosecutions, the accused shall enjoy the right to a speedy and public trial" The objective is to minimize trial delays and possibly limit the amount of time a citizen must stay in jail (if he or she cannot afford bail). Federal law has clarified the "speedy" term, mandating that no more than one hundred days should pass between arrest and the start of a federal criminal trial.

Finally, the amendment states that a person accused of a federal offense must be tried by impartial jurors. Jurors are usually selected from a community list of registered voters. A federal jury is composed of twelve members and may convict only if all twelve jurors agree on a guilty verdict. By comparison, several states use only six-member juries. But a unanimous verdict also is required for these juries.

Plea Bargaining. Note that a majority of people accused of crimes never have a jury trial. **Plea-bargaining** procedures are used, whereby the accused, in exchange for admitting guilt, is charged with a lesser crime. Plea bargaining has been declared constitutional so long as the plea is voluntarily made and understood fully by the defendant. Although plea bargaining has been criticized as a mockery of justice, the judiciary has accepted it as a method of reducing the vast backlog of cases and, consequently, saving both time and money.

The Eighth Amendment: Excessive Bail and Cruel and Unusual Punishment

The Eighth Amendment states that "Excessive bail shall not be required, nor excessive fines imposed" and forbids "cruel and unusual punishment."

Excessive Bail and Fines. Bail is a specified amount of money, set by the court, that serves as a guarantee that an individual will appear for his or her trial at a designated time in the future. Bail allows the individual to prepare a defense outside of a jail cell and is based on the assumption that the presumed innocent citizen should not stay incarcerated. However, bail is not a guaranteed right: The Constitution states only that it should not be excessive. A judge may deny bail altogether if he or she feels the accused may flee or is dangerous to society. This **preventive detention policy** has been declared constitutional by the courts.

Cruel and Unusual Punishment: The Death Penalty. In recent years, the death penalty has been challenged on the grounds that it constitutes cruel and unusual punishment. The Supreme Court has disagreed, stating that the death sentence, per se, does not violate the Constitution if applied equitably. However, the Court, in *Furman v. Georgia* (1972), ruled that the death penalty could not be applied by the states in an arbitrary and discriminatory fashion against minority groups and poor defendants. The Court has cautioned that lower courts must carefully consider mitigating factors—the defendant's age and prior police record, the use of alcohol or drugs, the precise circumstances of the murder—before imposing a death sentence. The states have rewritten their death-penalty statutes, with some eliminating automatic imposition of the penalty once a defendant has been convicted, and others providing a two-step process: a

trial to determine guilt or innocence, followed by a separate hearing to decide whether death is warranted (*Gregg v. Georgia,* 1976). In 2002 the Supreme Court issued two important rulings involving capital punishment:

- Only juries, not judges, must decide whether the death penalty should be imposed in a specific case (*Ring v. Arizona*).
- The execution of mentally retarded criminals violates the cruel and unusual punishment clause of the Constitution (*Atkins v. Virginia*).

In March of 2005, the Supreme Court, via a 5–4 vote in *Roper v. Simmons,* ruled that the death penalty for juvenile offenders (for example, 16- and 17-year-old offenders) was unconstitutional.

The number of annual executions in the United States gradually increased in the 1990s, but then began to decrease along with a drop in the public's overall support for executions. In 2005 there were roughly 3,700 people on death row in the United States.

Conclusions

Despite imperfections in America's civil liberties system, even critics would concede that the scope of protection accorded the accused is extensive. Furthermore, the Supreme Court has strengthened democracy by expanding these individual freedoms through numerous decisions. In a comparable way, the Court has assisted the civil rights struggle, especially since 1954. We now turn to that topic.

■ CIVIL RIGHTS

The **civil rights** struggle for racial equality is symbolized by the time span between the 1896 *Plessy v. Ferguson* case and the 1954 historic *Brown v. Board of Education of Topeka* decision that declared the separate-but-equal segregation doctrine unconstitutional in public schools. However, the struggle to integrate the schools was far from over. Furthermore, new Supreme Court decisions and federal laws in subsequent decades were necessary in order to fight discrimination in public accommodations, employment, housing, and voting.

The Struggle for Black Equality and Racial Desegregation

The American civil rights movement began with the struggles of African Americans to abolish the abhorrent practice of slavery, establish legal equality, and end school segregation.

Slavery and the Civil War

The establishment and perpetuation of slavery in the South was a contributing factor leading to the Civil War. The infamous *Dred Scott* decision (1857) ruled that all blacks, slave or free, were not citizens and, therefore, had no right to sue in a federal court. The decision also held that Congress had no power to control the spread of slavery in the new territories. *Dred Scott* polarized the nation further and seemingly invalidated the series of political compromises between slave and free states that had forestalled a final political rift.

Once the war had begun, Lincoln's Emancipation Proclamation (1863) freed the slaves in the rebellious states. In 1865, the Thirteenth Amendment permanently abolished the institution of slavery. The Fourteenth Amendment (1868) asserted that all persons born or naturalized in the nation were citizens.

Its key provision on civil rights mandated that no state shall "deny to any person within its jurisdiction the equal protection of the laws." The Fifteenth Amendment (1870) asserted that a state could not deny the right to vote on "account of race, color, or previous condition of servitude."

The Civil Rights Cases and Plessy v. Ferguson

The three postwar constitutional amendments did not establish racial equality. Indeed, in the Civil Rights Cases of 1883, the Supreme Court overturned the Civil Rights Act of 1875, which had forbidden racial discrimination and separation in public accommodations such as hotels and theaters. The Court reasoned that the 1875 law had applied only to governmental acts of discrimination, not private wrongs. In *Plessy v. Ferguson* (1896), the Court ruled that the **separate-but-equal doctrine** was constitutional, in that separate facilities (in this case, railway cars in Louisiana) for the races, so long as they were equivalent in quality, did not violate the equal-protection clause of the Fourteenth Amendment. This decision sanctified legal segregation for the next fifty-eight years, with **Jim Crow laws** spreading throughout the South. African Americans were segregated from whites in virtually every societal aspect: schools, transportation, parks, public rest rooms, hospitals, prisons, and even in cemeteries. Violence toward African Americans was all too common as well. However, the National Association for the Advancement of Colored People (NAACP) was created in 1909 and led the fight to overturn this entrenched segregation pattern. The NAACP's legal goal was to show that "separate but equal" actually meant unequal educational opportunity and citizenship. The organization's efforts were centered on the federal courts.

Court Rulings Leading to Brown v. Board of Education of Topeka

In 1938, the Supreme Court began to chip away at the separate-but-equal doctrine in *Missouri ex rel. Gaines v. Canada*. The Court ruled that a Missouri law forbidding admission of a qualified black student to an all-white law school (there was no law school of equal quality for blacks in the state) was unconstitutional. In 1950, the Court decided that a separate University of Texas law school for African Americans was not equal in terms of prestige or reputation to the University of Texas law school attended solely by whites (*Sweatt v. Painter*). The judicial stage was set for the historic *Brown v. Board of Education of Topeka* decision.

The Brown Decision

On May 17, 1954 the Court held that educational segregation based on race was unconstitutional, a violation of the equal-protection clause of the Fourteenth Amendment. Chief Justice Earl Warren stated in his opinion that segregation implied racial inferiority: "Does segregation of children in public schools solely on the basis of race, even though the physical facilities and other tangible factors may be equal, deprive the children of the minority group of equal educational opportunities? We believe that it does.

. . . To separate them from others of similar age and qualifications solely because of their race generates a feeling of inferiority as to their status in the community that may affect their hearts and minds in a way unlikely ever to be undone. . . . We conclude that in the field of public education the doctrine of separate but equal has no place. Separate educational facilities are inherently unequal. Therefore, we hold that the plaintiffs and others similarly situated for whom the actions have been brought are, by reason of the segregation complained of, deprived of the equal protection of the laws guaranteed by the Fourteenth Amendment."

From 1954 to the Present

In 1955 the Supreme Court ordered in *Brown v. Board of Education* that public schools desegregate "with all deliberate speed" and that the lower federal courts oversee this process. However, the desegregation of some 2,200 public-school systems in the South and border states could not be accomplished overnight. Civil rights organizations, such as the NAACP, had to fund numerous lawsuits to force an end to school segregation. States such as Delaware, Maryland, and Kentucky rapidly complied with the Court's ruling. But resistance mounted in other Deep South states and in Congress. Some 101 southern congressmen signed the Southern Manifesto, a document claiming that the *Brown* decision was unlawful and suggesting the passage of a constitutional amendment overturning *Brown*. In Arkansas (1957), Mississippi (1962), and Alabama (1963), violence at Little Rock's Central High School, the University of Mississippi in Oxford, and the University of Alabama in Tuscaloosa, respectively, had to be quelled by National Guard or federal troops sent by Presidents Eisenhower and Kennedy.

Other states tried nonviolent methods of resistance to desegregation—from freedom-of-choice plans allowing students to select the school they wished to attend to providing tuition grants so students could attend private schools. However, the Warren Court ruled all of these schemes unconstitutional.

The Civil Rights Act of 1964

The segregation pattern was not shaken massively until passage of the Civil Rights Act of 1964, a time when ninety-eight percent of African-American children attended all-black schools in the South. Title VI of this statute linked a cutoff of federal aid to any local or state government that continued the practice of racial discrimination. Southern schools began to desegregate rather than lose badly needed federal funding. Within eight years, the number of totally segregated public schools in the South had declined substantially.

Northern Segregation and Forced Busing

In northern public schools, segregation was due mainly to residential housing patterns—what was called **de facto** (in fact) rather than **de jure** (by law) **segregation** sanctioned by government. The Supreme Court ruled that busing of black children to white schools (or whites to black schools) to achieve integrated school districts was constitutional if those school districts had intentionally segregated the races. Busing's goals were to improve the quality of black education, reduce the psychological stigma of segregation, and facilitate harmonious black-white race relations. In some cities, busing was effective; in others, such as south Boston, busing was violently resisted. Frequently, busing resulted in what was called **white flight** to the suburbs. Hence, inner-city schools, with far fewer whites, remained black-majority institutions.

The Modern Civil Rights Movement Challenging Discrimination in Public Accommodations, Employment, Housing, and Voting

Public Accommodations

The *Brown* decision did not end discrimination in public accommodations. But it sparked a new round in the civil rights revolution. In Montgomery, Alabama, the city's blacks engaged in a year-long boycott (1955–1956) of the city's buses, after an African-American woman, Rosa Parks, refused to sit in the rear of a bus. The boycott's leader was the Reverend Dr. Martin Luther King, Jr., who borrowed from

the nonviolent protest techniques used by Mahatma Gandhi against the British in India. In Greensboro, North Carolina, four black college students engaged in a sit-in at a segregated Woolworth's lunch counter, encouraging similar sit-ins around the country. But civil rights activists in Birmingham, Alabama, and Neshoba County, Mississippi, were attacked or murdered. The federal government responded with five separate civil rights laws during the 1957–1964 period, the most dramatic being the passage of the Civil Rights Act of 1964. The act prohibited racial discrimination in transportation lines, hotels, restaurants, sporting arenas, and other areas. Discrimination in public accommodations was now considered an illegal restriction of interstate commerce.

Employment

The Civil Rights Act of 1964 also outlawed employment discrimination on the basis of race, color, religion, national origin, sex, and age. The act covered employers who had at least fifteen employees on their payrolls.

In 1991, Congress passed legislation that extended for the first time punitive damages to victims of employment discrimination based on race, sex, or physical disability. Remedies for sexual harassment were expanded as well. Both Republicans and Democrats argued that racial minorities and women deserved greater protection against bias in hiring, promotion, and general workplace relations. The law was aimed at countering a series of 1989 Supreme Court rulings that had made it more difficult for workers to bring and win job-discrimination lawsuits.

Housing

The Civil Rights Act of 1968 banned discrimination on the basis of race, color, religion, national origin, or sex in the sale or rental of housing. However, the act has not initiated widespread changes in housing ownership or occupancy. Economic reasons and persistent discrimination have left the central cities mainly black; the suburbs mainly white.

Voting Rights and Overall Political Gains

The Voting Rights Act of 1965 abolished literacy tests that were used by southern states to block the vast majority of black citizens from voting. The act empowered the attorney general to send federal registrars into southern counties. The law was extended in 1970 and 1975 to include other minorities. In 1982 its provisions were renewed for another twenty-five years. In 1964 the Twenty-fourth Amendment also had abolished the poll tax as a barrier to voting.

The Voting Rights Act led to a dramatic increase in national black voter registration (more than twelve million by 1990) and African-American elected officials (in 1960 there were fewer than 300; by 2004 there were more than 8,500) in Congress and at the state and local levels of government. Many of America's largest cities—Washington, D.C., New York, Los Angeles, Detroit, Atlanta, Chicago, and Philadelphia—subsequently elected African-American mayors. In 1984 the Reverend Jesse Jackson became the first serious African-American presidential candidate. Renewed efforts to register more black voters resulted in Jackson's successes in the early 1988 presidential primaries and caucuses. More recently, during the administrations of George W. Bush, former Joint Chiefs of Staff Chairman and Secretary of State Colin Powell and National Security Advisor and Secretary of State Condoleezza Rice were touted as possible

African-American presidential candidates. Note that public opinion polls reveal that a majority of American citizens now accept the idea of and would vote for an African-American presidential candidate.

The civil rights revolution is far from over. However, since 1954, there have been accomplishments. *De jure* segregation has been abolished. Public accommodations have been totally desegregated. Educationally, the median number of years spent in school by African Americans is now comparable to that of whites. In two other areas—black family income and unemployment—there has been less progress. However, overall, many more white Americans believe that racial equality has been achieved since 1954 than do African Americans.

■ THE STRUGGLE FOR WOMEN'S EQUALITY

The struggle for legal, social, economic, and political equality between the sexes has involved the acquisition of the vote (Nineteenth Amendment); closing the salary differential; and eradicating discrimination in employment, education, and credit. Women have also fought to change existing public policies relating to maternity leave and to achieve progress in American political life and the U.S. military. Finally, the struggle over abortion rights has been an integral part of the women's civil rights movement since the Supreme Court's *Roe v. Wade* decision in 1973.

Early History

In the early 1800s, women had few political rights and were the victims of oppressive, protective paternalism. They were considered legally subservient to their husbands, could not own their own property, and could not even be admitted to the public schools. To the extent that they worked at all, menial jobs with long hours and low wages were their lot. By the middle of the nineteenth century, women became politically organized, first becoming involved in the struggle to abolish slavery, then with the suffrage movement after the Civil War. Led by Susan B. Anthony and Elizabeth Cady Stanton, the suffragettes fought successfully for the passage of the Eighteenth (prohibition of intoxicating liquors) Amendment in 1919 and Nineteenth Amendment in 1920, which guaranteed that "the right of the citizens of the United States to vote shall not be denied or abridged by the United States or by any State on account of sex." The struggle for equality would intensify again during the 1960s.

Women and the Workplace: Then and Now

By the 1960s millions of women were entering the labor market. By 1990 more than half of all women with children under six were either working or seeking employment. But their wages lagged behind those paid to men. By the early 2000s women still earned only about seventy to seventy-five cents for every dollar working men received for doing the same kind of work. (In addition, many women have lower-paying jobs due to less education or experience, a reflection of marriage demands and child-rearing.) Accordingly, women demanded that they should be paid equivalent salaries to men in those jobs that involved similar skills and effort. Women also held relatively few corporate management jobs when compared to men and were subjected to the **glass ceiling syndrome,** a clear limitation on promotions to those types of positions.

Discrimination in Employment and Education

The Civil Rights Act of 1964 prohibited sexual discrimination in hiring, firing, or promoting an individual. (The 1991 Civil Rights Act allowed women to sue small and medium-sized businesses for damages stemming from on-the-job sexual harassment or other acts of job bias.) The Education Amendments of 1972, including the well-known Title IX provision, prevent schools and colleges from discriminating against women in the areas of admissions, financial aid, and women's athletic programs.

Discrimination in Credit

Prior to the Equal Credit Opportunity Act of 1974, single women were usually refused loans by banks or denied credit cards. The theoretical assumption was that women would marry, become pregnant, and consequently renege on their debts. Even when loans were given to married couples, a woman's income was not counted as part of the family's total income base. The loan was recorded only in the husband's name. Consequently, widowed or divorced women frequently had no credit history. The act eliminated these abuses.

Discrimination and the Supreme Court

During the 1970s the Burger Court (see Chapter 9 for more on the Supreme Court) was active in invalidating state laws that discriminated against women in jury selection (Florida and Louisiana had drawn prospective juries only from lists of male voters), child support (Utah had required divorced fathers to support their daughters only to age eighteen but sons to age twenty-one, the assumption being that women would marry earlier), and employee pension plans (women retirees could not receive less pension money per month than male retirees). The Court also approved state statutes that prohibited the Jaycees and Rotary from barring women members (business contacts at these clubs were important to both men and women). The overall thrust of the Burger Court (and the Rehnquist Court) was to abolish the stereotype that "a woman's place is only in the home" and that men are the only breadwinners in the family. This attitude was implied in Justice William Brennan's 1973 opinion in *Frontiero v. Richardson,* in which a law treating men and women in the military differently was overturned. The Court also has ruled in the area of sexual harassment, compelling employers to take all necessary steps in the workplace to eliminate this practice.

Discrimination and Employment Leaves

A continuing discrimination issue for women is the granting of job leave for new mothers, either with some funding or the guarantee of job security upon returning to work. Approximately one hundred-sixty foreign nations do provide assistance to women on maternity leave. In the United States, women's groups have lobbied for a federal law mandating a four-month unpaid leave for a mother or father of a newborn child. Such a bill was passed by Congress in 1990, but it was vetoed by President George H.W. Bush. Today, the United States remains one of the very few major, industrialized nations that has no national law requiring paid maternity leaves. However, the 1993 Family and Medical Leave Act does require covered employers to grant an eligible employee up to twelve work weeks of unpaid leave during any twelve-month time frame. One reason for the leave would be "for the birth and care of the newborn child of the employee."

The Equal Rights Amendment

Led by such feminists as Gloria Steinem and Betty Friedan (author of *The Feminine Mystique*), the demand for women's equality was incorporated into the Equal Rights Amendment, submitted to the states by Congress in 1972. The ERA read as follows: "Equality of rights under the law shall not be denied or abridged by the United States or any state on account of sex."

Opponents of the ERA charged that the amendment would force women to be drafted, lead to unisex bathrooms, and undermine traditional marital and family values. Defenders saw the ERA as an important guarantee of equality. The proposed amendment never received the thirty-eight-state vote necessary for ratification, and politically died in 1982. However, the public still supports the concept. States also have passed their own equal-rights amendments. Recently, women's groups have urged that another ERA be submitted to Congress.

Women in Politics and the Military

Women have made progress in America's political life since the days of the ERA fight. Although they are clearly underrepresented in Congress (see Chapter 6), given their majority status in the general population, they have had a few historic breakthroughs, such as the rise of Nancy Pelosi to the Democratic House Minority Leader position in 2003. Prominent women U.S. Senators such as Hillary Clinton (D., New York) and Dianne Feinstein (D., California) have received national attention as potential presidential and vice-presidential candidates. Women also have been appointed to important cabinet posts (Madeleine Albright and Condoleezza Rice as Secretaries of State under Clinton and George W. Bush, respectively) and Supreme Court judgeships (Sandra Day O'Connor, a Reagan appointee, and Ruth Bader Ginsburg, a Clinton selection). Finally, women comprise close to twenty-five percent of the nation's state legislators.

Women who serve in the military (in 2005, they comprised fifteen percent of the Army and Navy and nearly twenty percent of the Air Force) have fought for equality in career opportunities, promotions, and combat duty. (Congress opened all of the service academies to women in 1975.) The law has prohibited women from official combat duties, but women did play an active role in Panama in 1989, in the Persian Gulf War in 1991, and as combat pilots and logistical leaders in the Iraq War that began in 2003. There is also the question of whether both men and women should be forced to register for the draft, although current federal statutes mandate only male draftees.

Abortion and the Right to Privacy

A final, vital, and divisive issue for many American women (and for men as well) is the right to an abortion, a privacy issue that has been deemed a derivative right from the First, Third, Fourth, Fifth, and Ninth Amendments (also see *Griswold v. Connecticut*, 1965). Currently, the 1973 Supreme Court decision in *Roe v. Wade* remains the national policy, asserting that a woman has a constitutional right to an abortion during the first trimester, the second trimester can involve state regulation to protect the mother's health, and the state could ban abortions altogether during the third trimester of pregnancy. The Court based the *Roe* decision on the right of privacy implied in the Fourteenth Amendment's due process clause.

Pro-choice (abortion support) groups were worried that the Rehnquist Court might eventually overturn *Roe*. In particular, the Court's ruling in *Webster v. Reproductive Health Services* (1989), which upheld the state of Missouri's right to impose new regulations and restrictions on abortion, troubled many pro-choice women. The *Webster* ruling barred public hospitals from performing abortions and banned the

use of public funds in advising women to have these operations. Conversely, **pro-lifers**—those opposed to abortion—welcomed the *Webster* ruling. In 1992, the Rehnquist Court upheld a Pennsylvania statute in *Planned Parenthood v. Casey,* which mandated that underage girls contemplating an abortion must obtain parental permission and that pre-abortion counseling be used.

The judicial controversy over abortion continued, including restrictions on demonstrators in front of abortion clinics and the invalidation of a Nebraska partial-birth-abortion law in 2000. However, in the final analysis, *Roe v. Wade* was not overturned. The death of Chief Justice William Rehnquist in 2005 and the emergence of a new era in the Court's ideological composition signified a strong probability that the Court would hear other cases challenging *Roe*'s constitutionality.

■ THE CIVIL RIGHTS STRUGGLE OF OTHER GROUPS— HISPANICS, NATIVE AMERICANS, ASIAN AMERICANS, THE DISABLED, SENIOR CITIZENS, AND HOMOSEXUALS

The civil rights struggle has been extended to other groups in American society that collectively believe they face discrimination and/or the lack of equal opportunity in America. As discussed in the following sections, those groups include Hispanic Americans, Native Americans, Asian Americans, the disabled (see the Americans with Disabilities Act), senior citizens, and homosexuals. These groups have developed their own political organizations in order to promote their demands before the courts and/or Congress.

Hispanic Americans

Nearly fourteen percent of the American population is composed of Hispanic Americans. Those of Mexican descent number two-thirds of the Hispanic population, followed by Puerto Ricans, Cubans, and immigrants from Central and South America. Collectively, Hispanic Americans are the fastest-growing minority group in the nation and have now surpassed African Americans in total numbers. Indeed, by the middle of this century, Hispanics could account for one-quarter of the entire U.S. population.

More than twenty percent of Hispanic Americans live at or below the poverty line. Unemployment is a serious problem. Many are exploited by employers, being paid substandard wages in urban sweatshops or as rural farm workers. Educationally, Hispanics experience language problems, significant illiteracy, high drop-out rates from school, and fewer numbers of college graduates than other minorities. In the past, Hispanic children also have attended underfunded and segregated schools.

Politically, Hispanic Americans accounted for only five percent of congressional membership during the 109th Congress. However, the concentration of Hispanics in key electoral-vote states, such as California, Florida, Texas, and Illinois, has attracted the interest of both political parties. In addition, Hispanic voting turnout is growing (note that low-income Hispanics vote in greater numbers than low-income whites). Hispanics have formed important political organizations, such as the League of United Latin American Citizens (LULAC) and the Mexican American/Puerto Rican Legal Defense and Education Fund. These groups are also active in fighting discrimination through the federal courts.

Native Americans

When America was discovered by European explorers, there were probably ten to fifteen million Indians or Native Americans living in the New World. Today, there are about two million Native

Americans residing on American soil. Concentrated in western states and Alaska, slightly less than half of the total Native American population lives on government reservations where low income, high mortality rates, and other social problems are common.

The federal government's policy toward Native Americans has vacillated from treating them as citizens of separate, independent nations to attempting complete **assimilation** (the idea of "civilizing" the Indians and bringing them into white society). Congress has granted Indian tribes the right to develop their own constitutions, determine tribal membership, and handle their own systems of justice. Still, Native Americans were not awarded the full rights of American citizenship by Congress until 1924. Despite being citizens, Native Americans were denied the right to vote for decades by some states.

Native Americans became more politically militant in the 1960s, when groups such as the National Indian Youth Council and the American Indian Movement (AIM) began protesting federal policy toward their ancestral lands, past treaties, and ownership of mineral resources. In 1972 Indian groups marched on Washington D.C., protesting the policies of the Bureau of Indian Affairs (BIA). In the two decades since, Native Americans have intensified their political efforts in order to right historic wrongs and to restore fully their civil rights. They also have been helped economically by the 1988 Indian Gaming Regulatory Act that permitted casino gambling operations on their tribal lands.

Asian Americans

Although Asian Americans today have greater median incomes than either Hispanics or Native Americans (or whites, for that matter), they also can document previous acts of discrimination. Historically, the nineteenth and twentieth centuries witnessed Chinese and Japanese immigrants enduring prejudice in schooling, employment, and property ownership. The most egregious case occurred in 1942, when, as a reaction to the Japanese attack on Pearl Harbor, President Franklin Roosevelt signed an executive order placing 120,000 Japanese Americans living on the Pacific Coast into internment camps in seven western states. These citizens were forced to sell their property at a loss. They remained interned until 1945. (Some of the younger men served in segregated Japanese-American army combat units in the European campaign.) In 1988 Congress authorized compensation of $20,000 to each of the 60,000 camp survivors. Despite these setbacks, Japanese Americans today have the highest median number of years of schooling (in fact, forty percent of Asian Americans over the age of twenty-five are college graduates) and family income of any ethnic group in the nation.

The most recent wave of Asian immigration has been that of the Vietnamese, who escaped their country after communist forces were victorious in 1975. More than a million refugees came to the United States. Despite encountering some community prejudice, Vietnamese Americans have been reasonably successful in America. Less than one-third of Vietnamese-American families depend upon welfare. A number have become owners of small and mid-sized businesses.

Senior Citizens and the Disabled

As Americans live longer, senior citizens—that sector of the U.S. population over sixty-five (now thirteen percent; by 2040, it is possible that figure will double)—have developed into a potent political force (they have high voter turnout rates as well). Organizations supporting the interests of the elderly include the Gray Panthers and the American Association of Retired Persons (AARP). The elderly have

fought for legislation abolishing age discrimination in employment, better medical benefits, and extension of Social Security benefits.

The disabled also have demanded more equitable treatment from society. They have acquired wheelchair ramps for better access to public buildings, demanded handicapped parking spaces, and sought opportunities to learn through special-education programs. In 1990 the Americans with Disabilities Act (ADA) was passed and signed into law by President George H.W. Bush, which guarantees the rights of all handicapped citizens along with mandated accessibility to public buildings.

Gay and Lesbian Rights; Same-Sex Marriages

Estimates are that homosexuals (or **gays**) comprise anywhere from one to ten percent of the U.S. adult population. This significant minority group has fought against discrimination, based largely on lifestyle and in hiring, housing, and public accommodations. In addition, the growing problem of AIDS, or acquired immune deficiency syndrome, a fatal disease affecting mainly homosexual males, intravenous drug users, and recipients of blood transfusions, has complicated the struggle for gay and lesbian rights. Nevertheless, nearly 250 American cities have laws prohibiting discrimination against gays, and recent Gallup polls have found that a majority of Americans also favor equal job opportunities for gays.

Gay organizations, such as the Gay Liberation Front, have lobbied for homosexual rights vis-à-vis federal hiring procedures, membership in the military, easing of immigration policies, and even hiring in private law firms. Gay groups have gradually acquired considerable political power, especially in such cities as San Francisco, Houston, New York, Denver, and Washington, D.C. Gay organizations also have successfully pressured Congress to appropriate additional funds for AIDS research and treatment.

A recent issue confronting the gay community is the controversy over same-sex marriages. In 2004 thirteen states banned such marriages, on the grounds that marriage is conventionally and only defined as a union between a man and woman. By 2005 the ban was extended to nineteen states. From polls, it also appears that a majority of the public does not favor same-sex marriages, either. Congress passed the 1996 Defense of Marriage Act that, in effect, denied federal recognition. Conversely, states such as Vermont and Massachusetts allowed the practice, either through civil unions or actual endorsement of the relationship.

■ AFFIRMATIVE ACTION AND CIVIL RIGHTS

All of the previously discussed civil rights legislation prohibiting discrimination does little to overcome the effects of past discriminatory practices. The federal government's answer has been the policy of **affirmative action,** mandating that most employers, both public and private, make an earnest effort to hire and/or promote minority workers: women, African Americans, Hispanics, and so on. True equality of opportunity became the goal. However, critics assert that this policy is tantamount to reverse discrimination, whereby blacks or women are hired on the basis of their race or sex, not on their actual merits or qualifications. Consequently, the states have moved to eliminate affirmative action programs (including those relating to jobs, schools and universities, and contracting) formerly implemented by their government agencies. Both California's Proposition 209 and a comparable Washington state referendum in 1998 accomplished this policy through approval by voters in each state. The U.S. Supreme Court also has wrestled with affirmative action in a number of important rulings, as described in the following sections.

Regents of the University of California v. Bakke

In 1979 Alan Bakke, a qualified white male, applied to the university's medical school at Davis, California. But sixteen of the one hundred seats for the entering freshman class were assigned to non-white students, with several less qualified than Bakke. Bakke claimed reverse discrimination, arguing that the college policy constituted a violation of the Fourteenth Amendment's equal protection clause. The Supreme Court, while ordering Bakke to be admitted, also ruled that rigid racial quotas were inappropriate for university admission affirmative action programs, but that race could be used as one of several eligibility criteria in affirmative-action decisions.

United Steelworkers v. Weber

In this case, Brian Weber, a white steelworker, was rejected from a training program primarily aimed at increasing the number of blacks in the workforce. Weber charged reverse discrimination, but the Supreme Court (1979) ruled that the training programs, although founded on quotas, were constitutional, because they corrected racial imbalances in employment.

United States v. Paradise *(1987)*, Adarand Constructors v. Pena *(1995)*, Gratz v. Bollinger *(2003)*, *and* Grutter v. Bollinger *(2003)*

The *Paradise* (1987) case involved the Alabama Department of Public Safety, which had discriminated in the hiring and promoting of black state police officers. The Supreme Court supported a lower-court decision that had ordered one black trooper promoted for each white trooper promoted. Past discrimination toward black officers had to be overcome through equitable treatment now and in the future.

In *Adarand,* the Court decided that the concept of strict scrutiny would apply to future affirmative action cases; that is, affirmative action programs would have to demonstrate that they served a "compelling government interest." The programs would have to narrowly constructed so as to combat specific cases of discrimination.

In the *Bollinger* cases, the question of affirmative action and admission for two rejected white women to undergraduate and law school programs at the University of Michigan (U of M) was considered by the U.S. Supreme Court. In *Gratz,* the Court found that U of M's practice of awarding bonus points to under-represented undergraduate minority applicants represented an improper use of racial quotas and was a violation of the equal protection clause of the Fourteenth Amendment. But in *Grutter,* U of M's Law School's admissions policy of showing some preferences to minority law school candidates through formal, careful review, rather than an automatic bonus points approach, was ruled consistent with the higher objective of promoting diversity or what U of M called a critical mass of minority applicants.

Civil liberties guarantee individual freedoms of speech, religion, press, assembly, and petition against governmental interference. Similarly protected are the rights of the accused: no double jeopardy, protection against self-incrimination, the right to bail, the right to counsel, and others. These rights collectively are a further reflection of the innocent-until-proved-guilty principle of jurisprudence. However, civil liberties are not absolute. They can be limited by government, especially if the abuse of liberty leads to a clear and present danger.

The original Bill of Rights affected only the federal government. It required the process of incorporation to apply these rights to state governments as well. The incorporation process started with the case

of Gitlow v. New York *(1925), the first time that the due process clause of the Fourteenth Amendment was applied to state law.*

Civil rights involve the protection of both groups and individuals against state discrimination based on the suspect criteria of race, national origin, age, or sex. The historic, generational struggle over civil rights has involved African Americans, women, Hispanic Americans, Native Americans, gays, and other minorities. African Americans fought the institution of slavery, then segregation. In 1954, the Brown *decision finally overturned the separate-but-equal doctrine. Voting inequality and discrimination in housing, public accommodations, and employment also have been subjects of concern for African-Americans. The federal government has passed civil rights acts and other laws designed to rectify these ills. In the women's civil rights struggle, the right to vote and "liberation" from a traditional societal stereotype occupied the earlier phases of the movement. Modern issues of concern for women include comparable worth, abortion, service in the military, sexual harassment, and educational equality, among others. Other minorities also have sought equality of opportunity, especially through such contemporary policies as affirmative action. However, affirmative action policies have encountered increasing criticism in the past decade or so.*

Selected Readings

Anderson, Terry. *The Pursuit of Fairness—A History of Affirmative Action* (2004).

Bollinger, Lee C., and Geoffrey Stone, eds. *Free Speech in the Modern Era* (2002).

Brown, Dee. *Bury My Heart at Wounded Knee* (1971).

Cornell, Stephen. *The Return of the Native: American Indian Political Resurgence* (1988).

Cushman, Robert F. *Cases in Civil Liberties,* 5th Edition (1989).

Faux, Marian. *Roe v. Wade: The Untold Story of the Landmark Supreme Court Decision That Made Abortion Legal* (1988).

Freedman, Estelle B. *No Turning Back: The History of Feminism and the Future of Women* (2002).

Kessler-Harris, Alice. *Out to Work: A History of Wage-Earning Women in the United States* (1982).

Kluger, Richard. *Simple Justice: A History of Brown v. Board of Education and Black America's Struggle for Equality* (1976).

Levy, Leonard W. *The Establishment Clause: Religion and the First Amendment* (1986).

Moats, David. *Civil Wars: A Battle for Gay Marriage* (2004).

Test Yourself

1) Which of the following Supreme Court cases did not deal with the establishment clause?
 a) *Engel v. Vitale*
 b) *Van Orden v. Perry*
 c) *Texas v. Johnson*
 d) *Agostini v. Felton*

2) True or false: The 2002 Supreme Court case of *Zelman v. Simmons-Harris* upheld the constitutionality of the Cleveland, Ohio, school-voucher system.

3) The case of *New York Times v. United States* dealt with the core issue of
 a) libel and slander
 b) symbolic speech
 c) shield laws
 d) prior restraint

4) True or false: Currently, a federal shield law protects a journalist from having to divulge his or her confidential sources to a federal grand jury.

5) The 1961 case of *Mapp v. Ohio* established the
 a) exclusionary rule
 b) clear and present danger rule
 c) absence of malice rule in libel and slander cases
 d) none of the above

6) True or false: Double jeopardy means that no individual may be tried a second time for the same offense.

7) Which constitutional amendment forbids cruel and unusual punishment?
 a) First
 b) Fifth
 c) Sixth
 d) Eighth

8) True or false: In the case of *Atkins v. Virginia,* the Supreme Court ruled that the death penalty for juvenile offenders was unconstitutional.

9) The incorporation process began with which of the following cases?
 a) *Lemon v. Kurtzman*
 b) *Gitlow v. New York*
 c) *Engel v. Vitale*
 d) *Reynolds v. United States*

10) True or false: A local community can legally censor books, movies, or plays that it considers obscene.

11) The institution of slavery was permanently abolished by which constitutional amendment?
 a) Thirteenth
 b) Fourteenth
 c) Fifteenth
 d) none of the above

12) True or false: States in the South immediately complied with the *Brown* ruling by desegregating their school systems.

13) Segregation sanctioned by government is termed _____ segregation.
 a) *de facto*
 b) *de jure*
 c) constitutional
 d) none of the above

14) True or false: Hispanics are the fastest growing minority group in the nation.

15) The 2003 Supreme Court cases of *Gratz v. Bollinger* and *Grutter v. Bollinger* dealt with the issue of
 a) affirmative action and school admissions
 b) the incorporation clause of the Fourteenth Amendment
 c) gay rights and same-sex marriages
 d) the rights of the disabled and their access to public buildings

16) True or false: Due to the civil rights movement, women today earn nearly the same salary as men do for the same job or work.

17) Today, _____ million Native Americans reside on U.S. soil.
 a) two
 b) three
 c) four
 d) five

18) True or false: According to public opinion polls, an overwhelming number of Americans support same-sex marriages.

19) Which ethnic group has the highest median number of years of schooling and family income in America?
 a) Native Americans
 b) Cuban Americans
 c) Asian Americans
 d) African Americans

20) True or false: In general, California's Proposition 209 was supportive of state affirmative action policies.

Test Yourself Answers

1) **c.** *Texas v. Johnson* dealt with the constitutional issue of flag burning, or symbolic speech. Choices a, b, and d dealt with school prayer, displays of the Ten Commandments, and public dollars going to religious schools, respectively.

2) **True.** The voucher system was seen as upholding a secular purpose, not a religious objective.

3) **d.** This case involved the stopping of further publication of the Pentagon Papers, top-secret documents explaining the real reasons behind U.S. involvement in the Vietnam War. The Supreme Court ruled that the public's right to know superseded governmental secrecy.

4) **False.** Currently, there is no federal shield law. However, more than thirty states do have shield laws.

5) **a.** The exclusionary rule means that evidence that is improperly obtained cannot be used as evidence in a court of law. *Mapp* established that rule.

6) **False.** This is not quite correct. Double jeopardy means that an individual cannot be tried for the exact same crime once found *innocent* of that crime. However, individuals can be tried twice: once in state and then in federal court. Also, if found guilty, an individual can be tried again if new evidence warrants another trial.

7) **d.** The Eighth Amendment contains this prohibition. None of the other amendments listed has this provision.

8) **False.** *Atkins v. Virginia* prohibited the execution of mentally retarded criminals. It was *Roper v. Simmons* that declared the execution of juvenile offenders unconstitutional.

9) **b.** In *Gitlow,* the Court ruled that freedom of speech could not be impaired by the states. *Lemon* dealt with the government violations of the establishment clause, *Engel* with school prayer, and *Reynolds* with the issue of polygamy.

10) **True.** The Supreme Court has left the question as to what constitutes obscenity to each community. Local community standards, if in conflict with a book's or motion picture's values, can allow local leaders to censor such forms of entertainment.

11) **a.** The Fourteenth Amendment asserted that all persons born or naturalized in the nation were citizens. The Fifteenth asserted that a state could not deny the right to vote on account of "race, color, or previous condition of servitude."

12) **False.** The South resisted for a considerable period of time, despite the Supreme Court ordering in 1955 that public schools be desegregated "with all deliberate speed."

13) **b**. *De jure* segregation is by law, where *de facto* (in fact) is segregation occurring through housing or related economic patterns. "Constitutional" is nonsensical.

14) **True.** Hispanics may constitute one-quarter of the nation's population by the year 2050.

15) **a.** The two cases involved affirmative action programs at the University of Michigan and its admission policies involving minority applicants at the undergraduate and law school levels.

16) **False.** Women earn only about seventy-five cents of every dollar awarded to men who are doing the same job.

17) **a**. Most are concentrated in western states and in Alaska.

18) **False**. A majority of Americans are opposed to the practice.

19) **c**. In addition, forty percent of Asian Americans over the age of twenty-five are college graduates.

20) **False.** Proposition 209, approved by the voters in California, was based on eliminating "reverse discrimination" affirmative action programs by state agencies in the areas of jobs, schools and universities, and contracting.

Public Policy

One definition of politics (see Chapter 1) is the story of "who gets what, when, and how." In other words, the various political institutions that have been previously covered in this book are all concerned, directly or indirectly, with establishing public policies: laws, regulations, or decisions. Policies represent the final authoritative allocation of values. But governmental inaction can also represent a policy decision in and of itself.

The two general categories of public policy covered in this chapter—domestic and foreign (or national security)—impact heavily upon every citizen of the United States, both economically and socially. But even more important, the effectiveness of governmental policies determine whether the pressing social, economic, and international problems confronting American society will ultimately be resolved.

■ THE POLICYMAKING PROCESS

Every policy is shaped by both public and private actors and their interests, a framework of beliefs or attitudes toward a policy proposal, and the formal rules and institutions ingrained in the democratic political process. These factors are implicit in each of the policymaking stages described in the following sections.

What steps do governmental leaders take in order to develop a policy solution in answer to a pressing national problem? The policymaking process can be compartmentalized into five steps or stages.

Identification of the Problem and Agenda Setting

The problem must be recognized or identified as a problem by governmental leaders and placed on the **set of issues** (the **agenda**) being considered at a particular point in time. For example, the problem of equal pay for working women was not on the political agenda in the 1940s and early 1950s because most women stayed at home to raise families. However, the entrance of millions of women into the work force gradually turned this potential problem into a recognizable, serious issue for the public, concerned interest groups, Congress, the president, and the judiciary. Working conditions for women remain on the

national agenda in the early twenty-first century. Similarly, an increase in the nation's crime rate, once identified and placed upon the agenda as a major social and economic problem, may prompt calls from legislators and law enforcement personnel for the construction of new prisons and tougher jail sentences.

Policy Formulation

Policy formulation refers to creating an **action plan,** involving ways of solving a particular problem. Who develops this plan? Participants may include executive, legislative, and interest-group representatives. Many interest groups have ready-made policy solutions that they have been advocating for some time, and they wait for the emergence of the right problem upon which they can piggyback their ideas (for example, gun control groups after the Columbine school shootings).

However, it is rare that only one proposal is developed or that it receives unanimous support from all concerned parties. Conflicting proposals or reformulation of original plans is the norm. For example, the nation's growing reliance on imported oil is criticized by energy experts, but these experts come up with different action plans to reduce oil imports, such as promoting solar power, building more nuclear power plants, or even giving oil companies bigger tax breaks to encourage domestic drilling. While these and other energy proposals are discussed and debated, the original problem only grows worse: Today, the nation imports over sixty percent of its oil from foreign sources; in the early 1970s, the figure was one-third.

Policy Adoption

Policy adoption means that the formulation plan or plans have been converted into a concrete government response, usually in the form of a law passed by Congress. But the mere passage of a law does not mean that the problem is solved. For example, Congress has appropriated millions of dollars to prosecute the war against drugs in America. Yet, all indications are that the drug problem in America is worsening, rather than improving.

Policy Implementation

Implementation, or the carrying out of a policy, is essential to its effectiveness. When the Supreme Court ruled segregation unconstitutional (see Chapter 10), other institutions and public personnel had the responsibility of making integration a reality. Similarly, when Congress passes legislation mandating specific clear-air standards in America's large metropolitan areas, it is the Environmental Protection Agency (EPA) that must enforce those standards. Implementation can fail because of poor communication between policy formulators and implementers, inadequate resources to perform the implementation process (a cut in EPA funding would mean fewer inspectors), and poor attitudes toward the policy by the implementers (relevant bureaucrats could disagree with the wisdom of the policy).

Policy Evaluation

Policy evaluation involves judging what the operational consequences of a particular policy have been over time. A well-intentioned policy could create more harm than good. A classic case was Prohibition during the 1920s, when the manufacture and sale of alcoholic beverages were forbidden. But this attempt to legislate social morality led to bootlegging, crime, and illegal bathtub gin. Prohibition was eventually repealed by the Twenty-first Amendment. A more recent example involved the decision to construct a national interstate highway system in the 1950s. However, while the construction of the

system helped the economy and assisted individual mobility, it also led to traffic congestion and an increase in air pollution over subsequent decades. Conversely, clean air and water laws passed by Congress in the 1980s and 1990s have undoubtedly led to healthier air and drinking water in communities throughout the nation. For some issues, such as the 1996 Welfare Reform Act, the long-term impact remains an open question. Hence, it may take years of evaluation to determine the ultimate success or failure of complex public policies.

■ TYPES OF DOMESTIC AND FOREIGN POLICIES

Public policy can be divided into three broad categories: domestic, foreign, and defense.

Domestic Policy

Political scientists perceive three types of **domestic policy** (those dealing with issues within the United States): regulatory, distributive, and redistributive.

Regulatory Policy

Regulatory policies exert federal controls over individuals and corporations. Typical policies cover the protection of consumer rights and the environment.

Distributive Policy

Distributive policies involve direct government benefits to individuals, groups, and business firms. Examples include federal subsidies (payments) to the nation's farmers and federal support for research among the nation's pharmaceutical laboratories.

Redistributive Policy

Redistributive policies confer social benefits or entitlements, such as jobs or money, to specific groups through the transfer of resources (typically in the form of taxes) from other groups. Typically, people think of welfare payments to the poor as falling within this category. Other examples include the Head Start program for less-advantaged children in preschool and Social Security payments to retired senior citizens from the accumulated paychecks of younger workers.

Foreign Policy

Foreign policies can be either regulatory or distributive in relation to other nations. Trade sanctions directed at a nation would be aimed at modifying (or regulating) its behavior. Thus, in 1991, the United States and other western nations placed an economic boycott against Iraq in hopes that these pressures would force Iraq to withdraw from Kuwait (it did not). A distributive foreign policy is exemplified by a foreign-aid program to a specific nation, such as U.S. aid to Egypt or Israel.

Defense Policy

Defense policies deal with military or national security matters. Defense policy can fall into either the strategic or structural subcategory.

Strategic Defense Policy

Strategic defense policy deals with the utilization and location of military units overseas. For example, there were repeated calls by U.S. defense experts to begin the withdrawal of U.S. troops from Western Europe after the demise of the Soviet Union.

Structural Defense Policy

Structural defense policy is distributive in the sense that it deals with how defense resources—manpower, weapons, and funds—will be allocated. For example, a congressional decision to close military bases in a particular state or region of the nation will mean a loss of defense dollars to that region. Another example is the Defense Department's decision to build a new tactical fighter for the U.S. Air Force. The defense company receiving the government contract will make a good profit; in addition, the federal contract, worth billions of dollars, will benefit the economy of the community where the corporation is located.

■ DOMESTIC POLICYMAKING AND THE ECONOMY

Until the Great Depression, the prevailing economic philosophy in America was that of *laissez faire,* meaning that the federal government could aid corporations through subsidies or tax breaks, but also had to refrain from intervening in or closely regulating the marketplace. The collapse of the national economy after the stock market crash in 1929 changed this thinking forever. President Franklin D. Roosevelt's **New Deal programs** bequeathed a legacy of active governmental management of the economy. Consequently, today the federal government relies on monetary and fiscal policies in its efforts to create stable prices, low inflation, low unemployment, and high productivity.

Monetary Policy

Monetary policy refers to government controls over the amount of money in circulation and the cost of credit. The **monetarist** school of economics was led by economist Milton Friedman, who argued that the national money supply should be carefully correlated with the rate of economic growth. The principal institution coordinating monetary policy is the **Federal Reserve System,** often called the **Fed.**

The Federal Reserve System

Established in 1913 the Federal Reserve System (FRS) is composed of twelve regional banks and the Federal Reserve Board (FRB). Approximately 7,800 depository banks are members of the system. The FRB is directed by a seven-member board of governors who are appointed by the president to fourteen-year, staggered, nonrenewable terms in office. The FRB chairman (Alan Greenspan held this position from 1987 through 2005) has a four-year renewable term (all FRB appointments are confirmed by the Senate). The FRB is relatively independent of presidential and congressional controls.

The Fed's Operation

Banks that are members of the FRS can borrow from one of the twelve regional banks. But the Fed can regulate the economy through these loans. The Fed can:

- Raise or lower member banks' deposit requirements (this determines how much money is available for loans to citizens or businesses).

- Increase or decrease the discount (interest) rate charged to member banks (the cost of private loans will go up or down), a practice that is the Fed's most important tool.
- Buy or sell government bonds and securities, thus contracting or expanding the money supply.

So, the Fed increases the supply of money when economic growth is sluggish or unemployment is high (more money available will encourage purchases and investments, helping business growth and the creation of jobs), or decreases the money supply when the economy is experiencing **hyperinflation** (too much money is chasing too few goods). For example, the Fed will combat a lingering recession by cutting the discount rate anywhere from one-quarter to one percentage point. The hope is that lower interest rates will bolster a sagging economy.

Fiscal Policy

Fiscal policy involves managing the economy through changes in government spending, borrowing, and tax rates. Its intellectual roots can be traced to the ideas of British economist John Maynard Keynes. Keynes reasoned that depressions occurred because individuals stopped spending and investing, thereby causing reductions in productivity, jobs, and wages. Under these circumstances, government would have to increase its spending (even if it had to borrow funds) to assure maximum production and high employment. Note that Keynesian economics is personified in the Employment Act of 1946, a policy that made the government responsible for managing the economy's long-term development. The act's basic goals were to "promote maximum employment, production, and purchasing power," thus destroying forever the laissez-faire approach of minimal federal economic involvement.

Conversely, periods of inflation should be countered by the government's raising tax rates to reduce the amount of money in circulation.

Supply-Side Economic Theory

A different fiscal approach became popular in the 1980s during the presidency of Ronald Reagan. **Supply-side economics** stressed that tax cuts would encourage people to save, leading to an accumulation of investment capital and improved national productivity. This renewed economic activity would, over time, yield substantial government tax collections, covering any revenue lost through the original tax-cut process. Unfortunately, the theory did not work completely in that personal savings actually declined. Still, the economic lives of Americans were better off in the short run, with both income and personal consumption increasing sharply. After the recession of 1982, the economy did improve overall from 1983 to 1986. However, government budget deficits soared during the Reagan years, creating a problem that plagued the George H.W. Bush presidency.

The Federal Deficit

When the federal government spends more than it takes in through tax receipts, the government is said to run a **deficit.** The total of all past deficits equals the **gross national debt.** Although national deficits are not new, the growth of debt in the past was closely related to the ability of the economy to repay that debt. What was disturbing about the deficits of the 1980s was that the nation's gross national product (the monetary value of all goods and services produced annually; often expressed as GNP) was not growing fast enough to offer any hope of repayment. Furthermore, deficits shifted massive debt to

future generations, who would be burdened with the bills for current public services. The growing interest on the national debt also prevented needed dollars from flowing into the private sector for productive investment by businesses and households. During the Clinton administration a surging economy actually led to a budgetary surplus. However, after the attacks of 9/11/01 and the U.S. interventions in Iraq and Afghanistan, the deficit returned with a vengeance during the presidency of George W. Bush.

To reduce the federal deficit, political leaders either have to raise taxes or cut government spending (or both). Neither option is popular with the voters. Raising taxes hurts the individual's pocketbook, breeding political resentment toward officeholders; cutting spending may harm programs that are popular with different constituencies, such as farm subsidies. In short, everyone favors reducing the deficit in principle, but no one wants to pay the political piper by having to sacrifice income or self-interest.

Another reason is the inherent difficulty of cutting the federal budget. Much of the budget is devoted to programs that are politically uncontrollable or deemed economically essential: Social Security, federal retirement programs, interest on the national debt, or Medicare. One estimate is that spending on discretionary programs accounts for only a little more than twenty percent of the entire budget. The amount spent on national defense is a controllable budgetary item, but severely cutting military preparedness is considered a risky option in a world of innumerable threats to the nation's security.

The Gramm-Rudman-Hollings Act. In 1985 Congress tried to grapple with the deficit through the **Gramm-Rudman-Hollings Act.** The act created a schedule of reduced deficits so that the federal budget would eventually be balanced by 1993. Each year, if necessary, automatic cuts in both domestic and defense programs would allow deficit reductions to occur (some programs were exempt from cuts, such as Social Security). However, the act's effectiveness was diluted by congressional reliance on creative bookkeeping (for example, the cost of the savings-and-loan bailout was kept off budget so that the billions of dollars involved would not be added to the deficit) and delaying expenditures until the next fiscal year.

The Debate Over a Balanced-Budget Amendment. Another proposed solution for the deficit was to add a constitutional amendment mandating that Congress match tax revenues and government's projected spending each fiscal year. The amendment would have two escape clauses: Congress could waive the balanced budget requirement in wartime or through a two-thirds vote in both the House and Senate. Proponents argued that the amendment would, by law, eliminate future deficits. Opponents asserted that the amendment would inhibit the oft-needed economic stimulus of government spending and render fiscal policy approaches null and void. In general, the political momentum for a balanced-budget amendment has waned considerably.

Federal Taxation Policy—The Problem of Fairness

Benjamin Franklin once observed that nothing is certain in life "except death and taxes." Although most Americans do not like to pay taxes, they accept the idea that taxes are the "price we pay for civilization" (a quote attributed to Supreme Court Justice Oliver Wendell Holmes). But in recent years, citizens have charged that the American tax system is unfair. Tax cheating and evasion are becoming more common among all classes of taxpayers.

Progressive and Regressive Taxation. A **progressive tax** is based upon the idea that the higher one's income, the higher the rate of taxation one is supposed to pay. For example, in 2005 an individual with income under $7,300 was in the ten-percent marginal tax rate, but an individual with an annual income of over $326,450 faced a thirty-five percent marginal tax rate. But critics have long charged that the wealthy do not pay their fair share of taxes, due to countless loopholes and tax shelters in the law (however, other observers note that upper-income citizens pay a disproportionately high share of the federal income tax). Defenders of tax breaks for the wealthy argue that the American economy requires private capital. Wealthy people must be encouraged to invest extra money acquired through tax savings. For example, high-income citizens can buy municipal bonds and accumulate tax-free interest. But the average wage earner must pay taxes on any interest he or she accrues in a typical savings account. Critics also point to the Social Security payroll tax being **regressive**—that is, the **tax** falls more heavily on poorer citizens than the wealthy.

The 1986 Tax Reform Act and Subsequent Tax Reform Plans; the Flat Tax and Consumption Tax Proposals. In 1986 Congress tried to simplify the tax process by lowering tax rates and reducing tax brackets from fourteen to four. Many tax deductions were abolished or limited (one example: a business person's lunch was reduced to eighty-percent deductibility instead of the former 100-percent figure; the deductibility figure two decades later had been lowered to fifty percent). Millions of poor people no longer had to pay any taxes whatsoever. However, the act did not resolve the issue of fairness. Four years after the act, studies revealed that the upper-middle-income class was still paying a higher tax rate than the wealthy. Also, many large corporations remained undertaxed. The resulting furor led Congress and President George H.W. Bush in 1990 to tinker again with the tax laws. While the progressivity of the income tax was apparently improved, new federal taxes on cigarettes, alcohol, wine, beer, and gasoline were clearly regressive (the poor and middle-class taxpayers would spend a greater proportion of their income on these taxes than the wealthy). Subsequent attempts at simplifying the tax system occurred under the Clinton administration (1997) and President George W. Bush (2004). Despite these efforts, the tax system remains far too complicated for the average U.S. citizen.

To help simplify that tax system, proposals for a **flat tax** and consumption tax have been put forth by reformers. A national flat tax would eliminate the current tax code's system of complex deductions, credits, and exemptions with a simple fixed percentage on income above a certain level. The flat tax has been adopted by other nations (specifically in Eastern Europe), but has made little headway in the United States.

A **consumption tax** concentrates on what people actually spend (subtracting an individual's savings from his or her actual earnings). The consumption tax would be progressive in application and also have the advantage of dispensing with lengthy tax forms and deductions.

■ DOMESTIC POLICY: SOCIAL WELFARE, INCLUDING SOCIAL INSURANCE AND REGULATION PROGRAMS

As with economic policy, the federal government did not become massively involved in social policy until the onset of the Great Depression in the 1930s. Since that time, there have been two general kinds of government programs:

- Public-assistance programs that provide benefits to the poor, commonly called welfare.
- Social insurance and regulation programs that try to meet the needs of the general public.

Assisting the Poor

Even though liberals and conservative differ over the reasons poverty exists, state/local governments and Congress have still enacted a significant number of laws designed to help the poor and the homeless. Federal programs have included AFDC, TANU, Medicaid, food stamps, SSI, and Social Security.

Why Are People Poor? Conservative and Liberal Views

Political conservatives argue that people are poor because they are lazy, come from broken homes, or cannot discipline themselves to plan for the future. Conservatives oppose welfare programs on the grounds that they destroy the incentive to work, reward indolence, and create a cycle of dependency. Conversely, political liberals argue that society has failed to train or educate the poor properly. Government also has the obligation to ensure a decent standard of living for all Americans. Finally, racial and sexual discrimination is another cause of poverty.

Who Are the Poor?

In 2004 thirty-seven million people in America were classified as **poor** (the exact number can vary, depending upon current economic conditions in the nation), which is defined as falling below the federal government's official poverty line, which in 2004 was equivalent to an annual income of $18,850 for a family of four. The demographic characteristics of the poor include minority-group members (African Americans, Hispanic Americans, Native Americans); the elderly, many of whom are on fixed incomes; the young (especially African-American teenagers), who have high unemployment rates; rural families on farms; and households headed by a single woman.

The Homeless

A new development worsening the plight of the poor is the tragedy of the **homeless**— Americans who sleep on the streets or in shelters because they have no place to live. The estimated three-quarters of a million homeless consist, in part, of drug addicts and mentally ill people. But those individuals who lose their jobs also belong (along with their children) to this unfortunate group. The lack of low-cost public housing makes the problem even worse. Although conservatives tend to see the homeless as societal derelicts who are responsible for their own condition, liberals wish to spend more tax dollars on job retraining programs, subsidized housing, mental health, and drug-rehabilitation centers. Communities across the nation wrestle with the homeless problem, with solutions ranging from punitive laws to get them off the streets to the expenditure of additional funds to build the aforementioned shelters.

Major Programs to Assist the Poor

These programs included the now-abolished Aid to Families with Dependent Children and its replacement program, Temporary Assistance to Needy Families under the aegis of the 1996 Welfare Reform Act, Medicaid, the Food Stamp Program, and Supplemental Security Income are others.

AFDC and TANU. The AFDC program, which was the most expensive and heavily criticized by welfare reformers, represented a redistributive policy, whereby money was reallocated from affluent members of society to those individuals who were incapable of supporting themselves. Begun in 1935 as Aid to Dependent Children (AFDC), the program was not seen as welfare, because women with young children were not expected to have jobs, especially given the surplus of labor available during the Great Depression. AFDC provided cash benefits from local, state, and federal sources (the last contributed slightly more than half of all benefits) to more than eleven million individuals, of whom nearly seven million were children. AFDC extended aid to children whose fathers no longer provided financial support due to death, divorce, disability, or desertion. Opponents of AFDC argued that the system encouraged fathers to leave their families, because only then could cash benefits be received.

AFDC was replaced by the 1996 Welfare Reform Act, and more specifically block grant funding to the states, through Temporary Assistance to Needy Families (TANU). The key provisions of TANU are the following:

- Individuals are limited to two years of welfare assistance; welfare can continue conditioned on the recipient having a public- or private-sector job.
- Welfare benefits may not exceed five years over an individual's lifetime, but states can create a shorter or longer payment period at their discretion.
- States can block all welfare benefits to unmarried teenage mothers (AFDC had given welfare money to mothers of illegitimate children); in addition, no additional cash will be granted to children beyond the first two.
- Supplemental funding will be given to those states that successfully reduce the rate of illegitimate births.

TANU's early acclaim has faded somewhat as reductions in welfare caseloads have largely ended along with many individuals returning to the welfare rolls.

Medicaid. Medicaid is a federal and state program designed to help the poor pay for their medical bills. It was created in 1965 as an amendment to the Social Security Act. Medicaid benefits can vary from state to state, although they usually cover hospital, doctor, and lab costs. Some states have Medicaid funds to cover additional expenses such as dental care, drugs, or stays at nursing homes. Unfortunately, Medicaid does not apply to some forty million Americans who cannot afford regular medical care or insurance and who also are ineligible for Medicaid's benefits. Furthermore, the costs of Medicaid have skyrocketed, forcing some states to place caps upon the program or even to cut benefits. In 2005 the Department of Health and Human Services also was recommending future reductions in the Medicaid budget of $329 billion, especially in the area of long-term care.

Food Stamps. The **food stamp program** (one of the most popular welfare programs) had its roots in FDR's New Deal, but the modern version of this assistance program originated in the early 1970s. It is administered by the Department of Agriculture. Coupons are given to welfare recipients and are redeemed for food in local supermarkets. The cost of the program exceeded thirty-one billion dollars in 2005, with over twenty-five million Americans receiving food stamps during that year. The food stamp program is usually credited with improving the health and nutrition of the very poor.

Supplementary Security Income. Created in 1974, the objective of Supplementary Security Income (SSI) was to establish a minimum national income level for the elderly, blind, and disabled. SSI eligibility is a **means test.** Recipients must show that they are truly poor, with low incomes and few assets. The cost of SSI to the federal government has grown from eight billion dollars to over forty-three billion dollars.

Social Insurance and Regulation Programs

In addition to helping the poor, the federal government has formulated public policies directed at the needs of every American, irrespective of income. Two specific examples are social insurance and social regulation programs.

Social Security

A nationally planned social insurance program began in the United States in 1935 when Congress passed the Social Security Act, establishing unemployment insurance and retirement benefits. (It was subsequently expanded to cover the disabled and their survivors.) Under Social Security, employees and employers contribute through payroll taxes to a trust fund, with the worker receiving benefits once retirement age is reached, normally at age sixty-five (payroll taxes also cover the Medicare and unemployment-compensation operations). If the insured worker were to die, benefits would go to his or her spouse and children. Well over ninety percent of all workers in the United States are covered by the Social Security system with recipients numbering forty-eight million in 2004.

However, Social Security is not a personal savings account. Benefits upon retirement are determined by Congress and can be lowered if the system faces financial emergencies, as was the case in the 1980s. To maintain its fiscal solvency, Social Security taxes have been consistently increased during subsequent decades. During his second term, George W. Bush and his administration warned that Social Security's financial future was in jeopardy, due to more benefits being paid out than taxes coming into the system. Bush proposed a partial privatization scenario, allowing workers to invest a portion of their Social Security income into their own private investment plans (stocks and bonds). Supporters argued that citizens would gain a greater rate of return by investing on their own instead of accepting the current two-percent return in the Social Security system. Critics charged that this plan would take the security out of the system, not only because stocks and bonds frequently decline in value but also because many Americans do not have first-rate investment skills. Conversely, Social Security checks are guaranteed for retired Americans, although, to reiterate, Congress could pass legislation reducing Social Security benefits in the future.

Medicare and U.S. Health Care in General

Created in 1965, **Medicare** is health insurance for the elderly, and like Social Security, it also is funded by payroll taxes, with funds being directed into the Health Insurance Trust Account administered by the Social Security Administration. Part A of Medicare is mandatory health insurance. Medicare Part B is a voluntary medical insurance program to cover physicians' fees and is funded by premiums subtracted from the Social Security checks of participating retirees. A percentage of prescription drug costs were covered by Medicare starting in 2006. Note that the overall expense of U.S. health care has skyrocketed over the last five decades, due to Americans living longer, the expense of evolving medical technology and creating new drugs, the use of nursing homes and long-term care facilities, the flood of medical paperwork, and even

the premiums that physicians must pay for malpractice insurance. Health care spending, on a per capita basis in the United States, is among the highest of any industrialized nation.

Social Regulation Programs and Environmental Policy

An important policy concern for the federal government has been to protect citizens from dangerous social and economic hazards stemming from modern industrial society. Numerous federal agencies have been formed to ensure the purity of food, the quality of our air and water, the safety of drugs and consumer products, the honesty of advertising, and healthy working conditions. For example, the Occupational Safety and Health Administration (OSHA) was created in 1970 to enhance workplace safety. OSHA has regulated the handling of toxic chemicals in factories and issued standards that lower the risk of worker exposure to dangerous materials, such as asbestos, lead, and cotton dust. Although the costs of regulation may result in higher prices for the consumer, advocates of social regulation insist that saving human lives takes priority.

In addition to indoor environmental protection, outdoor air and water pollution have been major policy concerns for Americans for some time. Consequently, the 1969 National Environmental Policy Act (which established the **environmental impact statement process** that analyzed the costs and benefits of a government action upon the ecological system), the 1990 Clean Air Act (which curbed auto and truck emissions, reduced emissions from coal-burning utility plants, and abolished CFCs—chlorofluorocarbons that harmed the ozone layer), and the 1972 Clean Water Act (which protected fragile wetlands and fish and wildlife and banned the dissemination of toxic wastes into water supplies) were legislative acts consistent with those concerns.

Global ecological issues crystallized around the 1997 Kyoto Protocol, an international understanding aimed at reducing the emissions of greenhouse gases, which the U.S. Senate has never ratified because the treaty exempted developing countries; it also was deemed harmful to the American economy. In addition, policymakers have grappled with the controversial, contentious phenomenon of global warming—is it truly serious, is it mainly a natural or man-made development, and does global warming require immediate action by the world community of nations?

■ MAKING SENSE OF FOREIGN AND DEFENSE POLICY

America's political leaders must carefully plan the nation's foreign and defense policies. These policies are closely linked to the nation's survival and the quality of its way of life, which collectively represent the irreducible **national interest.** Even with the December 1991 official disintegration of the Soviet Union, America's main international adversary of the previous forty-five years, other threats to the nation's security remained and emerged over the next decade and a half. Although the experts considered the Cold War to be over, it became readily apparent in the post Cold War-era that terrorism and radical Islamists, nuclear proliferation (in Iran, North Korea, and Libya), civil wars, global warming, international oil supplies, drug trafficking, and trade conflicts, among many others, all remained potentially hazardous to American national security.

In addition, the need to have a strong defense seemed more apparent than ever. From late 1990 to early 1991, the United States, with its allies, had sent in hundreds of thousands of American troops and assembled an awesome collection of planes and naval vessels in the Persian Gulf after the Iraqi invasion

of Kuwait. A short but decisive war had broken Iraqi resistance, restored Kuwait's sovereignty, and assured a steady supply of imported oil to the West at reasonable prices. But who could be sure that future Saddam Husseins were not waiting for their moment on the international stage? After the terrorist attacks of 9/11/01 by members of Osama bin Laden's Al Qaeda organization, America went to war in Afghanistan (vanquishing the Taliban government that had given sanctuary to bin Laden) and once again in Iraq (this time deposing Saddam Hussein in 2003). The subsequent defense and homeland security spending consumed billions of dollars, creating a federal deficit of substantial proportions once again.

America's Foreign Policy History: From Isolationism to World Leadership

America pursued a foreign policy of **isolationism** early in its history. It did not have the military or economic strength to become involved in numerous regional or global conflicts. However, America's global status changed, especially during the second half of the twentieth century. Today, the rest of the world generally acknowledges the United States role of "superpower."

From Isolationism to World War II

As a very young nation, the United States needed time to develop its economy and political system. Fighting in costly wars could destroy the nation's internal development. The wisdom of Washington's Farewell Address admonition to avoid "entangling alliances" was heeded by succeeding generations of Americans. President James Monroe's Doctrine of 1823, warning Europe to stay out of the Western Hemisphere, was a reaffirmation of isolationism. This pattern persisted, despite the Mexican War of 1848, the Spanish-American War of 1898, and World War I (note America's refusal to become a member of the League of Nations in the 1920s, even though Woodrow Wilson had taken the nation into WWI under the idealist guise of "making the world safe for democracy").

For most of the 1920s and 1930s, the United States was preoccupied with internal problems, such as Prohibition and the Great Depression. The American people were determined to stay neutral, even with German and Japanese military forces on the march in Europe and Asia. But the Japanese attack on Pearl Harbor (December 7, 1941) brought the United States into World War II, and the nation was unified and committed to the war effort for the next four years. With the surrender of Japan and Germany in 1945, the United States became the pre-eminent power in the international system and was the instrumental force behind the creation of the United Nations.

True to its historical pattern, America looked forward to an era of peace when it could again forget about world politics. However, the start of the Cold War compelled the nation to abandon any hope of a return to isolationism. A policy of **realism**—that is, using various forms of power to contain international communism—became a firm necessity.

The Soviet Union, Containment, and the Cold War

Wartime friendship between the United States and the Soviet Union (USSR) rapidly dissolved into a permanent pattern of enmity as the Soviets expanded their power into Eastern Europe, and threatened U.S. interests in Europe, Asia, and the Middle East. In 1947 the United States devised the policy of **containment,** a long-term strategy of checking perceived Soviet expansionism by economic (the Marshall Plan, which aided Western Europe), diplomatic (the forming of alliances with other nations such as NATO and SEATO), and military (the Korean War in 1950) means. Throughout the 1950s Cold War

crises periodically erupted in such places as Indochina, Suez, Hungary, Lebanon, Quemoy and Matsu, and Cuba. Both nations nearly went to nuclear war during the Cuban Missile Crisis of 1962. However, America's will and military might compelled the USSR to remove those missiles. But containment also led the United States into the Vietnam War in 1965. It was a war that was eventually lost a decade later at the cost of $150 billion and 58,000 American lives.

By the mid-1970s, both nations had adopted a policy of *détente,* a relaxation of tensions that led to agreements on arms control, trade and cultural exchanges, and even a joint space flight. Specifically, the United States and Soviet Union also entered into a number of arms control agreements during this era, such as the Nuclear Test Ban Treaty (banning nuclear explosions in the atmosphere) and SALT (Strategic Arms Limitation Talks) in May 1972; a separate ABM Treaty limited antiballistic missile development. In 1972 President Richard Nixon visited Communist China, starting a process than eventually led to the United States officially recognizing that nation during the presidency of Jimmy Carter.

Reagan, Gorbachev, and the End of the Cold War

By the middle of the 1980s, the Soviet Union was confronting major economic difficulties, a result of spending too much on defense while neglecting the social welfare needs of its people. The USSR had felt compelled to match the massive American defense buildup begun by Ronald Reagan's administration in 1981. (Ironically, Reagan had justified the additional $1.5 trillion increase on defense by claiming that the USSR would soon achieve military superiority over the United States.) In 1985, Mikhail Gorbachev, a new and relatively youthful Soviet leader, decided to reverse the arms race and concentrate on improving his nation's economy. Under his twin themes of *glasnost* (open discussion) and *perestroika* (economic restructuring), Gorbachev attempted to introduce a nascent democracy and a mild form of capitalism into the Soviet Union. Gorbachev also withdrew Soviet troops from Afghanistan, allowed Eastern Europe to leave the Soviet empire, and negotiated new arms-control agreements with Europe and the United States. But the Soviet economy worsened and opposition to Gorbachev's other policies increased among Communist party hardliners and elements of the Soviet military. In August 1991 Gorbachev was placed under house arrest by these plotters, who tried to seize control of the nation. Although the coup was short-lived, it was Boris Yeltsin, and not Gorbachev, who emerged as the hero of the resistance. In the months that followed, many republics of the Soviet Union declared their independence. Under Yeltsin's prodding, the Soviet Union dissolved and formed a new Commonwealth of Independent States. Gorbachev resigned his office in December 1991.

The Post–Cold War Era and the Global Struggle against Terrorism

Containment had been successful. But the post–Cold War era meant that America's foreign and defense policies had to adjust to the new international realities. Ironically, the defeated powers from World War II—Germany and Japan—had become major economic competitors, with higher GNP growth rates than those of the United States. The economic and possibly political integration of Europe loomed on the horizon, further complicating America's trade relationships. By 2005 the European Union had expanded to include twenty-five members, including new members from Eastern Europe. Even the new Commonwealth inside the old USSR still possessed thousands of nuclear warheads, a for-

midable military capability. The fledgling democracy of Russia, the largest nation in the Commonwealth, remained suspect under the rule of Vladimir Putin.

China's and India's rapid industrialization consumed more energy resources, thereby making the world's oil supply that much tighter. In addition, the rising economic and military power of China, its policy toward internal human rights and political dissenters, and its troubled relationship with Taiwan, a nation that Chinese leaders repeatedly claimed was rightfully part of "one China," were factors roiling the U.S.–Chinese relationship.

Meanwhile India's relationship with Pakistan was another worry, as both nations threatened a nuclear exchange on several occasions. Finally, the United States was forced to intervene in the Balkans, as U.S. and NATO forces in 1995 together stopped ethnic cleansing in the civil war among Serb, Croatian, and Bosnian Muslim factions. In 1998 American planes bombed Yugoslav forces in the Serb province of Kosovo where an Albanian majority resided. Eventually, Russian and NATO forces occupied Kosovo as peacekeepers.

In Africa, civil wars and genocidal policies unfolded in such nations as Rwanda (1994), Angola, Zaire, and most recently the Darfur province in Sudan (2004).

In the Middle East, the Israeli-Arab/Palestinian peace process alternately waxed and waned, with violence and mayhem continuing to plague both sides. Additionally, the world's environment became an issue, as the prospect of global warming threatened serious economic and climatic disruptions. Despite this potential calamity, the United States refused to sign the Kyoto Treaty aimed at curbing greenhouse gases due to the burning of fossil fuels. Finally, the United States confronted a growing terrorist threat— the bombings of the World Trade Center in 1993, the 1998 attacks on the U.S. embassies in Kenya and Tanzania, and the bombing late in 2000 of the destroyer *USS Cole* in the harbor of Aden, Yemen, that killed seventeen U.S. sailors.

But all of these developments were overshadowed by America's battle against global terrorism, a war that was symbolized by Al Qaeda's passenger plane attacks of September 11, 2001, upon the World Trade Center Towers in New York City and the Pentagon in Washington, D.C., resulting in the deaths of more than 3,000 innocent people (a fourth hijacked airliner, apparently bound for either the White House or the Capitol Building, crashed in Pennsylvania after the heroic passengers attacked the hijackers on board). In the years that followed those attacks, the United States, following the George W. Bush doctrine of **pre-emption** (striking the terrorists before they could strike U.S. soil once again), fought terrorist networks abroad while spending billions on improving homeland security, including the nation's airports, borders, intelligence gathering capabilities, state and local law enforcement, defenses against bioterrorist attacks, and cargo ship inspections. President Bush was also greatly influenced by **neoconservatives** in his administration—that is, advisors who believed in the use of American power to transform authoritarian regimes into democracies. This thinking guided the 2003 U.S-led invasion of Iraq. Although free elections in January of 2005 and the writing of a new Iraqi constitution followed, a determined insurgency inside of Iraq led by foreign terrorists, Sunni dissidents, Al-Qaeda operatives, and former members of Saddam's army inflicted thousands of casualties, mainly via suicide bombers, upon Iraqi civilians, governmental officials, and security forces loyal to the new government. By the end of 2005 more than 2,000 American soldiers had died in Iraq with more than 15,000 wounded. Complicating America's central mission of creating a stable, moderate, and free Iraq were the continuing tensions among that nation's three ethnic divisions: the Kurds, the Shiites, and the Sunnis.

What should America's defense policies be in the post–Cold War and post-9/11 eras? Should the nation drastically reduce the size of its armed forces or cut back on new weapons systems, such as the next-generation submarine, bomber, or fighter aircraft and spend more money on anti-terrorist programs? Perhaps the most fundamental questions are how much should be spent on defense and whether the nation can afford the rising costs of national security? These types of questions must be considered and analyzed by the institutions and individuals concerned with defense and foreign policy analysis, formulation, implementation, and evaluation.

Foreign and Defense Policy: Major Actors and Institutions

As noted in the following sections, it is the president who is the main foreign policy actor. However, there are other important players and institutions active in foreign and defense policy formulation and/or implementation. They include the National Security Advisor and National Security Council, the Secretary of State and the State Department, the Secretary of Defense and the Defense Department, the Central Intelligence Agency and its director, the Director of National Intelligence, Congress, the public, and the media.

The President

The president is the key foreign policymaker, with his or her powers drawn from constitutional provisions, historical precedent, and institutional advantages. The Constitution designates the president as the commander-in-chief of the armed forces. This grant of power has allowed the chief executive to involve the nation in more than 125 military actions. Other important constitutional powers extended to presidents include the making of treaties and the appointing of ambassadors, ministers, or consuls. The president has two distinct advantages in the foreign policy arena:

- Access to unlimited information about foreign nations and leaders from a variety of intelligence sources (CIA, State, Defense).
- An acknowledged ability to rally public and congressional support behind new foreign/defense initiatives.

The National Security Council (NSC)

Established in 1947 the National Security Council consists of the president, the vice-president, the national security advisor, the secretaries of Defense and State, the CIA director, the chair of the Joint Chiefs of Staff, and other officials invited by the president. The NSC advises the president on foreign policy and formulates policy options for him to consider. The NSC is headed by the national security adviser (NSA), whose particular policy role can vary in each presidential administration. An extremely influential NSA was Henry Kissinger in the Nixon administration; he opened a dialogue with the People's Republic of China and negotiated an end to the Vietnam War. A NSA also can clash with the Secretary of State over policy options. This happened in the Carter administration when NSA Zbigniew Brzezinski differed with Secretary of State Cyrus Vance over the best method of gaining the release of American hostages in Iran. A third role was followed by President George W. Bush's NSA, Brent Scowcroft, who kept a low-profile, but nevertheless influential, position in the policymaking process. During the administration of George W. Bush, NSA (and later Secretary of State) Condoleezza Rice was instrumental in coordinating the struggle against terrorism after 9/11/01.

The Department and Secretary of State and Diplomacy

The Secretary of State is sometimes the president's chief foreign policy spokesperson. James Baker played this role in the George H.W. Bush administration; Colin Powell had a similar role during the first term of George W. Bush. State coordinates relations with the two hundred independent nations around the world through its network of embassies and consulates (intelligence personnel are also part of the network).

The core of State is its career diplomats who comprise the Foreign Service. Foreign Service personnel are knowledgeable about the culture and language of the nations to which they are assigned. Logically, State is organized along geographic and functional lines, such as the Bureau of African Affairs or the Bureau of Refugee Programs. In short, State can furnish valuable information to the president and his or her advisers regarding what kind of policy should be directed toward other nations. State also can lead diplomatic efforts to resolve international problems via peaceful means.

The Department of Defense

Created in 1947, the organizational goal of the Department of Defense (DOD) was to unite the disparate military services—Army, Navy (the Marine Corps is housed within the Navy department), and Air Force—under a civilian Secretary of Defense, thereby achieving a coherent defense strategy for the nation. The DOD's budget, the largest in the United States government, approaches the five hundred billion dollar level during President George W. Bush's second term in office.

A key part of DOD is the Joint Chiefs of Staff (JCS), which is composed of a chairman and the heads of the four services. The JCS advise the Secretary of Defense and the president on military strategy and budgetary needs. In the post–Cold War, post-9/11 era, competition among the rival services for budgetary resources remains intense.

The Central Intelligence Agency and Director of National Intelligence

Congress created the Central Intelligence Agency (CIA) in 1947. The director of the CIA is appointed by the president and confirmed by the Senate. Before 9/11, the CIA traditionally had three major functions:

- Coordinating all foreign policy information from State, Defense, and other intelligence agencies:
- Analyzing and evaluating this data.
- Informing the president and the NSC as to the policy significance of its data assessments.

In addition, the CIA operates a global intelligence network, accumulating potentially valuable information from both overt and covert methods. After 9/11 the CIA worked more closely with the FBI to coordinate intelligence-sharing on possible terrorist activity inside the United States.

In 2005 a new intelligence structure was created by Congress. John Negroponte became the first Director of National Intelligence, whereby all fifteen federal intelligence agencies report to him and he, in turn, briefs the President directly. The intention of the reorganization was to improve both the dissemination and accuracy of intelligence data.

Congress

Traditionally, Congress has deferred to the president regarding the handling and execution of foreign policy. After the Vietnam War, however, Congress tried to reassert its will in foreign relations, passing the

War Powers Act in 1973 over President Nixon's veto. The War Powers Act limits the president's power to keep U.S. combat troops overseas indefinitely. Conceivably, Congress could vote to bring the troops home after sixty days, with an additional thirty days granted for withdrawal. However, Congress has never invoked this provision of the War Powers Act. The act also calls upon presidents to consult with Congress within forty-eight hours of hostilities. Congress still has important powers in the foreign and defense policy processes—confirmation of presidential nominees by the Senate, ratification of treaties, control over appropriations, plus oversight or the investigation power.

Public Opinion and the Media

In general, the mass public, compared to the attentive public (no more than twenty percent of the adult population), does not possess detailed information about foreign policy or military-related issues. However, the public's general mood toward a foreign-policy event can be shaped through media reports. For example, the public clearly perceived the leader of Iraq, Saddam Hussein, as an evil dictator due to newspaper and television coverage that communicated that image. Consequently, support for the 1991 Persian Gulf War was overwhelming. Conversely, negative media reporting during the Vietnam War resulted in public opinion turning against the war, forcing an eventual withdrawal of American troops.

Two Intermestic Case Studies

Foreign and defense policies are **intermestic,** affecting both international and domestic objectives. Two case studies from the 1990s—American relations with Japan, and the proverbial guns versus butter dilemma—clearly illustrate the intermestic concept.

American-Japanese Relations. American-Japanese relations were increasingly strained in the early 1990s. Significant segments of the American public, Congress, and business community viewed Japan as an unfair trading partner. The growing perception, whether totally true or not, was that Japan could sell its autos, computers, or electronic equipment freely on the American market, but U.S. goods were systematically excluded from Japan's consumer market of one hundred and twenty million people. The result was a one-sided balance of trade, whereby Japan accumulated an annual forty-one billion dollar trade surplus with the United States in 1991.

Japan bashers called for increased **protectionism** toward Tokyo, involving strictly enforced, reduced quotas on Japanese auto imports and higher tariffs on other Japanese products. Japan countered that such moves would harm relations with the United States and would not eliminate the real reasons for the trade imbalance—a declining American economy, superior Japanese workers, and a higher savings rate in Japan (seventeen to twenty percent in Japan; four to five percent in the United States), which subsidized more efficient and higher-quality controls in industrial production.

Critics of protectionism toward Japan noted the intermestic repercussions of this policy. Internationally, radical leaders in Japan who disliked the United States might use protectionism as a way of eventually gaining political power. By claiming that America was trying to strangle Japan economically by boycotting its products, Japan's new leaders could retaliate by asking American military forces to withdraw from bases on Japanese soil. Also, Japan might quickly rearm, encouraging those latent forces of militarism still present in Japanese society. Domestically, protectionism could hurt the American economy, because Japanese firms and investments create jobs for millions of employed Americans while

simultaneously underwriting part of the federal deficit. It is not entirely improbable that Japanese investments could have been shifted over time to Europe, Asia, the Middle East, Africa, and Latin America.

Like it or not, the American economy's stability is increasingly dependent upon foreign capital (conversely, so is the Japanese economy). Objective analysts stressed that the two nations needed each other, a fundamental fact that remained true for policymakers in Washington and Tokyo in the early part of the twenty-first century.

Guns versus Butter. Defense budgets inevitably raise the question as to whether too many or too few resources are being devoted to military preparedness. The overall size of the defense budget (the "guns" side of the equation) is determined not only by the severity and number of international threats confronting American security at a particular point in time. Defense spending also has its domestic dimension. The presence of military bases around the nation helps local economies in terms of employment and production of goods and services. Members of Congress facing the closing of military bases in their districts will protest vehemently (as was the case in 2005 when a number of bases were considered for termination). Furthermore, defense corporations that receive fewer federal contracts for military hardware will not only have profits reduced, but they are likely to let workers go, again adversely affecting the economy. In short, there are strong incentives to avoid severe cuts in defense spending.

The "butter" side of the debate refers to the diversion of defense dollars (after cutting back on various defense items, from weapons to personnel) to social welfare programs—more shelters for the homeless, increasing expenditures on medical research, financing a national health plan, building mass-transit systems, or cleaning up the environment. Advocates of this approach stressed the **peace dividend** idea, claiming that with the end of the Cold War there was no longer a need to spend (at that time) all of the three hundred billion dollars or more on national defense. Furthermore, part of the billions saved could be used to reduce the federal deficit. However, in the early 1990s, it appeared that the peace dividend was largely illusory. Defense advocates, while agreeing to a smaller military in terms of personnel, argued that expensive weapons research and development had to proceed if America were to retain its technological edge, as demonstrated in the 1991 Persian Gulf war by the devastating effectiveness of Tomahawk cruise missiles, laser-guided bombs, the radar-invisible Stealth fighter, and the Patriot missile system. In short, national policymakers, confronting a complex interplay of both domestic and international favors, cannot avoid a continuing guns versus butter debate each fiscal year. This remains true given the enormous financial strain generated by the need to fight global terrorism in the future.

Public policy represents governmental solutions to social, political, and economic problems that beset American society. (Government inaction or delay is also a kind of negative policy decision.) The policy process involves five stages: agenda-building, formulation, adoption, implementation, and evaluation (note that evaluation of policy effectiveness may take considerable time). Every domestic or foreign policy process is affected by the interests, beliefs, and attitudes of the involved decision-makers and the democratic rules that underlie the entire process. Finally, domestic policy may be regulatory (OSHA and workplace safety), distributive (farm subsidies), or redistributive (the Social Security program). Foreign policy can be either regulatory (trade sanctions) or distributive (foreign aid). Defense policy can involve strategic principles (troop withdrawals) or structural choices (locations of military bases).

Domestic economic policies can rely on the monetarist approach advocated by Milton Friedman (controlling the money supply and interest rates) or the fiscal approach of John Maynard Keynes (changing government spending, borrowing, and tax rates). The monetarists utilize the Federal Reserve Board to expand or restrict the money supply through its loan policies toward member banks. Neither economic approach has been able to resolve the problem of federal deficits, a result of excessive government spending vis-à-vis lower tax receipts, unrealistic public and congressional expectations, and a largely uncontrollable federal budget. One deficit solution, the well-intentioned Gramm-Rudman-Hollings Act, was misapplied by Congress. Another solution, the proposed balanced budget amendment with its many attendant problems, has little chance of being adopted in the foreseeable future.

Domestic tax policies are viewed as unfair and unnecessarily complex by many Americans. Tax reforms have not yet resolved the dual problems of progressivity or regressivity. Domestic social welfare policies that aid the poor have helped millions of American citizens, even though their necessity remains a point of contention between liberals and conservatives. By contrast, social-insurance (Social Security and Medicare) and regulation programs (OSHA) have acquired greater legitimacy.

American foreign and defense policies have been formulated against the background of a fundamental shift from isolationism to full-scale internationalism, especially after World War II. A new, post-Cold War, post-9/11 era will mean that American leaders will have to reassess different threats and the appropriate level of defense spending needed to preserve the nation's security. Increasingly, these policy decisions will be complicated by the intermestic variables surrounding such decisions, as suggested by the concise look at two case studies—American-Japanese relations and the proverbial guns versus butter dilemma.

Selected Readings

Cammiosa, Anne Marie. *From Rhetoric to Reform? Welfare Policy in American Politics* (1998).

Crabb, Cecil V. Jr., and Pat M. Holt. *Invitation to Struggle: Congress, the President, and Foreign Policy*, 4th Edition (1992).

Fischer, Frank. *Evaluating Public Policy* (1995).

Fisher, Louis. *Presidential War Power* (2004).

Gaddis, John Lewis. *The United States and the End of the Cold War* (1997).

Greider, William. *Secrets of the Temple: How the Federal Reserve Runs the Country* (1987).

Holsti, Ole. *Public Opinion and American Foreign Policy* (1996).

Ishihara, Shintaro. *The Japan That Can Say No* (1990).

National Commission on Terrorist Attacks on the United States. *The 9/11 Commission Report* (2004).

Peters, B. Guy. *American Public Policy: Promise and Performance* (1996).

Phillips, Kevin. *The Politics of Rich and Poor: Wealth and the American Electorate* (1990).

Test Yourself

1) Which policymaking stage is the last one in the policymaking process?
 a) agenda-building
 b) formulation
 c) evaluation
 d) adoption

2) True or false: Structural defense policy deals with the utilization and location of U.S. military units overseas.

3) The economist Milton Friedman is associated with which school of economics?
 a) monetary
 b) fiscal
 c) supply-side
 d) none of the above

4) True or false: The Fed will increase the supply of money in circulation when the economy is sluggish or unemployment is high (or both).

5) Supply-side economics was especially in vogue during the presidency of
 a) Jimmy Carter
 b) Ronald Reagan
 c) George H.W. Bush
 d) Bill Clinton

6) True or false: The Social Security payroll tax can best be described as a progressive form of taxation.

7) In 2004 how many people were classified as poor; that is, falling below the federal government's official poverty line?
 a) eighteen million
 b) twenty-nine million
 c) thirty-two million
 d) thirty-seven million

8) True or false: Under TANU, part of the 1996 Welfare Reform Act, states are obliged to give welfare benefits to unmarried teenage mothers.

9) Medicare is funded through _____ taxes.
 a) payroll taxes
 b) income taxes
 c) state taxes
 d) none of the above

10) True or false: OSHA is concerned with workplace safety.

11) Washington's Farewell Address and the Monroe Doctrine of 1823 exemplified the early American policy of
 a) internationalism
 b) isolationism
 c) imperialism
 d) none of the above

12) True or false: An economic form of containment was the Marshall Plan.

13) After the terrorist attacks of 9/11/01, the United States went to war against the Taliban who were located in which country?
a) Iraq
b) Iran
c) Afghanistan
d) Indonesia

14) True or false: The "butter" side of the guns versus butter equation refers to the number of dollars devoted to social welfare programs.

15) The nation that Chinese leaders believe should rightfully be part of mainland China is
a) North Korea
b) Japan
c) Taiwan
d) India

16) True or false: The Department of Defense has the largest budget of any department in the U.S. government.

17) Zbigniew Brzezinski was the National Security Advisor during the _____ presidency.
a) Reagan
b) Nixon
c) George W. Bush
d) none of the above

18) True or false: The War Powers Act dictates that if Congress votes to bring U.S. troops home, a president would have thirty days to accomplish such a withdrawal.

19) The guns versus butter dilemma exemplifies _____ policy.
a) redistributive
b) distributive
c) intermestic
d) regulatory

20) True or false: In general, the public is well informed about the details of foreign and defense policies.

Test Yourself Answers

1) **c.** Evaluation judges what the operational consequences of a particular policy have been over time. Therefore, it is naturally the last stage. Note that a negative evaluation can lead to a new agenda item, thereby possibly initiating the entire policymaking process once again.

2) **False.** This is the definition of strategic defense policy. Structural policies deal with how defense resources will be allocated.

3) **a.** Milton Friedman argued that the national money supply should be correlated with the rate of economic growth. That correlation should be handled most often by the Federal Reserve System.

4) **True.** The Fed's decision to increase the money supply allows more money to become available, encouraging consumer spending, investing, helping business growth, and creating jobs.

5) **b.** The Reagan administration believed that tax cuts would encourage savings, leading to an accumulation of investment capital and improved national productivity. Unfortunately, the theory was flawed, leading to modest economic growth and a decline in personal savings.

6) **False.** It is actually regressive—that is, the tax falls more heavily on poorer citizens than the wealthy.

7) **d.** This was the figure given by the U.S. Census Bureau for that year. The figure was roughly twelve percent of the U.S. population.

8) **False.** TANU stipulates that the states should block benefits to unmarried teenage mothers.

9) **a.** Payroll taxes represent the correct choice, with federal funds being directed into the Health Insurance Trust Account administered by the Social Security Administration.

10) **True.** OSHA stands for the Occupational Safety and Health Administration, a federal agency established in 1970 to protect workers from pollutants, to outlaw unsafe work practices, and to limit worker exposure to dangerous toxins, such as asbestos, lead, and cotton dust.

11) **b.** The Farewell Address and the Monroe Doctrine exemplified isolationism, a policy in which America stayed out of European affairs in order to develop its young economy and fledgling political system.

12) **True.** The Marshall Plan gave considerable economic aid to Western Europe in 1947, so that an economy recovery would become possible. Europe would then be in a better position to resist Soviet expansion.

13) **c.** The Taliban had given sanctuary to Osama bin Laden's Al Qaeda organization. A U.S. intervention into Iraq eventually followed in 2003. The other two nations—Iran and Indonesia—are not relevant to the question.

14) **True.** This is self-evident from the equation, because "guns" represent dollars spent on defense needs.

15) **c.** Taiwan is viewed by Chinese leaders as part of the one-China concept. The other choices do not apply.

16) **True.** The DOD budget has crossed the four hundred billion dollar level, the largest budget in the federal government.

17) **d.** Brzezinski was the NSA during the Jimmy Carter presidency.

18) **True.** This is the time specified in the War Powers Act.

19) **c.** It is intermestic because it embraces both international and domestic dimensions.

20) **False.** The average American has perhaps general, but not detailed knowledge about both types of policies.

Glossary

AARP An extremely powerful interest group, with membership of more than thirty-five million senior citizens. It represents close to one-fifth of the nation's older population.

administrative law The body of law that deals with the legality of rules and procedures set forth by governmental bureaucracies.

affirmative action Government and private policies that strive to hire minorities in order to make up for previous patterns of discrimination.

agenda issue An unresolved societal problem now recognized as important by public officials and/or private individuals; thus, requiring support to obtain an eventual policy solution.

anti-Federalists The faction opposed to the ratification of the Constitution.

appellate jurisdiction A court that is hearing a case on appeal from a lower court has appellate jurisdiction. *See also* **jurisdiction; original jurisdiction.**

authoritarianism A totalitarian political system in which the government and its leaders are in complete control of every aspect of society.

bail An amount of money that serves as a guarantee that an individual will appear in court for his or her trial at a specified time.

balancing the ticket The principle that usually guides a presidential nominee's selection of a vice-presidential running mate, whereby the vice-presidential nominee has contrasting personal and political traits that maximize the ticket's appeal to many voters.

bandwagon effect Critics charge that publishing poll results will influence voters to vote for the candidate who appears to be far ahead of his opponent.

biased sample A sample that does not faithfully represent the population; hence, the poll results will be inaccurate. *See also* **Literary Digest.**

bicameral Refers to a legislature composed of two houses or chambers.

Bill of Rights The first ten amendments to the U.S. Constitution.

Bipartisan Campaign Reform Act An act that (a) bans soft money contributions to the national parties, but allows a sum of $10,000 per year per individual to be given to state and local parties; (b) restricts campaign ads from interest groups from being shown thirty days before primary elections and sixty days before the general election; (c) increases the hard money individual contribution to a candidate from $1,000 to $2,000 ($4,000 total for both the primary and general elections); (d) permits the total individual contributions to all federal candidates to range from $25,000 per year to $95,000 for the two-year election cycle; and (e) limits PACs to $5,000 per election or $10,000 per election cycle (primary plus general). Most of the act's provisions were declared constitutional (not abridging free speech) by the Supreme Court in December 2003 in *McConnell v. Federal Election Commission. See also* **hard money; political action committee (PAC); soft money.**

block grants Federal grants-in-aid that are directed at broad policy areas, such as crime or community development. Generally, states and localities have greater discretion in determining how these funds may be allocated with categorical grants. *See also* **categorical grants.**

Brown v. Board of Education of Topeka On May 17, 1954, the Supreme Court held that educational segregation based on race was unconstitutional, a violation of the equal-protection clause of the Fourteenth Amendment.

bureaucracy A large, complex administrative organization based on a hierarchical structure, with written rules and regulations; its purpose is to implement policy.

Bush v. Gore The 2000 case that stopped the manual recounting of ballots in Florida and gave the presidency to George W. Bush over Al Gore.

cabinet departments Collectively, the fifteen executive departments that administer the policies of the federal government.

categorical grants Federal grants-in-aid that are directed at a specific state or local governmental project. *See also* **block grants.**

caucuses A meeting of party members. Although used in some twenty states, the Iowa caucuses are particularly important because they represent the start of the presidential campaign, now in January of a presidential election year.

checks and balances/separation of powers The system of ambition checking ambition, whereby political power is fragmented and divided among the three branches of government: legislative, executive, and judicial.

civil law Concerned with disputes between two private parties, such as divorce.

civil liberties Those rights guaranteed to the individual by the Constitution and, more specifically, the Bill of Rights.

civil rights The right of citizens not to be discriminated against due to race, sex, religion, sexual orientation, age, disability, or national origin.

civil service Term applied to federal employees who are hired according to the merit principle (that is, based upon their abilities or qualifications for a federal job, not their political connections).

clear and present danger Unlawful speech that leads to an immediate and obvious harm to other individuals and/or property.

closed primary In the closed primary, only registered Republicans (or Democrats) may vote for Republican (or Democratic) nominees. *See also* **open primary; presidential primary.**

cloture The Senate rule that terminates a filibuster, requiring sixteen or more senators to sign a petition, then a three-fifths vote of approval, and then a one-hour debate limitation per senator. *See also* **filibuster.**

coalition of minorities Disillusionment with presidential policies by many groups in U.S. society that collectively produces a drop in presidential popularity. A public-opinion phenomenon that seems to engulf most presidents over time.

commander-in-chief role The presidential role that places him or her in control of the U.S. armed forces, as stipulated in the Constitution. Much to the distress of Congress, presidents have used this constitutional privilege in numerous military interventions overseas, with some leading to full-scale wars.

Common Cause Established in 1968 by John Gardner with nearly 300,000 members. Common Cause is concerned with accountability of government officials to the citizenry, stricter laws governing campaign contributions, the independence of public broadcasting, public financing for presidential elections, and the removal of barriers to voting.

common law Judge-made law; those rules that have been created by judges through their decisions in numerous cases.

comparable-worth doctrine The doctrine espoused by women's groups that asserts that women should be paid equivalent salaries to those of men when similar job responsibilities and skills are involved.

concurrent powers Those powers that can be exercised by both the national and state/local governments. Examples include taxation (federal income tax, state income tax, local sales tax), creation of courts, protection of civil rights, borrowing and spending money, and the chartering of banks or corporations.

confederation A political system in which the states have ultimate power and the central government is relatively weak.

conference committee A joint House-Senate committee whose purpose is to reconcile different versions of a bill.

Connecticut Compromise Also known as the Great Compromise, which provided for representation in the House to be based on population, and for the Senate to have equal representation for each state.

consumer-interest groups *See* **public- and consumer-interest groups.**

containment A foreign policy directed against the Soviet Union and its allies after World War II, which called for a variety of economic, diplomatic, and even military means to block communist expansion around the globe.

cooperative federalism Federalism that views the relationship between the states and the federal government as a marble cake—that is, one of overlapping powers and responsibilities. *See also* **dual federalism; federalism.**

criminal law Involves crimes against society, such as murder or armed robbery. Because the government is the enforcer of criminal law, it serves as the plaintiff (the party that brings the case to court) in all criminal trials; the party accused of the crime is termed the defendant.

de facto **segregation** Segregation or racial separation that has occurred through natural residential patterns or by private, non-political means.

de jure **segregation** Segregation that is sanctioned by law and the power of government.

dealignment The process whereby voters and public officials experience a decline in loyalty and attachment to the two major political parties.

delegate orientation Representatives or senators whose votes on bills are closely linked to voter preferences in their districts or states. *See also* **politico orientation; trustee orientation.**

delegated powers Powers specifically listed in the Constitution as belonging to Congress, such as the power to declare war or to borrow money.

détente A relaxation of tensions between the United States and the Soviet Union that occurred in the mid-1970s.

devolution The return of political power back to the states.

direct democracy A type of democracy in which all citizens participate in political life and decision-making (for example, the New England town meeting).

direct lobbying The lobbying technique that involves face-to-face interaction between a lobbyist and a legislator.

discharge petition The House may use the discharge method whereby an absolute majority—218 members—sign a petition requesting that the bill be forced out of committee for consideration on the floor.

distributive policy A policy that allocates direct benefits to individuals, groups, or business firms.

double jeopardy The Fifth Amendment admonition that an individual may not be tried again for the exact same crime after he or she is found innocent of that crime.

dual court system America's judiciary is a dual system: state and local courts and the federal judiciary.

dual federalism The doctrine, now outmoded, that the federal government's relationship to the states was akin to a layer cake, in that powers and responsibilities of the two levels of government could be clearly separated. *See also* **cooperative federalism; federalism.**

due process clause The constitutional guarantee, found in the Fifth and Fourteenth amendments, that government would not deprive any person of life, liberty, or property by any unfair, arbitrary, or unreasonable action. Due process applies to both federal and state governments.

economic interest groups Interest groups whose main motivation is to win monetary or job-security benefits for their memberships.

elastic clause The necessary and proper clause of Article I, Section 8, allowing the government to implement delegated powers by any appropriate means.

Electoral College The 538 electors—men and women—who actually elect the president in their respective states after the popular votes have been cast. A majority (270 votes) is needed for victory.

environmental groups Groups that make the public more conscious of—and lobby on behalf of—environmental problems, such as oil spills and pollution, and argue for the need to conserve America's natural resources. For example, the Sierra Club, founded in 1892, lobbies for clean air and water and unspoiled wilderness areas.

Era of Good Feelings A period of one-party rule symbolized by James Monroe's near-unanimous election in 1820.

establishment clause Refers to the First Amendment's prohibition against a state religion and the "wall of separation" between church and state.

ex post facto **laws** Laws that retroactively make an earlier non-criminal act a crime.

executive agreement A presidential agreement with another head of state. It has the power of law but does not require Senate approval.

Executive Office of the President (EOP) Office created in 1939 whose agencies have been created to help the president. The most important agencies are the White House Office, the Office of Management and Budget, the National Security Council, and the Council of Economic Advisers.

executive orders Presidential directives or regulations that have legal standing in so far as they can be directly linked to a constitutional source.

executive privilege Refers to the inherent presidential power of withholding sensitive or secret information from Congress, the public, and/or media on the grounds of national security, the need for presidents to preserve confidentiality, or the desire for a general separation of powers.

exit polls Polls that are based on questioning individuals after they have left voting booths on election day. The responses can allow TV networks to make early predictions regarding candidate winners or losers.

faithless elector An elector in the Electoral College who decides to change his or her vote, despite being previously pledged to a specific presidential candidate.

Federal Communications Commission (FCC) Agency established in 1934 to regulate the performance standards first of radio and then eventually of TV stations and other media.

federal deficit An economic condition in which government spending exceeds collected revenues.

Federal Election Commission (FEC) Agency created in 1974 to enforce campaign-finance laws.

federal union A political system in which there is a constitutional division of powers between the national government and the states, provinces, or sub-regions.

federalism Refers to the division and sharing of constitutionally assigned or implied powers between the national and state governments.

Federalist Papers The collection of articles written by Madison, Hamilton, and Jay that defended the new Constitution against the anti-Federalists during the ratification period.

filibuster A lengthy debate, which occurs only in the Senate, intended to talk a bill to death by preventing a floor vote from occurring.

fiscal policy Economic management techniques that rely on changes in government spending and borrowing. The altering of tax rates also is included.

fiscal year The federal government's twelve-month period, running from October 1 through September 30, during which the budget and other financial policies are formulated and implemented.

fluidity The idea that public opinion can change very quickly, sometimes overnight.

focus group Usually a small number of individuals, typically ten to twenty, with whom a candidate's political staff discusses, in-depth, their beliefs, emotions, and attitudes toward candidates and issues.

formal party organization Refers to party leaders who organize and operate party structures at the federal, state, and local levels of government.

free-exercise clause The First Amendment's guarantee that every individual is entitled to pursue his or her own religious beliefs free from government interference.

front-loading Refers to the states moving their caucuses and primaries to earlier dates.

full faith and credit clause Found in Article IV, Section 1, the clause mandates that a state must accept the official records, documents, and civil rulings (a property sales contract, as one example) of other states in the union.

Furman v. Georgia The Supreme Court ruled in a 5-to-4 vote that the death penalty as imposed by existing state laws was unconstitutional. The laws arbitrarily discriminated against minorities and the poor in that these groups were far more likely to be sentenced to death by judges and juries.

Gallup Poll's error The incident in 1948 when Gallup incorrectly predicted Dewey over Truman because it stopped polling too soon.

generational events Major, traumatic events that can permanently shape attitudes of each political generation.

gerrymandering Arranging boundaries in such a way as to constitute an unfair advantage for a political party, incumbents, or particular interests. In the 1960s, powerful rural state legislators created districts that differed markedly in population size, thus leading to underrepresented urban centers.

glasnost A Russian term meaning "openness" that refers to Gorbachev's policy that promoted democratic discussion among Soviet citizens in the 1980s.

government corporations Governmental bodies created by Congress that perform a public service but that are structured like private business firms; for example, the Tennessee Valley Authority (TVA).

government The people, institutions, and processes that are responsible for developing decisions and rules for all of society.

governmental interest groups Interest groups that represent foreign governments or U.S. state and local governments in Washington, D.C.

Gramm-Rudman-Hollings Act A 1985 law that tried to attack the budget deficit through mandated reductions so that a zero deficit would be attained by 1993.

grand jury A jury that decides whether there is enough evidence against the accused to warrant a petit (trial) jury. If so, an indictment is issued.

Grand Old Party (GOP) A nickname for the Republican Party.

gross national debt The sum of all annual federal deficits.

guns versus butter The continuing debate in American politics over whether more resources should be devoted to social-welfare programs rather than to national defense.

hard money Money contributed directly to political candidates or interest groups by individuals and political action committees. Hard money (so called because it is "harder" to raise than soft money) is limited and must be fully disclosed. Individuals are limited to $2,000 in hard money per candidate in a general election. *See also* **Bipartisan Campaign Reform Act; political action committee (PAC); soft money.**

Hatch Act The 1939 act that prohibited federal employees from engaging in partisan political activity in order to promote a neutral civil service. The act has been modified to allow greater political activity.

Help America Vote Act (HAVA) Legislation designed to improve the conduct of elections by eliminating administrative obstacles to voting that had occurred in the 2000 presidential elections, when some Americans may have been denied their right to vote or did not have their ballots counted.

Hobbes, Thomas Philosopher who viewed humanity as irrational, passionate, selfish, and even evil. The role of the state, according to Hobbes, was mainly to restrain the emotional and moral excesses of the ruled; otherwise, order would dissolve into chaos.

House Speaker *See* **Speaker of the House.**

ideological minor parties Parties that espouse radical ideas or values that are different from the perspective and values of most Americans. But these parties do attract some votes. A specific example was the Socialist party of Eugene V. Debs, which won nearly six percent of the vote in the 1912 presidential election.

impeachment The procedure by which a president, or any federal official, may be removed for misconduct in office. The House brings formal charges against the accused; the Senate acts as the jury. A two-thirds vote of the Senate is necessary for conviction and subsequent removal from office.

implied powers Powers that are logically deduced through court interpretation or congressional action and stem from the delegated powers granted Congress by the Constitution. These powers are directly related to the necessary and proper clause.

incorporation The process by which the Bill of Rights was applied to the states as well as to the federal government.

Independent Regulatory Commission The agency that possesses administrative, legislative, and judicial powers, all directed at regulating an important aspect of the national economy.

independent voters Voters whose allegiance to the main political parties is relatively weak or virtually nonexistent.

indirect lobbying Lobbying directed at public opinion or the grassroots membership of the interest group.

intensity A measure of how strongly people feel about a given issue and their determination to express their private opinions publicly.

interest aggregation The function of a political party that combines conflicting, disparate views of groups and individuals into policy compromises.

interest group A collection of individuals that shares common attitudes and tries to influence government for specific policy goals.

intermestic A term that recognizes that many public policies contain consequences for both international relations and domestic politics (energy and the environment).

interstate compacts These binding compacts, enforceable by the federal judiciary, try to manage problems that cross state borders.

interstate privileges and immunities clause Each state is expected to extend the same courteous treatment to citizens of other states as well as the same legal protections.

iron triangles An informal group consisting of the heads of bureaucratic agencies, members of congressional committees who have an interest in those agencies, and lobbyists for pressure groups.

isolationism A traditional U.S. foreign policy orientation that calls for nonalignment and neutrality in world affairs.

issue networks Refers to experts and policy specialists temporarily united by common concerns over a particular policy.

item veto A power granted to many state governors, but not to the president. This type of veto allows sections of a bill to be rejected by the executive, while permitting the remainder of the bill to become law.

judicial activists Advocates who argue that the courts frequently must make policy in order to meet pressing social needs and to help those who are weak economically or politically. Broad constructionsts believe that laws should be applied dynamically vis-à-vis those important value and technological changes that occur in society every generation.

jurisdiction The authority of a court to hear, try, and decide a case. *See also* **appellate jurisdiction; original jurisdiction.**

justiciable The idea that conflicts must be resolvable by the courts.

keynote address The first major speech at a national nominating convention, whereby the speaker extols the virtues of his or her own party, attacks the opposing party, and rallies the party faithful for the upcoming campaign.

laissez-faire **economic policy** An economic doctrine, popular in the nineteenth and twentieth centuries (prior to 1932), that asserted that government should not interfere in the marketplace or unnecessarily regulate big business.

legislative or special courts Courts created by Congress that serve a highly specialized function based upon congressional expressed powers. They are staffed by judges with fixed terms in office (usually fifteen-year terms). These courts hear a more restricted range of cases than those heard under the broad-based jurisdiction of the Article III constitutional courts.

legislative veto A congressional device to curb executive power through the use of a concurrent resolution (by one or both houses). The concurrent resolution is not subject to presidential veto. However, the legislative veto was ruled unconstitutional in the 1983 case of *Immigration and Naturalization Service v. Chadha.*

libel Purposeful, malicious, and knowingly false written defamation of an individual's character or reputation. *See also* **slander.**

Libertarian party Created in 1971, this minor party adheres to a mostly unregulated free market economy, the legalization of drugs, an ardent defense of civil liberties including the right to bear arms, a foreign policy of free trade, and a desire to avoid military interventions overseas.

line agency An agency that carries out government programs and provides various kinds of services.

Literary Digest The magazine that in 1936 incorrectly predicted Landon's win over Roosevelt due to unwittingly creating a biased sample through surveys mailed primarily to wealthier classes of voters. *See also* **biased sample.**

lobbying Refers to the historic practice of citizens waiting for and contacting representatives in the lobbies outside legislative chambers. Today, lobbyists, many of whom are ex-legislators themselves (federal law states that former legislators must wait at least one year before lobbying their ex-colleagues in Congress), try to persuade legislators to vote for or against a bill or convince members of executive agencies that a program is desirable or undesirable.

Lobbying Disclosure Act of 1995 This act closed loopholes in the lobbying process, such as providing a stricter definition of a lobbyist.

lobbyist A paid representative of an interest group who tries to influence the policy decisions and views of a public official.

Locke, John Philosopher who argued that human beings had the capacity to perceive and understand higher or natural law that posed standards for human conduct. Individuals also possessed natural rights and were governed according to the dictates of the social contract.

mandates Federal laws or court rulings that compel cities and states to implement certain policies even if no financial aid is given to them.

mass media Books, films, radio, newspapers, TV, magazines, journals, and the Internet—all of which transmit information to the American people and their political leaders.

material benefits Tangible benefits, such as better salaries or improved working conditions, that an interest group may provide to its members.

McCulloch v. Maryland 1819 Supreme Court case that established the concept of national supremacy. Chief Justice John Marshall declared that the state of Maryland did not have the power to tax the National Bank of the United States, an act that clearly violated the supremacy clause.

media *See* **mass media.**

media circles Refers to the respective levels of media influence, from the most powerful (the three largest networks, the *New York Times,* and so on) to the outer circle of local news.

media concentration Refers to media corporations that, according to some authorities, have disproportionate power; thus, possibly endangering the American tradition of diversity of thought and expression.

minor political party A political party that for reasons of ideology, economic protest, issues, or factionalism challenges the two major parties.

monetary policy An economic approach that seeks control over the money supply and the cost of credit, primarily through the Federal Reserve System.

Mothers Against Drunk Driving (MADD) An interest group that lobbied Congress to pass a 1984 law withholding federal highway funds from those states that did not raise the legal drinking age to twenty-one.

Motor-Voter law The 1995 act that allowed citizens to register to vote when applying for or renewing a driver's license (registration forms also can be found at unemployment, welfare, or other appropriate public agencies) or register via the mail.

National Party Chairperson (NPC) The NPC's responsibilities include hiring personnel, handling the party's administration, and being a spokesperson for a political party.

national supremacy The idea that states may not pass laws or enact policies that are in conflict with the Constitution, acts of Congress, or national treaties.

negative campaigning Campaigning designed to raise questions about a candidate's opponent by focusing on character deficiencies, especially through political commercials.

non-economic interest groups Issue-oriented groups that typically focus on public interest, consumer, and environmental issues.

nullification The doctrine first proposed by Thomas Jefferson and James Madison and later revived by John C. Calhoun that argued that the states could declare a federal law invalid if interpreted by them as a violation of the Constitution.

objective journalism Spearheaded by Adolph Ochs, owner of the *New York Times,* objective journalism avoided partisanship and exaggerated opinions, instead

favoring the facts of a story and a presentation of all sides of an issue. *See also* **yellow journalism.**

oligarchy A country ruled by relatively small self-appointed elite, perhaps by very wealthy landowners or a military junta.

ombudsman An official who would help citizens resolve their problems with bureaucratic agencies.

open primary A primary that allows any voter, regardless of partisan identification, to vote for a Republican or Democratic nominee. *See also* **closed primary; presidential primary**.

original jurisdiction A court that hears a case for the first time has original jurisdiction. A court that is hearing a case on appeal from a lower court has appellate jurisdiction. *See also* **appellate jurisdiction; jurisdiction.**

oversight function The power of Congress to investigate the performance of executive agencies or to hold hearings on major problems facing American society.

partisan orientation Representatives or senators whose votes on bills are heavily influenced by their respective party leaders.

party identification The degree to which citizens view themselves as loyal to the Republican or Democratic parties.

party in the electorate Voters who identify with a political party or are influenced by party loyalty at election time.

party in the government The appointed or elected officeholders in the legislative and executive branches of government. The term also may apply to the dominant party in the legislative and/or executive branches.

party platform A written document, approved at the national convention, that delineates where the party stands on the important political issues of the day. *See also* **plank.**

Patriot Act Legislation passed in 2001 expanding the government's power to investigate potential terrorist actions against the United States.

peace dividend Alleged savings from the defense budget that can be applied to social programs.

Pendleton Act 1883 act that made merit the basis for hiring personnel in the federal workforce through competitive examinations.

perestroika A Russian term meaning "restructuring," which Gorbachev used to promote his policies of economic change in the Soviet Union during the 1980s.

petit jury A jury that decides upon the ultimate innocence or guilt of an individual.

plank One specific issue in a party platform. *See also* **party platform.**

plea bargaining A legal tactic that allows a defendant to plead guilty in exchange for a lesser sentence.

Plessy v. Ferguson The Supreme Court ruled (in 1896) that the separate-but-equal doctrine was constitutional, in that separate facilities (in this case, railway cars in Louisiana) for the races were acceptable as long as they were equivalent in quality.

policy adoption The point at which a policy's action plan is converted into an actual law or decision.

policy evaluation The stage of the policy process that assesses whether a policy's operational consequences have resulted in a successful resolution of the original problem.

policy formulation A stage of the policy process in which an action plan is devised.

policy implementation The stage of the policy process in which the policy's operational intent is carried out by the appropriate administrators or bureaucrats.

political action committee (PAC) A committee established by corporations, labor unions, or other groups that distributes funds to election campaigns.

political efficacy The perception or feeling that an individual's voting act can truly make a difference in public policy, the functioning of government, and the quality of his or her own life.

political party A group of people who voluntarily band together for the purpose of winning political offices, and then making public policy.

political power The ability to influence the behavior of others so that they are compelled to take actions that they may normally wish to avoid.

political socialization The lifelong process by which an individual learns and develops his or her attitudes toward political issues, leaders, and government.

politico orientation Representatives or senators whose votes on bills are a blend of both the trustee and delegate orientations. *See also* **delegate orientation; trustee orientation.**

politics The authoritative allocation of values, or the idea of "who gets what, when, how."

poll tracking The polling technique whereby voting groups are surveyed almost continuously during a campaign in order to detect rapid shifts in opinions and attitudes.

power to persuade The real basis of presidential power, in that a president must convince others that his policies and decisions are in their best interests.

pre-emption The George W. Bush doctrine of striking terrorists before they strike U.S. soil once again; it also applies to enemy nations.

presidential greatness Students of the presidency typically cite the following virtues of great presidents: the ability to handle crises and challenges, personal courage, a vision for change that will inspire others, a willingness to use and stretch presidential powers for the good of the nation, skill in assembling a team of talented advisers, the wisdom to learn from and admit mistakes, and effective communication skills, especially in the era of TV and the mass media.

presidential nominating caucus Literally, a meeting of party members and one way of selecting national convention delegates rather than through a primary. The method, as used in Iowa, involves a series of meetings at various political levels—local, county, and state—culminating in the final selection of delegates to the national nominating convention.

presidential primary A nominating election, whereby voters can directly express their preference for a nominee or select delegates to the national convention. *See also* **closed primary; open primary.**

prior restraint Trying to censor, usually by the government, a media story before it is published.

privatization A proposed remedy for bureaucratic inefficiency, whereby services normally run by government, such as mail delivery, are handed over to private-sector firms.

professional groups Groups aligned with a particular profession. Typically included in this category are the American Medical Association (doctors; 300,000 members), the American Bar Association (lawyers; more than 400,000 members), the National Education Association (teachers; 2.7 million members), and the National Association of Realtors (real estate brokers; 1.2 million members).

Progressive party An important third-party movement in the early 1900s that emphasized political reform of corrupt big-city machines found in the Northeast and Midwest.

progressive tax A tax that requires wealthier citizens to pay a higher rate of taxes than lower-income citizens.

protectionism In international trade, a policy of erecting tariffs or quota barriers to raise the price of imports while protecting domestic industries.

psychological variables Voter perceptions relating to the sense of party identification; a candidate's issue positions; and the candidate's personality, style, or image. Any or all of these variables can influence the final voting decision.

public agenda The list of those issues publicized heavily by the media in order to attract the attention of the public.

public policy The actual "output" of government, or what a government does or does not do about a societal problem.

public and consumer interest groups Groups that seek political rewards that extend beyond the actual group membership, so that much of society benefits from their lobbying efforts. Where economic groups seek direct, private, material gain, a public-interest group such as the League of Women Voters (founded in 1920) works for simpler procedures to register voters, a goal that could theoretically strengthen democracy throughout the nation.

public opinion The collection of views and attitudes held by different groups and individuals in the United States toward the political system in general, and important public issues specifically.

purposive benefits Benefits won by an interest group but that are extended to individuals in society who are not members of the group (for example, clean air).

push polling Refers to the practice of asking respondents loaded questions (in which respondents are pushed toward a desired attitudinal outcome) about a candidate in order to receive negative responses.

quiescence Quiescent, or latent public opinion, refers to potential opinion that can become activated through events or the communication of more information, especially by the media.

random sampling A system whereby every individual in the population and geographic region has an equal mathematical chance of being included in the sample, just as in a lottery every number has the same probability of being selected.

realignment A shift in the party loyalties of the electorate so that the previous minority party becomes the majority party for a lengthy period.

redistributive policy A reallocation of public funds from middle-class and wealthy taxpayers to individuals who cannot support themselves or who are in need of other forms of governmental assistance.

registration The process, intended to prevent voter fraud, by which a voter's name, address, place of residence, and so on are recorded at the local registrar's office, thus making him or her eligible to vote.

regressive tax A tax that disproportionately affects lower-income taxpayers, such as a sales tax.

regulatory policy A policy that protects the general population from actual or potential economic, health, or environmental hazards.

relevance Relevant public opinion deals with how important or unimportant an issue may be to individuals.

representative democracy A democracy in which the people elect representatives who, in turn, make political policies and decisions.

republican form of government The term is generally understood to mean a representative democracy, whereby fundamental liberties are preserved. *See also* **representative democracy.**

residency requirement The requirement that a citizen must have lived in a locality for at least thirty days prior to an election in order to vote in local, state, and congressional races. Note that some states have eliminated or reduced this requirement.

Roe v. Wade The 1973 Supreme Court decision, asserting that (a) a woman has a constitutional right to an abortion during the first trimester; (b) the second trimester can involve state regulation to protect the mother's health; and (c) the state can ban abortions altogether during the third trimester of pregnancy.

Roosevelt's New Deal coalition An alliance of urban dwellers, blue-collar workers, Catholics, Jews, southern conservatives, and northern liberals that collectively created the basis for the Democratic party's political dominance from 1932 to 1968.

Rules Committee The traffic-cop committee in the House that schedules bills for floor action, allocates the length of time for debate, and decides whether the bill can be amended on the floor.

samples In polling procedures, representations that mirror much of the larger population's qualities or attributes.

self-incrimination The Fifth Amendment protection that states that an individual cannot be compelled to testify against him- or herself.

Senior Executive Service (SES) Established during the Carter presidency, the SES consists of top civil servants who are rewarded for effective job performance through bonuses, but are also more easily dismissed or demoted.

seniority A congressional tradition by which the member of the majority party with the longest continuous service on a committee automatically assumes the chair position of that committee.

separation of powers *See* **checks and balances/ separation of powers.**

Shays' Rebellion In 1786 farmers in western Massachusetts who could not pay their mortgages and/or high taxes interfered with the conduct of foreclosures and tax delinquency proceedings.

shield laws State laws designed to protect reporters from disclosing confidential news sources against their will. There is no federal shield law.

single-issue interest groups Groups primarily concerned with influencing policy in one substantive area. One example is the National Rifle Association (with 4.2 million members), which opposes gun control.

single-member district system The type of electoral system in the United States whereby there can be only one winner per office—the individual who receives a plurality of the votes.

slander Verbal or oral defamation that wrongfully disparages an individual's character or reputation. *See also* **libel**.

social contract The philosophical concept that the rulers and the ruled have mutual obligations—the ruled pledge support for the government, while the rulers protect the people's life, liberty, and property.

sociological factors Factors including a voter's socio-economic background and group affiliations, that, interacting with psychological factors, can collectively explain the voting decision.

soft money Money used by state and local parties for party-building activities to encourage selected turnout and registration. Under current law, soft money may not be given to the national political parties. *See also* **Bipartisan Campaign Reform Act**.

solid South The label attached to the former states of the Confederacy whose voters consistently voted for Democratic presidential candidates until the late 1960s. Thereafter, southern voters have gravitated toward conservative Republican presidents.

solidarity benefits The benefits of making friends and participating in social events that can be a major incentive for group membership. There is also the satisfaction of belonging to a group that has a unique cause, be it gun control or reducing taxes.

Speaker of the House Created by the Constitution, the Speaker is chosen by a vote of his majority party. He is the presiding officer of the House, assigns bills to committees, and influences the legislative process to a considerable degree. The Speaker is second in line to become president, after the vice-president.

spoils system "To the victor belong the spoils"—that is, the presidential tendency prior to 1883 to fill government positions with party supporters and friends, regardless of their particular expertise.

stability The idea that some individuals maintain their opinions for a very long time. The vast majority of Americans believe that democracy is a good, if not the best, form of government. This fundamental acceptance seems constant from generation to generation.

staff agency An agency that collects and distributes information for policymakers in the government.

standing committees Permanent structures that evaluate proposed legislation within their respective areas of expertise. Along with their smaller divisions, known as subcommittees, they can kill or pass along bills for final debate to each chamber floor.

stare decisis A term from the Latin meaning, "let the decision stand" that serves as the basic principle of common law. It also means a respect for precedent.

straight-party ticket A phenomenon in which voters select all of their candidates from one party. *See also* **ticket-splitting**.

strategic defense policy A policy that deals with the utilization and location of overseas military units.

strict constructionists People who argue that judges should adhere closely to the letter of the law, not make the law.

structural defense policy Distributive defense policy that is concerned with the allocation of defense resources, including manpower, weapons, and funding.

subgovernment A policy alliance that is composed of a bureaucratic agency, congressional committee, and interest group.

suffrage The right to vote.

sunset laws Laws mandating that agencies must be abolished if they are no longer necessary or are ineffective.

supply-side economics An economic theory based on the premise that reductions in federal taxes and spending will increase the private sector's productivity.

Swing voters Voters who change party loyalties periodically, rather than staying exclusively with the candidates of one party.

theocracy Refers to religious leaders constituting and running the government, such as in contemporary Iran.

three-fifths compromise A Constitutional Convention agreement that considered slaves to be worth three-fifths of a white voter for purposes of representation in the House of Representatives.

ticket-splitting Voters dividing their candidate selection between the two major parties, a phenomenon that has become far more common as of late. *See also* **straight-party ticket.**

trustee orientation Representatives or senators whose votes on a bill are mainly reflections of their own judgment rather than an extension of their constituents. *See also* **delegate orientation; politico orientation.**

umbrella parties The idea that both major parties accept members from nearly all groups and social classes in America. By clinging to the political center, they maximize their voting appeal.

unitary government A political system in which the central government has supreme power, and in which states and localities derive all their power from that governmental level.

U.S. v. Curtiss-Wright Export Corp. The Supreme Court case that decided that the president had exclusive power in the handling of international relations.

veto A presidential power that is used to reject a bill passed by Congress. In Latin, literally, "I forbid."

War Powers Act Legislation passed in 1973 authorizing Congress to bring American combat troops home after sixty days, despite presidential opposition. The act also calls for close congressional-presidential consultation prior to the beginning of combat operations.

watchdog role The role of the media centering on protecting the public from political, social, or economic excesses by exposing those individuals responsible for them.

whistle-blower Bureaucrat who reveals waste or corruption in his or her agency or department.

writ of certiorari An order by the Supreme Court to send up the case record because there is a claim that the lower court mishandled the case (more than ninety percent of all writs are denied by the Court).

yellow journalism A type of journalism attributed to William Randolph Hearst at the turn of the century that was intended to promote newspaper sales through sensational, exaggerated news stories. *See also* **objective journalism.**

Appendix A

■ THE DECLARATION OF INDEPENDENCE OF THE THIRTEEN COLONIES

In CONGRESS, July 4, 1776

The unanimous Declaration of the thirteen United States of America,

When in the Course of human events, it becomes necessary for one people to dissolve the political bands which have connected them with another, and to assume among the powers of the earth, the separate and equal station to which the Laws of Nature and of Nature's God entitle them, a decent respect to the opinions of mankind requires that they should declare the causes which impel them to the separation.

We hold these truths to be self-evident, that all men are created equal, that they are endowed by their Creator with certain unalienable Rights, that among these are Life, Liberty and the pursuit of Happiness. That to secure these rights, Governments are instituted among Men, deriving their just powers from the consent of the governed, That whenever any Form of Government becomes destructive of these ends, it is the Right of the People to alter or to abolish it, and to institute new Government, laying its foundation on such principles and organizing its powers in such form, as to them shall seem most likely to effect their Safety and Happiness. Prudence, indeed, will dictate that Governments long established should not be changed for light and transient causes; and accordingly all experience hath shewn, that mankind are more disposed to suffer, while evils are sufferable, than to right themselves by abolishing the forms to which they are accustomed. But when a long train of abuses and usurpations, pursuing invariably the same Object evinces a design to reduce them under absolute Despotism, it is their right, it is their duty, to throw off such Government, and to provide new Guards for their future security. Such has been the patient sufferance of these Colonies; and such is now the necessity which constrains them to alter their former Systems of Government. The history of the present King of Great Britain [George III] is a history of repeated injuries and usurpations, all having in direct object the establishment of an absolute Tyranny over these States. To prove this, let Facts be submitted to a candid world.

He has refused his Assent to Laws, the most wholesome and necessary for the public good.

He has forbidden his Governors to pass Laws of immediate and pressing importance, unless suspended in their operation till his Assent should be obtained; and when so suspended, he has utterly neglected to attend to them.

He has refused to pass other Laws for the accommodation of large districts of people, unless those people would relinquish the right of Representation in the Legislature, a right inestimable to them and formidable to tyrants only.

He has called together legislative bodies at places unusual, uncomfortable, and distant from the depository of their public Records, for the sole purpose of fatiguing them into compliance with his measures.

He has dissolved Representative Houses repeatedly, for opposing with manly firmness his invasions on the rights of the people.

He has refused for a long time, after such dissolutions, to cause others to be elected; whereby the Legislative powers, incapable of Annihilation, have returned to the People at large for their exercise; the State remaining in the mean time exposed to all the dangers of invasion from without, and convulsions within.

He has endeavoured to prevent the population of these States; for that purpose obstructing the Laws for Naturalization of Foreigners; refusing to pass others to encourage their migrations hither, and raising the conditions of new Appropriations of Lands.

He has obstructed the Administration of Justice, by refusing his Assent to Laws for establishing Judiciary powers.

He has made Judges dependent on his Will alone, for the tenure of their offices, and the amount and payment of their salaries.

He has erected a multitude of New Offices, and sent hither swarms of Officers to harass our people, and eat out their substance.

He has kept among us, in times of peace, Standing Armies without the consent of our legislatures.

He has affected to render the Military independent of and superior to the Civil power.

He has combined with others to subject us to a jurisdiction foreign to our constitution and unacknowledged by our laws; giving his Assent to their Acts of pretended Legislation:

For Quartering large bodies of armed troops among us:

For protecting them, by a mock Trial, from punishment for any Murders which they should commit on the Inhabitants of these States:

For cutting off our Trade with all parts of the world:

For imposing Taxes on us without our Consent:

For depriving us, in many cases, of the benefits of Trial by Jury:

For transporting us beyond Seas to be tried for pretended offences:

For abolishing the free System of English Laws in a neighbouring Province, establishing therein an Arbitrary government, and enlarging its Boundaries so as to render it at once an example and fit instrument for introducing the same absolute rule into these Colonies:

For taking away our Charters, abolishing our most valuable Laws, and altering fundamentally the Forms of our Governments:

For suspending our own Legislatures, and declaring themselves invested with power to legislate for us in all cases whatsoever.

He has abdicated Government here, by declaring us out of his Protection and waging War against us.

He has plundered our seas, ravaged our Coasts, burnt our towns, and destroyed the lives of our people.

He is at this time transporting large Armies of foreign Mercenaries to compleat the works of death, desolation and tyranny, already begun with circumstances of Cruelty and perfidy scarcely paralleled in the most barbarous ages, and totally unworthy the Head of a civilized nation.

He has constrained our fellow Citizens taken Captive on the high Seas to bear Arms against their Country, to become the executioners of their friends and Brethren, or to fall themselves by their Hands.

He has excited domestic insurrections amongst us, and has endeavoured to bring on the inhabitants of our frontiers, the merciless Indian Savages, whose known rule of warfare, is an undistinguished destruction of all ages, sexes and conditions.

In every stage of these Oppressions We have Petitioned for Redress in the most humble terms: Our repeated Petitions have been answered only by repeated injury. A Prince whose character is thus marked by every act which may define a Tyrant, is unfit to be the ruler of a free people.

Nor have We been wanting in attentions to our British brethren. We have warned them from time to time of attempts by their legislature to extend an unwarrantable jurisdiction over us. We have reminded them of

the circumstances of our emigration and settlement here. We have appealed to their native justice and magnanimity, and we have conjured them by the ties of our common kindred to disavow these usurpations, which, would inevitably interrupt our connections and correspondence. They too have been deaf to the voice of justice and of consanguinity. We must, therefore, acquiesce in the necessity, which denounces our Separation, and hold them, as we hold the rest of mankind, Enemies in War, in Peace Friends.

We, therefore, the Representatives of the united States of America, in General Congress, Assembled, appealing to the Supreme Judge of the world for the rectitude of our intentions, do, in the Name, and by the Authority of the good People of these Colonies, solemnly publish and declare, That these United Colonies are, and of Right ought to be Free and Independent States; that they are Absolved from all Allegiance to the British Crown, and that all political connection between them and the State of Great Britain, is and ought to be totally dissolved; and that as Free and Independent States, they have full Power to levy War, conclude Peace, contract Alliances, establish Commerce, and to do all other Acts and Things which Independent States may of right do. And for the support of this Declaration, with a firm reliance on the protection of divine Providence, we mutually pledge to each other our Lives, our Fortunes and our sacred Honor.

The signers of the Declaration represented the new states as follows:

New Hampshire
Josiah Bartlett, William Whipple, Matthew Thornton

Massachusetts
John Hancock, Samuel Adams, John Adams, Robert Treat Paine, Elbridge Gerry

Rhode Island
Stephen Hopkins, William Ellery

Connecticut
Roger Sherman, Samuel Huntington, William Williams, Oliver Wolcott

New York
William Floyd, Philip Livingston, Francis Lewis, Lewis Morris

New Jersey
Richard Stockton, John Witherspoon, Francis Hopkinson, John Hart, Abraham Clark

Pennsylvania
Robert Morris, Benjamin Rush, Benjamin Franklin, John Morton, George Clymer, James Smith, George Taylor, James Wilson, George Ross

Delaware
Caesar Rodney, George Read, Thomas McKean

Maryland
Samuel Chase, William Paca, Thomas Stone, Charles Carroll of Carrollton

Virginia
George Wythe, Richard Henry Lee, Thomas Jefferson, Benjamin Harrison, Thomas Nelson, Jr., Francis Lightfoot Lee, Carter Braxton

North Carolina
William Hooper, Joseph Hewes, John Penn

South Carolina
Edward Rutledge, Thomas Heyward, Jr., Thomas Lynch, Jr., Arthur Middleton

Georgia
Button Gwinnett, Lyman Hall, George Walton

Appendix B

■ INDEX GUIDE TO THE CONSTITUTION

Preamble

Article I: The Legislative Department. Organization of Congress and terms, qualifications, appointment, and election of Senators and Representatives.

Procedure in impeachment.

Privileges of the two houses and of their members.

Procedure in lawmaking.

Powers of Congress.

Limitations on Congress and on the States.

Article II: The Executive Department.

Election of President and Vice-President.

Powers and duties of the President.

Ratification of appointments and treaties.

Liability of officers to impeachment.

Article III: The Judicial Department.

Independence of the judiciary.

Jurisdiction of national courts.

Guarantee of jury trial.

Definition of treason.

Article IV: Position of the States and territories.

Full faith and credit to acts and judicial proceedings.

Privileges and immunities of citizens of the several States.

Rendition of fugitives from justice.

Control of territories by Congress.

Guarantees to the States.

Article V: Method of amendment.

Article VI: Supremacy of the Constitution, laws, and treaties of the United States.

Oath of office.

Prohibition of a religious test.

Article VII: Method of ratification of the Constitution.

Amendments

I. Freedom of religion, speech, press and assembly; right of petition.

II. Right to keep and bear arms.

III. Limitations in quartering soldiers.

IV. Protection from unreasonable searches and seizures.

V. Due process in criminal cases. Limitation on right of eminent domain.

VI. Right to speedy trial by jury, and other guarantees.

VII. Trial by jury in suits at law.

VIII. Excessive bail or unusual punishments forbidden.

IX. Retention of certain rights by the people.

X. Undelegated powers belong to the States or to the people.

XI. Exemption of States from suit by individuals.

XII. New method of electing President.

XIII. Abolition of slavery.

XIV Definition of citizenship. Guarantees of due process and equal protection against State action. Apportionment of Representatives in Congress. Validity of public debt.

XV. Voting rights guaranteed to freedmen.

XVI. Tax on incomes "from whatever source derived."

XVII. Popular election of Senators.

XVIII. Prohibition of intoxicating liquors.

XIX. Extension of suffrage to women.

XX. Abolition of "lame duck" session of Congress. Change in presidential and congressional terms.

XXI. Repeal of 18th Amendment.

XXII. Limitation of President's terms in office.

XXIII. Extension of suffrage to District of Columbia in presidential elections.

XXIV. Abolition of polltax requirement in national elections.

XXV. Presidential succession and disability provisions.

XXVI. Extension of suffrage to eighteen-year-olds.

XXVII. Allows congressional pay raises but only "until an election of Representatives shall have intervened."

Appendix C

■ THE CONSTITUTION OF THE UNITED STATES OF AMERICA

Preamble

We the people of the United States, in order to form a more perfect union, establish justice, insure domestic tranquility, provide for the common defense, promote the general welfare, and secure the blessings of liberty to ourselves and our posterity, do ordain and establish this Constitution for the United States of America.

Article I

Section 1

All legislative powers herein granted shall be vested in a Congress of the United States, which shall consist of a Senate and House of Representatives.

Section 2

The House of Representatives shall be composed of members chosen every second year by the people of the several states, and the electors in each state shall have the qualifications requisite for electors of the most numerous branch of the state legislature.

No person shall be a Representative who shall not have attained to the age of twenty-five years, and been seven years a citizen of the United States, and who shall not, when elected, be an inhabitant of that state in which he shall be chosen.

Representatives and direct taxes shall be apportioned among the several states which may be included within this union, according to their respective numbers, which shall be determined by adding to the whole number of free persons, including those bound to service for a term of years, and excluding Indians not taxed, three fifths of all other Persons. The actual Enumeration shall be made within three years after the first meeting of the Congress of the United States, and within every subsequent term of ten years, in such manner as they shall by law direct. The number of Representatives shall not exceed one for every thirty thousand, but each state shall have at least one Representative; and until such enumeration shall be made, the state of New Hampshire shall be entitled to chuse three, Massachusetts eight, Rhode Island and Providence Plantations one, Connecticut five, New York six, New Jersey four, Pennsylvania eight, Delaware one, Maryland six, Virginia ten, North Carolina five, South Carolina five, and Georgia three.

When vacancies happen in the Representation from any state, the executive authority thereof shall issue writs of election to fill such vacancies.

The House of Representatives shall choose their speaker and other officers; and shall have the sole power of impeachment.

Section 3

The Senate of the United States shall be composed of two Senators from each state, chosen by the legislature thereof, for six years; and each Senator shall have one vote.

Immediately after they shall be assembled in consequence of the first election, they shall be divided as equally as may be into three classes. The seats of the Senators of the first class shall be vacated at the expiration of the second year, of the second class at the expiration of the fourth year, and the third class at the expiration of the sixth year, so that one third may be chosen every second year; and if vacancies happen by resignation, or otherwise, during the recess of the legislature of any state, the executive thereof may make temporary appointments until the next meeting of the legislature, which shall then fill such vacancies.

No person shall be a Senator who shall not have attained to the age of thirty years, and been nine years a citizen of the United States and who shall not, when elected, be an inhabitant of that state for which he shall be chosen.

The Vice-President of the United States shall be President of the Senate, but shall have no vote, unless they be equally divided.

The Senate shall choose their other officers, and also a President pro tempore, in the absence of the Vice-President, or when he shall exercise the office of President of the United States.

The Senate shall have the sole power to try all impeachments. When sitting for that purpose, they shall be on oath or affirmation. When the President of the United States is tried, the Chief Justice shall preside: And no person shall be convicted without the concurrence of two thirds of the members present.

Judgment in cases of impeachment shall not extend further than to removal from office, and disqualification to hold and enjoy any office of honor, trust or profit under the United States: but the party convicted shall nevertheless be liable and subject to indictment, trial, judgment and punishment, according to law.

Section 4

The times, places and manner of holding elections for Senators and Representatives, shall be prescribed in each state by the legislature thereof; but the Congress may at any time by law make or alter such regulations, except as to the places of choosing Senators.

The Congress shall assemble at least once in every year, and such meeting shall be on the first Monday in December, unless they shall by law appoint a different day.

Section 5

Each House shall be the judge of the elections, returns and qualifications of its own members, and a majority of each shall constitute a quorum to do business; but a smaller number may adjourn from day to day, and may be authorized to compel the attendance of absent members, in such manner, and under such penalties as each House may provide.

Each House may determine the rules of its proceedings, punish its members for disorderly behavior, and, with the concurrence of two thirds, expel a member.

Each House shall keep a journal of its proceedings, and from time to time publish the same, excepting such parts as may in their judgment require secrecy; and the yeas and nays of the members of either House on any question shall, at the desire of one fifth of those present, be entered on the journal.

Neither House, during the session of Congress, shall, without the consent of the other, adjourn for more than three days, nor to any other place than that in which the two Houses shall be sitting.

Section 6

The Senators and Representatives shall receive a compensation for their services, to be ascertained by law, and paid out of the treasury of the United States. They shall in all cases, except treason, felony and breach of the peace, be privileged from arrest during their attendance at the session of their respective Houses, and in going to and returning from the same; and for any speech or debate in either House, they shall not be questioned in any other place.

No Senator or Representative shall, during the time for which he was elected, be appointed to any civil office under the authority of the United States, which shall have been created, or the emoluments whereof shall have been increased during such time: and no person holding any office under the United States, shall be a member of either House during his continuance in office.

Section 7

All bills for raising revenue shall originate in the House of Representatives; but the Senate may propose or concur with amendments as on other Bills.

Every bill which shall have passed the House of Representatives and the Senate, shall, before it become a law, be presented to the President of the United States; if he approve he shall sign it, but if not he shall return it, with his objections to that House in which it shall have originated, who shall enter the objections at large on their journal, and proceed to reconsider it. If after such reconsideration two thirds of that House shall agree to pass the bill, it shall be sent, together with the objections, to the other House, by which it shall likewise be reconsidered, and if approved by two thirds of that House, it shall become a law. But in all such cases the votes of both Houses shall be determined by yeas and nays, and the names of the persons voting for and against the bill shall be entered on the journal of each House respectively. If any bill shall not be returned by the President within ten days (Sundays excepted) after it shall have been presented to him, the same shall be a law, in like manner as if he had signed it, unless the Congress by their adjournment prevent its return, in which case it shall not be a law.

Every order, resolution, or vote to which the concurrence of the Senate and House of Representatives may be necessary (except on a question of adjournment) shall be presented to the President of the United States; and before the same shall take effect, shall be approved by him, or being disapproved by him, shall be repassed by two thirds of the Senate and House of Representatives, according to the rules and limitations prescribed in the case of a bill.

Section 8

The Congress shall have power to lay and collect taxes, duties, imposts and excises, to pay the debts and provide for the common defense and general welfare of the United States; but all duties, imposts and excises shall be uniform throughout the United States;

To borrow money on the credit of the United States;

To regulate commerce with foreign nations, and among the several states, and with the Indian tribes;

To establish a uniform rule of naturalization, and uniform laws on the subject of bankruptcies throughout the United States;

To coin money, regulate the value thereof, and of foreign coin, and fix the standard of weights and measures;

To provide for the punishment of counterfeiting the securities and current coin of the United States;

To establish post offices and post roads;

To promote the progress of science and useful arts, by securing for limited times to authors and inventors the exclusive right to their respective writings and discoveries;

To constitute tribunals inferior to the Supreme Court;

To define and punish piracies and felonies committed on the high seas, and offenses against the law of nations;

To declare war, grant letters of marque and reprisal, and make rules concerning captures on land and water;

To raise and support armies, but no appropriation of money to that use shall be for a longer term than two years;

To provide and maintain a navy;

To make rules for the government and regulation of the land and naval forces;

To provide for calling forth the militia to execute the laws of the union, suppress insurrections and repel invasions;

To provide for organizing, arming, and disciplining, the militia, and for governing such part of them as may be employed in the service of the United States, reserving to the states respectively, the appointment of the officers, and the authority of training the militia according to the discipline prescribed by Congress;

To exercise exclusive legislation in all cases whatsoever, over such District (not exceeding ten miles square) as may, by cession of particular states, and the acceptance of Congress, become the seat of the government of the United States, and to exercise like authority over all places purchased by the consent of the legislature of the state in which the same shall be, for the erection of forts, magazines, arsenals, dockyards, and other needful buildings; And

To make all laws which shall be necessary and proper for carrying into execution the foregoing powers, and all other powers vested by this Constitution in the government of the United States, or in any department or officer thereof.

Section 9

The migration or importation of such persons as any of the states now existing shall think proper to admit, shall not be prohibited by the Congress prior to the year one thousand eight hundred and eight, but a tax or duty may be imposed on such importation, not exceeding ten dollars for each person.

The privilege of the writ of habeas corpus shall not be suspended, unless when in cases of rebellion or invasion the public safety may require it.

No bill of attainder or *ex post facto* Law shall be passed.

No capitation, or other direct, tax shall be laid, unless in proportion to the census or enumeration herein before directed to be taken.

No tax or duty shall be laid on articles exported from any state.

No preference shall be given by any regulation of commerce or revenue to the ports of one state over those of another: nor shall vessels bound to, or from, one state, be obliged to enter, clear or pay duties in another.

No money shall be drawn from the treasury, but in consequence of appropriations made by law; and a regular statement and account of receipts and expenditures of all public money shall be published from time to time.

No title of nobility shall be granted by the United States: and no person holding any office of profit or trust under them, shall, without the consent of the Congress, accept of any present, emolument, office, or title, of any kind whatever, from any king, prince, or foreign state.

Section 10

No state shall enter into any treaty, alliance, or confederation; grant letters of marque and reprisal; coin money; emit bills of credit; make anything but gold and silver coin a tender in payment of debts; pass any bill of attainder, *ex post facto* law, or law impairing the obligation of contracts, or grant any title of nobility.

No state shall, without the consent of the Congress, lay any imposts or duties on imports or exports, except what may be absolutely necessary for executing it's inspection laws: and the net produce of all duties and imposts, laid by any state on imports or exports, shall be for the use of the treasury of the United States; and all such laws shall be subject to the revision and control of the Congress.

No state shall, without the consent of Congress, lay any duty of tonnage, keep troops, or ships of war in time of peace, enter into any agreement or compact with another state, or with a foreign power, or engage in war, unless actually invaded, or in such imminent danger as will not admit of delay.

Article II

Section 1

The executive power shall be vested in a President of the United States of America. He shall hold his office during the term of four years, and, together with the Vice-President, chosen for the same term, be elected, as follows:

Each state shall appoint, in such manner as the Legislature thereof may direct, a number of electors, equal to the whole number of Senators and Representatives to which the State may be entitled in the Congress: but no Senator or Representative, or person holding an office of trust or profit under the United States, shall be appointed an elector.

The electors shall meet in their respective states, and vote by ballot for two persons, of whom one at least shall not be an inhabitant of the same state with themselves. And they shall make a list of all the persons voted for, and of the number of votes for each; which list they shall sign and certify, and transmit sealed to the seat of the government of the United States, directed to the President of the Senate. The President of the Senate shall, in the presence of the Senate and House of Representatives, open all the certificates, and the votes shall then be counted. The person having the greatest number of votes shall be the President, if such number be a majority of the whole number of electors appointed; and if there be more than one who have such majority, and have an equal number of votes, then the House of Representatives shall immediately choose by ballot one of them for President; and if no person have a majority, then from the five highest on the list the said House shall in like manner choose the President. But in choosing the President, the votes shall be taken by States, the representation from each state having one vote; A quorum for this purpose shall consist of a member or members from two thirds of the states, and a majority of all the states shall be necessary to a choice. In every case, after the choice of the President, the person having the greatest number of votes of the electors shall be the Vice-President. But if there should remain two or more who have equal votes, the Senate shall choose from them by ballot the Vice-President.

The Congress may determine the time of choosing the electors, and the day on which they shall give their votes; which day shall be the same throughout the United States.

No person except a natural born citizen, or a citizen of the United States, at the time of the adoption of this Constitution, shall be eligible to the office of President; neither shall any person be eligible to that office who shall not have attained to the age of thirty five years, and been fourteen Years a resident within the United States.

In case of the removal of the President from office, or of his death, resignation, or inability to discharge the powers and duties of the said office, the same shall devolve on the Vice-President, and the Congress may by law provide for the case of removal, death, resignation or inability, both of the President and Vice-President, declaring what officer shall then act as President, and such officer shall act accordingly, until the disability be removed, or a President shall be elected.

The President shall, at stated times, receive for his services, a compensation, which shall neither be increased nor diminished during the period for which he shall have been elected, and he shall not receive within that period any other emolument from the United States, or any of them.

Before he enter on the execution of his office, he shall take the following oath or affirmation: "I do solemnly swear (or affirm) that I will faithfully execute the office of President of the United States, and will to the best of my ability, preserve, protect and defend the Constitution of the United States."

Section 2

The President shall be commander in chief of the Army and Navy of the United States, and of the militia of the several states, when called into the actual service of the United States; he may require the opinion, in writing, of the principal officer in each of the executive departments, upon any subject relating to the duties of their respective offices, and he shall have power to grant reprieves and pardons for offenses against the United States, except in cases of impeachment.

He shall have power, by and with the advice and consent of the Senate, to make treaties, provided two thirds of the Senators present concur; and he shall nominate, and by and with the advice and consent of the Senate, shall appoint ambassadors, other public ministers and consuls, judges of the Supreme Court, and all other officers of the United States, whose appointments are not herein otherwise provided for, and which shall be established by law: but the Congress may by law vest the appointment of such inferior officers, as they think proper, in the President alone, in the courts of law, or in the heads of departments.

The President shall have power to fill up all vacancies that may happen during the recess of the Senate, by granting commissions which shall expire at the end of their next session.

Section 3

He shall from time to time give to the Congress information of the state of the union, and recommend to their consideration such measures as he shall judge necessary and expedient; he may, on extraordinary occasions, convene both Houses, or either of them, and in case of disagreement between them, with respect to the time of adjournment, he may adjourn them to such time as he shall think proper; he shall receive ambassadors and other public ministers; he shall take care that the laws be faithfully executed, and shall commission all the officers of the United States.

Section 4

The President, Vice-President and all civil officers of the United States, shall be removed from office on impeachment for, and conviction of, treason, bribery, or other high crimes and misdemeanors.

Article III

Section 1

The judicial power of the United States, shall be vested in one Supreme Court, and in such inferior courts as the Congress may from time to time ordain and establish. The judges, both of the supreme and inferior courts, shall hold their offices during good behaviour, and shall, at stated times, receive for their services, a compensation, which shall not be diminished during their continuance in office.

Section 2

The judicial power shall extend to all cases, in law and equity, arising under this Constitution, the laws of the United States, and treaties made, or which shall be made, under their authority; to all cases affecting ambassadors, other public ministers and consuls; to all cases of admiralty and maritime jurisdiction; to controversies to which the United States shall be a party; to controversies between two or more states; between a state and citizens of another state; between citizens of different states; between citizens of the same state claiming lands under grants of different states, and between a state, or the citizens thereof, and foreign states, citizens or subjects.

In all cases affecting ambassadors, other public ministers and consuls, and those in which a state shall be party, the Supreme Court shall have original jurisdiction. In all the other cases before mentioned, the Supreme Court shall have appellate jurisdiction, both as to law and fact, with such exceptions, and under such regulations as the Congress shall make.

The trial of all crimes, except in cases of impeachment, shall be by jury; and such trial shall be held in the state where the said crimes shall have been committed; but when not committed within any state, the trial shall be at such place or places as the Congress may by law have directed.

Section 3

Treason against the United States, shall consist only in levying war against them, or in adhering to their enemies, giving them aid and comfort. No person shall be convicted of treason unless on the testimony of two witnesses to the same overt act, or on confession in open court.

The Congress shall have power to declare the punishment of treason, but no attainder of treason shall work corruption of blood, or forfeiture except during the life of the person attainted.

Article IV

Section 1

Full faith and credit shall be given in each state to the public acts, records, and judicial proceedings of every other state. And the Congress may by general laws prescribe the manner in which such acts, records, and proceedings shall be proved, and the effect thereof.

Section 2

The citizens of each state shall be entitled to all privileges and immunities of citizens in the several states.

A person charged in any state with treason, felony, or other crime, who shall flee from justice, and be found in another state, shall on demand of the executive authority of the state from which he fled, be delivered up, to be removed to the state having jurisdiction of the crime.

No person held to service or labor in one state, under the laws thereof, escaping into another, shall, in consequence of any law or regulation therein, be discharged from such service or labor, but shall be delivered up on claim of the party to whom such service or labor may be due.

Section 3

New states may be admitted by the Congress into this union; but no new states shall be formed or erected within the jurisdiction of any other state; nor any state be formed by the junction of two or more states, or parts of states, without the consent of the legislatures of the states concerned as well as of the Congress.

The Congress shall have power to dispose of and make all needful rules and regulations respecting the territory or other property belonging to the United States; and nothing in this Constitution shall be so construed as to prejudice any claims of the United States, or of any particular state.

Section 4

The United States shall guarantee to every state in this union a republican form of government, and shall protect each of them against invasion; and on application of the legislature, or of the executive (when the legislature cannot be convened) against domestic violence.

Article V

The Congress, whenever two thirds of both houses shall deem it necessary, shall propose amendments to this Constitution, or, on the application of the legislatures of two thirds of the several states, shall call a convention for proposing amendments, which, in either case, shall be valid to all intents and purposes, as part of this Constitution, when ratified by the legislatures of three fourths of the several states, or by conventions in three fourths thereof, as the one or the other mode of ratification may be proposed by the Congress; provided that no amendment which may be made prior to the year one thousand eight hundred and eight shall in any manner affect the first and fourth clauses in the ninth section of the first article; and that no state, without its consent, shall be deprived of its equal suffrage in the Senate.

Article VI

All debts contracted and engagements entered into, before the adoption of this Constitution, shall be as valid against the United States under this Constitution, as under the Confederation.

This Constitution, and the laws of the United States which shall be made in pursuance thereof; and all treaties made, or which shall be made, under the authority of the United States, shall be the supreme law of the land; and the judges in every state shall be bound thereby, anything in the Constitution or laws of any State to the contrary notwithstanding.

The Senators and Representatives before mentioned, and the members of the several state legislatures, and all executive and judicial officers, both of the United States and of the several states, shall be

bound by oath or affirmation, to support this Constitution; but no religious test shall ever be required as a qualification to any office or public trust under the United States.

Article VII

The ratification of the conventions of nine states, shall be sufficient for the establishment of this Constitution between the states so ratifying the same.

Done in convention by the unanimous consent of the states present the seventeenth day of September in the year of our Lord one thousand seven hundred and eighty-seven and of the independence of the United States of America the twelfth. In witness whereof We have hereunto subscribed our Names,

G. Washington	—Presidt. and deputy from Virginia
New Hampshire:	John Langdon, Nicholas Gilman
Massachusetts:	Nathaniel Gorham, Rufus King
Connecticut:	Wm. Saml. Johnson, Roger Sherman
New York:	Alexander Hamilton
New Jersey:	Wil. Livingston, David Brearly, Wm. Paterson, Jona. Dayton
Pennsylvania:	B. Franklin, Thomas Mifflin, Robt. Morris, Geo. Clymer, Thos FitzSimons, Jared Ingersoll, James Wilson, Gouv Morris
Delaware:	Geo. Read, Gunning Bedford, Jr., John Dickinson, Richard Bassett, Jaco. Broom
Maryland:	James McHenry, Dan of St Thos. Jenifer, Danl Carroll
Virginia:	John Blair, James Madison, Jr.
North Carolina:	Wm. Blount, Richd. Dobbs Spaight, Hu Williamson
South Carolina:	J. Rutledge, Charles Cotesworth Pinckney, Charles Pinckney, Pierce Butler
Georgia:	William Few, Abr Baldwin

Amendments to the Constitution of the United States

Amendment I (1791)

Congress shall make no law respecting an establishment of religion, or prohibiting the free exercise thereof; or abridging the freedom of speech, or of the press; or the right of the people peaceably to assemble, and to petition the government for a redress of grievances.

Amendment II (1791)

A well regulated militia, being necessary to the security of a free state, the right of the people to keep and bear arms, shall not be infringed.

Amendment III (1791)

No soldier shall, in time of peace be quartered in any house, without the consent of the owner, nor in time of war, but in a manner to be prescribed by law.

Amendment IV (1791)

The right of the people to be secure in their persons, houses, papers, and effects, against unreasonable searches and seizures, shall not be violated, and no warrants shall issue, but upon probable cause, supported by oath or affirmation, and particularly describing the place to be searched, and the persons or things to be seized.

Amendment V (1791)

No person shall be held to answer for a capital, or otherwise infamous crime, unless on a presentment or indictment of a grand jury, except in cases arising in the land or naval forces, or in the militia, when in actual service in time of war or public danger; nor shall any person be subject for the same offense to be twice put in jeopardy of life or limb; nor shall be compelled in any criminal case to be a witness against himself, nor be deprived of life, liberty, or property, without due process of law; nor shall private property be taken for public use, without just compensation.

Amendment VI (1791)

In all criminal prosecutions, the accused shall enjoy the right to a speedy and public trial, by an impartial jury of the state and district wherein the crime shall have been committed, which district shall have been previously ascertained by law, and to be informed of the nature and cause of the accusation; to be confronted with the witnesses against him; to have compulsory process for obtaining witnesses in his favor, and to have the assistance of counsel for his defense.

Amendment VII (1791)

In suits at common law, where the value in controversy shall exceed twenty dollars, the right of trial by jury shall be preserved, and no fact tried by a jury, shall be otherwise reexamined in any court of the United States, than according to the rules of the common law.

Amendment VIII (1791)

Excessive bail shall not be required, nor excessive fines imposed, nor cruel and unusual punishments inflicted.

Amendment IX (1791)

The enumeration in the Constitution, of certain rights, shall not be construed to deny or disparage others retained by the people.

Amendment X (1791)

The powers not delegated to the United States by the Constitution, nor prohibited by it to the states, are reserved to the states respectively, or to the people.

Amendment XI (1798)

The judicial power of the United States shall not be construed to extend to any suit in law or equity, commenced or prosecuted against one of the United States by citizens of another state, or by citizens or subjects of any foreign state.

Amendment XII (1804)

The electors shall meet in their respective states and vote by ballot for President and Vice-President, one of whom, at least, shall not be an inhabitant of the same state with themselves; they shall name in their ballots the person voted for as President, and in distinct ballots the person voted for as Vice-President, and they shall make distinct lists of all persons voted for as President, and of all persons voted for as Vice-President, and of the number of votes for each, which lists they shall sign and certify, and transmit sealed to the seat of the government of the United States, directed to the President of the Senate; The President of the Senate shall, in the presence of the Senate and House of Representatives, open all the certificates and the votes shall then be counted; the person having the greatest number of votes for President, shall be the President, if such number be a majority of the whole number of electors appointed; and if no person have such majority, then from the persons having the highest numbers not exceeding three on the list of those voted for as President, the House of Representatives shall choose immediately, by ballot, the President. But in choosing the President, the votes shall be taken by states, the representation from each state having one vote; a quorum for this purpose shall consist of a member or members from two-thirds of the states, and a majority of all the states shall be necessary to a choice. And if the House of Representatives shall not choose a President whenever the right of choice shall devolve upon them, before the fourth day of March next following, then the Vice-President shall act as President, as in the case of the death or other constitutional disability of the President. The person having the greatest number of votes as Vice-President, shall be the Vice-President, if such number be a majority of the whole number of electors appointed, and if no person have a majority, then from the two highest numbers on the list, the Senate shall choose the Vice-President; a quorum for the purpose shall consist of two-thirds of the whole number of Senators, and a majority of the whole number shall be necessary to a choice. But no person constitutionally ineligible to the office of President shall be eligible to that of Vice-President of the United States.

Amendment XIII (1865)

Section 1. Neither slavery nor involuntary servitude, except as a punishment for crime whereof the party shall have been duly convicted, shall exist within the United States, or any place subject to their jurisdiction.

Section 2. Congress shall have power to enforce this article by appropriate legislation.

Amendment XIV (1868)

Section 1. All persons born or naturalized in the United States, and subject to the jurisdiction thereof, are citizens of the United States and of the state wherein they reside. No state shall make or enforce any law which shall abridge the privileges or immunities of citizens of the United States; nor shall any state

deprive any person of life, liberty, or property, without due process of law; nor deny to any person within its jurisdiction the equal protection of the laws.

Section 2. Representatives shall be apportioned among the several states according to their respective numbers, counting the whole number of persons in each state, excluding Indians not taxed. But when the right to vote at any election for the choice of electors for President and Vice-President of the United States, Representatives in Congress, the executive and judicial officers of a state, or the members of the legislature thereof, is denied to any of the male inhabitants of such state, being twenty-one years of age, and citizens of the United States, or in any way abridged, except for participation in rebellion, or other crime, the basis of representation therein shall be reduced in the proportion which the number of such male citizens shall bear to the whole number of male citizens twenty-one years of age in such state.

Section 3. No person shall be a Senator or Representative in Congress, or elector of President and Vice-President, or hold any office, civil or military, under the United States, or under any state, who, having previously taken an oath, as a member of Congress, or as an officer of the United States, or as a member of any state legislature, or as an executive or judicial officer of any state, to support the Constitution of the United States, shall have engaged in insurrection or rebellion against the same, or given aid or comfort to the enemies thereof. But Congress may by a vote of two-thirds of each House, remove such disability.

Section 4. The validity of the public debt of the United States, authorized by law, including debts incurred for payment of pensions and bounties for services in suppressing insurrection or rebellion, shall not be questioned. But neither the United States nor any state shall assume or pay any debt or obligation incurred in aid of insurrection or rebellion against the United States, or any claim for the loss or emancipation of any slave; but all such debts, obligations and claims shall be held illegal and void.

Section 5. The Congress shall have power to enforce, by appropriate legislation, the provisions of this article.

Amendment XV (1870)

Section 1. The right of citizens of the United States to vote shall not be denied or abridged by the United States or by any state on account of race, color, or previous condition of servitude.

Section 2. The Congress shall have power to enforce this article by appropriate legislation.

Amendment XVI (1913)

The Congress shall have power to lay and collect taxes on incomes, from whatever source derived, without apportionment among the several states, and without regard to any census of enumeration.

Amendment XVII (1913)

The Senate of the United States shall be composed of two Senators from each state, elected by the people thereof, for six years; and each Senator shall have one vote. The electors in each state shall have the qualifications requisite for electors of the most numerous branch of the state legislatures.

When vacancies happen in the representation of any state in the Senate, the executive authority of such state shall issue writs of election to fill such vacancies: Provided, that the legislature of any state may empower the executive thereof to make temporary appointments until the people fill the vacancies by election as the legislature may direct.

This amendment shall not be so construed as to affect the election or term of any Senator chosen before it becomes valid as part of the Constitution.

Amendment XVIII (1919)

Section 1. After one year from the ratification of this article the manufacture, sale, or transportation of intoxicating liquors within, the importation thereof into, or the exportation thereof from the United States and all territory subject to the jurisdiction thereof for beverage purposes is hereby prohibited.

Section 2. The Congress and the several states shall have concurrent power to enforce this article by appropriate legislation.

Section 3. This article shall be inoperative unless it shall have been ratified as an amendment to the Constitution by the legislatures of the several states, as provided in the Constitution, within seven years from the date of the submission hereof to the states by the Congress.

Amendment XIX (1920)

The right of citizens of the United States to vote shall not be denied or abridged by the United States or by any state on account of sex.

Congress shall have power to enforce this article by appropriate legislation.

Amendment XX (1933)

Section 1. The terms of the President and Vice-President shall end at noon on the 20th day of January, and the terms of Senators and Representatives at noon on the 3d day of January, of the years in which such terms would have ended if this article had not been ratified; and the terms of their successors shall then begin.

Section 2. The Congress shall assemble at least once in every year, and such meeting shall begin at noon on the 3d day of January, unless they shall by law appoint a different day.

Section 3. If, at the time fixed for the beginning of the term of the President, the President elect shall have died, the Vice-President elect shall become President. If a President shall not have been chosen before the time fixed for the beginning of his term, or if the President elect shall have failed to qualify,

then the Vice-President elect shall act as President until a President shall have qualified; and the Congress may by law provide for the case wherein neither a President elect nor a Vice-President elect shall have qualified, declaring who shall then act as President, or the manner in which one who is to act shall be selected, and such person shall act accordingly until a President or Vice-President shall have qualified.

Section 4. The Congress may by law provide for the case of the death of any of the persons from whom the House of Representatives may choose a President whenever the right of choice shall have devolved upon them, and for the case of the death of any of the persons from whom the Senate may choose a Vice-President whenever the right of choice shall have devolved upon them.

Section 5. Sections 1 and 2 shall take effect on the 15th day of October following the ratification of this article.

Section 6. This article shall be inoperative unless it shall have been ratified as an amendment to the Constitution by the legislatures of three-fourths of the several states within seven years from the date of its submission.

Amendment XXI (1933)

Section 1. The eighteenth article of amendment to the Constitution of the United States is hereby repealed.

Section 2. The transportation or importation into any state, territory, or possession of the United States for delivery or use therein of intoxicating liquors, in violation of the laws thereof, is hereby prohibited.

Section 3. This article shall be inoperative unless it shall have been ratified as an amendment to the Constitution by conventions in the several states, as provided in the Constitution, within seven years from the date of the submission hereof to the states by the Congress.

Amendment XXII (1951)

Section 1. No person shall be elected to the office of the President more than twice, and no person who has held the office of President, or acted as President, for more than two years of a term to which some other person was elected President shall be elected to the office of the President more than once. But this article shall not apply to any person holding the office of President when this article was proposed by the Congress, and shall not prevent any person who may be holding the office of President, or acting as President, during the term within which this article becomes operative from holding the office of President or acting as President during the remainder of such term.

Section 2. This article shall be inoperative unless it shall have been ratified as an amendment to the Constitution by the legislatures of three-fourths of the several states within seven years from the date of its submission to the states by the Congress.

Amendment XXIII (1961)

Section 1. The District constituting the seat of government of the United States shall appoint in such manner as the Congress may direct:

A number of electors of President and Vice-President equal to the whole number of Senators and Representatives in Congress to which the District would be entitled if it were a state, but in no event more than the least populous state; they shall be in addition to those appointed by the states, but they shall be considered, for the purposes of the election of President and Vice-President, to be electors appointed by a state; and they shall meet in the District and perform such duties as provided by the twelfth article of amendment.

Section 2. The Congress shall have power to enforce this article by appropriate legislation.

Amendment XXIV (1964)

Section 1. The right of citizens of the United States to vote in any primary or other election for President or Vice-President, for electors for President or Vice-President, or for Senator or Representative in Congress, shall not be denied or abridged by the United States or any state by reason of failure to pay any poll tax or other tax.

Section 2. The Congress shall have power to enforce this article by appropriate legislation.

Amendment XXV (1967)

Section 1. In case of the removal of the President from office or of his death or resignation, the Vice-President shall become President.

Section 2. Whenever there is a vacancy in the office of the Vice-President, the President shall nominate a Vice-President who shall take office upon confirmation by a majority vote of both Houses of Congress.

Section 3. Whenever the President transmits to the President pro tempore of the Senate and the Speaker of the House of Representatives his written declaration that he is unable to discharge the powers and duties of his office, and until he transmits to them a written declaration to the contrary, such powers and duties shall be discharged by the Vice-President as Acting President.

Section 4. Whenever the Vice-President and a majority of either the principal officers of the executive departments or of such other body as Congress may by law provide, transmit to the President pro tempore of the Senate and the Speaker of the House of Representatives their written declaration that the President is unable to discharge the powers and duties of his office, the Vice-President shall immediately assume the powers and duties of the office as Acting President.

Thereafter, when the President transmits to the President pro tempore of the Senate and the Speaker of the House of Representatives his written declaration that no inability exists, he shall resume the powers and duties of his office unless the Vice-President and a majority of either the principal officers of the executive department or of such other body as Congress may by law provide, transmit within four days to the President pro tempore of the Senate and the Speaker of the House of Representatives their written declaration that the President is unable to discharge the powers and duties of his office. Thereupon Congress shall decide the issue, assembling within forty-eight hours for that purpose if not in session. If the Congress, within twenty-one days after receipt of the latter written declaration, or, if Congress is not in session, within twenty-one days after Congress is required to assemble, determines by two-thirds vote of both Houses that the President is unable to discharge the powers and duties of his office, the Vice-President shall continue to discharge the same as Acting President; otherwise, the President shall resume the powers and duties of his office.

Amendment XXVI (1971)

Section 1. The right of citizens of the United States, who are eighteen years of age or older, to vote, shall not be denied or abridged by the United States or any state on account of age.

Section 2. The Congress shall have the power to enforce this article by appropriate legislation.

Amendment XXVII (1992)

No law varying the compensation for the services of the Senators and Representatives shall take effect until an election of Representatives shall have intervened.

Appendix D

■ THE *FEDERALIST* NO. 10

The Utility of the Union as a Safeguard Against Domestic Faction and Insurrection

Daily Advertiser

Thursday, November 22, 1787

[James Madison]

To the People of the State of New York:

AMONG the numerous advantages promised by a well constructed Union, none deserves to be more accurately developed than its tendency to break and control the violence of faction. The friend of popular governments never finds himself so much alarmed for their character and fate, as when he contemplates their propensity to this dangerous vice. He will not fail, therefore, to set a due value on any plan which, without violating the principles to which he is attached, provides a proper cure for it. The instability, injustice, and confusion introduced into the public councils, have, in truth, been the mortal diseases under which popular governments have everywhere perished; as they continue to be the favorite and fruitful topics from which the adversaries to liberty derive their most specious declamations. The valuable improvements made by the American constitutions on the popular models, both ancient and modern, cannot certainly be too much admired; but it would be an unwarrantable partiality, to contend that they have as effectually obviated the danger on this side, as was wished and expected. Complaints are everywhere heard from our most considerate and virtuous citizens, equally the friends of public and private faith, and of public and personal liberty, that our governments are too unstable, that the public good is disregarded in the conflicts of rival parties, and that measures are too often decided, not according to the rules of justice and the rights of the minor party, but by the superior force of an interested and overbearing majority. However anxiously we may wish that these complaints had no foundation, the evidence, of known facts will not permit us to deny that they are in some degree true. It will be found, indeed, on a candid review of our situation, that some of the distresses under which we labor have been erroneously charged on the operation of our governments; but it will be found, at the same time, that other causes will not alone account for many of our heaviest misfortunes; and, particularly, for that prevailing and increasing distrust of public engagements, and alarm for private rights, which are echoed from one end of the continent to the other. These must be chiefly, if not wholly, effects of the unsteadiness and injustice with which a factious spirit has tainted our public administrations.

By a faction, I understand a number of citizens, whether amounting to a majority or a minority of the whole, who are united and actuated by some common impulse of passion, or of interest, adversed to the rights of other citizens, or to the permanent and aggregate interests of the community.

There are two methods of curing the mischiefs of faction: the one, by removing its causes; the other, by controlling its effects.

There are again two methods of removing the causes of faction: the one, by destroying the liberty which is essential to its existence; the other, by giving to every citizen the same opinions, the same passions, and the same interests.

It could never be more truly said than of the first remedy, that it was worse than the disease. Liberty is to faction what air is to fire, an aliment without which it instantly expires. But it could not be less folly to abolish liberty, which is essential to political life, because it nourishes faction, than it would be to wish the annihilation of air, which is essential to animal life, because it imparts to fire its destructive agency.

The second expedient is as impracticable as the first would be unwise. As long as the reason of man continues fallible, and he is at liberty to exercise it, different opinions will be formed. As long as the connection subsists between his reason and his self-love, his opinions and his passions will have a reciprocal influence on each other; and the former will be objects to which the latter will attach themselves. The diversity in the faculties of men, from which the rights of property originate, is not less an insuperable obstacle to a uniformity of interests. The protection of these faculties is the first object of government. From the protection of different and unequal faculties of acquiring property, the possession of different degrees and kinds of property immediately results; and from the influence of these on the sentiments and views of the respective proprietors, ensues a division of the society into different interests and parties.

The latent causes of faction are thus sown in the nature of man; and we see them everywhere brought into different degrees of activity, according to the different circumstances of civil society. A zeal for different opinions concerning religion, concerning government, and many other points, as well of speculation as of practice; an attachment to different leaders ambitiously contending for pre-eminence and power; or to persons of other descriptions whose fortunes have been interesting to the human passions, have, in turn, divided mankind into parties, inflamed them with mutual animosity, and rendered them much more disposed to vex and oppress each other than to co-operate for their common good. So strong is this propensity of mankind to fall into mutual animosities, that where no substantial occasion presents itself, the most frivolous and fanciful distinctions have been sufficient to kindle their unfriendly passions and excite their most violent conflicts. But the most common and durable source of factions has been the various and unequal distribution of property. Those who hold and those who are without property have ever formed distinct interests in society. Those who are creditors, and those who are debtors, fall under a like discrimination. A landed interest, a manufacturing interest, a mercantile interest, a moneyed interest, with many lesser interests, grow up of necessity in civilized nations, and divide them into different classes, actuated by different sentiments and views. The regulation of these various and interfering interests forms the principal task of modern legislation, and involves the spirit of party and faction in the necessary and ordinary operations of the government.

No man is allowed to be a judge in his own cause, because his interest would certainly bias his judgment, and, not improbably, corrupt his integrity. With equal, nay with greater reason, a body of men are unfit to be both judges and parties at the same time; yet what are many of the most important acts of legislation, but so many judicial determinations, not indeed concerning the rights of single persons, but concerning the rights of large bodies of citizens? And what are the different classes of legislators but advocates and parties to the causes which they determine? Is a law proposed concerning private debts? It is a question to which the creditors are parties on one side and the debtors on the other. Justice ought to hold the balance between them. Yet the parties are, and must be, themselves the judges; and the most numerous party, or, in other words, the most powerful faction must be expected to prevail. Shall domestic manufactures be encouraged, and in what degree, by restrictions on foreign manufactures? Are questions which would be differently decided by the landed and the manufacturing classes, and probably

by neither with a sole regard to justice and the public good. The apportionment of taxes on the various descriptions of property is an act which seems to require the most exact impartiality; yet there is, perhaps, no legislative act in which greater opportunity and temptation are given to a predominant party to trample on the rules of justice. Every shilling with which they overburden the inferior number, is a shilling saved to their own pockets.

It is in vain to say that enlightened statesmen will be able to adjust these clashing interests, and render them all subservient to the public good. Enlightened statesmen will not always be at the helm. Nor, in many cases, can such an adjustment be made at all without taking into view indirect and remote considerations, which will rarely prevail over the immediate interest which one party may find in disregarding the rights of another or the good of the whole.

The inference to which we are brought is, that the *causes* of faction cannot be removed, and that relief is only to be sought in the means of controlling its *effects*.

If a faction consists of less than a majority, relief is supplied by the republican principle, which enables the majority to defeat its sinister views by regular vote. It may clog the administration, it may convulse the society; but it will be unable to execute and mask its violence under the forms of the Constitution. When a majority is included in a faction, the form of popular government, on the other hand, enables it to sacrifice to its ruling passion or interest both the public good and the rights of other citizens. To secure the public good and private rights against the danger of such a faction, and at the same time to preserve the spirit and the form of popular government, is then the great object to which our inquiries are directed. Let me add that it is the great desideratum by which this form of government can be rescued from the opprobrium under which it has so long labored, and be recommended to the esteem and adoption of mankind.

By what means is this object attainable? Evidently by one of two only. Either the existence of the same passion or interest in a majority at the same time must be prevented, or the majority, having such coexistent passion or interest, must be rendered, by their number and local situation, unable to concert and carry into effect schemes of oppression. If the impulse and the opportunity be suffered to coincide, we well know that neither moral nor religious motives can be relied on as an adequate control. They are not found to be such on the injustice and violence of individuals, and lose their efficacy in proportion to the number combined together, that is, in proportion as their efficacy becomes needful.

From this view of the subject it may be concluded that a pure democracy, by which I mean a society consisting of a small number of citizens, who assemble and administer the government in person, can admit of no cure for the mischiefs of faction. A common passion or interest will, in almost every case, be felt by a majority of the whole; a communication and concert result from the form of government itself; and there is nothing to check the inducements to sacrifice the weaker party or an obnoxious individual. Hence it is that such democracies have ever been spectacles of turbulence and contention; have ever been found incompatible with personal security or the rights of property; and have in general been as short in their lives as they have been violent in their deaths. Theoretic politicians, who have patronized this species of government, have erroneously supposed that by reducing mankind to a perfect equality in their political rights, they would, at the same time, be perfectly equalized and assimilated in their possessions, their opinions, and their passions.

A republic, by which I mean a government in which the scheme of representation takes place, opens a different prospect, and promises the cure for which we are seeking. Let us examine the points in which it varies from pure democracy, and we shall comprehend both the nature of the cure and the efficacy which it must derive from the Union.

The two great points of difference between a democracy and a republic are: first, the delegation of the government, in the latter, to a small number of citizens elected by the rest; secondly, the greater number of citizens, and greater sphere of country, over which the latter may be extended.

The effect of the first difference is, on the one hand, to refine and enlarge the public views, by passing them through the medium of a chosen body of citizens, whose wisdom may best discern the true interest of their country, and whose patriotism and love of justice will be least likely to sacrifice it to temporary or partial considerations. Under such a regulation, it may well happen that the public voice, pronounced by the representatives of the people, will be more consonant to the public good than if pronounced by the people themselves, convened for the purpose. On the other hand, the effect may be inverted. Men of factious tempers, of local prejudices, or of sinister designs, may, by intrigue, by corruption, or by other means, first obtain the suffrages, and then betray the interests, of the people. The question resulting is, whether small or extensive republics are more favorable to the election of proper guardians of the public weal; and it is clearly decided in favor of the latter by two obvious considerations:

In the first place, it is to be remarked that, however small the republic may be, the representatives must be raised to a certain number, in order to guard against the cabals of a few; and that, however large it may be, they must be limited to a certain number, in order to guard against the confusion of a multitude. Hence, the number of representatives in the two cases not being in proportion to that of the two constituents, and being proportionally greater in the small republic, it follows that, if the proportion of fit characters be not less in the large than in the small republic, the former will present a greater option, and consequently a greater probability of a fit choice.

In the next place, as each representative will be chosen by a greater number of citizens in the large than in the small republic, it will be more difficult for unworthy candidates to practice with success the vicious arts by which elections are too often carried; and the suffrages of the people being more free, will be more likely to centre in men who possess the most attractive merit and the most diffusive and established characters.

It must be confessed that in this, as in most other cases, there is a mean, on both sides of which inconveniences will be found to lie. By enlarging too much the number of electors, you render the representatives too little acquainted with all their local circumstances and lesser interests; as by reducing it too much, you render him unduly attached to these, and too little fit to comprehend and pursue great and national objects. The federal Constitution forms a happy combination in this respect; the great and aggregate interests being referred to the national, the local and particular to the State legislatures.

The other point of difference is, the greater number of citizens and extent of territory which may be brought within the compass of republican than of democratic government; and it is this circumstance principally which renders factious combinations less to be dreaded in the former than in the latter. The smaller the society, the fewer probably will be the distinct parties and interests composing it; the fewer the distinct parties and interests, the more frequently will a majority be found of the same party; and the smaller the number of individuals composing a majority, and the smaller the compass within which they are placed, the more easily will they concert and execute their plans of oppression. Extend the sphere, and you take in a greater variety of parties and interests; you make it less probable that a majority of the whole will have a common motive to invade the rights of other citizens; or if such a common motive exists, it will be more difficult for all who feel it to discover their own strength, and to act in unison with each other. Besides other impediments, it may be remarked that, where there is a consciousness of unjust or

dishonorable purposes, communication is always checked by distrust in proportion to the number whose concurrence is necessary.

Hence, it clearly appears, that the same advantage which a republic has over a democracy, in controlling the effects of faction, is enjoyed by a large over a small republic, is enjoyed by the Union over the States composing it. Does the advantage consist in the substitution of representatives whose enlightened views and virtuous sentiments render them superior to local prejudices and schemes of injustice? It will not be denied that the representation of the Union will be most likely to possess these requisite endowments. Does it consist in the greater security afforded by a greater variety of parties, against the event of any one party being able to outnumber and oppress the rest? In an equal degree does the increased variety of parties comprised within the Union, increase this security. Does it, in fine, consist in the greater obstacles opposed to the concert and accomplishment of the secret wishes of an unjust and interested majority? Here, again, the extent of the Union gives it the most palpable advantage.

The influence of factious leaders may kindle a flame within their particular States, but will be unable to spread a general conflagration through the other States. A religious sect may degenerate into a political faction in a part of the Confederacy; but the variety of sects dispersed over the entire face of it must secure the national councils against any danger from that source. A rage for paper money, for an abolition of debts, for an equal division of property, or for any other improper or wicked project, will be less apt to pervade the whole body of the Union than a particular member of it; in the same proportion as such a malady is more likely to taint a particular county or district, than an entire State.

In the extent and proper structure of the Union, therefore, we behold a republican remedy for the diseases most incident to republican government. And according to the degree of pleasure and pride we feel in being republicans, ought to be our zeal in cherishing the spirit and supporting the character of Federalists.

PUBLIUS

Appendix E

■ THE *FEDERALIST* NO. 51

The Structure of the Government Must Furnish the Proper Checks and Balances Between the Different Departments

Independent Journal

Wednesday, February 6, 1788

[James Madison]

To the People of the State of New York:

TO WHAT expedient, then, shall we finally resort, for maintaining in practice the necessary partition of power among the several departments, as laid down in the Constitution? The only answer that can be given is, that as all these exterior provisions are found to be inadequate, the defect must be supplied, by so contriving the interior structure of the government as that its several constituent parts may, by their mutual relations, be the means of keeping each other in their proper places. Without presuming to undertake a full development of this important idea, I will hazard a few general observations, which may perhaps place it in a clearer light, and enable us to form a more correct judgment of the principles and structure of the government planned by the convention.

In order to lay a due foundation for that separate and distinct exercise of the different powers of government, which to a certain extent is admitted on all hands to be essential to the preservation of liberty, it is evident that each department should have a will of its own; and consequently should be so constituted that the members of each should have as little agency as possible in the appointment of the members of the others. Were this principle rigorously adhered to, it would require that all the appointments for the supreme executive, legislative, and judiciary magistracies should be drawn from the same fountain of authority, the people, through channels having no communication whatever with one another. Perhaps such a plan of constructing the several departments would be less difficult in practice than it may in contemplation appear. Some difficulties, however, and some additional expense would attend the execution of it. Some deviations, therefore, from the principle must be admitted. In the constitution of the judiciary department in particular, it might be inexpedient to insist rigorously on the principle: first, because peculiar qualifications being essential in the members, the primary consideration ought to be to select that mode of choice which best secures these qualifications; secondly, because the permanent tenure by which the appointments are held in that department, must soon destroy all sense of dependence on the authority conferring them.

It is equally evident, that the members of each department should be as little dependent as possible on those of the others, for the emoluments annexed to their offices. Were the executive magistrate, or the judges, not independent of the legislature in this particular, their independence in every other would be merely nominal.

But the great security against a gradual concentration of the several powers in the same department, consists in giving to those who administer each department the necessary constitutional means and personal motives to resist encroachments of the others. The provision for defense must in this, as in all other cases, be made commensurate to the danger of attack. Ambition must be made to counteract ambition. The interest of the man must be connected with the constitutional rights of the place. It

may be a reflection on human nature, that such devices should be necessary to control the abuses of government. But what is government itself, but the greatest of all reflections on human nature? If men were angels, no government would be necessary. If angels were to govern men, neither external nor internal controls on government would be necessary. In framing a government which is to be administered by men over men, the great difficulty lies in this: you must first enable the government to control the governed; and in the next place oblige it to control itself. A dependence on the people is, no doubt, the primary control on the government; but experience has taught mankind the necessity of auxiliary precautions.

This policy of supplying, by opposite and rival interests, the defect of better motives, might be traced through the whole system of human affairs, private as well as public. We see it particularly displayed in all the subordinate distributions of power, where the constant aim is to divide and arrange the several offices in such a manner as that each may be a check on the other—that the private interest of every individual may be a sentinel over the public rights. These inventions of prudence cannot be less requisite in the distribution of the supreme powers of the State.

But it is not possible to give to each department an equal power of self-defense. In republican government, the legislative authority necessarily predominates. The remedy for this inconveniency is to divide the legislature into different branches; and to render them, by different modes of election and different principles of action, as little connected with each other as the nature of their common functions and their common dependence on the society will admit. It may even be necessary to guard against dangerous encroachments by still further precautions. As the weight of the legislative authority requires that it should be thus divided, the weakness of the executive may require, on the other hand, that it should be fortified. An absolute negative on the legislature appears, at first view, to be the natural defense with which the executive magistrate should be armed. But perhaps it would be neither altogether safe nor alone sufficient. On ordinary occasions it might not be exerted with the requisite firmness, and on extraordinary occasions it might be perfidiously abused. May not this defect of an absolute negative be supplied by some qualified connection between this weaker department and the weaker branch of the stronger department, by which the latter may be led to support the constitutional rights of the former, without being too much detached from the rights of its own department?

If the principles on which these observations are founded be just, as I persuade myself they are, and they be applied as a criterion to the several State constitutions, and to the federal Constitution it will be found that if the latter does not perfectly correspond with them, the former are infinitely less able to bear such a test.

There are, moreover, two considerations particularly applicable to the federal system of America, which place that system in a very interesting point of view.

First. In a single republic, all the power surrendered by the people is submitted to the administration of a single government; and the usurpations are guarded against by a division of the government into distinct and separate departments. In the compound republic of America, the power surrendered by the people is first divided between two distinct governments, and then the portion allotted to each subdivided among distinct and separate departments. Hence a double security arises to the rights of the people. The different governments will control each other, at the same time that each will be controlled by itself.

Second. It is of great importance in a republic not only to guard the society against the oppression of its rulers, but to guard one part of the society against the injustice of the other part. Different interests

necessarily exist in different classes of citizens. If a majority be united by a common interest, the rights of the minority will be insecure. There are but two methods of providing against this evil: the one by creating a will in the community independent of the majority—that is, of the society itself; the other, by comprehending in the society so many separate descriptions of citizens as will render an unjust combination of a majority of the whole very improbable, if not impracticable. The first method prevails in all governments possessing an hereditary or self-appointed authority. This, at best, is but a precarious security; because a power independent of the society may as well espouse the unjust views of the major, as the rightful interests of the minor party, and may possibly be turned against both parties. The second method will be exemplified in the federal republic of the United States. Whilst all authority in it will be derived from and dependent on the society, the society itself will be broken into so many parts, interests, and classes of citizens, that the rights of individuals, or of the minority, will be in little danger from interested combinations of the majority. In a free government the security for civil rights must be the same as that for religious rights. It consists in the one case in the multiplicity of interests, and in the other in the multiplicity of sects. The degree of security in both cases will depend on the number of interests and sects; and this may be presumed to depend on the extent of country and number of people comprehended under the same government. This view of the subject must particularly recommend a proper federal system to all the sincere and considerate friends of republican government, since it shows that in exact proportion as the territory of the Union may be formed into more circumscribed Confederacies, or States oppressive combinations of a majority will be facilitated: the best security, under the republican forms, for the rights of every class of citizens, will be diminished: and consequently the stability and independence of some member of the government, the only other security, must be proportionately increased. Justice is the end of government. It is the end of civil society. It ever has been and ever will be pursued until it be obtained, or until liberty be lost in the pursuit. In a society under the forms of which the stronger faction can readily unite and oppress the weaker, anarchy may as truly be said to reign as in a state of nature, where the weaker individual is not secured against the violence of the stronger; and as, in the latter state, even the stronger individuals are prompted, by the uncertainty of their condition, to submit to a government which may protect the weak as well as themselves; so, in the former state, will the more powerful factions or parties be gradnally induced, by a like motive, to wish for a government which will protect all parties, the weaker as well as the more powerful. It can be little doubted that if the State of Rhode Island was separated from the Confederacy and left to itself, the insecurity of rights under the popular form of government within such narrow limits would be displayed by such reiterated oppressions of factious majorities that some power altogether independent of the people would soon be called for by the voice of the very factions whose misrule had proved the necessity of it. In the extended republic of the United States, and among the great variety of interests, parties, and sects which it embraces, a coalition of a majority of the whole society could seldom take place on any other principles than those of justice and the general good; whilst there being thus less danger to a minor from the will of a major party, there must be less pretext, also, to provide for the security of the former, by introducing into the government a will not dependent on the latter, or, in other words, a will independent of the society itself. It is no less certain than it is important, notwithstanding the contrary opinions which have been entertained, that the larger the society, provided it lie within a practical sphere, the more duly capable it will be of self-government. And happily for the *republican cause,* the practicable sphere may be carried to a very great extent, by a judicious modification and mixture of the *federal principle.*

PUBLIUS

Appendix F

■ THE MONROE DOCTRINE

December 2, 1823

Message to Congress from President James Monroe

... At the proposal of the Russian Imperial Government, made through the minister of the Emperor [the Russian Tsar] residing here, a full power and instructions have been transmitted to the minister of the United States at St. Petersburg to arrange by amicable negotiations the respective rights and interests of the two nations on the northwest coast of this continent. A similar proposal had been made by His Imperial Majesty to the Government of Great Britain, which has likewise been acceded to. The Government of the United States has been desirous by this friendly proceeding of manifesting the great value which they have invariably attached to the friendship of the Emperor and their solicitude to cultivate the best understanding with his Government. In the discussions to which this interest has given rise and in the arrangements by which they may terminate, the occasion has been judged proper for asserting, as a principle in which the rights and interests of the United States are involved, that the American continents, by the free and independent condition which they have assumed and maintain, are henceforth not to be considered as subjects for future colonization by any European powers. ...

It was stated at the commencement of the last session that a great effort was then making in Spain and Portugal to improve the condition of the people of those countries, and that it appeared to be conducted with extraordinary moderation. It need scarcely be remarked that the result has been so far very different from what was then anticipated. Of events in that quarter of the globe, with which we have so much intercourse and from which we derive our origin, we have always been anxious and interested spectators. The citizens of the United States cherish sentiments the most friendly in favor of the liberty and happiness of their fellow-men on that side of the Atlantic. In the wars of the European powers in matters relating to themselves we have never taken any part, nor does it comport with our policy so to do. It is only when our rights are invaded or seriously menaced that we resent injuries or make preparation for our defense. With the movements in this hemisphere we are of necessity more immediately connected, and by causes which must be obvious to all enlightened and impartial observers. The political system of the allied powers is essentially different in this respect from that of America. This difference proceeds from that which exists in their respective Governments; and to the defense of our own, which has been achieved by the loss of so much blood and treasure, and matured by the wisdom of their most enlightened citizens, and under which we have enjoyed unexampled felicity ...We owe it, therefore, to candor and to the amicable relations existing between the United States and those [allied] powers to declare that we should consider any attempt on their part to extend their system to any portion of this hemisphere as dangerous to our peace and safety. With the existing colonies or dependencies of any European power we have not interfered and shall not interfere. But with the [Latin American] Governments who have declared their independence and maintained it, and whose independence we have, on great consideration and on just principles, acknowledged, we could not view any interposition for the purpose of oppressing them, or controlling in any other manner their destiny, by any European power in any other light than as the manifestation of any unfriendly disposition toward the United States. In the war between those new

Governments and Spain we declared our neutrality at the time of their recognition, and to this we have adhered, and shall continue to adhere, provided no change shall occur which, in the judgment of the competent authorities of this Government, shall make a corresponding change on the part of the United States indispensable to their security.

The late events in Spain and Portugal show that Europe is still unsettled. Of this important fact no stronger proof can be adduced than that the allied powers should have thought it proper, on any principle satisfactory to themselves, to have interposed by force in the internal concerns of Spain. To what extent such interposition may be carried, on the same principle, is a question in which all independent powers whose governments differ from theirs are interested, even those most remote, and surely none more so than the United States. Our policy in regard to Europe, which was adopted at an early stage of the wars which have so long agitated that quarter of the globe, nevertheless remains the same, which is, not to interfere in the internal concerns of any of its powers; to consider the government de facto as the legitimate government for us; to cultivate friendly relations with it, and to preserve those relations by a frank, firm, and manly policy, meeting in all instances the just claims of every power, submitting to injuries from none.

But in regard to those continents circumstances are eminently and conspicuously different. It is impossible that the allied powers should extend their political system to any portion of either continent without endangering our peace and happiness; nor can anyone believe that our southern brethren, if left to themselves, would adopt it of their own accord. It is equally impossible, therefore, that we should behold such interposition in any form with indifference. If we look to the comparative strength and resources of Spain and those new [Latin American] Governments, and their distance from each other, it must be obvious that she can never subdue than. It is still the true policy of the United States to leave the parties to themselves, in the hope that other powers will pursue the same course. . . .

Appendix G

■ THE DECLARATION OF SENTIMENTS (WOMEN'S RIGHTS)

Seneca Falls, New York, 1848

Source: U.S. Dept. of State

The Declaration of Sentiments and Resolutions was drafted by Elizabeth Cady Stanton for the women's rights convention at Seneca Falls, New York, in 1848. Based on the American Declaration of Independence, the Sentiments demanded equality with men before the law, in education and employment. Here, too, was the first pronouncement demanding that women be given the right to vote.

Sentiments

When, in the course of human events, it becomes necessary for one portion of the family of man to assume among the people of the earth a position different from that which they have hitherto occupied, but one to which the laws of nature and of nature's God entitle them, a decent respect to the opinions of mankind requires that they should declare the causes that impel them to such a course.

We hold these truths to be self-evident: that all men and women are created equal; that they are endowed by their Creator with certain inalienable rights; that among these are life, liberty, and the pursuit of happiness; that to secure these rights governments are instituted, deriving their just powers from the consent of the governed. Whenever any form of government becomes destructive of these ends, it is the right of those who suffer from it to refuse allegiance to it, and to insist upon the institution of a new government, laying its foundation on such principles, and organizing its powers in such form, as to them shall seem most likely to effect their safety and happiness.

Prudence, indeed, will dictate that governments long established should not be changed for light and transient causes; and, accordingly, all experience has shown that mankind are more disposed to suffer, while evils are sufferable, than to right themselves by abolishing the forms to which they were accustomed. But when a long train of abuses and usurpations, pursuing invariably the same object, evinces a design to reduce them under absolute despotism, it is their duty to throw off such government and to provide new guards for their future security. Such has been the patient sufferance of the women under this government, and such is now the necessity which constrains them to demand the equal station to which they are entitled.

The history of mankind is a history of repeated injuries and usurpations on the part of man toward woman, having in direct object the establishment of an absolute tyranny over her. To prove this, let facts be submitted to a candid world.

He has never permitted her to exercise her inalienable right to the elective franchise.

He has compelled her to submit to law in the formation of which she had no voice.

He has withheld from her rights which are given to the most ignorant and degraded men, both natives and foreigners.

Having deprived her of this first right as a citizen, the elective franchise, thereby leaving her without representation in the halls of legislation, he has oppressed her on all sides.

He has made her, if married, in the eye of the law, civilly dead. He has taken from her all right in property, even to the wages she earns.

He has made her morally, an irresponsible being, as she can commit many crimes with impunity, provided they be done in the presence of her husband. In the covenant of marriage, she is compelled to promise obedience to her husband, he becoming, to all intents and purposes, her master-the law giving him power to deprive her of her liberty and to administer chastisement.

He has so framed the laws of divorce, as to what shall be the proper causes and, in case of separation, to whom the guardianship of the children shall be given, as to be wholly regardless of the happiness of the women—the law, in all cases, going upon a false supposition of the supremacy of man and giving all power into his hands.

After depriving her of all rights as a married woman, if single and the owner of property, he has taxed her to support a government which recognizes her only when her property can be made profitable to it.

He has monopolized nearly all the profitable employments, and from those she is permitted to follow, she receives but a scanty remuneration. He closes against her all the avenues to wealth and distinction which he considers most honorable to himself. As a teacher of theology, medicine, or law, she is not known.

He has denied her the facilities for obtaining a thorough education, all colleges being closed against her.

He allows her in church, as well as state, but a subordinate position, claiming apostolic authority for her exclusion from the ministry, and, with some exceptions, from any public participation in the affairs of the church.

He has created a false public sentiment by giving to the world a different code of morals for men and women, by which moral delinquencies which exclude women from society are not only tolerated but deemed of little account in man.

He has usurped the prerogative of Jehovah himself, claiming it as his right to assign for her a sphere of action, when that belongs to her conscience and to her God.

He has endeavored, in every way that he could, to destroy her confidence in her own powers, to lessen her self-respect, and to make her willing to lead a dependent and abject life.

Now, in view of this entire disfranchisement of one-half the people of this country, their social and religious degradation, in view of the unjust laws above mentioned, and because women do feel themselves aggrieved, oppressed, and fraudulently deprived of their most sacred rights, we insist that they have immediate admission to all the rights and privileges which belong to them as citizens of the United States.

In entering upon the great work before us, we anticipate no small amount of misconception, misrepresentation, and ridicule; but we shall use every instrumentality within our power to effect our object. We shall employ agents, circulate tracts, petition the state and national legislatures, and endeavor to enlist the pulpit and the press in our behalf. We hope this Convention will be followed by a series of conventions embracing every part of the country.

Resolutions

Whereas, the great precept of nature is conceded to be that "man shall pursue his own true and substantial happiness." Blackstone in his *Commentaries* remarks that this law of nature, being coeval with mankind and dictated by God himself, is, of course, superior in obligation to any other. It is binding over all the globe, in all countries and at all times; no human laws are of any validity if contrary to this, and such of them as are valid derive all their force, and all their validity, and all their authority, mediately and immediately, from this original; therefore,

Resolved, that such laws as conflict, in any way, with the true and substantial happiness of woman, are contrary to the great precept of nature and of no validity, for this is superior in obligation to any other.

Resolved, that all laws which prevent woman from occupying such a station in society as her conscience shall dictate, or which place her in a position inferior to that of man, are contrary to the great precept of nature and therefore of no force or authority.

Resolved, that woman is man's equal, was intended to be so by the Creator, and the highest good of the race demands that she should be recognized as such.

Resolved, that the women of this country ought to be enlightened in regard to the laws under which they live, that they may no longer publish their degradation by declaring themselves satisfied with their present position, nor their ignorance, by asserting that they have all the rights they want.

Resolved, that inasmuch as man, while claiming for himself intellectual superiority, does accord to woman moral superiority, it is preeminently his duty to encourage her to speak and teach, as she has an opportunity, in all religious assemblies.

Resolved, that the same amount of virtue, delicacy, and refinement of behavior that is required of woman in the social state also be required of man, and the same transgressions should be visited with equal severity on both man and woman.

Resolved, that the objection of indelicacy and impropriety, which is so often brought against woman when she addresses a public audience, comes with a very ill grace from those who encourage, by their attendance, her appearance on the stage, in the concert, or in feats of the circus.

Resolved, that woman has too long rested satisfied in the circumscribed limits which corrupt customs and a perverted application of the Scriptures have marked out for her, and that it is time she should move in the enlarged sphere which her great Creator has assigned her.

Resolved, that it is the duty of the women of this country to secure to themselves their sacred right to the elective franchise.

Resolved, that the equality of human rights results necessarily from the fact of the identity of the race in capabilities and responsibilities.

Resolved, that the speedy success of our cause depends upon the zealous and untiring efforts of both men and women for the overthrow of the monopoly of the pulpit, and for the securing to woman an equal participation with men in the various trades, professions, and commerce.

Resolved, therefore, that, being invested by the Creator with the same capabilities and same consciousness of responsibility for their exercise, it is demonstrably the right and duty of woman, equally with man, to promote every righteous cause by every righteous means; and especially in regard to the great subjects of morals and religion, it is self-evidently her right to participate with her brother in teaching them, both in private and in public, by writing and by speaking, by any instrumentalities proper to be used, and in any assemblies proper to be held; and this being a self-evident truth growing out of the divinely implanted principles of human nature, any custom or authority adverse to it, whether modern or wearing the hoary sanction of antiquity, is to be regarded as a self-evident falsehood, and at war with mankind.

Appendix H

■THE EMANCIPATION PROCLAMATION
JANUARY 1, 1863

By the President of the United States of America:

A Proclamation.

Whereas, on the twenty-second day of September, in the year of our Lord one thousand eight hundred and sixty-two, a proclamation was issued by the President of the United States, containing, among other things, the following, to wit:

"That on the first day of January, in the year of our Lord one thousand eight hundred and sixty-three, all persons held as slaves within any State or designated part of a State, the people whereof shall then be in rebellion against the United States, shall be then, thenceforward, and forever free; and the Executive Government of the United States, including the military and naval authority thereof, will recognize and maintain the freedom of such persons, and will do no act or acts to repress such persons, or any of them, in any efforts they may make for their actual freedom.

"That the Executive will, on the first day of January aforesaid, by proclamation, designate the States and parts of States, if any, in which the people thereof, respectively, shall then be in rebellion against the United States; and the fact that any State, or the people thereof, shall on that day be, in good faith, represented in the Congress of the United States by members chosen thereto at elections wherein a majority of the qualified voters of such State shall have participated, shall, in the absence of strong countervailing testimony, be deemed conclusive evidence that such State, and the people thereof, are not then in rebellion against the United States."

Now, therefore I, Abraham Lincoln, President of the United States, by virtue of the power in me vested as Commander-in-Chief, of the Army and Navy of the United States in time of actual armed rebellion against the authority and government of the United States, and as a fit and necessary war measure for suppressing said rebellion, do, on this first day of January, in the year of our Lord one thousand eight hundred and sixty-three, and in accordance with my purpose so to do publicly proclaimed for the full period of one hundred days, from the day first above mentioned, order and designate as the States and parts of States wherein the people thereof respectively, are this day in rebellion against the United States, the following, to wit:

Arkansas, Texas, Louisiana, (except the Parishes of St. Bernard, Plaquemines, Jefferson, St. John, St. Charles, St. James Ascension, Assumption, Terrebonne, Lafourche, St. Mary, St. Martin, and Orleans, including the City of New Orleans) Mississippi, Alabama, Florida, Georgia, South Carolina, North Carolina, and Virginia, (except the forty-eight counties designated as West Virginia, and also the counties of Berkley, Accomac, Northampton, Elizabeth City, York, Princess Ann, and Norfolk, including the cities of Norfolk and Portsmouth[)], and which excepted parts, are for the present, left precisely as if this proclamation were not issued.

And by virtue of the power, and for the purpose aforesaid, I do order and declare that all persons held as slaves within said designated States, and parts of States, are, and henceforward shall be free; and that the Executive Government of the United States, including the military and naval authorities thereof, will recognize and maintain the freedom of said persons.

And I hereby enjoin upon the people so declared to be free to abstain from all violence, unless in necessary self-defence; and I recommend to them that, in all cases when allowed, they labor faithfully for reasonable wages.

And I further declare and make known, that such persons of suitable condition, will be received into the armed service of the United States to garrison forts, positions, stations, and other places, and to man vessels of all sorts in said service.

And upon this act, sincerely believed to be an act of justice, warranted by the Constitution, upon military necessity, I invoke the considerate judgment of mankind, and the gracious favor of Almighty God.

In witness whereof, I have hereunto set my hand and caused the seal of the United States to be affixed.

Done at the City of Washington, this first day of January, in the year of our Lord one thousand eight hundred and sixty-three, and of the Independence of the United States of America the eighty-seventh.

By the President: ABRAHAM LINCOLN

WILLIAM H. SEWARD, Secretary of State.

Appendix I

■ THE CONSTITUTION OF THE CONFEDERATE STATES OF AMERICA MARCH 11, 1861

Preamble

We, the people of the Confederate States, each State acting in its sovereign and independent character, in order to form a permanent federal government, establish justice, insure domestic tranquillity, and secure the blessings of liberty to ourselves and our posterity invoking the favor and guidance of Almighty God do ordain and establish this Constitution for the Confederate States of America.

Article I

Section 1

All legislative powers herein delegated shall be vested in a Congress of the Confederate States, which shall consist of a Senate and House of Representatives.

Section 2

(1) The House of Representatives shall be composed of members chosen every second year by the people of the several States; and the electors in each State shall be citizens of the Confederate States, and have the qualifications requisite for electors of the most numerous branch of the State Legislature; but no person of foreign birth, not a citizen of the Confederate States, shall be allowed to vote for any officer, civil or political, State or Federal.

(2) No person shall be a Representative who shall not have attained the age of twenty-five years, and be a citizen of the Confederate States, and who shall not when elected, be an inhabitant of that State in which he shall be chosen.

(3) Representatives and direct taxes shall be apportioned among the several States, which may be included within this Confederacy, according to their respective numbers, which shall be determined by adding to the whole number of free persons, including those bound to service for a term of years, and excluding Indians not taxed, three-fifths of all slaves. The actual enumeration shall be made within three years after the first meeting of the Congress of the Confederate States, and within every subsequent term of ten years, in such manner as they shall by law direct. The number of Representatives shall not exceed one for every fifty thousand, but each State shall have at least one Representative; and until such enumeration shall be made, the State of South Carolina shall be entitled to choose six; the State of Georgia ten; the State of Alabama nine; the State of Florida two; the State of Mississippi seven; the State of Louisiana six; and the State of Texas six.

(4) When vacancies happen in the representation from any State the executive authority thereof shall issue writs of election to fill such vacancies.

(5) The House of Representatives shall choose their Speaker and other officers; and shall have the sole power of impeachment; except that any judicial or other Federal officer, resident and acting solely

within the limits of any State, may be impeached by a vote of two-thirds of both branches of the Legislature thereof.

Section 3

(1) The Senate of the Confederate States shall be composed of two Senators from each State, chosen for six years by the Legislature thereof, at the regular session next immediately preceding the commencement of the term of service; and each Senator shall have one vote.

(2) Immediately after they shall be assembled, in consequence of the first election, they shall be divided as equally as may be into three classes. The seats of the Senators of the first class shall be vacated at the expiration of the second year; of the second class at the expiration of the fourth year; and of the third class at the expiration of the sixth year; so that one-third may be chosen every second year; and if vacancies happen by resignation, or other wise, during the recess of the Legislature of any State, the Executive thereof may make temporary appointments until the next meeting of the Legislature, which shall then fill such vacancies.

(3) No person shall be a Senator who shall not have attained the age of thirty years, and be a citizen of the Confederate States; and who shall not, then elected, be an inhabitant of the State for which he shall be chosen.

(4) The Vice-President of the Confederate States shall be president of the Senate, but shall have no vote unless they be equally divided.

(5) The Senate shall choose their other officers; and also a president pro tempore in the absence of the Vice-President, or when he shall exercise the office of President of the Confederate states.

(6) The Senate shall have the sole power to try all impeachments. When sitting for that purpose, they shall be on oath or affirmation. When the President of the Confederate States is tried, the Chief Justice shall preside; and no person shall be convicted without the concurrence of two-thirds of the members present.

(7) Judgment in cases of impeachment shall not extend further than to removal from office, and disqualification to hold any office of honor, trust, or profit under the Confederate States; but the party convicted shall, nevertheless, be liable and subject to indictment, trial, judgment, and punishment according to law.

Section 4

(1) The times, places, and manner of holding elections for Senators and Representatives shall be prescribed in each State by the Legislature thereof, subject to the provisions of this Constitution; but the Congress may, at any time, by law, make or alter such regulations, except as to the times and places of choosing Senators.

(2) The Congress shall assemble at least once in every year; and such meeting shall be on the first Monday in December, unless they shall, by law, appoint a different day.

Section 5

(1) Each House shall be the judge of the elections, returns, and qualifications of its own members, and a majority of each shall constitute a quorum to do business; but a smaller number may adjourn from day to day, and may be authorized to compel the attendance of absent members, in such manner and under such penalties as each House may provide.

(2) Each House may determine the rules of its proceedings, punish its members for disorderly behavior, and, with the concurrence of two-thirds of the whole number, expel a member.

(3) Each House shall keep a journal of its proceedings, and from time to time publish the same, excepting such parts as may in their judgment require secrecy; and the yeas and nays of the members of either House, on any question, shall, at the desire of one-fifth of those present, be entered on the journal.

(4) Neither House, during the session of Congress, shall, without the consent of the other, adjourn for more than three days, nor to any other place than that in which the two Houses shall be sitting.

Section 6

(1) The Senators and Representatives shall receive a compensation for their services, to be ascertained by law, and paid out of the Treasury of the Confederate States. They shall, in all cases, except treason, felony, and breach of the peace, be privileged from arrest during their attendance at the session of their respective Houses, and in going to and returning from the same; and for any speech or debate in either House, they shall not be questioned in any other place. No Senator or Representative shall, during the time for which he was elected, be appointed to any civil office under the authority of the Confederate States, which shall have been created, or the emoluments whereof shall have been increased during such time; and no person holding any office under the Confederate States shall be a member of either House during his continuance in office. But Congress may, by law, grant to the principal officer in each of the Executive Departments a seat upon the floor of either House, with the privilege of discussing any measures appertaining to his department.

Section 7

(1) All bills for raising revenue shall originate in the House of Representatives; but the Senate may propose or concur with amendments, as on other bills.

(2) Every bill which shall have passed both Houses, shall, before it becomes a law, be presented to the President of the Confederate States; if he approve, he shall sign it; but if not, he shall return it, with his objections, to that House in which it shall have originated, who shall enter the objections at large on their journal, and proceed to reconsider it. If, after such reconsideration, two-thirds of that House shall agree to pass the bill, it shall be sent, together with the objections, to the other House, by which it shall likewise be reconsidered, and if approved by two-thirds of that House, it shall become a law. But in all such cases, the votes of both Houses shall be determined by yeas and nays, and the names of the persons voting for and against the bill shall be entered on the journal of each House respectively. If any bill shall not be returned by the President within ten days (Sundays excepted) after it shall have been presented to him, the same shall be a law, in like manner as if he had signed it, unless the Congress, by their adjournment, prevent its return; in which case it shall not be a law. The President may approve any appropriation and disapprove any other appropriation in the same bill. In such case he shall, in signing the bill, designate the appropriations disapproved; and shall return a copy of such appropriations, with his objections, to the House in which the bill shall have originated; and the same proceedings shall then be had as in case of other bills disapproved by the President.

(3) Every order, resolution, or vote, to which the concurrence of both Houses may be necessary (except on a question of adjournment) shall be presented to the President of the Confederate States; and before the same shall take effect, shall be approved by him; or, being disapproved by him, shall be repassed by two-thirds of both Houses, according to the rules and limitations prescribed in case of a bill.

Section 8

The Congress shall have power

(1) To lay and collect taxes, duties, imposts, and excises for revenue, necessary to pay the debts, provide for the common defense, and carry on the Government of the Confederate States; but no bounties shall be granted from the Treasury; nor shall any duties or taxes on importations from foreign nations be laid to promote or foster any branch of industry; and all duties, imposts, and excises shall be uniform throughout the Confederate States.

(2) To borrow money on the credit of the Confederate States.

(3) To regulate commerce with foreign nations, and among the several States, and with the Indian tribes; but neither this, nor any other clause contained in the Constitution, shall ever be construed to delegate the power to Congress to appropriate money for any internal improvement intended to facilitate commerce; except for the purpose of furnishing lights, beacons, and buoys, and other aids to navigation upon the coasts, and the improvement of harbors and the removing of obstructions in river navigation; in all which cases such duties shall be laid on the navigation facilitated thereby as may be necessary to pay the costs and expenses thereof.

(4) To establish uniform laws of naturalization, and uniform laws on the subject of bankruptcies, throughout the Confederate States; but no law of Congress shall discharge any debt contracted before the passage of the same.

(5) To coin money, regulate the value thereof, and of foreign coin, and fix the standard of weights and measures.

(6) To provide for the punishment of counterfeiting the securities and current coin of the Confederate States.

(7) To establish post offices and post routes; but the expenses of the Post Office Department, after the 1st day of March in the year of our Lord eighteen hundred and sixty-three, shall be paid out of its own revenues.

(8) To promote the progress of science and useful arts, by securing for limited times to authors and inventors the exclusive right to their respective writings and discoveries.

(9) To constitute tribunals inferior to the Supreme Court.

(10) To define and punish piracies and felonies committed on the high seas, and offenses against the law of nations.

(11) To declare war, grant letters of marque and reprisal, and make rules concerning captures on land and water.

(12) To raise and support armies; but no appropriation of money to that use shall be for a longer term than two years.

(13) To provide and maintain a navy.

(14) To make rules for the government and regulation of the land and naval forces.

(15) To provide for calling forth the militia to execute the laws of the Confederate States, suppress insurrections, and repel invasions.

(16) To provide for organizing, arming, and disciplining the militia, and for governing such part of them as may be employed in the service of the Confederate States; reserving to the States, respectively, the appointment of the officers, and the authority of training the militia according to the discipline prescribed by Congress.

(17) To exercise exclusive legislation, in all cases whatsoever, over such district (not exceeding ten miles square) as may, by cession of one or more States and the acceptance of Congress, become the seat of the Government of the Confederate States; and to exercise like authority over all places purchased by the consent of the Legislature of the State in which the same shall be, for the erection of forts, magazines, arsenals, dockyards, and other needful buildings; and

(18) To make all laws which shall be necessary and proper for carrying into execution the foregoing powers, and all other powers vested by this Constitution in the Government of the Confederate States, or in any department or officer thereof.

Section 9

(1) The importation of negroes of the African race from any foreign country other than the slaveholding States or Territories of the United States of America, is hereby forbidden; and Congress is required to pass such laws as shall effectually prevent the same.

(2) Congress shall also have power to prohibit the introduction of slaves from any State not a member of, or Territory not belonging to, this Confederacy.

(3) The privilege of the writ of habeas corpus shall not be suspended, unless when in cases of rebellion or invasion the public safety may require it.

(4) No bill of attainder, *ex post facto* law, or law denying or impairing the right of property in negro slaves shall be passed.

(5) No capitation or other direct tax shall be laid, unless in proportion to the census or enumeration hereinbefore directed to be taken.

(6) No tax or duty shall be laid on articles exported from any State, except by a vote of two-thirds of both Houses.

(7) No preference shall be given by any regulation of commerce or revenue to the ports of one State over those of another.

(8) No money shall be drawn from the Treasury, but in consequence of appropriations made by law; and a regular statement and account of the receipts and expenditures of all public money shall be published from time to time.

(9) Congress shall appropriate no money from the Treasury except by a vote of two-thirds of both Houses, taken by yeas and nays, unless it be asked and estimated for by some one of the heads of departments and submitted to Congress by the President; or for the purpose of paying its own expenses and contingencies; or for the payment of claims against the Confederate States, the justice of which shall have been judicially declared by a tribunal for the investigation of claims against the Government, which it is hereby made the duty of Congress to establish.

(10) All bills appropriating money shall specify in Federal currency the exact amount of each appropriation and the purposes for which it is made; and Congress shall grant no extra compensation to any public contractor, officer, agent, or servant, after such contract shall have been made or such service rendered.

(11) No title of nobility shall be granted by the Confederate States; and no person holding any office of profit or trust under them shall, without the consent of the Congress, accept of any present, emolument, office, or title of any kind whatever, from any king, prince, or foreign state.

(12) Congress shall make no law respecting an establishment of religion, or prohibiting the free exercise thereof; or abridging the freedom of speech, or of the press; or the right of the people peaceably to assemble and petition the Government for a redress of grievances.

(13) A well-regulated militia being necessary to the security of a free State, the right of the people to keep and bear arms shall not be infringed.

(14) No soldier shall, in time of peace, be quartered in any house without the consent of the owner; nor in time of war, but in a manner to be prescribed by law.

(15) The right of the people to be secure in their persons, houses, papers, and effects, against unreasonable searches and seizures, shall not be violated; and no warrants shall issue but upon probable cause, supported by oath or affirmation, and particularly describing the place to be searched and the persons or things to be seized.

(16) No person shall be held to answer for a capital or otherwise infamous crime, unless on a presentment or indictment of a grand jury, except in cases arising in the land or naval forces, or in the militia, when in actual service in time of war or public danger; nor shall any person be subject for the same offense to be twice put in jeopardy of life or limb; nor be compelled, in any criminal case, to be a witness against himself; nor be deprived of life, liberty, or property without due process of law; nor shall private property be taken for public use, without just compensation.

(17) In all criminal prosecutions the accused shall enjoy the right to a speedy and public trial, by an impartial jury of the State and district wherein the crime shall have been committed, which district shall have been previously ascertained by law, and to be informed of the nature and cause of the accusation; to be confronted with the witnesses against him; to have compulsory process for obtaining witnesses in his favor; and to have the assistance of counsel for his defense.

(18) In suits at common law, where the value in controversy shall exceed twenty dollars, the right of trial by jury shall be preserved; and no fact so tried by a jury shall be otherwise reexamined in any court of the Confederacy, than according to the rules of common law.

(19) Excessive bail shall not be required, nor excessive fines imposed, nor cruel and unusual punishments inflicted.

(20) Every law, or resolution having the force of law, shall relate to but one subject, and that shall be expressed in the title.

Section 10

(1) No State shall enter into any treaty, alliance, or confederation; grant letters of marque and reprisal; coin money; make anything but gold and silver coin a tender in payment of debts; pass any bill of attainder, or *ex post facto* law, or law impairing the obligation of contracts; or grant any title of nobility.

(2) No State shall, without the consent of the Congress, lay any imposts or duties on imports or exports, except what may be absolutely necessary for executing its inspection laws; and the net produce of all duties and imposts, laid by any State on imports, or exports, shall be for the use of the Treasury of the Confederate States; and all such laws shall be subject to the revision and control of Congress.

(3) No State shall, without the consent of Congress, lay any duty on tonnage, except on seagoing vessels, for the improvement of its rivers and harbors navigated by the said vessels; but such duties shall not conflict with any treaties of the Confederate States with foreign nations; and any surplus revenue thus

derived shall, after making such improvement, be paid into the common treasury. Nor shall any State keep troops or ships of war in time of peace, enter into any agreement or compact with another State, or with a foreign power, or engage in war, unless actually invaded, or in such imminent danger as will not admit of delay. But when any river divides or flows through two or more States they may enter into compacts with each other to improve the navigation thereof.

ARTICLE II

Section I

(1) The executive power shall be vested in a President of the Confederate States of America. He and the Vice-President shall hold their offices for the term of six years; but the President shall not be reeligible. The President and Vice-President shall be elected as follows:

(2) Each State shall appoint, in such manner as the Legislature thereof may direct, a number of electors equal to the whole number of Senators and Representatives to which the State may be entitled in the Congress; but no Senator or Representative or person holding an office of trust or profit under the Confederate States shall be appointed an elector.

(3) The electors shall meet in their respective States and vote by ballot for President and Vice-President, one of whom, at least, shall not be an inhabitant of the same State with themselves; they shall name in their ballots the person voted for as President, and in distinct ballots the person voted for as Vice-President, and they shall make distinct lists of all persons voted for as President, and of all persons voted for as Vice-President, and of the number of votes for each, which lists they shall sign and certify, and transmit, sealed, to the seat of the Government of the Confederate States, directed to the President of the Senate; the President of the Senate shall, in the presence of the Senate and House of Representatives, open all the certificates, and the votes shall then be counted; the person having the greatest number of votes for President shall be the President, if such number be a majority of the whole number of electors appointed; and if no person have such majority, then from the persons having the highest numbers, not exceeding three, on the list of those voted for as President, the House of Representatives shall choose immediately, by ballot, the President. But in choosing the President the votes shall be taken by States, the representation from each State having one vote; a quorum for this purpose shall consist of a member or members from two-thirds of the States, and a majority of all the States shall be necessary to a choice. And if the House of Representatives shall not choose a President, whenever the right of choice shall devolve upon them, before the 4th day of March next following, then the Vice-President shall act as President, as in case of the death, or other constitutional disability of the President.

(4) The person having the greatest number of votes as Vice-President shall be the Vice-President, if such number be a majority of the whole number of electors appointed; and if no person have a majority, then, from the two highest numbers on the list, the Senate shall choose the Vice-President; a quorum for the purpose shall consist of two-thirds of the whole number of Senators, and a majority of the whole number shall be necessary to a choice.

(5) But no person constitutionally ineligible to the office of President shall be eligible to that of Vice-President of the Confederate States.

(6) The Congress may determine the time of choosing the electors, and the day on which they shall give their votes; which day shall be the same throughout the Confederate States.

(7) No person except a natural-born citizen of the Confederate States, or a citizen thereof at the time of the adoption of this Constitution, or a citizen thereof born in the United States prior to the 20th of December, 1860, shall be eligible to the office of President; neither shall any person be eligible to that office who shall not have attained the age of thirty-five years, and been fourteen years a resident within the limits of the Confederate States, as they may exist at the time of his election.

(8) In case of the removal of the President from office, or of his death, resignation, or inability to discharge the powers and duties of said office, the same shall devolve on the Vice-President; and the Congress may, by law, provide for the case of removal, death, resignation, or inability, both of the President and Vice-President, declaring what officer shall then act as President; and such officer shall act accordingly until the disability be removed or a President shall be elected.

(9) The President shall, at stated times, receive for his services a compensation, which shall neither be increased nor diminished during the period for which he shall have been elected; and he shall not receive within that period any other emolument from the Confederate States, or any of them.

(10) Before he enters on the execution of his office he shall take the following oath or affirmation:

Section 2

(1) The President shall be Commander in Chief of the Army and Navy of the Confederate States, and of the militia of the several States, when called into the actual service of the Confederate States; he may require the opinion, in writing, of the principal officer in each of the Executive Departments, upon any subject relating to the duties of their respective offices; and he shall have power to grant reprieves and pardons for offenses against the Confederate States, except in cases of impeachment.

(2) He shall have power, by and with the advice and consent of the Senate, to make treaties; provided two-thirds of the Senators present concur; and he shall nominate, and by and with the advice and consent of the Senate shall appoint, ambassadors, other public ministers and consuls, judges of the Supreme Court, and all other officers of the Confederate States whose appointments are not herein otherwise provided for, and which shall be established by law; but the Congress may, by law, vest the appointment of such inferior officers, as they think proper, in the President alone, in the courts of law, or in the heads of departments.

(3) The principal officer in each of the Executive Departments, and all persons connected with the diplomatic service, may be removed from office at the pleasure of the President. All other civil officers of the Executive Departments may be removed at any time by the President, or other appointing power, when their services are unnecessary, or for dishonesty, incapacity, inefficiency, misconduct, or neglect of duty; and when so removed, the removal shall be reported to the Senate, together with the reasons therefor.

(4) The President shall have power to fill all vacancies that may happen during the recess of the Senate, by granting commissions which shall expire at the end of their next session; but no person rejected by the Senate shall be reappointed to the same office during their ensuing recess.

Section 3

(1) The President shall, from time to time, give to the Congress information of the state of the Confederacy, and recommend to their consideration such measures as he shall judge necessary and expedient; he may, on extraordinary occasions, convene both Houses, or either of them; and in case of disagreement between them, with respect to the time of adjournment, he may adjourn them to such time as he shall think proper; he shall receive ambassadors and other public ministers; he shall take care that the laws be faithfully executed, and shall commission all the officers of the Confederate States.

Section 4

(1) The President, Vice-President, and all civil officers of the Confederate States, shall be removed from office on impeachment for and conviction of treason, bribery, or other high crimes and misdemeanors.

ARTICLE III

Section 1

(1) The judicial power of the Confederate States shall be vested in one Supreme Court, and in such inferior courts as the Congress may, from time to time, ordain and establish. The judges, both of the Supreme and inferior courts, shall hold their offices during good behavior, and shall, at stated times, receive for their services a compensation which shall not be diminished during their continuance in office.

Section 2

(1) The judicial power shall extend to all cases arising under this Constitution, the laws of the Confederate States, and treaties made, or which shall be made, under their authority; to all cases affecting ambassadors, other public ministers and consuls; to all cases of admiralty and maritime jurisdiction; to controversies to which the Confederate States shall be a party; to controversies between two or more States; between a State and citizens of another State, where the State is plaintiff; between citizens claiming lands under grants of different States; and between a State or the citizens thereof, and foreign states, citizens, or subjects; but no State shall be sued by a citizen or subject of any foreign state.

(2) In all cases affecting ambassadors, other public ministers and consuls, and those in which a State shall be a party, the Supreme Court shall have original jurisdiction. In all the other cases before mentioned, the Supreme Court shall have appellate jurisdiction both as to law and fact, with such exceptions and under such regulations as the Congress shall make.

(3) The trial of all crimes, except in cases of impeachment, shall be by jury, and such trial shall be held in the State where the said crimes shall have been committed; but when not committed within any State, the trial shall be at such place or places as the Congress may by law have directed.

Section 3

(1) Treason against the Confederate States shall consist only in levying war against them, or in adhering to their enemies, giving them aid and comfort. No person shall be convicted of treason unless on the testimony of two witnesses to the same overt act, or on confession in open court.

(2) The Congress shall have power to declare the punishment of treason; but no attainder of treason shall work corruption of blood, or forfeiture, except during the life of the person attainted.

ARTICLE IV

Section 1

(1) Full faith and credit shall be given in each State to the public acts, records, and judicial proceedings of every other State; and the Congress may, by general laws, prescribe the manner in which such acts, records, and proceedings shall be proved, and the effect thereof.

Section 2

(1) The citizens of each State shall be entitled to all the privileges and immunities of citizens in the several States; and shall have the right of transit and sojourn in any State of this Confederacy, with their slaves and other property; and the right of property in said slaves shall not be thereby impaired.

(2) A person charged in any State with treason, felony, or other crime against the laws of such State, who shall flee from justice, and be found in another State, shall, on demand of the executive authority of the State from which he fled, be delivered up, to be removed to the State having jurisdiction of the crime.

(3) No slave or other person held to service or labor in any State or Territory of the Confederate States, under the laws thereof, escaping or lawfully carried into another, shall, in consequence of any law or regulation therein, be discharged from such service or labor; but shall be delivered up on claim of the party to whom such slave belongs, or to whom such service or labor may be due.

Section 3

(1) Other States may be admitted into this Confederacy by a vote of two-thirds of the whole House of Representatives and two-thirds of the Senate, the Senate voting by States; but no new State shall be formed or erected within the jurisdiction of any other State, nor any State be formed by the junction of two or more States, or parts of States, without the consent of the Legislatures of the States concerned, as well as of the Congress.

(2) The Congress shall have power to dispose of and make all needful rules and regulations concerning the property of the Confederate States, including the lands thereof.

(3) The Confederate States may acquire new territory; and Congress shall have power to legislate and provide governments for the inhabitants of all territory belonging to the Confederate States, lying without the limits of the several Sates; and may permit them, at such times, and in such manner as it may by law provide, to form States to be admitted into the Confederacy. In all such territory the institution of negro slavery, as it now exists in the Confederate States, shall be recognized and protected by Congress and by the Territorial government; and the inhabitants of the several Confederate States and Territories shall have the right to take to such Territory any slaves lawfully held by them in any of the States or Territories of the Confederate States.

(4) The Confederate States shall guarantee to every State that now is, or hereafter may become, a member of this Confederacy, a republican form of government; and shall protect each of them against

invasion; and on application of the Legislature (or of the Executive when the Legislature is not in session) against domestic violence.

ARTICLE V

Section 1

(1) Upon the demand of any three States, legally assembled in their several conventions, the Congress shall summon a convention of all the States, to take into consideration such amendments to the Constitution as the said States shall concur in suggesting at the time when the said demand is made; and should any of the proposed amendments to the Constitution be agreed on by the said convention, voting by States, and the same be ratified by the Legislatures of two-thirds of the several States, or by conventions in two-thirds thereof, as the one or the other mode of ratification may be proposed by the general convention, they shall thenceforward form a part of this Constitution. But no State shall, without its consent, be deprived of its equal representation in the Senate.

ARTICLE VI

Section 1

(1) The Government established by this Constitution is the successor of the Provisional Government of the Confederate States of America, and all the laws passed by the latter shall continue in force until the same shall be repealed or modified; and all the officers appointed by the same shall remain in office until their successors are appointed and qualified, or the offices abolished.

(2) All debts contracted and engagements entered into before the adoption of this Constitution shall be as valid against the Confederate States under this Constitution, as under the Provisional Government.

(3) This Constitution, and the laws of the Confederate States made in pursuance thereof, and all treaties made, or which shall be made, under the authority of the Confederate States, shall be the supreme law of the land; and the judges in every State shall be bound thereby, anything in the constitution or laws of any State to the contrary notwithstanding.

(4) The Senators and Representatives before mentioned, and the members of the several State Legislatures, and all executive and judicial officers, both of the Confederate States and of the several States, shall be bound by oath or affirmation to support this Constitution; but no religious test shall ever be required as a qualification to any office or public trust under the Confederate States.

(5) The enumeration, in the Constitution, of certain rights shall not be construed to deny or disparage others retained by the people of the several States.

(6) The powers not delegated to the Confederate States by the Constitution, nor prohibited by it to the States, are reserved to the States, respectively, or to the people thereof.

ARTICLE VII

Section 1

(1) The ratification of the conventions of five States shall be sufficient for the establishment of this Constitution between the States so ratifying the same.

(2) When five States shall have ratified this Constitution, in the manner before specified, the Congress under the Provisional Constitution shall prescribe the time for holding the election of President and Vice-President; and for the meeting of the Electoral College; and for counting the votes, and inaugurating the President. They shall, also, prescribe the time for holding the first election of members of Congress under this Constitution, and the time for assembling the same. Until the assembling of such Congress, the Congress under the Provisional Constitution shall continue to exercise the legislative powers granted them; not extending beyond the time limited by the Constitution of the Provisional Government.

Adopted unanimously by the Congress of the Confederate States of South Carolina, Georgia, Florida, Alabama, Mississippi, Louisiana, and Texas, sitting in convention at the capitol, the city of Montgomery, Ala., on the eleventh day of March, in the year eighteen hundred and sixty-one.

HOWELL COBB, President of the Congress.

South Carolina: R. Barnwell Rhett, C. G. Memminger, Wm. Porcher Miles, James Chesnut, Jr., R. W. Barnwell, William W. Boyce, Lawrence M. Keitt, T. J. Withers.

Georgia: Francis S. Bartow, Martin J. Crawford, Benjamin H. Hill, Thos. R. R. Cobb.

Florida: Jackson Morton, J. Patton Anderson, Jas. B. Owens.

Alabama: Richard W. Walker, Robt. H. Smith, Colin J. McRae, William P. Chilton, Stephen F. Hale, David P. Lewis, Tho. Fearn, Jno. Gill Shorter, J. L. M. Curry.

Mississippi: Alex. M. Clayton, James T. Harrison, William S. Barry, W. S. Wilson, Walker Brooke, W. P. Harris, J. A. P. Campbell.

Louisiana: Alex de Clouet, C. M. Conrad, Duncan F. Kenner, Henry Marshall.

Texas: John Hemphill, Thomas N. Waul, John H. Reagan, Williamson S. Oldham, Louis T. Wigfall, John Gregg, William Beck Ochiltree.

Index

Collins College OUTLINES

Fully Revised and Updated

Written by professors, teachers, and experts in various fields, the titles in the Collins College Outlines series provide students with a fast, easy, and simplified approach to the curricula of important introductory courses, and also provide a perfect preparation for AP exams. Each title contains a full index and a "Test Yourself" section with full explanations for each chapter.

BASIC MATHEMATICS
Lawrence A. Trivieri
ISBN 0-06-088146-1 (paperback)

INTRODUCTION TO CALCULUS
Joan Van Glabek
ISBN 0-06-088150-X (paperback)

INTRODUCTION TO AMERICAN GOVERNMENT
Larry Elowitz
ISBN 0-06-088151-8 (paperback)

INTRODUCTION TO PSYCHOLOGY
Joseph Johnson and Ann L. Weber
ISBN 0-06-088152-6 (paperback)

MODERN EUROPEAN HISTORY
John R. Barber
ISBN 0-06-088153-4 (paperback)

ORGANIC CHEMISTRY
Michael Smith
ISBN 0-06-088154-2 (paperback)

UNITED STATES HISTORY TO 1877
Light Cummins and Arnold M. Rice
ISBN 0-06-088159-3 (paperback)

WESTERN CIVILIZATION TO 1500
John Chuchiak and Walter Kirchner
ISBN 0-06-088162-3 (paperback)

ABNORMAL PSYCHOLOGY
(coming in 2007)
Sarah Sifers
ISBN 0-06-088145-3 (paperback)

UNITED STATES HISTORY FROM 1865
(coming in 2007)
John Baick and Arnold M. Rice
ISBN 0-06-088158-5 (paperback)

ELEMENTARY ALGEBRA
(coming in 2007)
Joan Van Glabek
ISBN 0-06-088148-8 (paperback)

SPANISH GRAMMAR
(coming in 2007)
Ana Fairchild and Juan Mendez
ISBN 0-06-088157-7 (paperback)